Exploiting East Asian Cinemas

Global Exploitation Cinemas

Also in the Series:
Disposable Passions: Vintage Pornography and the Material Legacies of Adult Cinema, by David Church
Grindhouse: Cultural Exchange on 42nd Street, and Beyond, edited by Austin Fisher & Johnny Walker

Exploiting East Asian Cinemas

Genre, Circulation, Reception

Edited by
Ken Provencher and Mike Dillon

Bloomsbury Academic
An imprint of Bloomsbury Publishing Inc

B L O O M S B U R Y
NEW YORK · LONDON · OXFORD · NEW DELHI · SYDNEY

Bloomsbury Academic
An imprint of Bloomsbury Publishing Inc

1385 Broadway	50 Bedford Square
New York	London
NY 10018	WC1B 3DP
USA	UK

www.bloomsbury.com

BLOOMSBURY and the Diana logo are trademarks of Bloomsbury Publishing Plc

First published 2018

© Ken Provencher, Mike Dillon, and contributors 2018

Library of Congress Cataloging-in-Publication Data
A catalog record for this book is available from the Library of Congress.

ISBN: HB: 978-1-5013-1965-5
ePDF: 978-1-5013-1967-9
eBook: 978-1-5013-1966-2

Cover design by Seventh Tower Creative Solutions
Cover image © Film *Dragon on Fire* 1978, © I.F.D. Films

Series: Global Exploitation Cinemas

Typeset by Deanta Global Publishing Services, Chennai, India
Printed and bound in the United States of America

To find out more about our authors and books visit www.bloomsbury.com. Here you will find extracts, author interviews, details of forthcoming events, and the option to sign up for our newsletters.

Contents

List of Illustrations

List of Illustrations

Acknowledgments

The editors wish to thank the *Global Exploitation Cinemas* Series Editors Johnny Walker and Austin Fisher for their constant enthusiasm and support for this project. We also want to thank all of the contributors for their responsiveness and cooperation throughout the long process of development. Two anonymous readers of our proposal, and one anonymous reader of the completed manuscript, provided us with extremely helpful comments and suggestions. Thanks as well to Dong Hoon Kim.

Everyone at Bloomsbury Academic has been fantastic to work with throughout development and production. We want to thank especially Katie Gallof, our patient and encouraging editor, and Susan Krogulski, who was essential in helping us organize the text and images. Production Editor Lauren Crisp and Designer Louise Dugdale were also an enormous help at Team Bloomsbury.

Foreword

Julian Stringer

Having spent too much time laboring at his job, the protagonist has turned into a poor husband and a neglectful father, but because he is anxious to win back the affection of his daughter, he agrees to accompany her on a journey to visit her mother. On departing the railway station, however, the two find themselves in a difficult situation—thronged by snarling mutants. Their initiation into combat with these aggressive hybrids turns into an unexampled adventure of trials, atonements, and apotheosis, and in the end there is a return of sorts—albeit a sad one. With escape from the deadly foes within grasp, the father makes the profound discovery that what he actually needs (as opposed to what he wants) is to love his daughter unconditionally. He therefore sacrifices himself for his child, and in so doing reveals that he has been undertaking a double odyssey all along—an outer (visible) one of survival, and an inner (invisible) one toward emotional fulfillment.

The alert reader may recognize in the above description the skeleton plot of *Train to Busan* (*Busanhaeng*; Yeon, 2016; henceforth *Train*), a zombie movie from South Korea that became an international hit at the same time Ken Provencher and Mike Dillon were putting together this stimulating collection of original pieces on *Exploiting East Asian Cinemas*. It is a film that embodies many of the tendencies of exploitation filmmaking from and about the region analyzed by the numerous contributors to this lively and wide-ranging volume. *Train* is characterized by violence and sensationalism, elements also emphasized in its global marketing campaigns. The focus throughout its running time is on the shocking, the taboo, or the otherwise transgressive—evidenced, for example, by the ways in which it provides, alongside the customary gore, an emotional outlet for current events via an impolite engagement with thorny aspects of South Korean society such as social protest, the break-up of the family unit, and rigid workplace hierarchies. Also, it blurs the boundaries between the marginal and the mainstream, being a modestly budgeted production that has nevertheless achieved blockbuster status domestically as well as high visibility overseas.

Further still, *Train* feeds the contemporary transnational fad for zombie movies while spawning its own progeny in the form of an animated prequel (*Seoul Station*; Yeon, 2016) and a reported forthcoming English-language remake.

For the present purposes, an additional point of interest is that *Train* offers a powerful illustration of the (often unremarked) continuities between the specific cultural form under discussion and international storytelling principles. In narrative terms, it is organized in a classic three-act structure. The movie is built on audience interest in, and sympathy for, a central character, Seok-woo (Gong Yoo), who is placed in jeopardy. This man is a socially powerful if emotionally cowardly individual who strives to balance his busy working and family lives, but who comes up against seemingly insurmountable obstacles (the zombies) out of which a struggle ensues. Utilizing the classic triumvirate of commercial audiovisual storytelling—character, desire, and conflict—*Train* first presents a problem, introduces an antagonist, and then illustrates the ways in which the initially troublesome situation is resolved. Furthermore, everything happens in "real-time" and in a continuous space, and the film's end is contained in its beginning.

Similarities such as these raise questions of what precisely characterizes the diverse narratives presented by Korean, Japanese, and Chinese exploitation cinemas. What kinds of stories do they tell? How do they tell them? Do only "good" stories compel us to keep on watching? And if a particular movie narrates a "good" story, how readily can it be identified as exploitative?

To be more exact, consider how closely *Train* resonates with broader traditions of storytelling that transcend budget, genre, nation, region, issues of taste, and indeed cinema as a medium of artistic endeavor. Simply put, it recalls the narrative archetypes elucidated by Joseph Campbell in his celebrated 1949 book *The Hero with a Thousand Faces* (so beloved by George Lucas and other globally prominent filmmakers). Campbell claimed that universal storytelling principles may be found in all cultures and at all times, and his core arguments certainly resonate in the context of this particular contemporary Korean zombie movie. "The standard path of the mythological adventure of the hero," wrote Campbell, "is a magnification of the formula represented in the rites of passage: *separation-initiation-return*. . . . A hero ventures forth from the world of the common day into a region of supernatural wonder; fabulous forces are there encountered and a decisive victory is won; the hero comes back from this mysterious adventure with the power to bestow boons on his fellow man [*sic*]" (23; italics in original). To be sure, *Train* doodles variations on these themes: for instance, the decisive

victory and the hero's return with powers anew are emotional and psychological rather than actual, and the protagonist dies at the end. But the key point is that the pattern fits closely enough to make it noteworthy.

Did *Train*'s screenwriters, Park Joo-suk and Yeon Sang-ho (who also directed), assemble their script with Joseph Campbell's book on hand? The resemblances are striking. Seok-woo's "hero's journey" begins when he answers a call to adventure (responding to his daughter's announcement that she intends to travel from Seoul to Busan). He is taken out of the ordinary world (of humans) and crosses a symbolic threshold (the doors of the KTX train). There he meets a mentor, Sang-hwa (Ma Dong-seok)—neither a coward nor a bad husband and father—who teaches him the life lesson that parenthood is more about sacrifice than a matter of slogging away like a mad squirrel. Numerous tests and ordeals then follow, accompanied by shifting relations among a gaggle of allies and enemies. After this the hero "seizes the sword" (or, in this case, the baseball bat) before metaphorically "dying" and being resurrected to discover his true cause (which is to die, literally).

In short, *Train*'s links to subtle, powerful forms of tale telling suggest that East Asian exploitation cinema's historical affinities with wider storytelling dimensions should not be overlooked. Yes, the movie is sensational and excessive, but its plot is also artfully constructed. (As well as contemplating the distinction between narrative and spectacle, it is surely helpful to think in terms of scriptwriting "beats" which aid the rhythmic force of narrative flow.) Indeed, grasping the importance of script work illuminates how vitally important story ideas and outlines are to both the production and the marketing-related concerns that recur across these pages. The script serves as the blueprint for all aspects of creative decision making; directing, acting, editing, and so on. Then, too, its key elements provide the basis for the intricate promotional campaigns that launch a film toward different audiences in diverse markets. While exploitation cinema is habitually discussed in terms of thrills and shocks, its frequently sophisticated storytelling aspects are no less crucial.

As you contemplate these varied chapters, then, please spare a thought for the hard-working scribes who generate the story material out of which exploitation movies from and about East Asia are shaped. In their daily exertions, individuals such as Park and Yeon demonstrate a keen ability to be conscious, to pay attention to what is going on around them, to point out incongruities and inequalities, to write from a place of insight and compassion and directness and truth. When such professionals do their job well—when they communicate what they must say

with force and clarity—the viewer responds enthusiastically. At such moments we feel something, and in feeling come to care about individual characters—no matter how selfish, cowardly, or oafish they may on first acquaintance appear to be. And from the primary asset of emotional understanding flows the secondary benefit of critical thinking.

The legendary Hollywood producer Irving Thalberg once decreed that "The most important person in the motion picture process is the writer ... and we must do everything in our power to prevent them (i.e., writers) from ever realizing it." Pondering *Train's* zombie odyssey, not to mention the embarrassment of storytelling riches to be found in J-horror, *kaijū eiga*, the samurai film, *wuxia pian*, and the yakuza film—to mention only a few of the other fascinating species of movies discussed herein—makes one wonder to what extent this statement also holds true for East Asian cinemas of the exploitative kind.

Work cited

Campbell, Joseph. *The Hero with a Thousand Faces*, 3rd ed. Novato, CA: New World Library, 2008 (1949).

Notes on Text

Names of Asian origin are listed surname first. For works published in English, names are listed as they are published, typically in Western form. This applies most to Chinese, Japanese, or South Korean authors who publish regularly in English.

If a film has been distributed internationally with an English-language title, we use that title, with original titles noted parenthetically.

Non-English words and phrases are italicized. This does not include the names of locations, such as Beijing or Seoul, and words that are commonly recognized in the West, such as "yakuza."

Editors' Introduction

Ken Provencher and Mike Dillon

Go to the Internet Movie Database (IMDb) page for Park Chan-wook's South Korean thriller *Oldboy* (*Oldeuboi*, 2003), and you will find both traditional and nontraditional forms of categorization. The page identifies the movie's title, year of release, country of origin, director, and genre—information readily available elsewhere. But perhaps nowhere except IMDb will you find a section consisting of some 280 user-generated "keywords," a standard feature on the website. They are there ostensibly to give filmgoers the ability to map out plot details or themes bearing similarities to other works. Seen in practice, however, the keywords offer an amusing glimpse into which aspects of the film people found noteworthy in their viewing experiences. Simultaneously vague and overly precise, the list ranges from generic terms like "love," "mysterious villain," "slow motion scene," and "hair salon," to more colorful phrases that account for *Oldboy*'s grim, seemingly exploitative sensibilities, such as "severed tongue," "stabbed with scissors," and "father daughter incest."

Clicking on any of those keywords brings up a cross-referenced list of all other films tagged with the same terms. Where else can we see a character "stabbed with scissors"? IMDb lists 141 films, putting *Oldboy* on the same page as Jean-Luc Godard's *Pierrot le Fou* (1965) and the killer-doll horror sequel *Curse of Chucky* (Don Mancini, 2013). While traditional, authoritative modes of categorization place *Oldboy* in a bordered context—as an auteur-directed contemporary East Asian film of award-winning stature—nontraditional, nonprofessional modes of categorization re-contextualize the film into a transnational, transgeneric, transtemporal catalog of particular (if not downright peculiar) plot events.

It has been nearly fifteen years since *Oldboy* arrived like a jolt of electricity onto the international scene, where it was vaunted by mainstream critics and became must-see cinema even for those typically allergic to foreignness and subtitling. The IMDb keywords it has amassed in that period point to the ways

in which seemingly exploitative materials so often manifest in, and are made legible through, their linkages to discourses of genre, filmmaking style, and cultural origins. Seen in this context, the sensationalistic violence and taboo subject matter of *Oldboy* stick out to us because of their awkward presentation within the inoffensive, strictly informative nature of public forums like IMDb.[1] The film is exotic and challenging, yet normalized by the mechanisms audiences use to categorize and essentialize.

For academic volumes like this one, *Oldboy* is an example par excellence of exploitation cinema caught up in the currents of transnational cultural flow. On the one hand, the film is tied to a specific national cinema—in particular, one with a firm reputation in the West for producing similar, revenge-themed genre pieces, including Kim Jee-woon's *I Saw the Devil* (*Angmareul boatda*, 2010) or Park's *Sympathy for Mr. Vengeance* (*Boksuneun naui geot*, 2002) and *Lady Vengeance* (*Chinjeolhan geumjassi*, 2005).[2] But on the other, it is teeming with boundary-crossing qualities that beckon analysis: the property is based on a Japanese manga (*Ōrudo bōi*) by Tsuchiya Garon; the film owes part of its success to international DVD marketing campaigns that branded it a pivotal work from a burgeoning "extreme" movement out of East Asia; and it was later the basis for a Hollywood remake (Spike Lee, 2013). If *Oldboy*'s cultural credentials rest atop multiple axes of the national, regional, and global, it likewise straddles an important line between high artistic achievement and lurid exploitation. The film exhibits narrative daring and formal flourishes that heralded a new wave of Korean cinema while also being completely bonkers.

When Jeffrey Sconce, Eric Schaefer, and Joan Hawkins published their seminal works on exploitation cinema—in 1995, 1999, and 2000, respectively— VHS and theatrical markets in the Americas and Europe had become more accommodating to East Asian cinema.[3] The type of cinema most heavily circulated was the very type of cinema Sconce and Hawkins were writing about: action, horror, fantasy, comedy, and sex films. These were, for many Western viewers, the gateway to East Asian audiovisual culture. Concurrent English-language publications on East Asian cinema targeted audiences for these films, providing guides on what to watch and how, and with an enthusiasm infectious enough to (at least partly) overcome easy cultural generalizations.[4] Book-length studies with more journalistic or academic approaches also appeared, generally focused on only one nation, and attempted to define something "new" happening in the cinemas of China, Japan, and Korea.[5] While each of these books served to broaden readers' knowledge and enhance the appeal of specific national cinemas

to international audiences, it is difficult to summarize the concept of "newness" across contemporary East Asian cinemas without addressing their increasingly transnational production and distribution methods. What was "new" about the cinemas in question perhaps had as much to do with international co-productions and content delivery systems—broadening the viewership of such cinema, which includes consumers, journalists, and scholars—as with political, economic, or socio-cultural changes within or between nations.

In the new millennium, digital distribution of films via DVD and streaming video services has overtaken the VHS and theatrical markets. Access to films produced independently, or released straight to video (after theatrical exhibition in their home countries) no longer requires leaving the house to attend an international film festival or special screening, or to patronize a video store. Whether through legitimate distribution channels or illegitimate ones, like peer-to-peer file sharing, fans of East Asian genre cinemas are accessing ever-increasing catalogs of works, while producers (and scholars) of these works seem to be in a perpetual struggle to catch up. Digital media have complicated the definitions of what qualifies as "exploitation" or "paracinema." Joan Hawkins recognized this in her 2009 essay "Culture Wars," in which she sourced the new-millennium integration of "art" and "horror" cinema directly within DVD distribution—using Park Chan-wook as a representative target of this integration trend.[6] Jasper Sharp, in his exhaustive history of Japanese soft-core pornography, credited DVD and international film festivals as "greasing the tracks" so that "even the most obscure celluloid oddities" are accessible to audiences who watch them far removed from their original time and place of production and exhibition.[7]

As digital technology accelerates the circulation of "oddities," sometimes blurring the line between art and exploitation, transnational cinema studies in academia have also proliferated, attempting to blur the lines between nations. Here it is worth revisiting the concerns of Sconce's "Trashing the Academy" essay. Sconce provided a useful twofold definition of what constitutes "paracinema": (1) a delimited set of works placed outside the realm of elitist culture and canonization, however that is defined, and (2) a reading strategy of those works that places the reader in direct opposition to cultural elitism. In the same essay, he also conducted a preliminary investigation into paracinematic culture's tension with traditional academic culture (again, branded as elitist). Without stretching the point too far, by appearing to side with the paracinematologists against conservative elites, we detect a similar tension between the burgeoning

field of transnational cinema studies and the well-established field of national film studies. East Asian cinema in particular has been the site of debate among scholars regarding how best to utilize concepts of transnationalism. More recent scholarly activity has openly embraced transnational connections between East Asian cinemas, even as scholars question the transnational approach as potentially ignoring (or worse, erasing) what may be inequalities of industries and economies between nations. Genre works (action, horror, or otherwise "dark" genres) have been the focus of several books on East Asian transnational cinema, as these works tend to have the largest number of international markets, thereby illustrating transnational networks of production, distribution, and consumption.[8]

Nation-centric analyses of East Asian genre cinema still occupy (if not dominate) the field, however, and this reflects, in part, a continuing academic emphasis on the importance of regional disciplines and expertise. Whereas scholars of earlier generations based in English-language countries have used their expertise as cinema studies practitioners to study Chinese, Japanese, or South Korean cinema, it is not uncommon today for East Asian cinema to be a target of research and teaching for specialists in area studies. The local archives and fieldwork opportunities available to area studies scholars have opened up several grounds of inquiry into East Asian cinemas that are simply inaccessible to many scholars in the field of cinema studies. But a central question of perspective applies to any study of East Asian cinemas: is the purpose of inquiry an attempt to explain some representative aspect of a national or regional culture, using cinema as illustrative grounds? Or is the nation or region the illustrative grounds for arguing a representative aspect of a broader, more transnational cinema culture?

This book takes up both questions. The title, *Exploiting East Asian Cinemas*, suggests our approach is to make use of a delimited, or bracketed, region called "East Asia" as grounds for investigating various modes of exploitation cinema. The producers, distributors, and audiences analyzed here are both inside and outside this bracketed region, which we define roughly as China, Japan, and South Korea. Each one of these countries is likewise bracketed, as their borders may shift depending on the observer or the time period in question. We also take up the sometimes confusing and subjective definitions of "art" versus "exploitation" cinema as further grounds of investigation. Overall, we see these two modes of inquiry—the bracketing concepts of East Asian nations as well as art versus exploitation—as mutually bound. We aim to show that the blurring

of lines between high and low art, and between national borders, benefits an analysis of East Asian cinemas, just as it serves the producers, distributors, and consumers of works identified in some way as "East Asian."

In this respect, we agree with the editors of three recent collections on international exploitation cinema: *Alternative Europe* (2004), *Horror to the Extreme* (2009), and *European Nightmares* (2012). They have argued that focusing on a region has the effect of calling into question the coherence of that region.[9] *Alternative Europe*'s editors consider Europe's "cultural, aesthetic, economic, political, and ideological demarcations" to be "far from clear."[10] *European Nightmares*'s editors likewise define European "texture" as "marked by multiplicity and multi-voicedness."[11] Closer to our region, *Horror to the Extreme*'s editors argue that "the notion of Asian cinema provides both a converging point as well as the point of departure."[12] We take a similar view of East Asian cinema as a "notion," or construct, and that close attention reveals connections between nations both inside and outside of the region. Even "East Asian cinema" itself, we argue, is a concept exploited in the global marketplace—a construct of a construct. (That is one reason why we have pluralized the term "cinema" in the book's title, to suggest the multiplicities that render "East Asian cinema" a malleable, nonexclusive category.)

If we were to graph the concepts of "East Asian cinema," "art," and "exploitation," as analyzed in this book, it would be a set of overlapping circles, with each intersection revealing the fluidity of those concepts. At the same time, we recognize the persistence—in the industry, in the marketplace, and in the academy—of the utility of categorizing cinema by region and cultural value. This persistence in cinema discourse, of identifying a film's regional origins and its rank within the supra-region of "world cinema," is as transnational as the networks of production, distribution, and consumption that we are analyzing.

In the spirit of these conceptual frameworks, this book is divided into three interrelated parts. The first, Genres Across Borders, examines three prominent genres associated with East Asian cinema: kung fu, *kaijū* (giant monster), and samurai. Rick Altman's seminal study of genre includes a brief but intriguing insight concerning the similarities between genres and nations:[13] both are concepts built upon the longevity and stability of certain institutions and traditions, but are also malleable and subject to different interpretations. This manner of thinking informs how the opening chapters regard the production contexts, distribution networks, and consumptive practices surrounding the overseas repackaging of East Asian exploitation cinemas.

To this effect, Kenneth Chan's "Steampunked Kung Fu: Technologized Modernity in Stephen Fung's *Tai Chi* Films" launches this book by looking at genre experimentation within martials arts cinema following the massive global success of Ang Lee's *Crouching Tiger, Hidden Dragon* (2000). Chan's analysis focuses primarily on *Tai Chi Zero* and *Tai Chi Hero* (both 2012), Fung's innovative hybrid of kung fu and the retro-machine aesthetic of steampunk. Chan sees in these films a dichotomy between Chinese traditional forms and enormous questions of modernity, technological advancement, and China's ongoing relationship to the West as its national clout increases in the twenty-first century. "Steampunked Kung Fu" identifies obvious transnational economic and cultural forces acting upon the "traditional" generic language of Chinese kung fu cinema.

By contrast, Steven Rawle's chapter—"*Ôru Kaijū Dai Shingeki* (All Monsters Attack!): The Regional and Transnational Exploitation of the *Kaijū Eiga*"—shows us how a property with strong national ties can be co-opted by global markets. Despite the recent resurgence of the *kaijū* in Hollywood blockbusters like *Pacific Rim* (Guillermo Del Toro, 2013), the genre's history (most famously exemplified by Tōhō studio's Godzilla/*Gojira* films) is characterized more often by bargain-basement production values. Rawle concludes that, when reedited and redubbed for new markets, these properties developed lives of their own as the objects of camp and subcultural appreciation.

In "Blood and Blades: Transnational Heroic Violence in *Twilight Samurai* and *The Last Samurai*," Ken Provencher likewise considers how generic imagery can be recycled in multiple cultural contexts and placed in the service of contemporary cultural priorities. He argues that recent Hollywood and Japanese cinema both engage in a transnational exploitation of samurai culture; by freeing samurai identity from its historical origins, these respective cinemas enhance the accessibility of samurai heroism to contemporary audiences. The inclusion of Provencher's essay here also points to an important distinction within this anthology: that exploitation is a malleable concept not only as it traverses national and cultural boundaries, but categories of art, trash, and mainstream cinema as well. For example, while kung fu films and the *Godzilla* series (despite the classical status of the 1954 original) have undeniable roots in "trash" cinema consumption, samurai films have historically been a bit more ambidextrous, subject to lowbrow treatment as well being a credible staple of legitimate international art cinema. As Provencher in particular demonstrates, even prestige cinematic tropes are not immune to exploitative rebranding

as East Asian iconography is extracted and transmogrified toward different cultural-commercial ends.

These early chapters demonstrate the proximate relationship between genre and economies of film distribution, in which genre tropes pegged to specific original cultures are shown to be quite available for appropriation and reinterpretation in other countries. Like any other commercial cinema, East Asian exploitation films exist first and foremost in a *marketplace*, and a crowded one at that, in which their production at the lower ends of the industrial scale are a most significant marker of identification. Part II of this book thereby attempts to build upon Part I's focus on genre, pivoting ever so slightly to examine how exploitation, or the notion of "exploiting," functions mainly as a set of economic decisions and marketing patterns in the creation of commercially viable products. Accompanying this, of course, is a careful study of how notions of culture and nation are mobilized in the popularization or artistic legitimation of such products, which are so firmly steeped in exploitation.

In "Dragons, Ninjas, and Kickboxers: The Minor Transnational Action Films of IFD," Man-Fung Yip studies the Hong Kong company IFD Films and Arts, which specialized in low-budget, English-language action films throughout the 1970s and 1980s. Highly derivative of major trends in global martial arts cinema—and catering to popular appetites for films in the vein of Bruce Lee and, later, stars like Jean-Claude Van Damme—IFD's films played an enormous, but underappreciated, role in fostering a vibrant era of transnational commercial exploitation. This makes companies like IFD, though operating on a scale often invisible to mainstream filmgoers, a superb example of transnationalism and cultural border-crossing.

Tom Mes turns to more widely recognized areas of popular transnational cinema, J-Horror and the Asia Extreme. His chapter, "Asia Restrained: J-Horror's Poor Beginnings and the Mismarketing of Excess," looks at the marketing of contemporary Japanese horror (whose visibility was raised by their Hollywood remakes) as well the proximity of those films to the narrower, cult-oriented successes of "extreme" directors like Miike Takashi. Taking a contrary approach to the conventional scholarship on Asia Extreme—much of which focus on how the promotion campaigns of such films often reveal Orientalist tendencies that exoticize Asian cinema as "transgressive"—Mes notes how Western strategies for promoting J-horror typically overlook some important local factors. In reality, the industrial practices of low-budget Japanese horror use formal

approaches that are more accurately characterized by aesthetic restraint, not the pervasive button-pushing that Western conceptions of Asian exploitation cinema would suggest.

Mila Zuo's "Gifting Beauty: The Exploitations of Fan Bingbing" takes still another approach to the notion of "exploitation," applying it not to a genre or to a specific set of films, but to the star image of Chinese actress/model Fan Bingbing. Contending that Fan's stardom (both on and off the screen) offers a glimpse into the gender politics and economies of physical beauty in post-Mao Chinese society, Zuo examines how Fan's career has involved a mutual system of exploitation between her, her adoring public, and the broader media industry. Unlike, for example, Bruce Lee, whose star image was exploited by producers after his untimely death in the form of look-alikes (as covered in Man-Fung Yip's chapter above), Fan Bingbing seems in complete control of her image, in both glamorous and de-glamorizing modes. And yet, her physicality is no less an exploitable commodity in the transnational marketplace, suggesting yet another possible dimension of contemporary East Asian exploitation cinema.

Part III of this book considers the tricky intersection(s) between Exploitation, Art, and Politics, and the frequent head-scratching we academics engage in when trying to devise clear delineations between what is art and what is trash. Hawkins has shown us "the degree to which high culture trades on the same images, tropes, and themes that characterize low culture."[14] The differences between exploitation and art cinema are made hazy by their shared characteristics: their similarly marginal positions vis-à-vis mainstream hegemonic cinemas, their small budgets, and their tendencies toward artistic provocation. This final section considers precisely what the discursive relationship between art and exploitation brings to bear on a wider set of politics within East Asian contexts. More significantly, it considers how transnationalism and cultural and economic fluidity inform those politics.

Whereas Zuo analyzes the feminine beauty of Fan, Elena del Río focuses on the masculine persona of Japanese star-director Kitano Takeshi in "Kitano's Outrageous Exploitation Cinema: Yakuza Nobility and the Biopolitics of Crime." Del Río argues that Kitano's recent spate of yakuza films seems to be geared toward a Japanese audience, thereby eschewing or possibly repudiating the global markets that earned him his reputation as an international art cinema auteur. By purging his films—narratively, thematically, and aesthetically—of the transnational, Kitano appears to be retreating into a closed, hermetic world of

exploitative masculine violence with its own "codes" for relating to the changing facets of Japan's global economy.

Similarly, Hye Seung Chung and David Scott Diffrient's "A Cinematic Half-Twist: Art, Exploitation, and the Subversion of Sexual Norms in Kim Ki-duk's *Moebius*" is also an auteurist analysis, engaging in a textual study of the South Korean drama *Moebius* (2013) and its controversial subject matter, including castration, rape, and incest. Utilizing these exploitative forms to subvert and challenge social institutions and hierarchies of taste, director Kim blurs any neat divisions between artistic statement and exploitative provocation.

Jun Okada's "*Hara Kazuo and Extreme Private Eros: Love Song 1974*" is likewise an auteur study, but directed toward documentary filmmaking, specifically Hara's *Extreme Private Eros* (1974). Looking at Hara's showcasing of class, gender, and racial politics that are considered wildly taboo in conservative Japan, Okada discusses how documentary's supposed claim to authenticity and realism clashes with the film's excessive and exploitative formal choices. She then addresses what meanings these paradoxical modes of representation reveal about a range of social issues.

The final chapter in this book is Kyu Hyun Kim's "Don't Bother to Dispatch the FBI: Representations of Serial Killers in New Korean Cinema." Citing the rise of serial killer-themed thrillers in South Korean cinema, Kim argues that the figure of psychotic, often motiveless murderers invites viewers to reflect upon the presumed structures of the genre and its uses of exploitation conventions. Although presented with varying psychological profiles, serial killers in films like *I Saw the Devil* (Kim Jee-woon, 2010) and *The Chaser* (Na Hong-jin, 2008) have nevertheless become an important trope for destabilizing normative socio-political conceptions of "evil" within South Korean popular cinema.

Together, the aim of these ten chapters is to adopt a broad and inclusive notion of exploitation cinema—as genre, style, economic rung, or subject matter—and tie it to specific works and identifiable cinematic trends emerging from East Asia. This relationship will be used to discern how putative understandings of "exploitation" inform/are informed by connections made to national or regional cultures and politics. Likewise, it serves as the basis for understanding how South Korean, Chinese, and Japanese exploitation films travel and mutate within global markets typified by specific habits for promoting, consuming, and understanding exploitation that are often beholden still to Western discourses pertaining to the place called "East Asia."

Notes

1 Owned by Amazon.com since 1998, IMDb's role as advertiser should not be underestimated, but its surface design emphasizes information over sales.

2 Together, *Sympathy for Mr. Vengeance, Oldboy*, and *Lady Vengeance* (aka *Sympathy for Lady Vengeance*), although narratively unrelated, constitute Park's "Vengeance Trilogy," a moniker that was designated by Western critics and marketers.

3 Jeffrey Sconce, "'Trashing' the Academy: Taste, Excess, and an Emerging Politics of Cinematic Style," *Screen* 36, no. 4 (1995): 371–93; Eric Schaefer, "*Bold! Daring! Shocking! True!*": *A History of Exploitation Films, 1919–1959* (Durham and London: Duke University Press, 1999); and Joan Hawkins, *Cutting Edge: Art-Horror and the Horrific Avant-Garde* (Minneapolis, MN: University of Minnesota Press, 2000).

4 Mass market entertainment guides to East Asian genre cinema in the late 1990s, early 2000s include Stefan Hammond and Mike Wilkins, *Sex and Zen, A Bullet in the Head: The Essential Guide to Hong Kong's Mind-bending Films* (New York: Fireside, 1996); Bey Logan, *Hong Kong Action Cinema* (Woodstock, NY: Overlook Press, 1996); Thomas Weisser, *Asian Cult Cinema* (New York: Boulevard Books, 1997); Stuart Galbraith IV, *Monsters Are Attacking Tokyo!* (Venice, CA: Feral House, 1998); Anthony C. Y. Leong, *Korean Cinema: The New Hong Kong* (Victoria, BC: Trafford, 2002); and Brian Thomas, *Video Hound's Dragon: Asian Action and Cult Flicks* (Detroit, MI: Visible Ink Press, 2003).

5 A selection of academic and journalistic books on East Asian cinemas of the 1990s and early 2000s includes Nick Browne, Paul G. Pickowicz, Vivian Sobchack, and Esther Yau, ed., *New Chinese Cinemas: Forms Identities, Politics* (Cambridge, UK: Cambridge University Press, 1994); Frederick Dannen and Barry Long, *Hong Kong Babylon: An Insider's Guide to the Hollywood of the East* (New York: Miramax Books, 1997); Lisa Odham Stokes and Michael Hoover, *City on Fire: Hong Kong Cinema* (London: Verso, 1999); Mark Schilling, *Contemporary Japanese Film* (Trumbull, NE: Weatherhill, 1999); David Bordwell, *Planet Hong Kong: Popular Cinema and the Art of Entertainment* (Cambridge, MA: Harvard University Press, 2000); Hyangjin Lee, *Contemporary Korean Cinema* (Manchester: Manchester University Press, 2000); Kyung Hyun Kim, *The Remasculinization of Korean Cinema* (Durham, NC: Duke University Press, 2004); Chi-Yun Shin and Julian Stringer, ed., *New Korean Cinema* (New York: New York University Press, 2005); and Tom Mes and Jasper Sharp, *The Midnight Eye Guide to New Japanese Film* (Berkeley, CA: Stonebridge Press, 2005).

6 Joan Hawkins, "Culture Wars: Some New Trends in Art Horror," in *Horror Zone: The Cultural Experience of Contemporary Horror Cinema*, ed. Ian Conrich (New York: I. B. Tauris, 2010), 125–38.

7 Jasper Sharp, *Behind the Pink Curtain* (Godalming, UK: FAB Press, 2008), 9.

8 Recent books analyzing East Asian genre cinema in a transnational context include Patrick Galloway, *Asia Shock!: Horror and Dark Cinema from Japan, Korea, Hong Kong, and Thailand* (Berkeley, CA: Stone Bridge Press, 2006); Leon Hunt and Leung Wing-fai, eds., *East Asian Cinemas: Exploring Transnational Connections on Film* (New York: I. B. Tauris, 2008); and Jinhee Choi and Mitsuyo Wada-Marciano, eds., *Horror to the Extreme: Changing Boundaries in Asian Cinema* (Hong Kong: Hong Kong University Press, 2009).

9 Ernest Mathijs and Xavier Mendik, eds., *Alternative Europe: Eurotrash and Exploitation Cinema Since 1945* (London: Wallflower, 2004); Choi and Wada-Marciano; and Patricia Allmer, Emily Brick and David Huxley, eds., *European Nightmares: Horror Cinema in Europe Since 1945* (New York: Wallflower, 2012).

10 Mathijs and Mendik, "Introduction," 1–2.

11 Allmer, Brick, and Huxley, "Introduction," 2.

12 Choi and Wada-Marciano, 2.

13 Rick Altman, *Film/Genre* (London: British Film Institute, 1999), 86–87.

14 Hawkins, *Cutting Edge*, 3.

Part One

Genres without Borders

Part One

Genres without Borders

Steampunked Kung Fu: Technologized Modernity in Stephen Fung's *Tai Chi* Films

Kenneth Chan

Introduction: Exploiting Kung Fu

Ang Lee's *Crouching Tiger, Hidden Dragon* (臥虎藏龍, 2000) is one of those seminal works that have directed popular and critical attention to a cinematic genre, the *wuxia pian* (武俠片, Chinese martial arts film). Since its release, Lee's film has generated in its wake a substantive revitalization of the genre in both Hollywood and Chinese transnational production networks, with filmmakers like Zhang Yimou, John Woo, Tsui Hark, Chen Kaige, Stephen Chow, Wong Kar-wai, Peter Chan, Feng Xiaogang, and, most recently, Hou Hsiao-hsien, all trying their hand at directing twenty-first century versions of the *wuxia pian*. But this interest in the genre also had a retrospective inflection, particularly in Chinese cinema studies over the past decade, as scholars turned their critical focus onto the *wuxia pian*'s history and aesthetic form.[1] By foregrounding the historicity of the genre here, I am not only accentuating the long cultural tradition in Chinese cinematic history from which Lee's film emerged, but also pointing to the genre's historical entanglements with American cinema that have helped shape both cinemas' developments. Of particular relevance to this book's focus and to the topic of American exploitation cinema culture, "The martial arts film," according to Randall Clark, "holds an unusual position in the history of exploitation films: it is the only major exploitation genre that first appeared overseas, and was later adopted by American filmmakers."[2] Of course, the questionable location of martial arts films within the category of exploitation cinema is a matter of historical and cultural perspective, considering how the *wuxia pian* occupies pride of place in *mainstream* cinematic culture for Chinese audiences across the

globe. But, from the standpoint of American film history, it is understandable
how the martial arts film has come to be associated with exploitation cinema, on
account of the genre's characteristics, conventions, and modes of consumption.
Eric Schaefer characterizes the classical exploitation films from 1919 to 1959
as (1) having "'forbidden' topic[s]," (2) being "made cheaply, with extremely
low production values," (3) being "distributed independently," and (4) being
"generally exhibited in theaters not affiliated with the majors."[3] The martial arts
film fits almost neatly into these definitional parameters, particularly in terms
of the onscreen violence and the lower production budgets of the Hong Kong
studios from the 1950s to the 1980s, for instance. Furthermore, cementing kung
fu-films' association with exploitation cinema is the fact that these films were
often screened in grindhouse theaters alongside Blaxploitation and sexploitation
films (except for a very brief moment in the 1970s when Chinese martial arts
cinema dominated American mainstream box offices, a phenomenon David
Desser describes as "the kung fu craze," with Golden Harvest's second Bruce Lee
film *Fist of Fury* (精武門, 1972), another Golden Harvest title *Deep Thrust: The
Hand of Death* (鐵掌旋風腿, 1972), and Shaw Brothers' *Five Fingers of Death*
(天下第一拳, 1972) occupying the top three chart positions in May 1973).[4]

By referencing the *wuxia pian*'s American connection to exploitation, I seek
to map out some critical observations with which to frame one's understanding
of this post-*Crouching Tiger, Hidden Dragon* era of transnational Chinese
co-productions of the *wuxia* genre. Within this framework, I can then situate
my close reading of Hong Kong-based director Stephen Fung's double feature,
Tai Chi Zero and *Tai Chi Hero* (太極: 從零開始 and 太極2: 英雄崛起, both
2012), as a case study of recent Chinese filmmaking that engages in cross-
cultural "exploitation" through the circuits of transnational cinemas.

As the editors of this book have shown, exploitation cinema is a complicated
and much more fluid genre and practice to define. Going beyond the boundaries
of the classical exploitation film in the United States, the genre and mode of
exploitation cinema have evolved with the politics of culture. In the rationale
for his extensive study of the classical exploitation form, Schaefer points out that
"looking at the marginalized exploitation industry serves to direct our attention
to the centrality that issues of sex, drug use, nudity, prostitution, and other
'transgressive' behaviors played in American society" and that these films "do
not tell us as much about the Other as they do about the fears and anxieties of
those who made and saw the movies." The "exploitation film [also] functioned
as an alternative to Hollywood while also shedding light on the mainstream

motion picture business."[5] With the shift in cultural politics and social values, the taboo subjects central to the classical exploitation film have now become mainstream in Hollywood and global cinema. The graphic nudity and sex in R-rated movies, the violent imagery of torture porn, such as the *Saw* series of films, and the cinema of Quentin Tarantino[6] are Hollywood examples that come quickly to mind. J-horror, Tartan Film's "Asia Extreme" distribution label, the New French Extremity films, and Hong Kong Category III titles further illustrate how exploitation aesthetics and themes have entered the global mainstream.[7] My goal here is not to pass moral judgment on these aspects of contemporary cinema, but instead to argue that cinema, as a technologized form of capitalist mass commodification, has the capacity to ingest and incorporate these "exploitative" elements into its structural propensity toward visual spectacle, especially in this age of digital CGI and summer blockbuster action flicks. In other words, the lines between exploitation and mainstream cinemas have blurred considerably, which only increases the diversification of visual cultures available today. This boundary-crossing process is, of course, further enabled by a transnational system of digital delivery and distribution.[8] The American and global mainstreaming of the *wuxia pian* is part of this cinematic trend.

Exploitation cinema is also about the politics of power. The online Oxford dictionary defines the verb "exploit" as to "make full use of and derive benefit from" something or someone, which often assumes a derogatory valence where one is "use[d] . . . in an unfair or selfish way."[9] Obviously, exploitation film exploits its taboo subject matter in order to draw in audiences. However, the power dynamics of exploitation cinema do reveal themselves to be much more complex and ambiguous when questions become slightly more nuanced: What is the nature of the exploitation in the various forms of exploitation cinema? Have they shifted with history? Who exploits and who is exploited in these cinematic narratives? Is the power distribution homogenously divided between exploiter and exploited, or is the power differential fluid and slippery in its movement? Does exploitation transcend the diegetic to permeate the processes of filmmaking, distribution, and consumption? This exploitation power play is further complicated by the potential for the taboo, the transgressive, and the marginalized to be culturally and politically subversive, often in productive ways. As Schaefer observes, "There is often an impulse to see the marginal or transgressive as somehow more authentic than the mainstream, containing the power to subvert dominant systems and values. There can be no doubt that exploitation films presented what was the most sustained domestic challenge to

Hollywood's hegemony over aesthetics and content in the commercial cinema."[10] While one celebrates this potentiality, it is also crucial to realize that these shifts in power and agency are frequently ideologically and culturally conflicted. Or, to use Schaefer's terminology about the genre, they are "complex and filled with contradictions."[11] An example of this contradiction is the Blaxploitation movement of the 1970s, where the subversive energies of racial empowerment initiated by the movement's inaugurating film *Sweet Sweetback's Baadasssss Song* (1971) were eventually co-opted into and reconfigured to serve Hollywood's box office machinery.[12]

This example of Blaxploitation is significant in that it not only illustrates the gradual seepage of what is considered exploitation elements into the cinematic mainstream, but also marks Hollywood's desire—spurred by a climate of multiculturalism—to appropriate and, sometimes, cannibalize minority and global cultures into its smorgasbord approach to box office domination. *Crouching Tiger, Hidden Dragon* and the revitalization of the *wuxia pian* constitute part of Hollywood's exploitative strategy of transnational cinematic appeal in the new millennium. But what is also revealing here in the global reach of this strategy is that Hollywood's hegemony now extends to co-production models within a network of Asian sites, capitalizing on new funding sources, multiple shooting locations, cheaper production labor, increased postproduction expertise, locally targeted marketing, and varied distribution patterns. These co-production models further confirm the increasingly complicated power dynamic at work in transnational cinemas, in that hegemony is no longer unidirectional or is purely antagonistic in a nationalistic sense—the rise of Mainland China as a modern, technologically sophisticated, capitalist powerhouse in the twenty-first century poses a colossal challenge to Hollywood's global dominance. For Hollywood cannot ignore "a global Chinese audience that includes more moviegoers and more television households than the United States and Europe combined," which Michael Curtin describes as a "vast and increasingly wealthy Global China market [that] . . . serve[s] as a foundation for emerging media conglomerates that could shake the very foundations of Hollywood's century-long hegemony."[13] Hence, Hollywood's desire to address the Chinese challenge and to tap into the huge Chinese market has incentivized collaborative alliances with Chinese entities in cinematic production and distribution, a strategy of turning a perceived global threat into a possible solution to a declining theatrical and DVD market in the United States. Warner Bros' forays into Chinese co-production projects perfectly illustrate this approach.[14]

The emergence of this robust Global China market has also bolstered an economically, technologically, artistically, and culturally confident Mainland Chinese film industry, which, over the past decade, has plunged headlong into big-budget co-production projects with not only Hollywood but also other East Asian and Southeast Asian partners. Many of the financially successful projects tend to fall into the *wuxia*, action, and/or fantasy categories, with some of these films even dominating and topping the Chinese and Asian box offices, while barely making a dent in the United States. The more recent titles that come to mind include *Detective Dee: Mystery of the Phantom Flame* (狄仁傑之通天帝國, 2010), *Painted Skin: The Resurrection* (畫皮II, 2012), *Journey to the West* (西遊·降魔篇, 2013), *Young Detective Dee: Rise of the Sea Dragon* (狄仁傑之神都龍王, 2013), *Monster Hunt* (捉妖記, 2015), *Mojin—The Lost Legend* (鬼吹燈之尋龍訣, 2015), and *Zhongkui: Snow Girl and the Dark Crystal* (钟馗伏魔: 雪妖魔灵, 2015).[15] Stephen Fung's *Tai Chi Zero* and *Tai Chi Hero* belong to this group of films, most of which deploy visually stunning and increasingly sophisticated special effects and exploit 3D technology to enhance the action spectacles already inherent in the martial arts genre. The box office successes of these films in Mainland China and across Asia have helped create and boost a newfound cultural confidence among filmmakers, which encourages them to take on aesthetic innovations and cinematically ambitious projects. To sustain this mode of blockbuster success, filmmakers exploit various genre modes and aesthetic paradigms in their hybrid configurations by drawing from both Asian and Western pop cultural practices and traditions. Tsui Hark's Detective Dee films, for example, rely on the popularity of the American television series *CSI* to update the hybrid supernatural-martial arts genre, while *Mojin—The Lost Legend*, as *New York Times* reviewer Daniel Gold observes, "seeks adventure blockbuster status like 'Raiders of the Lost Ark,' 'Lara Croft: Tomb Raider,' [and] 'The Mummy.'"[16] These cross-cultural strategies, at times, generate a conscious pushback against, if not reversal of, the exploitation power dynamic in Hollywood's hegemonic appropriations.

In the remainder of this chapter, I turn to Stephen Fung's *Tai Chi* films as a fascinating and insightful instance of this appropriative exploitation that relies on Hollywood forms to rethink the cross-cultural power dynamic in global cinematic relations. *Tai Chi Zero* and *Tai Chi Hero* amalgamate, rather creatively, the martial arts film with a form of retro science fiction: steampunk films. While the deployment of this subcultural, fin-de-siècle fantasy aesthetic injects new life to contemporary Chinese martial arts cinema, I unpack the

Tai Chi films' cultural logic by suggesting that they reformulate the familiar tension between Chinese cultural traditionalism and technologized modernity, forcing a rethinking of China's and Chinese cultures' relationship to the West. Does technology function as a cinematic/cultural trope to signify China's entry into the circuit of cosmopolitan engagement? And if so, what are the ideological and cultural implications of this mode of representation? Much of my analysis not only examines in detail the aesthetics and imagery of steampunk elements in the films, but also considers how these elements play a role in the narrative structuring of modernity in the lives of the films' main characters as they negotiate the arrival of Western imperial forces in the late nineteenth century and the inevitable restructuring of Chinese life and society with technological advancement. This morality tale of China's entry into the twentieth century through a technologized modernity, ultimately, resonates with and parallels the film's contemporary metanarrative of cultural anxiety induced by Chinese cinema's entry into the world of twenty-first-century digital media and technology.

Steampunking Kung Fu

In a recent study of contemporary Chinese science fiction cinema, Wei Yang theorizes "that Chinese sf films are better understood as 'sf-themed' films in which sf elements coexist with elements of other genres and are invariably used to support the purposes of these other genres." Such an approach "represent[s] a particular phase in the development of Chinese sf cinema, one in which local filmmakers borrow directly from Hollywood sf but also deviate from it in significant ways, through parody, genre mixing, and other intertextual strategies."[17] The *Tai Chi* films are a prime example of this embedding of a science fiction mode—steampunk, in this case—in a popular Chinese cinematic genre with a rather traditional narrative formula. But in engaging in this cinematic practice, filmmakers like Fung also need to be conscious of the racial history of Asia's technologized presence in Hollywood representations, especially by way of a form of "techno-Orientalism" that Greta Aiyu Niu "define[s] as a practice of ascribing, erasing, and/or disavowing relationships between technology and Asian peoples and subjects."[18] From Frank Capra's *Lost Horizon* (1937) to the evil Fu Manchu and Flash Gordon's arch nemesis Ming the Merciless, technology figures into the racialized and racist presentations of Asians as villainous threats

to white America. Technology also inflects the paradoxical vacillation between threat and instrumentality in this cultural discourse of techno-Orientalism, which Betsy Huang explains in the following manner:

> To both contain the "horde" and to make use of it for its own economic interests, the West constructs Chinese as *instruments* for national and global (i.e., Western) progress—a construction that renders them at once exploitable, containable, and inhuman. . . . These images of a technologized Chinese workforce are the latest iteration of the West's enduring ambivalence toward "Orientals" as both necessary instruments for *and* impediments to progress.[19]

This paradox extends to science fiction in that "the technologizing of Asia began with premodern orientalist figurations before they took the form of robots, androids, and other types of machinery."[20] To a certain degree of success, Stephen Fung treads a fine line in the *Tai Chi* films as he deftly negotiates the cultural political minefield of this historical precedence. But, the films' deployment of steampunk as technologized fantasy, to shuttle discursively between a Chinese cultural traditionalism and a technological modernity, runs the potential risk of stumbling into the very pitfalls that techno-Orientalism poses.

The director's choice of exploiting steampunk as the science fiction mode to insert into his *wuxia* films is a clever one. The tactic here is calibrated on three levels. First, steampunk as a subcultural phenomenon works effectively in terms of the verisimilitude of the films' historical time period. Set in the late nineteenth century, when "Western powers have invaded China," as the prologue of *Tai Chi Hero* chronicles, "China was facing unprecedented challenges. In order to save China from the invaders, the 'Self-Strengthening Movement' was created. Prince Dun leads the troops. Empress Cixi trusted Prince Dun. He built railroads and factories modernizing the military to fight the Western armies."[21] As the "sick man of Asia," China was carved into spheres of Western colonial influence because the declining empire was consistently overwhelmed by European gunboat diplomacy and its superior firepower. Steampunk's Victorian-style envisioning of that technology, in all its stunning flourishes, effectively signifies in vivid cinematic terms the historicity of the films. In this respect, Stephen Fung is in good cinematic company, especially as one considers Hollywood's consistent usage of steampunk as a retrofuturist aesthetic: *Buck Rogers* (1939), *20,000 Leagues Under the Sea* (1954), *The Time Machine* (1960), *The Land That Time Forgot* (1974), *The Elephant Man* (1980), *Edward Scissorhands* (1990), *Back to the Future Part III* (1990), *Twelve Monkeys* (1995), *Wild Wild West* (1999),

The League of Extraordinary Gentlemen (2003), *Hellboy* (2004), *The Prestige* (2006), *The Golden Compass* (2007), *Captain America: The First Avenger* (2011), and, of course, *Hugo* (2011), just to name the obvious few. The work of Georges Méliès, *Metropolis* (1927), *Time Bandits* (1981), *Brazil* (1985), and Anime classics *Akira* (1988) and *Ghost in the Shell* (1995) are the better known global cinema titles that come to mind.[22]

Beyond this rather superficial referencing of nineteenth-century colonial technology, on a deeper, second level lies a cultural political potential that steampunk as a visual aesthetic offers. In his pictorially stunning *Steampunk: An Illustrated History of Fantastical Fiction, Fanciful Film and Other Victorian Visions*, Brian Robb explains how steampunk started out as "a subgenre of science fiction and fantasy literature, primarily concerned with *alternative* history, especially an imaginary 'Victorian era' when steam power and mechanical clockwork dominated technology." In other words, this subset of science fiction literature of the 1970s and 1980s "chronicled a future that never happened, one in which the industrial revolution took a different direction. It featured the technology (and often attitudes) of today filtered through the past, hence the 'punk' appellation."[23] So, the *Tai Chi* films' fantastical fabulations of nineteenth-century technological innovation are consonant with steampunk's alternative retrofuturism. The production team obsessed over the period mise en scène, everything from daily objects to what executive producer Chen Kuofu describes as "many outrageous props,"[24] including a bicycle-powered electrical generator, a toy-train set, Edison light bulbs, a tripod camera, an old gramophone ironically spewing forth Antonín Dvořák's "New World Symphony," and much larger contraptions, such as an early iteration of the automobile, the monstrous railway-track-laying tank (Troy No. 1) with crane-like appendages capable of destroying the Chen Village, the "German-made Krupp cannon" that was deployed against our heroes, and "Heaven's Wings," a Da Vinci-inspired flying machine that comes to save the day close to the end of the second film.[25] True to the philosophical and political spirit of the steampunk movement, the production team took great liberty in their creations, especially in the more fantastical mechanical set pieces, in order to not only reimagine the aesthetic of the period but also engage in an anti-imperialist critique of European designs on a weakened China—as Brian Robb confirms, "Much Steampunk literature and storytelling is counter-factual, occasionally counter-cultural, and often displays a resistance to the imperialism of the Victorian age."[26] The mechanical monstrosities of the track-laying tank and the German cannons figure, in both material and metaphoric ways, the terrorizing

encroachment of European imperialism. One can thus argue that Fung has successfully exploited here a Euro-American aesthetic and its countercultural potentiality to enact a postcolonial critique as a form of cultural appeal to global Chinese audiences.

On a third and final level, steampunk as a form of retro*futurism* is not simply a nostalgic, backward-looking aestheticism; it is also a forward-looking cultural modality in the way it touches upon and relates to specific cultural political concerns of the late twentieth and early twenty-first centuries. "One of steampunk's most significant contributions," Elizabeth Guffey and Kate C. Lemay contend, "is that it revises our conception of the *digital*, forcing us to reconsider its roots and historical import, but also insisting that we try to envision how it has impacted our expectations."[27] Just as the Victorian fin-de-siècle period marks a radical transition toward a technologized modern era that is defined by world-changing cultural movements, our entry into a digital era has similarly entailed seismic shifts that completely transform the way we communicate and the way we live. The *Tai Chi* films lay out this historical parallelism through its non-diegetic self-reflexivity as cinema in the digital age. For example, the opening credit sequence of *Tai Chi Zero* offers an intermingling of comic-style graphics and live-action. This visual stylization repeats itself later in a form that mimics a video-game screen console during the segment in which our hero Yang Lu Chan (Yuan Xiaochao, or better known as Jayden Yuan) devises ways to sneak into the Chen Village, only to be hindered by kung-fu-skilled villagers. Accompanied by a seemingly anachronistic surf-rock soundtrack one would usually expect to find in a Tarantino film, the fight sequence with the various village characters resembles a video-game screen interface featuring the requisite battles at different game-levels, which are announced by titles such as "Stage One: The Entrance," "Round 1: Lu Chan vs. Uncle Qin," and "Stage One: Uncle Qin Wins." Words flash, spin, scatter across the screen, and even scroll from right to left (as Lu Chan is kicked in the opposite direction, thereby scattering the non-diegetic words). "3 Hits," "K. O.," and "Perfect" pepper and light up the screen during choreographed fight sequences, which are often relayed in slow motion (See Figures 1.1 and 1.2). Visually and aurally, this sequence from *Tai Chi Zero* emblematizes the convergence culture[28] of the digital age, as entertainment commodities inhabit multiple media platforms simultaneously.[29] Of course, on the one hand, one can convincingly argue that all of this is just gimmicky artifice, a superficial, exploitative way of updating the *wuxia* genre to appeal to a new generation of

Figures 1.1 and 1.2 Video-game screen interface in fight sequence. *Tai Chi Zero* (2012), directed by Stephen Fung, produced by Chen Kuofu and Stephen Fung.

viewers brought up on gaming cultures and social media. On the other hand, in a politically unconscious way, the films symbolically gesture to China's role in providing labor, expertise, and manufacturing infrastructures for the computer, IT, and media industries within a global capitalist economy. Hence, they inscribe, too, a cultural anxiety of what this technological modernity means for Chinese cultural identity, which often has, unfortunately, relied on a problematic binary opposition that locks an "authentic" China and Chineseness into a form of cultural traditionalism, vis-à-vis a modernity that ideologically remains a domain of the West.

Modernizing Kung Fu

As Stephen Fung's *Tai Chi* films appropriate and exploit steampunk science fiction for its contemporary audience appeal, they also use these genre elements to negotiate, anxiously, between a Chinese cultural traditionalism and a technologized modernity that first emerged from the West. To analyze this specific point, I want to note first that the films' combined narrative is a rather traditional and conventional one for Chinese martial arts cinema, apart from the steampunk flourishes scattered throughout the plot. The films depict the rise of Yang Lu Chan as "an unrivaled kung fu master" of Tai Chi. Born in a relatively well-to-do family, Lu Chan was considered a "freak" because he was born with a "weird growth on his head" that looked like a devil's horn. This specific birth defect, called "Three Blossoms on the Crown," endowed him with the ability to learn kung-fu moves by sight, hence making him a potential martial arts prodigy. Before she dies, Lu Chan's mother hands over custody of her son to a martial arts teacher, who turns out to be a political rebel recruiting fighters against the Qing government. He controls Lu Chan's abilities to his advantage by punching the growth on Lu Chan's head, which turns Lu Chan into a supercharged kung-fu zombie maniac who goes on a crazy rampage. But, unfortunately, this process also shortens Lu Chan's life. When the horn turns black, Lu Chan's life is endangered. As circumstances would have it, the government soldiers raid the rebels' location one day, giving Lu Chan a chance to flee to the Chen Village to find a cure for his illness by learning martial arts from Grandmaster Chen (Tony Leung Ka Fai). But he arrives at the time when the village is facing a major crisis: Master Chen's daughter Yu Niang (Angelababy) is betrothed to a man by the name of Fang Zi Jing (Eddie Peng). Fang, who grew up in the village, now works for a railway company that is sanctioned by the Qing government and is connected to the East India Company. His role is to persuade the village to allow the company to build the railway line through their territory. When the village elders refuse his offer, Fang brings the technological might of the East India Company to bear on the villagers. He commandeers a tank-like monster that has crane appendages, allowing him to destroy homes in the village. Of course, as terrifying as the tank monster is, it is no match for the martial art skills and the ingenuity of Master Chen and Lu Chan. Hence, Fang is defeated and his engagement to Yu Niang broken off. He scurries away to nurse his wounds and plot his revenge. In the meantime, Yu Niang agrees to marry Lu Chan as a means of saving him from being punished for learning the Chen-style kung

fu. According to family rules, only family members can learn this kung fu. The second film opens with the arrival of Master Chen's eldest son Chen Zai Yang (Feng Shaofeng). The father and son had a falling out years ago because Zai Yang did not want to learn kung fu. He was more interested in building machines, and his ultimate dream was to construct a flying machine. The backstory is that Zai Yang was in debt from working on his inventions, and our villain Fang Zi Jing has convinced him to go back to the village to usurp his father, Master Chen, as grandmaster. In return, Fang promised to pay Zai Yang's debts. Zai Yang knows hardly any kung fu, but he uses his technological wizardry to pretend that he does. In shame, after being exposed for the sham that he is, Zai Yang is cast out of the village once more, but this time his sister Yu Niang hands him a 1000-year-old root that he could sell to repay his debts. In reality, his father is secretly behind this gift. Zai Yang then uses the money to build his plane called "Heaven's Wings." Meanwhile, Fang Zi Jing has now returned with the German cannon to bombard the Chen Village. In order to prevent massive casualties, Master Chen concocts a plan to surrender himself so that Lu Chan and Yu Niang can escape to Beijing and inform the Prince of Fang's corruption. But the plan almost fails because of the sheer number of soldiers they had to battle, if not for the timely arrival of Zai Yang and his magnificent flying machine. Because the plane can only accommodate the weight of two people, Zai Yang parachutes into the hands of the soldiers so that Lu Chan and Yu Niang can escape. After the standard, but still spectacular, fight scene at the end of the film to convince the Prince that they are indeed from the Chen family, Lu Chan and Yu Niang succeed in their mission. The railroad is diverted from the village, and everyone but Fang Zi Jing lives happily ever after.

The key argument I want to make here is that the films confront the tension between Chinese cultural traditionalism and technological modernity through their plot structure and the steampunk mise en scène. While cultural traditionalism in the form of Tai Chi does rule the day, the films subtly accommodate technology in their writing of Chinese modernity, and they concede technology's necessity in moving China into the twentieth (and twenty-first) century. Lu Chan's mastery of Tai Chi is, of course, central in that this form of martial arts enables him to defeat the forces of corruption that the villain Fang and his machines represent, and it functions too as a stand-in for Chinese culture, which similarly triumphs over the forces of modern technology. In order to make this cultural nationalist argument, Chinese culture is ironically naturalized in the way the film philosophizes about Tai Chi, as evident in

this quiet but important scene in the second film where Lu Chan arrives at a philosophical epiphany under Master Chen's tutelage:

> *Master Chen*: Chen-style kung fu is simple and a part of everyday life. The best way to live is to adapt and learn from nature, be in harmony with it. That is the way of Tai Chi and the heart of our martial arts style.
> *Lu Chan*: To live life . . . do you mean eat, drink, shit, and fart, that's all part of kung fu?

Looking around, Lu Chan sees the Chen villagers deploying their Tai Chi skills as they harvest the field. The quotidian flows of nature play into the push and pull of Tai Chi, enabling the practitioner to use the brute force of her attacker against himself. This relationship with nature is further reified in terms of gender and sexuality as Lu Chan only becomes fully cured from his malady and completely reaches his kung-fu potential when he and Yu Niang finally consummate their marriage. As Master Chen advises her daughter, "He can certainly fight common people. But to go forward and truly develop Chen-style kung fu, he has to rely on . . . your Yin to be in harmony with his Yang."[30] This connection to nature and natural processes provides a counterpoint to the harsh, mechanical brutality of technology put to destructive use as war machines. In other words, the *human constructed-ness* of Tai Chi as a form of martial arts (which is not unlike the *human constructed-ness* of technology and machines) is eclipsed discursively by Tai Chi's naturalization in the films' formulation. With Tai Chi functioning ideologically as a metonymy for China, the films imbue Chinese culture with a kind of prelapsarian originality, a natural purity that transcends the corrupt materiality of Western technology and the violence that it helps propagate.

But, the linchpin in understanding the films' careful yet uneasy accommodation and eventual embrace of a technological Chinese future is in the subplot of Chen Zai Yang's relationship to his father. In replicating his childhood error of using machinery to fake his martial arts skill, Zai Yang fools everyone in his village but Master Chen by using that same technology to mimic the Tai Chi skills. His deception is also further technologized when he has his wife insert an ingenious device within the family's bronze bell so that it can start spinning on its own, thereby tapping into the villagers' superstitious fears. It is not technology that is at fault here, as this subplot seems to suggest; it is, rather, the unethical use of technology that is to be condemned. Master Chen embodies this logic in admitting, near the end of *Tai Chi Hero*, his own failure to encourage his son

in his desire to dabble in machine design. After Zai Yang arrives in his newly built flying machine to save Lu Chan and Yu Niang, Master Chen poignantly confides to a tearful Zai Yang that "I've never accepted who you are. I've never acknowledged your abilities. It's my fault. I've opposed the elders of my lifetime, but I'm not brave enough to break the rules of our ancestors . . . Today, you proved yourself. You are far better than I." It is indeed a monumental moment for a Chinese patriarch and a martial arts master to acknowledge his mistake to his son, a moment that the films use to great effect to symbolize the first steps necessary in confronting the tension between cultural traditionalism and a technologized modernity within a Chinese future.

Conclusion

As contemporary versions of what was once an exploitation genre, *Tai Chi Zero* and *Tai Chi Hero* illustrate the global mainstreaming of the *wuxia pian* through transnational co-productions. These films rely on the cinematic modernization of the kung-fu genre to appeal to a new generation of audiences accustomed to sophisticated Hollywood CGI and action spectacles. More specifically, director Fung's films also focus on the very notion of technology—be it the retrofuturist aesthetic of steampunk, the contemporary video-game stylizations, or the narrative's historical association of nineteenth-century technology with an imperialist West—to connect with global Chinese audiences. The films exploit technology in ways that are both typical and innovative, thereby creating a cultural logic that is double edged and conflicted. On the one hand, the films' engagement with a Chinese modernity requires that they uneasily marry an essentialist form of cultural traditionalism with the notion of a technologized Chinese futurity. On the other, it is in negotiating between these cultural positions that Fung is also able to turn his exploitation of technology on its head, in order to tap into its subversive possibilities and to enact a necessary postcolonial critique.

To conclude, I want to take a slightly different turn toward a more positive inflection to this contradictory position that Fung's films have placed Chinese cultural identity. Someone once said to me that kung fu is itself a form of technology, where the body is engineered into disciplinary control, and weaponry provides cyborg extensions to human embodiment.[31] What the character Zai Yang is doing with technological invention is, hence, similar to

the structural patterns of the martial arts. But, more importantly, twenty-first-century (Chinese) posthuman identity entails epistemological and psychical incorporation of technology into one's sense of individual and social subjectivity. As Katherine Hayles proclaims:

> The construction of the posthuman does not require the subject to be a literal cyborg. Whether or not interventions have been made on the body, new models of subjectivity emerging from such fields as cognitive science and artificial life imply that even a biologically unaltered *Homo sapiens* counts as posthuman. The defining characteristics involve the construction of subjectivity, not the presence of nonbiological components.[32]

Whether director Fung intended it or not, his *Tai Chi* films provide us with a retrofuturist morality tale that forces us to rethink Chinese (and human) cultural identity and its relationship to cultural traditions, as we forge ahead into a brave new world of digital technology and posthuman subjectivity.

Notes

1 Leon Hunt, *Kung Fu Cult Masters: From Bruce Lee to Crouching Tiger* (London: Wallflower Press, 2003). Meaghan Morris, Siu Leung Li, and Stephen Chan Ching-kiu, eds., *Hong Kong Connections: Transnational Imagination in Action Cinema* (Durham, NC: Duke University Press, 2005). Stephen Teo, *Chinese Martial Arts Cinema: The Wuxia Tradition* (Edinburgh, UK: Edinburgh University Press, 2009).
2 Randall Clark, *At a Theater or Drive-In Near You: The History, Culture, and Politics of the American Exploitation Film* (New York, NY: Garland Publishing, 1995), 129.
3 Eric Schaefer, *"Bold! Daring! Shocking! True!": A History of Exploitation Films, 1919–1959* (Durham, NC: Duke University Press, 1999), 4–6.
4 David Desser, "The Kung Fu Craze: Hong Kong Cinema's First American Reception," in *The Cinema of Hong Kong: History, Arts, Identity*, eds. Poshek Fu and David Desser (Cambridge, UK: Cambridge University Press, 2000), 20.
5 Schaefer, *"Bold! Daring! Shocking! True!"* 13–14.
6 See my essay on Tarantino's impact upon commercial cinema through his defunct distribution label Rolling Thunder Pictures: Kenneth Chan, "The Shaw-Tarantino Connection: Rolling Thunder Pictures and the Exploitation Aesthetics of Cool," *Mediascape: UCLA's Journal of Cinema and Media Studies* (Fall 2009), http://www.tft.ucla.edu/mediascape/Fall09_ShawBrothers.html, accessed July 27, 2016.

7 For detailed discussions of these examples, see Jinhee Choi and Mitsuyo Wada-Marciano, eds., *Horror to the Extreme: Changing Boundaries in Asian Cinema* (Hong Kong, PRC: Hong Kong University Press, 2009). (See, particularly, Chapter 5, Chi-Yun Shin's "The Art of Branding: Tartan 'Asia Extreme' Films.") Alexandra West, *Films of the New French Extremity: Visceral Horror and National Identity* (Jefferson, NC: McFarland, 2016). Darrell W. Davis and Yeh Yueh-Yu, "Warning! Category III: The Other Hong Kong Cinema," *Film Quarterly* 54, no. 4 (2001): 12–26.

8 Stefano Baschiera notes that "'foreign films' find a new association and links with more mainstream generic products thanks to the new categorisation [*sic*] and suggestion for further viewing" on digital distribution platforms. Stefano Baschiera, "Streaming World Genre Cinema," *Frames Cinema Journal*, no. 6 (2014), http://framescinemajournal.com/article/streaming-world-genre-cinema/, accessed September 26, 2016.

9 http://www.oxforddictionaries.com/us/definition/american_english/exploit, accessed July 27, 2016.

10 Schaefer, *"Bold! Daring! Shocking! True!"*, 14.

11 Ibid., 15.

12 For more on this process, see Ed Guerrero, *Framing Blackness: The African American Image in Film* (Philadelphia, PA: Temple University Press, 1993), 69–111.

13 Michael Curtin, *Playing to the World's Biggest Audience: The Globalization of Chinese Film and TV* (Berkeley, CA: University of California Press, 2007), 3–4.

14 For example, see Patrick Frater and Shirley Lau, "Warner's Flagship Entertainment Unveils 12 China Movies," *Variety*, March 15, 2016, http://variety.com/2016/film/asia/flagship-unveils-13-china-movie-projects-1201731176/, accessed October 1, 2016.

15 *Zhongkui: Snow Girl and the Dark Crystal* is also coproduced by Warner Bros.

16 Daniel M. Gold, "Review: 'Mojin: The Lost Legend,' in Search of a Burial Ground," *New York Times* (December 17, 2015), http://mobile.nytimes.com/2015/12/18/movies/review-mojin-the-lost-legend-in-search-of-a-burial-ground.html?_r=1&referer=https://www.google.co.in/, accessed July 29, 2016.

17 Wei Yang, "Voyage into an Unknown Future: A Genre Analysis of Chinese SF Film in the New Millennium," *Science Fiction Studies* 40, no. 1 (2013): 133–4.

18 Greta Aiyu Niu, "Techno-Orientalism, Nanotechnology, Posthumans, and Post-Posthumans in Neal Stephenson's and Linda Nagata's Science Fiction," *MELUS* 33, no. 4 (2008): 74.

19 Betsy Huang, "Premodern Orientalist Science Fictions," *MELUS* 33, no. 4 (2008): 24.

20 Ibid., 39.

21 For all citations of the film's dialogue and extensive insert titles, I have relied mostly on the subtitles of the DVD versions, with minor alterations, based on my own translation, for clarity and grammatical correctness. *Tai Chi Zero*, Dir. Stephen Fung, Well Go USA Entertainment, DVD, 2012. *Tai Chi Hero*, Dir. Stephen Fung, Well Go USA Entertainment, DVD, 2012.

22 For a listing and discussion of these and many other films, see Brian J. Robb, *Steampunk: An Illustrated History of Fantastical Fiction, Fanciful Film and Other Victorian Visions* (Minneapolis, MN: Voyageur Press, 2012). Author K. W. Jeter coined the term "steampunk" only in 1987 (ibid., 8), but the aesthetic had a long historical precedence going back to late Victorian literature, and it made its presence visible during film's early evolution.

23 Ibid., 8. Emphasis mine.

24 "Behind the Zenes," bonus feature, *Tai Chi Zero*, Dir. Stephen Fung, Well Go USA Entertainment, DVD, 2012.

25 Production Designer Tim Yip describes how they "followed this period very closely. For example, the monster . . . It is very interesting. Da Vinci came up with so many intriguing designs." "Behind the Zenes."

26 Robb, *Steampunk*, 10.

27 Elizabeth Guffey and Kate C. Lemay, "Retrofuturism and Steampunk," in *The Oxford Handbook of Science Fiction*, ed. Rod Latham (Oxford, UK: Oxford University Press, 2014), 439. Emphasis mine.

28 Henry Jenkins, *Convergence Culture: Where Old and New Media Collide* (New York, NY: New York University Press, 2006).

29 "Steampunk's graphic iconography made it a natural aesthetic for visual media beyond films and television. The worlds of comics, graphic novels, computer and videogames have all drawn on Steampunk for inspiration, and some have made a considerable contribution to the expansion of the genre." Robb, *Steampunk*, 125.

30 I want to contend here, as an important aside on the gender politics of the films, that this heteronormative plot construction of the female protagonist as an instrumental conduit toward the success of Lu Chan, Tai Chi, and Chinese culture is essentially sexist in its assumptions.

31 I want to credit this idea to an audience member in a talk I gave in Boulder at the University of Colorado's Center of Asian Studies Speaker Series, on March 6, 2015.

32 N. Katherine Hayles, *How We Became Posthuman: Virtual Bodies in Cybernetics, Literature, and Informatics* (Chicago, IL: The University of Chicago Press, 1999), 4.

2

Ōru Kaijū Dai Shingeki (All Monsters Attack!): The Regional and Transnational Exploitation of the Kaijū Eiga

Steven Rawle

Introduction

As if we needed another example of Japanese soft power, at the time of writing this chapter the augmented reality game *Pokémon GO* had exploded internationally. Developed by the San Francisco-based company Niantic, the game turned the real world into a realm of exploratory Pokémon-hunting, with local areas of interest turned into PokéStops or gyms.[1] First released in just three countries on July 6, 2016, the app was downloaded over 10 million times in its first seven days, and more than 30 million in its first two weeks, by which time it had been released widely throughout Europe and Canada.[2] The phenomenon produced a flood of press, including people finding dead bodies;[3] the trolling of the Westboro Baptist Church, when the gym at their location was controlled by a pink Clefairy named LOVEISLOVE;[4] and later, the short-lived appearance of a gym in the Korean demilitarized zone.[5] The release initially led to a resurgence in fortunes for Nintendo, with a major bump in its share price,[6] followed by a massive contraction once it became apparent that the Japanese company owned just 13 percent of the app, wiping 708 billion yen ($6.7 billion) from its value.[7] This was despite a highly effective release in Japan, on July 20, with a commercial tie-in with McDonald's that saw restaurants become gyms and PokéStops.[8]

While this chapter is more concerned with big monsters (*daikaijū*) than pocket ones, this is a timely reminder of the cultural soft power of Japan and its transnational application (developed in collaboration with companies in

the United States—Nintendo also owns a stake in Niantic). Douglas McGray's observation about "Japan's gross national cool"[9] has rarely been more prominent in mainstream cultural discourses.

The "mighty engine of national cool" that McGray observed was sending the world "rare Godzilla and Ultraman action figures" that sell for immense sums of money is a sign of a particular kind of soft power.[10] But as William Tsutsui's nostalgic academic memoir *Godzilla on my Mind: Fifty Years of the King of Monsters*[11] demonstrated, rarely were the giant monster movies of the 1960s and 1970s considered cool. Alongside the growing crisis in the Japanese film industry, the quality of the *kaijū eiga* (literally, monster movies) being produced was in decline, along with budgets and audiences, as the films became targeted more and more at children. Godzilla, the titan of the genre, became cuter, the face and eyes became rounder (Figures 2.1 and 2.2 show a comparison), while the monster action became more like wrestling than rampaging urban destruction. Flash forward 40 years, and there is much global excitement about the *kaijū eiga*. Guillermo del Toro's *Pacific Rim* (2013) borrowed the term *kaijū* to refer to its pantheon of giant alien monsters, while its skyscraper-high fighting robots (jaegers, after the German word for hunter) owe much to the mecha of *Neon Genesis Evangelion* (*Shin seiki evangerion*, Anno Hideaki, 1995–96). Some fan art even imagined Jet Jaguar (*Jetto Jagā*), a robot first seen in *Godzilla vs. Megalon* (*Gojira tai Megaro*, Fukuda Jun, 1973), as one of *Pacific Rim's* jaegers.[12] The subsequent success[13] of the Gareth Edwards-directed, Legendary Pictures-produced *Godzilla* (2014), with a worldwide gross of over $500 million,[14] helped

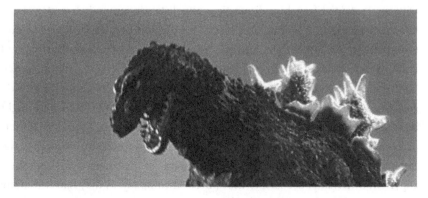

Figure 2.1 The fearsome lizard design of Godzilla in *King Kong vs. Godzilla* (1962), with long, narrow head and small eyes (Tōhō/Universal).

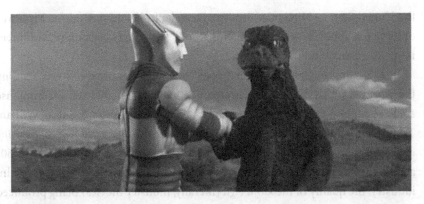

Figure 2.2 The friendlier design of the heroic 1970s Godzilla, with Jet Jaguar in *Godzilla vs. Megalon* (1973), featuring shorter, rounder features and bigger eyes (Tōhō/Media Blasters).

further heighten popular interest in the giant monster genre. A sequel was quickly announced,[15] along with a crossover in another King Kong film, as a follow up to *Kong: Skull Island* (Jordan Vogt-Roberts, 2017).[16] At the straight-to-video and TV end of the scale, we can also include within this trend films produced by "mockbuster" studio The Asylum, such as *Atlantic Rim* (Jared Cohn, 2013), *Sharknado* (Anthony C. Ferrante, 2013), and *Mega Shark versus Mecha Shark* (Emile Edwin Smith, 2014).

When Roland Emmerich's 1998 Sony version of *Godzilla* was released to overwhelmingly negative reviews from critics and fans (albeit with moderate, if below expectation, box office success), Tōhō had chosen not to compete with any potential franchise. From the animalistic design and character of the creature to its lack of atomic breath (not to mention how easily it was killed), everything about Emmerich's film has been disavowed as a Godzilla film, and Tōhō rebooted the series just two years later. Following Edwards's film however, Tōhō quickly announced their own rebooted Godzilla series, beginning with *Shin gojira* in 2016, directed by Anno Hideaki.[17] While the title of Tōhō's film might be seen as a reclamation of Gojira by Japanese cinema (it translates close to *New* or *True Godzilla*), it's worth remembering that Tōhō were the distributors of the Legendary film in Japan, and retain overall rights to the property through their copyright ownership, licensed to the American company, as they had with Sony in the 1990s. When Sony's rights to the series lapsed in 2003,[18] the contentious computer generated design of the animalistic lizard from Emmerich's film was rebranded, as Zilla rather than Godzilla. Tōhō's control of the rights to Godzilla is

tight, retaining ownership over characters, designs, all the *kaijū* and titles to the series (the international licensing of the Godzilla films is much more fragmented, as we'll see below); posters for the 2014 American film even state "GODZILLA TM & ©Toho Co. Ltd." on them.[19]

With the 1954 *Gojira* (Honda Ishirō) being the roots of the *kaijū* genre in Japan, Tōhō's exercising of their ownership of Godzilla throughout the existence of the series speaks greatly to the ways in which this property has been exploited. Throughout this chapter, I will explore the local, regional, and transnational exploitation of the *kaijū eiga*. As already implied, the notion of exploitation here is more along the lines of generic commercial exploitation, rather than terminology in relation to an *exploitation* cinema. As I. Q. Hunter has argued, "given cinema's tendency to repetition, imitation, remakes and 'sequelitis', it is often difficult to disentangle exploitation, except by its substandard budget, from the usual methods of cashing in on box-office hits."[20] The exploitation of the *kaijū eiga* to a significant degree relies strongly on aspects of repetition and recycling, as the development of most genres do. Following the success of *Gojira*, Tōhō in particular instituted a lengthy cycle of science fiction films (the genre of which we might see the *kaijū eiga* most productively as a subgenre) with giant monsters, robots, and threats from inner and outer space. Other Japanese studios also followed suit and produced their own variations on the Godzilla formula, as did several other film industries, in East Asia and beyond.

The early films in the emerging genre often shared core themes about antinuclear threats, and by the late 1960s and 1970s were largely films for or about children (Shochiku's *The X from Outer Space* [*Uchū daikaijū girara*, lit: *Space Monster Guilala*, Nihonmatsu Kazui, 1967] was promoted in its trailer as "igniting the dreams of young fans across the nation").[21] While this reveals exploitation common to the development of many genres, the *kaijū eiga* also sees a different sense of exploitation when it comes to the West. While the latest remake and the homages of *Pacific Rim* are respectfully deferential to their source material, the genre has largely been appropriated through a lens that casts it more as exploitation cinema by distributors outside the mainstream (such as New World Pictures, American International Pictures, and Transworld) that localized the films through dubbing, reediting, and the insertion of new scenes featuring American actors that produced a more paracinematic dimension to their texts. Also, as David Church explores in his book *Grindhouse Nostalgia: Memory, Home Video and Exploitation Film Fandom*,[22] exploitation cinema's reliance on home entertainment video formats is crucial in some of the ways

in which *kaijū* films developed as an exploitation cinema in the West, especially through television. However, while this testifies to imbalances of cultural power, as the West simultaneously co-opts and mocks the products of an Other cinema, I don't simply want to cast this as a West and the rest scenario, as the *kaijū eiga*, as it is now largely referred to with its Japanese language name, has developed in a way that exploits global cultural flows in multiple directions, as Western material is transculturated in several different ways.

It's worth noting here that the term genre is somewhat inadequate to capture the full scale of the role of repetition and recycling of Japanese popular culture. The synergies of the media mix (*media mikkusu*)[23] or Production Committee (*seisakuiinkai*) "simultaneous mix"[24] systems that encompass the range of branded products, from films to TV series, manga, games, toys, and advertising, more strongly represent the breadth of expressions and practices at play in Japanese character franchises, including Godzilla and *Pokémon*. For the purposes of the discussion here, this chapter is more concerned with the development of a film genre that, in particular, takes on the appearance of the exploitation film when it moves beyond Japanese borders and the forms of their media mix. The *kaijū eiga* has transcended national borders since its inception, although it remains heavily linked to Japan, and to Tōhō in particular. As we'll see, this has led to specific kinds of exploitation for the *kaijū eiga* locally and regionally, but has also seen it become positioned *as* a form of the exploitation film. Hunter's remark about the entangled forms of exploitation therefore become especially relevant as the genre and its various forms move across borders.

Birth of a monster and its offspring

It isn't my intention here to read *Gojira* or the films that were spawned as part of the cycle, but to explore the generic exploitation of the series in Japan and beyond. The original 1954 *Gojira* has been canonized as a classic of world cinema, re-released by prestige distributors such as the British Film Institute and the Criterion Collection. The first film in the series has long been held as a serious example of atomic era cinema, explored by numerous academic critics[25] and in more popular fan circles that straddle the breadth of the *kaijū* phenomenon. Hence, we see the development of the film as a key example of national cinema, linked to the national imagination and viewed historically, despite Chon Noriega's now somewhat out-of-date comment, from 1987, that "Godzilla (horror) films

are not perceived historically, but aesthetically according to Hollywood technical standards."²⁶ We have somewhat moved on from this position, but largely only in respect of the canonization of the original film, from a historical perspective, not the rest of the series, for reasons we'll come on to later. This historicizing is perhaps expected, given the prominence of the Godzilla series (28 films between 1954 and 2004, alongside transmedia extensions such as comics, cartoons, video games, toys, and other media appearances), but wasn't always the case. Donald Richie and Joseph L. Anderson pay little attention to the budding series in their seminal text *The Japanese Film: Art and Industry* in 1959, with just a short reflection on *Gojira* at the beginning of the wave of science fiction films. They comment that it is seemingly part-designed for the international market ("some snippets of Japanese culture and lots of English spoken"), particularly films like *The Mysterians* (*Chikyū bōeigun*, lit: *Earth Defense Force*, Honda Ishirō, 1957).²⁷ Notably, Richie and Anderson place the "Japanese monster picture" in the same breath as other commercial genres that were exploitable for a "fast profit": ghost stories (another important aspect of Japanese cinema's international exposure in the early twenty-first century); Tōhō's monster movies and musicals; and Nikkatsu's sexy, rebellious adolescent *taiyōzoku* (sun tribe) films.²⁸ The sidelining of popular trends in favor of more artistic, *auteurist* work is typical of approaches to national cinema, where the more marginal works of an art cinema are generally favored as more indicative of the national political consciousness, with genre trends more ephemeral or international in outlook. As Elena Caoduro and Beth Carroll have argued, "the theorisation of world cinema has often privileged the realist tradition and expressions of art cinema, building a canon of world cinema auteurs and mapping styles of filmmaking from different corners of the globe, often overlooking the role of genres, the popular and the vernacular."²⁹

Richie and Anderson make a connection between *Gojira* and one of its international forebears, *The Beast from 20,000 Fathoms* (Eugène Lourié, 1953). Elements of the film's plot are similar to *Gojira*'s, in that a giant prehistoric beast is roused from its slumber in the Arctic by a nuclear test, and finds its way to New York to wreak havoc there (in this regard, it shares some similarities with Emmerich's *Godzilla*, in which the beast finds its way to New York from the South Pacific following French nuclear testing). To some degree *Gojira* was seen as something of a rip-off of Lourié's film: Tsutsui notes how the film's working title was alleged to have been *The Giant Monster from 20,000 Miles Beneath the Sea*, but also that "the message of the original Godzilla is so much more

nuanced, the special effects so different, and the emotions stirred so much more profound that any charges of cinematic plagiarism seem all but irrelevant."[30] With the influence of this film and the original *King Kong* (Edgar Wallace and Merian C. Cooper, 1933),[31] it speaks to ways in which genres develop globally, but also how they land in national cultures. As Elena Oliete-Aldea, Beariz Oria, and Juan Tarancón have argued, genres develop in transnational spaces, but their expressions are rooted in more local circumstances that are always in flux:

> films, regardless of their generic resemblances, engage in a context that is always changing as a consequence of concrete political, social and cultural forces, and genre conventions—although developed in a supranational sphere—always derive their meanings from these forces as much as from the histories and traditions they carry with them.[32]

The influence of genre predecessors on the original *Gojira* demonstrate this pull of the transnational and the national, which is not simply a case of mimicry, but a specifically national exploitation of the genre that later becomes an originary force in the global imaginary landscape surrounding this particular genre. As evidence of this is the fan-produced *Wikizilla*, or *Kaijupedia*.[33] The website is largely devoted to the documentation of monsters from Tōhō's films, TV series, books, and comics, as well as those produced by other studios. Also included is the Rhedosaurus from *The Beast from 20,000 Fathoms*, and Kong. The inclusion of King Kong perhaps isn't surprising, given the ape's appearance in two Tōhō films, *King Kong vs. Godzilla* (*Kingu Kongu tai Gojira*, Honda Ishirō, 1962) and *King Kong Escapes* (*Kingu Kongu no gyakushū*, lit: *King Kong's Counterattack*, Honda, 1967), in which Kong fights Mechani-Kong, the creation of quasi-Bond villain Dr. Who. In addition, the *Kaijupedia* includes creatures from RKO-era films, such as the generic dinosaurs Kong fights on Skull Island in *King Kong*, but also the little Kong from the sequel *Son of Kong* (Ernest Schoedsack, 1933), named Kiko (although the name is never used in the film). Through the labor of the genre's fans, we see what Oliete-Aldea et al. describe as the ways in which "genres evolve in a supranational exchange of recognizable narrative and aesthetic choices while engaging in and responding to specific social challenges."[34]

Tōhō exploited Western material throughout their *kaijū* films. Two key examples were produced in the 1960s: *Frankenstein Conquers the World* (*Furankenshutain tai chitei kaijū Baragon*, lit: *Frankenstein vs. Subterranean Monster Baragon*, Honda, 1965) and *War of the Gargantuas* (*Furankenshutain no kaijū: Sanda tai Gaira*, lit: *Frankenstein's Monsters: Sanda vs. Gaira*, Honda, 1966).

Both films were co-productions with United Productions of America (UPA) and featured American leads (Nick Adams and Russ Tamblyn, respectively). As might be expected from the titles, the films are inspired by Mary Shelley's *Frankenstein*, although here Frankenstein refers to the monster, not the scientist. In the first of the two films, the heart of Frankenstein's monster is transported to Japan by the Nazis, and it becomes irradiated following the Hiroshima bombings. Years later, a feral boy on the streets of Hiroshima grows into a giant monster under the watch of an American scientist (Adams, who also appears in the Godzilla film *Invasion of Astro-Monster* [*Kaijū daisensō*, lit: *Monster Great War*, released in the United States as *Monster Zero*, Honda, 1965]). When the horned beast Baragon appears, the giant Frankenstein's monster comes to the rescue. In the sequel, two Frankenstein monsters appear: Sanda, a gentle, friendly giant; and Gaira, an aggressive gargantuan, from the mountains and the sea, respectively. Gaira's assault on the Japanese mainland is stopped by Sanda, until, after being forced out to sea, both are engulfed by an underwater volcano. The films' influences are demonstrative of how cultural material is appropriated and indigenized, conforming with Koichi Iwabuchi's contention, in *Recentering Globalization*, that "transnationally circulated images and commodities ... tend to become culturally odorless in the sense that origins are subsumed by the local transculturation process" through appropriation and hybridization.[35]

As Rick Altman has pointed out, there is no automatic process through which a cycle becomes a genre. Not all cycles produce genres.[36] The production of a genre—its exploitation as a commercial entity—depends on labor from a variety of sources. As I mentioned above, the labor of fans has been active in producing distinctions within the genre, from an ahistorical standpoint—this isn't a process of linear evolution in that respect, with the a posteriori addition of creatures to the *kaijū* pantheon. The labor of producers is also important in this respect. Altman describes genrification's roots as "a process of cycle-making creolization."[37] Genrification here relies on the exploitation of indigenous material and its hybridization with international material (the very creolization of the local and the foreign at play in the transnational), but also processes of repetition and variation. Following the success of *Gojira*, Tōhō produced a series of *kaijū* and *tokusatsu*[38] (literally, special effects) films, many directed by Honda with effects by Tsuburaya. In addition to the examples previously referenced, this included the likes of the *kaijū Rodan* (*Sora no daikaijū Radon*, lit: *Radon: Giant Monster of the Sky*, Honda, 1956),[39] submarine film *Atragon* (*Kaitei gunkan*, lit: *Undersea Warship*, Honda, 1963), *Dogora, the Space Monster* (*Uchū*

daikaijū Dogora, Honda, 1964), and *Space Amoeba* (*Gezora, Ganime, Kamēba: kessen! Nankai no daikaijū*, lit: *Gezora—Ganime—Kameba: Decisive Battle! Giant Monster of the South China Sea*, Honda, 1970).[40] In *Film Sequels: Theory and Practice from Hollywood to Bollywood*, Carolyn Jess-Cooke discusses the sequelization of *Gojira* and the development of the genre's narrative template:

> the reflection on a national tragedy and its socio-political aftermath ([in *Godzilla Raids Again* (*Gojira no gyakushū*, Oda Motoyoshi, 1955)],[41] Nagasaki); the interaction of three people (two of whom are again romantically involved...) and the triangulation of their fates; the discovery of Godzilla...; and the search for a weapon to Godzilla.[42]

She argues that subsequent *kaijū* films made in Japan similarly used the monsters to allegorically represent Cold War developments: Mothra's appearance coincided with the signing of the Treaty of Mutual Cooperation and Security in 1960 and the growth of the Japanese economy; King Ghidorah was the growing Chinese nuclear threat, Rodan the Soviet Union, while the Kong-Godzilla face-off represented the tensions between Japan and the United States. Jess-Cooke, however, doesn't make an argument about the genrification of the *kaijū* or *tokusatsu* films, as the series turned this template into a formula (moving from a cycle to a genre). The accusation of commercial exploitation is instead leveled, by Jess-Cooke, at Emmerich's in-name-only *Godzilla*. The series hybridized aspects of the science fiction genre, such as alien invasion, underwater exploration (and civilizations), Bond-style villains and espionage, and technology, alongside the focus on spectacle, as the rampaging monsters, particularly in the Godzilla films of the 1960s and 1970s turned toward the spectacle of wrestling (this is something shared by television variants such as *Ultraman*). So, while there remains the form of critical reverence shown for the early films, such as that of Jess-Cooke, the development of the genre shows the hallmarks of generic exploitation through repetition and recycling.

The declining budgets of the Godzilla series, and the more exploitative targeting of a very young audience, saw the Shōwa series come to a close in 1975, as *kaijū* and *tokusatsu* shows became staples of television in Japan. As Yoshikuni Igarashi argues, the "shift in the targeted audience confirms the banalization of the monster in the series, the effects immediately discernible even in the quality of production." This effected a distancing of the series from war and the impact of nuclear attack; in addition to a less serious tone, the monster became "tamed and transformed into a guardian of postwar Japan's prosperity."[43] For Tsutsui, this is when Godzilla became a symbol of *wareware Nihonjin* (we Japanese) rather than

the destroyer of Japan.[44] The pretense that Richie and Anderson observed in films like *The Mysterians* gave way to the *kawaii* (cute) design of Godzilla, as well the appearance of an offspring, the talking Minilla, and increasingly a focus on younger protagonists (romance is rarely a factor by this time). The anti-bullying themed *All Monsters Attack (Gojira-Minira-Gabara: Ōru kaijū daishingeki*, Honda, 1969)[45] sees both the young protagonist and Minilla sharing their stories of being bullied. The environmentally-conscious *Godzilla vs. Hedorah (Gojira tai Hedora*, Banno Yoshimitsu, 1971) is presented as a youthful fantasy of the protagonist, who, like a surrogate for the audience, plays with Godzilla toys at the beginning of the film (Figure 2.3); there's almost a suggestion that Godzilla's appearance is at the behest of the boy's imagination.

Echoing the style of the exploitation film described by Eric Schaefer in *Bold! Daring! Shocking! True! A History of Exploitation Films, 1919–1959*, the series also began to use more stock footage, recycled music, and repetitive plots. For instance, *Godzilla vs. Gigan (Chikyū kōgeki meirei: Gojira tai Gaigan*, lit: *Earth Attack Command: Godzilla vs. Gigan*, Fukuda Jun, 1972) recycled footage from five previous Godzilla films, along with *War of the Gargantuas* (although reconstructed, rather than featuring the 'greatest hits' approach of *All Monsters Attack*), and music from a range of sources, composed by Ifukube Akira, the series' regular composer, to create the new film, even featuring a rather threadbare-looking Godzilla costume and monster dialogue in speech bubbles.[46] The film is notable also for its more graphic violence than in previous films, with blood on show for the first time (which was cut from the American release version). The films effectively became exploitation films through their use of such aesthetic

Figure 2.3 Toys in *Godzilla vs. Hedorah* (1971) emphasize the general shift toward younger audiences as well as the convergence of the media mix (Tōhō/Sony).

strategies. As Hunter mentioned, it can often be difficult to disentangle forms of the exploitation film from exploitative strategies of recycling employed by major studios, and toward the end of the Shōwa series, we see both forms of exploitation at play.

Exploitative strategies remained visible through the later Heisei and Millennium series, from 1984 onwards. The films regularly combined plots involving orphaned children with female protagonists to cover broader audience demographics, and despite the more contemporary special effects and return to city-destroying action, the films were often still pitched at younger audiences: Tōhō released *Godzilla, Mothra and King Ghidorah: Giant Monsters All-Out Attack* (*Gojira, Mosura, Kingu Gidora: Daikaijū sōkōgeki*, Kaneko Shūsuke, 2001) in a double bill with the first Hamutarō film, *Ham Ham Land Big Adventure* (*Tottoko Hamutarō: Hamu Hamu Rando daibōken*, Nabeshima Osamu, 2001), about the exploits of a *kawaii* hamster.[47] Tōhō's exploitation of the *kaijū eiga*, especially of the Godzilla series, conforms with Hunter's point that we can often find it difficult to disentangle the tactics of blockbuster production and distribution with genuine exploitation cinema. With the Godzilla films, the declining budgets produced a definite exploitation effect despite the films being embedded within commercial studio production. Jess-Cooke's positioning of Emmerich's *Godzilla* at the more commercial side of the genre doesn't necessarily mean it is alone there.

Tōhō's rivals also produced their own *kaijū* films. Alongside Shochiku's *The X from Outer Space* were a host of major studio productions: Daiei instigated their own series, most notably in *Gamera* (*Daikaijū Gamera*, Yuasa Noriaki, 1965), about a giant flying space turtle awoken by a nuclear explosion in the Arctic, which has spawned eleven sequels; Daiei also produced three *Daimajin* films (Yasuda Kimiyoshi, Misumi Kenji, all 1966), about a giant stone statue that comes to life to free its worshippers from feudal oppression; the studio also produced a sci-fi film quickly after *Gojira* in 1956 entitled *Spacemen Appear in Tokyo* (*Uchūjin tōkyō ni arawaru*, Shima Koji) that, despite the presence of a giant starfish-like creature rampaging down a city street on the cover of its American DVD release (with the title *Warning from Space*), features no such scene (it's more akin to *The Day the Earth Stood Still* [Robert Wise, 1951], with an alien disguised as a human who tries to persuade the world against the use of nuclear weapons). Nikkatsu produced *Gappa, The Colossal Beast* (*Daikyojū Gappa*, Haruyasu Noguchi, 1967). This final film closely resembles the plot of a British monster film, *Gorgo* (directed by *The Beast from 20,000 Fathoms's* Eugène Lourié in 1961), in which two unscrupulous

sailors sell a 65-foot-tall reptile to a circus in London after discovering it off the Irish coast, only for its mother to arrive to rescue it, destroying much of London in the process. *Gappa* replaced the reptile with a bird-like lizard creature, but followed a very similar plot. The genre was also exploited around Asia, including South Korean films *Yongary: Monster from the Deep* (*Taekoesu Yongary*, Kim Ki-duk, 1967) and *Space Monster Wangwagwi* (*Ujugoe-in Wangwagwi*, Hyeok-jinn Gwon, 1967). *Yongary* in particular shares several overt similarities with the Godzilla films, including a child protagonist and a scene in which the monster dances to a rock and roll version of traditional song 'Arirang' (Godzilla first danced in *Invasion of Astro-Monster*, just prior to *Yongary's* production). A single Hindi monster film was produced, called *Gogola* (Balwant Dave, 1966), the only remnants of which are a promotional poster for its Mumbai release that bills it as "an action packed story of a Sea-monster with Thrills, Suspense and What Not? [*sic*]" and its soundtrack, which is freely available on YouTube. *The Mighty Peking Man* (*Goliathon*, Meng-hua-Ho, 1977) was a Hong Kong film timed more to coincide with release of a remake of *King Kong* in 1976.

Perhaps the most notorious *kaijū* film is *Pulgasari* (1985), a North Korean film directed by Shin Sang-ok, the South Korean director who was kidnapped by Kim Jong-il. While in captivity, Shin directed a number of films, of which *Pulgasari* is the best known (it is perhaps the best known of all North Korean films). Based on an old Korean legend, the monster is a metal-eating giant who fights alongside a group of peasants against a corrupt feudal lord as a means of promoting the North Korean regime's *Juche* ideology, its quasi-Socialist philosophy of independence, economic self-sufficiency, and military self-reliance. This form of genrification around South and East Asia further reinforces the supranational, but local, dimension of genre production (despite the genre's intensified association with Japan, with even a Japanese name), where exploitative imitation is grounded in local concerns and interests. But, of course, these films then circulate around the world, where they are retitled, reedited, dubbed, or subtitled, and come to take on more of the hallmarks of the exploitation film itself, rather more simply reflecting exploitative commercial practices.

Exploiting *Kaijū* in the West

While the exploitation of the *kaijū eiga* in Japan and around Asia demonstrates a process more typical of the commercial exploitation of a popular genre, we see

a somewhat different process once those films cross over to the West. Practices regarding the films in the West, particularly in the United States, have treated the genre much more as conventional exploitation cinema, with many of the ways in which the genre has been exploited, to a degree, sharing in the distribution and exhibition tactics of exploitation cinema. One of the key aspects of this is the place of the films on television and home video, where the spread of rights has tended to be more fragmented than Tōhō's unified ownership of the films in Japan. There is currently no single release, for instance, for all the Godzilla films outside Japan—whereas Tōhō released a 50th anniversary "Final Box" in 2004 and all the films on Blu-ray to coincide with the 60th anniversary after the release of the 2014 American film. Rights to the Godzilla films in the United States are spread across Classic Media, who acquired the rights to the UPA catalogue prior to their buyout by DreamWorks in 2012 (it was sold to NBCUniversal in 2016), Universal, Media Blasters (an independent company who specializes in cult Japanese cinema and anime), Kraken Releasing (part of anime specialist distributor Section23 Films), Miramax, and Sony. Classic Media also released *Rodan* and *War of the Gargantuas*, while the Gamera films (including the 1990s reboot trilogy) were released by Mill Creek, alongside the *Daimajin* trilogy, and the 1990s Mothra trilogy was handled by Sony. Media Blasters imprint Tokyo Shock also released a series of *kaijū* films, including *Frankenstein Conquers the World*, *Atragon*, *Dogora*, *Varan the Unbelievable* (*Daikaijū Baran*, Honda, 1958) and *Matango* (Honda, 1963, released in the United States as *Attack of the Mushroom People*). To make the releases more fragmented, there is a mixture of films that are dubbed into English or German,[48] in Japanese with English "dubtitles" (hard of hearing subtitles for English dubs rather than accurate translations of the Japanese dialogue), while some feature both international and original Japanese versions. In the UK, only the first *Gojira* is currently available, alongside the two King Kong films made by Tōhō, and an isolated release of *The Mysterians* by the BFI. For cult audiences, the fragmented rights mean that collecting the films can be difficult (*The Return of Godzilla* saw its first digital release in September 2016, its rights long tied up), although that spread of rights is also a consequence of the films' fragmented rights across theatrical and television distribution that saw them take on the appearance of exploitation films.

When *Gojira* was released in the United States by Transworld producer Joseph Levine, later famous for Embassy pictures like *The Graduate* (Mike Nichols, 1967), it was retitled *Godzilla: King of the Monsters!* (Terry O. Morse and Honda

Ishirō, 1956), was dubbed, reedited, and had new sequences featuring Raymond Burr, as an observer character called Steve Martin, inserted into it. The anti-American sentiment of the original film was minimized, with explicit reference to Nagasaki removed. As David Kalat has noted, the film appeared in a double bill with a film called *Prehistoric Women* (Gregg C. Tallas),[49] an exploitation nature film, with an educational voice-over teaching the viewer about the ways of a prehistoric tribe (in what looks like California, with a lot of partly-clad women diving into pools). A British quad poster, by Eros Films, for *Godzilla* demonstrates how the marketing of the film also took on some of the appeals of the exploitation film that Schaefer describes: their "adults only" designation (rated X), the appeal to spectacle, and the focus on the heterosexual couple (everyone in the poster is also Caucasian, there are no Asian faces).[50]

The continuing existence of the two different cuts of the original (along with the different versions of other *kaijū* films) also tends to speak to the "fluid, ever changing" nature of the exploitation film.[51] Later Godzilla films have also circulated in different forms, often with different names (see Table 2.1): for instance, 1974's *Godzilla vs. MechaGodzilla* (*Gojira tai Mekagojira*, Fukuda Jun) was released initially by Cinema Shares (run by former MGM and UPA sales manager Mel Maron) as *Godzilla vs. The Bionic Monster*; when this exploitatively proved too similar to *The Bionic Woman*, it was changed to *Godzilla vs. The Cosmic Monster*. It now circulates under its original title, although Kalat used the *Cosmic Monster* title in his encyclopedia. New World released the film uncut with its original title on VHS in 1988. Subsequent releases reverted to the Cinema Shares title (including a 1994 release from UAV that featured a still on the back from *Godzilla vs. Megalon*, with Godzilla and Jet Jaguar shaking hands[52]). Many other films have also been subject to changing titles and versions. *Gojira, Ebira, Mosura nankai no daikettō* (lit: *Godzilla, Ebirah, Mothra Great Battle in the South Seas*, Fukuda Jun, 1967), originally planned as a Tōhō co-production with American company Rankin-Bass as a King Kong film to promote their *King Kong Show* cartoon (1966–69, coproduced with Toei),[53] was first syndicated to television, with some minor amendments, including changes to the music and dubbing, as *Godzilla vs. The Sea Monster*. The film also had a limited theatrical release by Continental Pictures as *Ebirah, Horror of the Deep*, a title by which the film is still known today (the most recent Kraken release uses both titles on its cover). In Germany, the film was released as *Frankenstein and the Monster from the Seas* (*Frankenstein und die Ungeheuer aus dem Meer*), as several *kaijū* films were renamed using the Frankenstein title, including *King Kong Escapes* as

Table 2.1 Alternative titling for Shōwa *Kaijū* films.

Original Japanese Title	Original US Release	Alternative Titles	
Kingu Kongu no gyakushū (lit: *King Kong's Counterattack*, 1967)	*King Kong Escapes* (Universal)	*King Kong: Son of Frankenstein* (*King Kong: Frankensteins Sohn*) (German title)	
Gojira, Ebira, Mosura nankai no daikettō (lit: *Godzilla, Ebirah, Mothra Great Battle in the South Seas*, 1967)	*Godzilla vs. The Sea Monster* (Walter Reade, US TV syndication)	*Ebirah, Horror of the Deep* (US release, Continental Pictures)	*Frankenstein and the Monster from the Seas* (*Frankenstein und die Ungeheuer aus dem Meer*) (German title)
Kaijū sōshingeki (lit: *Charge of the Monsters*,1968)	*Destroy All Monsters* (American International Pictures)	*The Heirs of King Kong* (*Gli Eredi di King Kong*) (Italian title)	
Gojira-Minira-Gabara: Ōru kaijū daishingeki (lit: *Godzilla, Minilla, Gabara: All Monsters Attack*, 1969)	*Godzilla's Revenge* (Maron Films)	*The Return of Gorgo* (*Il Ritorno di Gorgo*) (Italian title)	*Son of Godzilla, Part Two* (Alternative Italian title)
Gojira tai Hedora (*Godzilla vs. Hedorah*, 1971)	*Godzilla vs. The Smog Monster* (American International Pictures)	*Frankenstein's Fight against the Devil Monster* (*Frankensteins Kampf gegen die Teufelmonster*) (German title)	
Gojira tai Megaro (lit: *Godzilla vs. Megalon*, 1973)	*Godzilla vs. Megalon* (Cinema Shares)	*Gorgo and Superman Fight in Tokyo* (*Gorgo y Superman se citan en Tokio*) (Spanish title)	*King Kong: Demons from Outer Space* (*King-Kong: Dämonen aus dem Weltall*) (German title)
Gojira tai Mekagojira (lit: *Godzilla vs. MechaGodzilla* 1974)	*Godzilla vs. The Bionic Monster* (Cinema Shares)	*Godzilla vs. The Cosmic Monster* (US re-release, Cinema Shares)	*Godzilla vs. MechaGodzilla* (New World VHS)

King Kong: Frankensteins Sohn (King Kong: Son of Frankenstein), while Godzilla vs. Hedorah became Frankensteins Kampf gegen die Teufelmonster (Frankenstein's Fight against the Devil Monster), and the German title for Frankenstein Conquers the World, Frankenstein: Der Schrecken mit dem Affengesicht, translates literally as Frankenstein: The Horror with the Monkey Face. Tsutsui has also noted this phenomenon, alongside such retitling as the Italian release of Destroy All Monsters as Il Ritorno di Gorgo (The Return of Gorgo),⁵⁴ although the picture is even more confusing than this. Destroy All Monsters was released as Gli Eredi di King Kong (The Heirs of King Kong). All Monsters Attack was released as Il Ritorno di Gorgo, although a DVD cover also gives its title as Son of Godzilla, Part Two. Godzilla vs. Megalon was released in Spain as Gorgo y Superman se citan en Tokio (Gorgo and Superman Fight in Tokyo) with Jet Jaguar referred to throughout the dubbed track as Superman (subsequent releases have also retained the title and the dub, but also refer to Jet Jaguar by name on the box cover); in Germany, the film was released as King-Kong: Dämonen aus dem Weltall (King Kong: Demons from Outer Space). While this messy retitling has become the subject of online mockery, it also demonstrates the status of the films globally as exploitation films, as they take advantage of global and more local trends to position the films in local markets. They also demonstrate the transnational spread of cultural material, and the problematic dimensions of copyright regimes that rework what Iain Robert Smith calls "the Hollywood meme" as it travels across borders and is interpreted locally.⁵⁵

Many of the films produced by Tōhō and Daiei in the 1960s were picked up for distribution by American International Pictures, and later UPA. AIP also produced some kaijū films of their own, including the giant ape film Konga (John Lemont, 1961), in which mad scientist Michael Gough grows his chimpanzee with a serum developed after an African trip,⁵⁶ and Reptilicus (Poul Bang and Sidney W. Pink, 1961), an infamously bad Danish-American co-production in which Copenhagen is menaced by a thawed-out creature discovered by copper miners in Lapland. More significantly for the genre's standing as exploitation films, kaijū eiga found their way into television syndication through these companies, and became staples of Saturday afternoon programming or in Creature Double Features. This helped to develop the core cult audience for kaijū films, along with some of the most common ways in which the films are discussed, largely as campy spectacles. The paracinematic spectacle of the Godzilla films in the United States is largely a consequence of the dubbed versions shown on television.⁵⁷ Reviews of Godzilla films on the Internet Movie Database articulate much of the

form of nostalgia that David Church has discussed. Video-mediation, Church argues, is central to exploitation film nostalgia. As he argues, "technological frameworks can allow specific films to serve as objects of textual nostalgia and vehicles for contextual nostalgia associated with uneven historical terrain."[58] Thus, "technologies of film distribution may have reciprocally influential effects upon perceptions of audiences."[59] Audiences for Godzilla films also articulate memories of seeing the films at drive-ins, on television, and later on DVD. In the case of *Godzilla vs. Megalon*, often held as one of the worst of the series, there is a repeated reference to a single point of nostalgia: *Mystery Science Theater 3000* (*MST3K*).[60] *MST3K* is a particularly strong recurring memory for these viewers on IMDB (with only one, minor reference to the film's prime time premiere on NBC, which was introduced by John Belushi in a Godzilla costume). Godzilla films featured twice on *MST3K* (*Megalon* along with *Godzilla vs. The Sea Monster*), although neither episode is available on home video due to licensing issues (the *Megalon* episode was available, but replaced on a subsequent release). *Gamera* though was a staple of *MST3K*, with five of the series' films making appearances. This was down to their place in the catalogue of Sandy Frank Entertainment, who licensed the films for television (the first film was released theatrically by AIP).

In the UK, the situation is quite different, and the films circulated very rarely. *King Kong vs. Godzilla* was a recurring feature on regional ITV stations throughout the 1970s, and there have been sporadic screenings since (in 1999, *Mothra* [*Mosura*, Honda, 1961] was screened on the sci-fi channel after *MST3K*), but one notable season in December 1999 on Channel Four screened six films after midnight, introduced by the presenters from *Vids*, in segments entitled *Vidzilla*. *Vids* (1999–2001) screened in the 4Later slot on weekends, and was an ironic, cult-inflected video review show. The Godzilla segments present the films as cult classics (comparing them with the then fairly recent American version as a means of articulating a particular oppositional taste), with retellings of the plots, and trivia about their productions. The segments prior to the three double bills set up the films as cult, camp classics ripe for rediscovery, which were largely unseen (Carlton had released some Godzilla films on VHS in the 1990s), including the original version of *Gojira*. When the BBC scheduled a monster night to coincide with the release of Emmerich's film in July 1998, it too presented the cult credentials of the genre, with a documentary about the monsters presented by *Moviedrome* host and cult director Alex Cox (reflecting, according the broadcast's *Radio Times* listing, the genre's "unconvincing origins as a man in a suit"[61]), and a segment entitled *Monster Wars*, in which celebrities

gambled on the outcomes of showdowns between *kaijū*. The centerpiece of the night, though, was a screening of the 1976 *King Kong* remake, not a Godzilla film (implicitly highlighting their disreputability). At 12:45 a.m., though, the night ended with the premiere of the 1991 *Godzilla vs King Ghidorah* (*Gojira tai Kingu Gidora*, Omori Kazuki). In restating the genre's deviation from norms of Hollywood cinema (positively and negatively), mediators such as these demonstrate the nostalgic frame for *kaijū eiga* that positions it as campy cult cinema in the West. In so doing, they fluctuate between historical reverence and mockery, articulating distinctions of cultural power.[62]

Conclusion

The exploitation of the *kaijū eiga*, as well as the *kaijū eiga as* exploitation film, traces several cultural flows: first, those *into* Japan, with the development of the classic hybrid form of the genre; and secondly, those within and outside Japan across East Asia, where the genre's recycling and localization positions Japanese culture in the above-but-within-Asia cultural position in which Iwabuchi places it in *Recentering Globalization*. The exploitation of the genre in Japan in particular is very much a conservative one, following dominant industry trends until the material is repeatedly exhausted. The adoption of the term *kaijū* by fans and by films such as *Pacific Rim* reminds us of the Japanese origins of the genre, even though its roots are defined through the transculturation of an already emergent genre. Transnational fandoms have also played a role in the development of the genre, as the ahistorical reclamation of monsters, like the Rhedosaurus of *The Beast from 20,000 Fathoms*, have become identified as *kaijū*, rather than part of science fiction or horror cinema, but within their own subgenre associated with this Japanese term.

In the United States and the West more generally, there has been a tendency to transculturate and co-opt that material as paracinematic, especially as television adopted the genre as a staple of programming from the 1960s onwards. The growing and knowing camp irony sees the films play more as exploitation films, often associated with distributors outside the mainstream, that is, until the release of the two US versions of *Godzilla* in 1998 and 2014, as well as other American films, such as *Cloverfield* (Matt Reeves, 2008), that have aligned the monster film with other emergent genres trends—in this case, found-footage horror. As such, these attitudes tend to speak to visions of Japanese culture—

both mainstream and *otaku*—that place these films as signifiers of a Japanese culture more generally, in that the regional derivations (as well as many of the local ones) remain obscure outside hardcore *kaijū* fandoms.

Central to this practice of transculturating this material as exploitation cinema has been the process of dubbing. As Mark Nornes reminds us, dubbing is condemned "as the lowest form of translation." Dubbed, a film's "foreign language is completely extracted, replaced with sameness,"[63] where the characters in dubbed versions of *Yongary* or *Gamera* in their AIP versions become American, despite surrounding signs associated with Japan or South Korea. While we might think of this as a purely nostalgic effect of cheap forms of dubbing (some films used Tōhō's Hong Kong-produced dubs, others their own) and their familiarity from television, more recent films received deliberately ironic dub tracks, such as *Godzilla 2000* (*Gojira nisen: Mireniamu*, Okawara Takao, 1999), the first film in the Millennium series. In Sony's dub, characters speak in Asian-accented English, using phrases such as "Gott in Himmel!" and "Great Caesar's Ghost!" that self-consciously and nostalgically emphasize the paracinematic pleasures of the dubbed track. Perhaps the strongest example of this paracinematic promotion came with New World's release of *Godzilla 1985* (R. J. Kizer and Hashimoto Koji, 1985), a reworking of *The Return of Godzilla* (simply released in Japan as *Gojira* in 1984, directed by Hashimoto). The film underwent the same process of dubbing, editing, and inserting Raymond Burr as the first *Gojira* (becoming effectively a sequel to *Godzilla: King of the Monsters*). The film was promoted as campy excess, the trailers telling us Godzilla's "acting technique was revolutionary. His presence . . . overwhelming. He possessed more raw talent than any performer of his generation. . . . Now he is back. And he's more magnificent, more glamorous, more devastating than ever." The trailer promotes a particular strategy for the film's reading, as a form of mockery, tapping into old nostalgia, just as later dubbed versions were to do, for a particular form of exploitation cinema remembered largely from home viewing.

Notes

1 PokéStops and gyms can be found at local landmarks, businesses, schools, universities, or places of worship that become, respectively, places where players can collect items, such as balls or eggs to help catch Pokémon, or can fight their monsters against those of other players.

2 Brett Molina, "'Pokémon Go' fastest mobile game to 10M downloads," July 20, 2016, http://www.usatoday.com/story/tech/gaming/2016/07/20/pokemon-go-fastest-mobile-game-10m-downloads/87338366/, accessed July 26, 2016.

3 BBC News, "Pokemon Go player finds dead body in Wyoming river while searching for a Pokestop." July 10, 2016, http://www.bbc.co.uk/newsbeat/article/36757858/pokemon-go-player-finds-dead-body-in-wyoming-river-while-searching-for-a-pokestop, accessed July 26, 2016.

4 Patricia Hernandez, "Pokémon Go Fan Trolls Westboro Baptist Church, Church Fires Back," July 7, 2016, http://kotaku.com/pokemon-go-fan-trolls-westboro-baptist-church-church-f-1783449276, accessed July 26, 2016. The church responded by calling the Pokémon a "sodomite."

5 Mike Wehner, "The mysterious Pokémon Go gym at the border of North Korea and South Korea has disappeared," July 13, 2016, http://www.dailydot.com/debug/pokemon-go-gym-north-korea-dmz/, accessed July 26, 2016.

6 BBC News, "Nintendo shares up more than 50 percent since Pokemon Go release" (July 14, 2016), http://www.bbc.co.uk/news/business-36791275, accessed July 26, 2016.

7 Yuji Nakamura and Takashi Amano, "Nintendo Slumps By Most Since 1990 on Dashed Pokemon Go Hopes" (July 25, 2016), http://www.bloomberg.com/news/articles/2016-07-25/nintendo-set-to-plunge-after-saying-pokemon-go-s-impact-limited, accessed July 26, 2016.

8 Jonathan Soble, "Pokémon Go, With a Corporate Tie-in, Debuts in Japan" (July 22, 2016), http://www.nytimes.com/2016/07/23/business/international/pokemon-go-japan-mcdonalds.html?_r=0, accessed July 26, 2016.

9 Douglas McGray, "Japan's Gross National Cool." *Foreign Policy*, May 1 (2002): 44–54, http://foreignpolicy.com/2009/11/11/japans-gross-national-cool/, accessed July 26, 2016.

10 Ibid.

11 William Tsutsui, *Godzilla on My Mind: Fifty Years of the King of Monsters* (New York: Palgrave MacMillan, 2004).

12 Jet Jaguar had been the product of a competition run by Tōhō for children to design a new superhero. The original design had initially been named Red Alone (*Reddo arōn*), a name later referenced in the name of the mecha Jet Alone in *Neon Genesis Evangelion*.

13 *Pacific Rim*'s domestic box office was relatively underwhelming ($101 million against a reported $190 million production budget), although it did gross over $300 million internationally, with over a third of that coming from China (see Box Office Mojo, "*Pacific Rim* (2013)," http://www.boxofficemojo.com/movies/?page=main&id=pacificrim.htm), accessed October 7, 2016. A sequel had been announced at the time of writing, although Del Toro was not attached to direct.

14 Box Office Mojo, "*Godzilla* (2014)," http://www.boxofficemojo.com/ movies/?id=godzilla2012.htm, accessed July 26, 2016.

15 Anita Busch, "'Godzilla' Sequel in the Works at Warner Bros. and Legendary" (May 18, 2014), http://deadline.com/2014/05/godzilla-2-sequel-warner-bros-legendary-gareth-edwards-732650/, accessed July 26, 2016.

16 Dave McNary, "'Godzilla vs. Kong' Set for 2020 as Warner Bros. and Legendary Unite Monster Franchises" (October 14, 2015), http://variety.com/2015/film/news/godzilla-vs-kong-2020-sequel-warner-bros-legendary-1201618127/, accessed July 26, 2016.

17 By the end of October 2016, *Shin gojira* was the highest grossing live-action film of the year in Japan, behind Shinkai Makoto's *Your Name* (*Kimi no na wa*, 2016). With over five million admissions in its first nine weeks of release, *Shin Gojira* is the first Godzilla film to achieve that feat in Japan (on first release) since *King Kong vs. Godzilla* in 1962 (see Gman2887, "Shin Godzilla Box Office Watch" (September 29, 2016), http://www.scified.com/topic/42307), accessed October 7, 2016. By way of comparison, Edwards's *Godzilla* reported just over two million admissions in Japan (see Tōhō Kingdom, "'*Godzilla* (2014)," http://www.tohokingdom.com/movies/godzilla_2014.html#bo), accessed October 7, 2016.

18 Sony's head of marketing, Bob Levin, confirmed that Sony had the rights to develop a sequel, as long as a film was in active development within five years of the release of the first film, which experienced a troubled development phase. See Keith Aiken, "Godzilla Unmade: The History of Jan De Bont's Unproduced TriStar Film—Part 4 of 4" (May 31, 2015), http://www.scifijapan.com/articles/2015/05/31/godzilla-unmade-the-history-of-jan-de-bonts-unproduced-tristar-film-part-4-of-4/, accessed July 28, 2016.

19 The film itself attributes copyright to its producers, Warner Bros., Legendary Pictures, and Ratpac-Dune Entertainment, a film finance company part owned by director Brett Ratner. The opening titles state that it is "based on the character Godzilla owned and created by Toho Co. Ltd."

20 I. Q. Hunter, *British Trash Cinema* (London: British Film Institute, 2013), 24.

21 The film's trailer presents the selection process for the naming of the monster, from a competition of elementary-aged school children. Translation of the trailer comes from the English-language subtitles on the Criterion Collection Eclipse boxset, *When Horror Came to Shochiku*.

22 David Church, *Grindhouse Nostalgia: Memory, Home Video and Exploitation Film Fandom* (Edinburgh: Edinburgh University Press, 2016).

23 See Marc Steinberg, *Anime's Media Mix: Franchising Toys and Characters in Japan* (Minneapolis, MN and London: University of Minnesota Press, 2012).

24 Woojeong Joo, Rayna Denison, and Hiroko Furukawa, "Manga Movies Project
 Report 1: Transmedia Japanese Franchising," (2013), http://d284f45nftegze.
 cloudfront.net/RLDenison/MANGA%20MOVIES%20PROJECT%20REPORT%20
 1%20TRANSMEDIA%20FRANCHISING%20.pdf, accessed October 10, 2016

25 See Mark Anderson, "Mobilizing Gojira: Mourning Modernity as Monstrosity,"
 in In Godzilla's Footsteps: Japanese Pop Culture Icons on the Global Stage, eds.
 William M. Tsutsui and Michiko Ito (New York and Basingstoke: Palgrave
 MacMillan, 2006), 21–40.; Jason Barr, The Kaiju Film: A Critical Study of Cinema's
 Biggest Monsters (Jefferson: McFarland, 2016); Michael J. Blouin, Japan and the
 Cosmopolitan Gothic: Specters of Modernity (New York: Palgrave MacMillan, 2013);
 David Deamer, Deleuze, Japanese Cinema and the Atom Bomb (New York and
 London: Bloomsbury, 2014); Yoshikuni Igarashi, Bodies of Memory: Narratives of
 War in Postwar Japanese Culture, 1945–1970 (Princeton, NJ: Princeton University
 Press, 2000); Yomota Inuhiko, "The Menace from the South Seas: Honda Ishirō's
 Godzilla (1954)," in Japanese Cinema: Texts and Contexts, eds. Alastair Phillips and
 Julian Stringer (London and New York: Routledge, 2007), 102–11; Susan J. Napier,
 "Panic Sites: The Japanese Imagination of Disaster from Godzilla to Akira," The
 Journal of Japanese Studies 19, no. 2 (1993): 327–51; Chon Noriega, "Godzilla and
 the Japanese Nightmare: When "Them!" Is U.S.," Cinema Journal 27, no. 1 (1987):
 63–77; Steve Ryfle, Japan's Favorite Mon-star: The Unauthorized Biography of "The
 Big G" (Toronto: ECW Press, 1998); Jerome F. Shapiro, Atomic Bomb Cinema: The
 Apocalyptic Imagination on Film (New York and London: Routledge, 2002); Susan
 Sontag, "The Imagination of Disaster," in Against Interpretation and Other Essays
 (London: Penguin, 2009), 209–25; Motoko Tanaka, Apocalypse in Contemporary
 Japanese Science Fiction (New York: Palgrave MacMillan, 2014); Tsutsui, Godzilla on
 my Mind.

26 Noriega, "Godzilla and the Japanese Nightmare," 74.

27 Joseph L. Anderson and Donald Richie, The Japanese Film: Art and Industry
 (Rutland, MA and Tokyo: Charles E. Tuttle, 1959), 262–63.

28 Like Gojira, Nakahira Kō's Crazed Fruit [Kurutta kajitsu, 1956], which initiated
 the trend, also received a Criterion Collection release, featuring a Donald Richie
 commentary track.

29 Elena Caoduro and Beth Carroll, "Introduction: Rethinking Genre Beyond
 Hollywood," Frames Cinema Journal no. 6 (2014), http://framescinemajournal.
 com/article/introduction-rethinking-genre-beyond-hollywood/, accessed
 June 23, 2016.

30 Tsutsui, Godzilla on my Mind, 20.

31 It's well documented that Eiji Tsuburaya, the special effects director of the first eight
 Godzilla films, until Destroy All Monsters (Kaijū sōshingeki, Honda Ishirō, 1968), as

well as many other films and the popular *tokusatsu* television series *Ultra Q* (1966, which was followed by the iconic *Ultraman* [1966–67]), was heavily influenced by *King Kong*, and this reflected in the design and name of the monster. Gojira, in katakana, is ゴジラ (the form used on most advertising), Romanized as go-ji-ra. The word is the combination of two words, the transliteration of gorilla (as a nod to King Kong) (katakana: ゴリラ, rom: *gorira*) and the word for whale (katakana: クジラ, rom: *kujira*).

32 Elena Oliete-Aldea, Beatriz Oria, and Juan A. Tarancón, "Introduction: Questions of Transnationalism and Genre." in *Global Genres, Local Films: The Transnational Dimension of Spanish Cinema*, eds. Elena Oliete-Aldea, Beatriz Oria, and Juan A. Tarancón (New York and London: Bloomsbury, 2016), 3.

33 Anon. n.d. Kaijupedia, http://giantmonsters.wikia.com/wiki/Main_Page, accessed July 28, 2016

34 Oliete-Aldea, et al., "Introduction: Questions of Transnationalism and Genre," 3.

35 Koichi Iwabuchi, *Recentering Globalization: Popular Culture and Japanese Transnationalism* (Durham, NC and London: Duke University Press, 2002).

36 Rick Altman, *Film/Genre* (London: British Film Institute, 1999), 67–68.

37 Ibid., 199.

38 The term *tokusatsu* has also been adopted internationally to describe the Japanese special effects genre, although it is often applied to films and television series outside the *kaijū eiga*, such as Tōei's *Super Sentai Series* (*Sūpā sentai shirīzu*, 1975 to present), the best-known incarnation of which was *Kyōryū sentai Jūrenjā* (*Dinosaur Squadron Beast Ranger*), which ran from 1992 until 1993, and was localized by Saban in the United States as *Mighty Morphin Power Rangers* (1993–95).

39 Rodan exists in the same universe as Godzilla, appearing in five further films with Godzilla, as well as some stock footage appearances on Monster Island in the 1970s.

40 Released in the United States by American International Pictures as *Yog: Monster from Space*.

41 Although the title translates more literally as *Godzilla's Counterattack*, the film was originally released by Warner Brothers in 1959 as *Gigantis the Fire Monster*—its poster promising "Nothing Like it Before! The Fantastic War of the Giant Fire Monsters." Godzilla was renamed as Gigantis, "a hundred tons of hell and fire to ravage and destroy."

42 Carolyn Jess-Cooke, *Film Sequels: Theory and Practice from Hollywood to Bollywood* (Edinburgh: Edinburgh University Press, 2009), 37.

43 Igarashi, *Bodies of Memory*, 121.

44 Tsutsui, *Godzilla on My Mind*, 85.

45 Released in the United States as *Godzilla's Revenge*.

46 See also David Kalat, *A Critical History and Filmography of Toho's Godzilla Series* (Jefferson and London: McFarland, 1997), 120–25; and Ryfle, *Japan's Favorite Mon-star*, 173–75.

47 Subsequent Godzilla films were also released in double bills with the adventures of Hamtarō.

48 The 11 Blu-ray disc German *Ultimative* Collection of Godzilla films (featuring the first two films, the last three of the Heisei series, and all of the Millennium series films) features mostly the original Japanese soundtracks alongside German dubs, except the three Heisei films, which include English and German dubs. The discs all feature German subtitles, with Dutch ones on most.

49 Kalat, *A Critical History*, 30.

50 Eric Schaefer, *"Bold! Daring! Shocking! True!" A History of Exploitation Film, 1919–1959* (Durham, NC and London: Duke University Press, 1999), 4–6. Comparisons with recent posters for *Gojira* in the West reveal more stylized designs, the BFI's 2004 poster featuring the title's katakana text, while Criterion's cover art is more akin with the look of the 2014 version, with a more action-oriented view of the monster's back as he rampages through Tokyo.

51 Ibid., 11.

52 The website Toho Kingdom has collected a broad range of international VHS box art for a host of Tōhō's films. See Toho Kingdom, *VHS Box Art* (October 5, 2014), http://www.tohokingdom.com/articles/art_boxart.htm, accessed August 1, 2016.

53 Ryfle, *Japan's Favorite Mon-star*, 135. Rankin-Bass and Tōhō produced *King Kong Escapes* instead, turning this film into a Godzilla movie.

54 Tsutsui, *Godzilla on my Mind*, 194.

55 Iain Robert Smith, *The Hollywood Meme: Transnational Adaptations in World Cinema* (Edinburgh: Edinburgh University Press, 2017).

56 At one point, the chimp grows, and also turns into a gorilla.

57 "Japanese monster movies" feature on Jeffrey Sconce's list of core paracinematic film types. See Jeffrey Sconce, "'Trashing' the Academy: Taste, Excess, and an Emerging Politics of Cinematic Style," *Screen* 36, no. 4 (1995): 371.

58 Church, *Grindhouse Nostalgia*, 244.

59 Ibid., 247.

60 Ibid., 1–3. Discussing *The Touch of Satan* (Don Henderson, 1971), Church notes in the opening of his book that *MST3K* is often fused with fans' memories of cult films.

61 BBC Genome. n.d. *Monster Night—BBC Two England—11 July* 1998, http://genome.ch.bbc.co.uk/92b0364341c847ffaab395dc9973443f, accessed July 28, 2016.

62 Iain Robert Smith has observed a similar effect at play in discourse regarding the Filipino star Weng Weng. See Iain Robert Smith, "'You're Really a Miniature Bond':

Weng Weng and the Transnational Dimension of Cult Film Stardom," in *Cult Film Stardom: Offbeat Attractions and Processes of Cultification*, eds. Kate Egan and Sarah Thomas (London: Palgrave MacMillan, 2013), 226–39.

63 Abé Mark Nornes, *Cinema Babel: Translating Global* Cinema (Minneapolis, MN and London: University of Minnesota Press, 2007), 219.

Blood and Blades: Transnational Heroic Violence in *Twilight Samurai* and *The Last Samurai*

Ken Provencher

Introduction

On February 1, 2004, the main body of Japan's Ground Self-Defense Forces (JGSDF) held an awards ceremony in Asahikawa City, Hokkaido. The occasion was to celebrate the dispatch of a JGSDF unit to Samawah, Iraq, to assist American and British troops in reconstruction efforts. In attendance was Prime Minister Koizumi Junichirō, who encouraged the controversial deployment of the JGSDF to a war zone in another country (controversial due to Japan's Constitution renouncing proactive war). The ceremony ended with a speech by Colonel Banshō Kōichirō, who would lead the JGSDF group in Iraq. "Being of the country of bushidō," he said, "as the Self-Defense Forces we will make our efforts with order and dignity."[1]

Colonel Banshō's reference to bushidō was not just an illustration of his own views—his interpretation of a code of conduct for national armed forces—but a reflection of a short-lived, yet transnational, cinematic trend. At the time he made his remarks, *The Last Samurai* (2003) had settled into a dominant position in Japanese movie theaters, grossing $110 million by mid-February 2004, surpassing the film's American box office.[2] A mere five days before the JGSDF awards ceremony, the nominations for the 76th Academy Awards were announced in Los Angeles. *The Last Samurai*, with four nominations, and Sofia Coppola's Tokyo-located *Lost in Translation* (2003), also with four nominations, capped a year of Japan-themed American cinema that also included Quentin Tarantino's *Kill Bill Vol. 1* (2003). From Japan, *Twilight Samurai* (*Tasogare seibei*,

2002) received a nomination for best foreign language feature, and that same year, films such as *Azumi* (2003) and *The Blind Swordsman: Zatoichi* (*Zatōichi*, 2003) received significant international attention. Most of these films evoked samurai iconography and bushidō philosophy, and commentators in both countries wondered if some kind of "Japan boom" had occurred in America, at the same time a "samurai boom" seemed to be occurring in Japan.[3]

It would be an overstatement to say a "boom" had occurred; instead, Japan-themed Hollywood films of 2003 represent a flashpoint of sorts, an indication of market trends that can also include higher volumes of Japanese audiovisual pop culture products imported into the United States. And when considered alongside the international success of *Twilight Samurai*—a film that asserted the superiority of a samurai willing to die on command for what he knew were outdated ideals—Colonel Banshō's comments about bushidō at the JGSDF awards ceremony seem both timely and responsive to a transnational cultural phenomenon. As participants in the American-led multinational coalition Operation Iraqi Freedom, the JGSDF found itself in the position of not only carrying out but justifying their actions to supporters and detractors. Reaching for symbolic significance, Banshō did not have to go further than the crowd-pleasing images visible on Japan's movie screens. By way of rhetoric, samurai films—an inescapably violent genre that appeals to audiences through the myths of bushidō and the visual iconography of bloodied swords—become nationalist metonyms.

The JGSDF's mission in Iraq was to support reconstruction efforts, where fighting had already occurred. Nevertheless, by joining the American-led coalition, Japan committed ground forces to a combat zone, drawing criticism for what seemed to many observers like a reversal or a revision of its postwar status as a noncombatant nation. The *Asahi shinbun* in particular criticized the operation, singling out Colonel Banshō's use of the term "bushidō" at the awards ceremony. Managing editor Wakamiya Yoshibumi detected a symbolic connection to *The Last Samurai*, and found it odd that the movie was so popular at the time, since the main character, played by co-producer Tom Cruise, was more like an insurgent than a counterinsurgent.[4] What could not be denied was the appeal of Cruise's character to Japanese audiences. Cruise had reportedly read Nitobe Inazō's 1899 book *Bushidō: The Soul of Japan* as part of his research into the film's historical background. Cruise's character, Algren, a traumatized veteran of the American Indian Wars, finds his own disillusionment reflected in the anti-Westernization stance of the heroically doomed ex-samurai of the 1877 Satsuma Rebellion—a campaign he joins as an honorary samurai. The success of the film brought about

a re-publication of a Japanese translation of Nitobe's work (originally written in English), and it became a new bestseller. In early 2004, in the eyes of several commentators in Japan, a Hollywood-produced film and its literary offshoot were contributing to a "bushidō boom."[5]

The very word "bushidō" invites speculation as to who, or what, is being evoked regarding Japan's involvement in Iraq. The JGSDF were unarmed support identified as warriors, perhaps capable of heroic violence but bereft of opportunity. Arming them would not change their identity as warriors; it would simply increase their capacity for waging war, a capacity assumed to be inherent within all Japanese (as a "country of bushidō"), but tempered in the present time to maintain "order" and "dignity." Such language reflects what Nitobe defined as the "eight virtues" of bushidō: righteousness (*gi*), politeness (*rei*), bravery (*yū*), compassion (*jin*), sincerity (*makoto*), self-control (*jisei*), loyalty (*chū*), and of course honor (*meiyō*). These eight virtues had symbolic weight in both the film itself (as a glorification of those virtues) and in advertising. The Japanese program book for *The Last Samurai* listed seven of the eight virtues (omitting "self-control") in a fold out section of the front cover, explaining each one as vital to understanding the philosophy of the film's heroes. In non-Japanese advertising, the word "bushidō" appeared often in kanji characters, usually in the background of poster images. If the top-grossing Hollywood film in Japan in 2003 had a one-word theme, it would be "bushidō," and by extension, its associated virtues. The "soul of Japan," as defined by Nitobe in his classic work and by the makers of *The Last Samurai*, therefore, may be a paradox—a warrior philosophy of nonaggression—that best serves the public relations needs of a military mission undertaken by a nation forbidden to attack with its military.

As much as it seems an outlier in terms of its success overseas, *The Last Samurai* actually benefited from a revival of samurai films (*jidai-geki*) in Japan. Around fifteen months before attending the JGSDF awards ceremony, Prime Minister Koizumi attended a screening of *Twilight Samurai* and immediately endorsed it, enhancing the film's advertising campaign.[6] Set in the same time period as *The Last Samurai*, the film presents a widower samurai of low rank, obligated to care for his two young daughters and senile mother in a small house in Yamagata, desiring little else but to watch his children grow up in a secure, unified Japan. Lacking ambition in the samurai bureaucracy, Seibei is roused to violent action only when it benefits his family—and later, when he fights in the Boshin War, on the side of the doomed samurai. (We do not see Seibei fighting and dying in this war, but it is doubtful he shared the passionate conviction

of Algren; rather, Seibei's participation is a tragic loyalty to the bureaucracy.) With Koizumi's endorsement, and given the film's enormous popularity, and the outpouring of *jidai-geki* that came out shortly before and after, we can consider *Twilight Samurai* a major contribution to contemporary samurai cinema.[7]

It is difficult to measure the precise extent to which 9/11 and the Iraq War influenced the directors of *Twilight Samurai* and *The Last Samurai* (Yamada Yōji and Edward Zwick, respectively). However, by intersecting the genres of the samurai film and the war film, they have some relevance in Iraq War discourse. Yamada maintained that *Twilight Samurai* had immediate thematic concerns, seeing it as a depiction of "modern," "anxious" times that overseas audiences could relate to, even if they couldn't relate to economic and social anxieties specific to Japan.[8] More broadly, the 2002–04 "bushidō boom" was a brief cycle of commercial activity associated with samurai culture that also served as an outlet for commentators on the Iraq War to judge the rightness or wrongness of American and Japanese military action. The national origins of the films were almost irrelevant to their rhetorical utility. American reviewer Ty Burr, for instance, described *Twilight Samurai* as "an old man's movie in all the good ways: gentle, humanistic, rich with observation, quietly aware of all that can't be solved by the sword."[9] Both films achieved cross-cultural significance not only as samurai films, but as reflections on violence at a time of war.

Although *Twilight Samurai* and *The Last Samurai* share multiple textual and thematic similarities, along with more obvious surface connections—time of release, time of setting, and the casting of martial arts star Sanada Hiroyuki as a samurai fiercely devoted to his own brand of bushidō—previous articles, reviews, and studies comparing the films have placed them in stark contrast to one another. Most critics judge the Hollywood film as inferior to the Japanese film: "Comparing *The Last Samurai* to Yamada's film," runs a typical statement, "is like comparing junk to jade."[10] One profound difference between the two cannot be ignored: *Twilight Samurai* criticizes, while *The Last Samurai* romanticizes, loyalty to the doomed samurai class. This difference, however, does not negate both films' valorization of their heroic protagonists, and should not automatically elevate the "critical" Japanese film over the "romantic" Hollywood film. Against this tendency to praise foreign "art films" over Hollywood blockbusters, I argue that the profound intertextual connections between the two are more significant than their differences. Furthermore, given their utility as referents in militaristic and journalistic discourse about the Iraq War, I argue for both films' concurrent status as exploited—if not exploitation—cinema.

Specifically, I will show how both films engage in a transnational exploitation of samurai culture to render violence as justifiable and heroic. By depicting bushidō-principled heroes in opposition to the contemporary socio-cultural order, *Twilight Samurai* and *The Last Samurai* present an entertaining, yet disturbing, figure in contemporary cinema: the noble iconoclastic killer. Samurai identity marks a character as a righteous defender of self and others, while asserting violence as that character's only viable mode of action. The Japanese visuality of samurai violence, categorized by a specific type of weapon and a righteous, code-honoring hero, has proven adaptable to films produced inside and outside of Japan. In both films, "bushidō" is the codified justification for taking the life of another, and has been exploited in countless other, more traditionally defined exploitation films depicting samurai culture. To see it similarly evoked in populist cinema of Hollywood and Japan is to see the transnational mainstreaming of exploitation tropes.

Transnational appeal of the antinational samurai

Twilight Samurai and *The Last Samurai* depict their heroes as outsiders, identifying their rebelliousness with a contemporary audience's support for individual rights and for a chosen, not state-defined, identity. In their historical time, of course, samurai *were* defined by traditions of state, class, family, and gender, but the mythos of bushidō philosophy is such that a *true* samurai may have to go against tradition if it serves a higher purpose. This type of samurai heroism is hardly unique to *Twilight Samurai* and *The Last Samurai*. It may in fact be the rote characterization of samurai film heroes: those who stand out as *more* heroic than other samurai, and thereby represent ideals that transcend mere tradition. Nevertheless, both *Twilight Samurai* and *The Last Samurai* had a genuine novelty. *Twilight Samurai* was director Yamada's first *jidai-geki* after 40 years of making several dozen modern-set *gendai-geki*, while *The Last Samurai* was Hollywood's first large-scale work since the immediate postwar era to feature samurai in their historical time.[11] But their greatest impact on samurai film history is an effect of timing and textual correlation. Arriving as they did, so closely in their production and release, their textual similarities belie their mutual independence as productions. Their most notable effect is in combination, one film resonating with the other, and both films circulating widely outside their countries of origin. We can consider the two films as reinforcing each other through unspoken means: a transnational framing

of the samurai's relevance to contemporary culture that is worthy of attention precisely due to the lack of collaboration between the two projects.

The positive reactions of Japanese audiences to *The Last Samurai* (compared to negative reactions in the United States) are well documented, but so far there has been little discussion of how *Twilight Samurai* has circulated overseas, and how the two films structure their multinational appeal in similar ways.[12] Both films oscillate between nationalism and antinationalism, but on balance they offer severe (and sometimes overwrought) critiques of their countries of origin. The iconoclasm of the films' heroic samurai comes across as a credit to their nations, but the systems they oppose are nationally coded. *The Last Samurai* is a Hollywood film with an anti-American sentiment; Algren expresses it openly in his contempt for the US military. While the film doesn't glorify Japan, its romanticizing of bushidō reportedly gave Japanese audiences an outlet for their own nationalism during the "bushidō boom" triggered in part by the film's success.[13] Conversely, as with many anti-feudal *jidai-geki*, *Twilight Samurai* earned much of its prestige and acclaim overseas through its overt criticism of feudal Japan. Seibei demonstrates mere obeisance to his superiors, without passion or ambition, and even that small measure of loyalty ultimately costs him his life.[14] Yamada himself bolsters this interpretation, likening Seibei to a beleaguered modern-day salaryman whose tragic loyalty to premodern ideals "was made in the Edo period."[15] Both films, *Twilight Samurai* and *The Last Samurai*, have it both ways, setting up protagonists—one American, one Japanese—who represent, simultaneously, nation and antination. *Twilight Samurai* solidifies its multinational appeal by presenting a critique of Japan that reflects contemporary sensibilities, while also tapping into a free-floating "anxiety" inside and outside of Japan. The film's combination of Japanese specificity and contemporary "universality," like *The Last Samurai*'s, enhanced its exploitability on the cultural exchange circuit. To date, *Twilight Samurai* has appeared in Japanese film festivals—many of them sponsored in part by the Japan Foundation—in Kampala (Uganda), Manila (Philippines), Chennai (India), Nizwa (Pakistan), Yangon (Myanmar), and in three cities in Vietnam.[16]

Anachronistic heroes

How do two, separately produced films, one a Warner Bros. production, the other a Shōchiku production, resonate so closely, and to such broad audiences,

through the vehicle of a period military figure? Both *Twilight Samurai* and *The Last Samurai* labor in their textual and thematic construction to isolate the heroic samurai, ideologically, from corrupt forces of national communalism. In *Twilight Samurai*, Seibei's coworkers and superiors in the samurai bureaucracy see little beyond their own careers. Devoted to his daughters, Seibei maintains distance from most other samurai, and their mockery of him (until he demonstrates his physical talents in a duel) appears, to us, as a symptom of misguided values. *The Last Samurai*'s Imperial forces, meanwhile, have corrupt ambitions on a larger scale, shamelessly hiring foreign mercenaries to help wipe out the anti-Imperial rebellion led by the titular "last samurai" Katsumoto (Watanabe Ken). Algren, as one of those mercenaries, does little to hide his disgust with the Imperial government, and finds a spiritual ally in Katsumoto. These heroic samurai are made sympathetic by virtue of their anachronistic qualities: alienated from mainstream society, they are loyal to an imaginary state (in other words, to no state) that reflects their own static ideologies. Because their alienation is a matter of principled resistance, not opportunism, and persists even when the samurai class is obviously doomed, their certainty appears heroic. Their deaths are beautified through cinematic means: Seibei perishes offscreen in the Boshin War, memorialized in the narration of his proud daughter; Katsumoto dies onscreen, in a spectacular moment of transcendence, ordering Algren to finish him off while admiring the scenery of nearby cherry blossoms. Seibei and Katsumoto are most like samurai, therefore, when they are most unlike other samurai, equipped with a conservative psychology that appears ironic when undetermined by, and at times hostile to, their nation of origin.

While both films may seem to criticize westernization and the outlawing of the samurai class, neither film argues for a return to isolationism and feudalism. The increasing globalization of economics and politics in the films appears as a necessary evil in the modern world, something we cannot control as individuals but that we must react to *as* individuals, not as representatives of a nation-state. As mentioned above, the films have a crucial difference in their attitude toward feudalism, with *Twilight Samurai* judging it more harshly. But they offer a similar critique of the systematic *reaction* of the samurai to the test of westernization. The "true" samurai in both films is a symbolic argument for the right to craft an individual identity in an increasingly borderless world, even if it means crossing cultures or opposing the state.

Significantly, both *Twilight Samurai* and *The Last Samurai* are set in the Early Meiji period (1868–77), which saw the beginning of Japan's modernization

of its military and foreign policy. By joining the samurai rebellion against the burgeoning Imperial Japanese government, those samurai who resisted transition—the titular subjects of *Twilight Samurai* and *The Last Samurai*—were branded enemies of the state. Violently opposed to national progress, these rebellious samurai fall between nations—between Japan and the West, who collaborated even as they competed, and between feudal Japan and Imperial Japan. These "true" samurai claim loyalty to the nation not as it is, but as it was, or as they want it to be—a dream state. Disloyal to their *present* nation, they assert an outlaw identity that was once lawful, which has the ironic, and dramatically appealing, effect of elevating their individuality and heroism. Even Seibei, who shows little outward loyalty to the nation (either as it is or was), assumes heroic dimensions—in a quieter form—when obeying orders to assassinate an outlaw samurai, and later, to join the Boshin War as representative of his clan. We know he doesn't believe in the ideological position of either assignment (that it propagates the values of the clan), and yet he is also bereft of nihilism and cynicism. He takes these orders because *not* to take them would be detrimental to the future of his daughters. Such a position gives him heroic stature, as being outside nation and clan simultaneously.

To draw audiences into sympathy with samurai resistant to industrial progress, both films alienate the sympathetic samurai from his unsympathetic peers by giving the lead characters an attractive passivity. Seibei in *Twilight Samurai* refuses constant invitations from his work colleagues to join them for after-hours drinking, which we are made to understand is out of devotion to his daughters. Katsumoto in *The Last Samurai* expresses his desire to halt Japan's modernization in terms of humble service to the Emperor, not out of paranoia or self-glorification. Algren, for his part, is so disgusted with the military policy and imperial culture of the United States—which is defined in terms of advanced weaponry and ruthlessness tinged with racism—that his mission to help train Japan's Imperial army and defeat Katsumoto seems more of an opportunity to destroy himself than a demonstration of loyalty to American trade interests. Joining Katsumoto's rebellion earns Algren a status nearly equal to (if not precisely equal to) those among him who were born samurai. This status is reified through the gifts of a homemade sword, a set of armor, and a prominent position on the climactic battlefield. Algren does not demand these things; he receives and appreciates them. Meanwhile, the proactive dealing, scheming, and jockeying for position that characterizes most other samurai in the films are placed in inferior contrast to the quiet stubbornness of the heroic few.

Home security

Related to the heroic samurai's conservatism and no less appealing to mass audiences is the films' idealization of everyday life and domestic vitality. There are marginal differences in the emphases of the two films on the evanescence of "home," but in both cases, happy domesticity is the heroic samurai's supreme goal. The justification for violence in the films is nearly always conflated into a protection of home and family. This point is crucial in establishing "heroic" violence that is at once brutal and necessary. Seibei's skill as a fighter is clearly superior to his coworkers'; he wins duels even without a long sword (which he sold, significantly, to pay for his wife's funeral). The two duels he fights, and wins, have little suspense. We never question his abilities, which are so advanced he can spare one opponent's life and take the other's as if they were preordained results. We also never question his motives, which are pure despite the complex relationships involving the duels. His first duel is with the abusive ex-husband of his childhood friend Tomoe (Miyazawa Rie), whose brother is actually the one challenged but lacks Seibei's skills. Dueling with a stick instead of a sword, Seibei masterfully disarms and knocks out his opponent, a tactic that spares everyone from severe legal punishment (as duels have been outlawed). The second duel is to the death, and sanctioned by the clan, as the opponent is a "disowned" samurai who has refused to resign his position by killing himself. Seibei dispatches him without any of the grace of the first duel (without a long sword, he battles in close quarters), but with equal conviction—we understand his success means a more secure future for his daughters. Protecting his friends, supporting his children, Seibei can have no darker purposes, certainly no personal pleasure or glory in winning duels. And yet he wins, due to an astonishing swiftness of reflex, an almost unconscious display of violent aggression.

Algren and Katsumoto in *The Last Samurai* are no less spotless (morally) and ruthless (physically) in their duels with others. In a remarkable scene, an unarmed Algren defeats three armed men in approximately twenty seconds, which are then replayed in slow motion as if we're entering the instinctive realm of Algren's mind, where he can anticipate every move and countermove. One of his still-living opponents says, "The samurai are finished!" before Algren decapitates him, assuring us of the rightness of Algren's moral position as well as the effectiveness of his samurai-level fighting technique. Algren's death stroke is gratuitous only if the victim's threat against samurai excluded Algren himself; but Algren, to his enemies, is a threat equal to the rebellion, so his self-defense is a matter of both

survival and principle. Algren defends not only his life but a *way* of life under attack by corrupt forces who deserve no sympathy. A group of ninjas, working for state agents, ambushes Katsumoto and his family during a village festival. Katsumoto and Algren's slaughtering of these home invaders is a literal preservation of the traditional samurai household. The audience of *The Last Samurai*, like those of more crudely designed samurai films properly labeled as exploitation, is meant to be persuaded into moral complicity with murderous violence.

The fantasy of a peaceful Japan that can absorb foreign influence without jeopardizing its native culture is, for the heroic samurai, impossible to realize. Seibei, Algren, and Katsumoto know this, but they insist in continuing their own form of "protection" of the premodern state. We perceive them as heroic because the samurais' passions are scaled down to meet our own, while those who pursue modernization (or, in the case of *Twilight Samurai*, outdated feudal bureaucracy) appear dehumanized and immodest in their ambitions. Seibei, Algren, and Katsumoto are violent men who desire stability; the films resolve this paradox by isolating the three in a utopian world of domestic bliss and philosophical certainty, areas untrammeled by history and accessible to contemporary audiences.

Seibei's world is the small house he occupies with his two daughters and his mentally impaired mother. One of Yamada's primary concerns in preparing locations and sets was to emphasize the microcosm, the mediocrity of daily living. Surface features of the home were tempered to look aged and well-used, and clothing, hair, food, and Yamagata accents were reproduced conscientiously.[17] The effect is not one of squalor, but of stability. The family is poor, not wretched; they struggle without suffering. Seibei's devotion to his daughters is pure, not overbearing or possessive. Modernization is inevitable, but the film argues it is not necessary for happiness—not for Seibei, anyway, as long as his daughters are cared for. Katsumoto also has a domestic paradise, a village in the mountains where he takes Algren in order to learn the ways of the American enemy. Algren adjusts so easily to his foreign environment (after the requisite and comically toned culture shocks) that it could only represent what he always wished for himself: he explains in narration that since he left home as a teenager, he had never been in the same place for such a long time. Like Katsumoto, and like Seibei, Algren takes up arms in defense of his own concept of home—not the home nation, but the "home" he discovered in the mountains.

There is an almost uncanny resemblance between *Twilight Samurai* and *The Last Samurai* in the way they dramatize and idealize the formation of

new families. Seibei subdues the abusive ex-husband of a woman he loves in a duel; Algren kills the husband of Katsumoto's sister, Taka (Koyuki). Both men eventually replace the husbands they defeated. There are two sets of children: Seibei, a widower, has two daughters, and Taka, freshly widowed, has two sons; all four are roughly the same age. The childrens' approval of their new stepmother and stepfather validates the respectability of their newly formed families. The couples also partake in a ritual exclusive to samurai households: the woman dresses the man in proper samurai attire before he ventures out into combat. (Figures 3.1 and 3.2) In both films, the best marriages are those that are

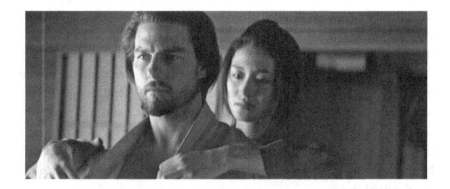

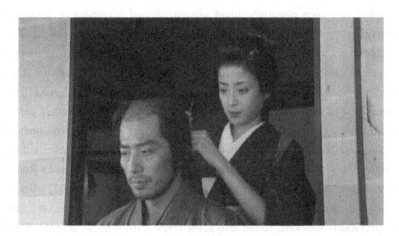

Figures 3.1 and 3.2 Algren (Tom Cruise) and Seibei (Sanada Hiroyuki) have replaced the husbands they defeated. Taka (Koyuki) and Tomoe (Miyazawa Rie) assist in their proper dressing as samurai before combat. From *The Last Samurai*, directed by Edward Zwick, distributed by Warner Bros., 2003; and *Twilight Samurai*, directed by Yamada Yōji, distributed by Shōchiku, 2002.

chosen, not arranged or preapproved. But the breaking of social conventions of marriage ends at the stage of selection. The household itself is still samurai, and the comforts associated with a "true" samurai family appear stronger than anything else the modern world can provide.

Positive and negative judges

To make their points clear, both films implant "judges" of samurai behavior: negative judges who represent misguided principles, and positive judges, usually in the form of a narrator who is not a samurai, whose approval of certain samurai attitudes and actions directs the approving eye of the audience. How the audience perceives the heroism of a samurai is not left to chance: the films declare outright, in voice-over, the values of the heroic who have faded into legend. The self-consciousness of the films' direct address pulls us into sympathy with the narrators, whose non-samurai identities (a Japanese woman, an American man, and an Englishman) bridge our connection to the samurai. While the position of the "negative" judge is to represent misguided principles by showing contempt for what we recognize as honorable samurai behavior, the position of the "positive" judge is to enforce (and reinforce) the films' critical stance.

Typical onscreen negative judges are established members or leaders of a powerful group whose value systems are corrupt. Seibei's status-obsessed uncle and coworkers mock him for his dedication to his daughters because it opposes the careerist ambitions they have for themselves. In *The Last Samurai*, Algren's superior Colonel Bagley (Tony Goldwyn) cannot comprehend Algren's inability to see Japan as anything other than a financial opportunity: Bagley can only stare and say, "Good God" in surprise and contempt when Algren appears for the climactic battle dressed up in samurai armor. Bagley's negative judgment of Algren's samuraization is echoed in *Kill Bill* when yakuza boss O-Ren Ishii (Lucy Liu) calls The Bride (Uma Thurman) a "silly Caucasian girl" who "likes to play with samurai swords." Both Bagley and O-Ren die by the very swords they previously mocked. Seibei also gains respect from those who doubted his strength and abilities by winning duels. Negative judges of "true" samurai are not allowed to have their opinions stick; they are convinced of their wrongness and sometimes punished for it by the violent hand of the once-abject samurai.

Positive judges are a dramatic necessity in films whose heroic characters, according to principle, are unable to praise themselves. Seibei's older daughter Ito (Hashiguchi Erina) and the English intellectual Graham in *The Last Samurai* (Timothy Spall) open and close both films with clear statements about how we should view Seibei and Katsumoto and Algren, respectively. The three of them are deserving of attention because they represent what has become lost in the here and now. (Here and now means, of course, the narrators' own time of speaking as well as our own time of listening.) Ito is proud of her father for his sacrifices on her behalf, while Graham sees honor—"a forgotten word"—in the samurai, a group that includes Algren. In overall structure, the films are two people's reminiscences of admirable figures, and as such, the opinions of the narrators are beyond question. Who would argue with a daughter's appreciation of her own father, who we just saw commit a murder-for-hire before abandoning his children to join a suicidal rebellion? (Her point of view isn't coded as naïve or ironic.) The narration of Ito and Graham, along with Algren's narration that is a series of readings from his own diaries, would seem to be completely superfluous if it weren't for the pointed judgments they render. Seibei, who doesn't speak much for himself, needs Ito to perceive and communicate the symbolic weight of his actions, while Algren, in handing Graham his diaries, urges him to disseminate knowledge of the film's events to those looking for a lesson in heroic glory. Criticizing the violent actions of the heroes, it is implied, means lacking the honor necessary to appreciate them.

Likewise, near the end of *The Last Samurai*, the Meiji Emperor (Nakamura Shichinosuke) is profoundly moved by Algren's offer of service when Algren delivers Katsumoto's sword to the throne room. "If you believe me to be your enemy," says Algren, "command me, and I will gladly take my life." The Emperor takes the sword in both hands and pronounces, "We cannot forget who we are, or where we come from." During that line, the film cuts to a slow zoom-in close-up of Algren, who stares straight ahead in silent agreement. The Emperor's "we," instead of indicating the Japanese exclusively, includes Algren by visual association. Previously in the film, Katsumoto addressed the Emperor as a living god who needed to find his voice. In this final scene, the Emperor not only finds his voice, but he uses it in judgment, pushing back at the American ambassador, condemning his industrialist advisor Omura, and bestowing Algren with Imperial favor. Algren hasn't become Japanese, but he has become an honorary samurai—a member of the royal "we."

Conclusion

To break down samurai identity into ideological components is to dehistoricize the meaning of "samurai" and to erase the samurai's national, or nationally coded, stamp. At the above-mentioned JGSDF awards ceremony in 2004, Colonel Banshō described his troops as representing "the country of bushidō," not "the country of samurai." If he had used the word "samurai," he would have embedded (and embodied) his troops more clearly within a lineage of nation, gender, and race. (He also would have raised more eyebrows among his listeners, especially those sensitive to any official disregard of Japan's war-prohibiting Constitution.) Instead, he characterized the troops by a Japan-originated model of military behavior that, by reason, could be demonstrated by non-Japanese, even nonmilitary non-Japanese. When samurai become vessels of bushidō, samurai identity becomes radically inclusive, an honorary title that cannot be purchased or inherited. It is the characterization of samurai by behavior, not by family history or citizenship, that loosens the samurai identity and opens up the possibility of anyone judged to be following bushidō tenets to claim—or, more preferably, to have others claim on his or her behalf—the title of a "true" samurai.

Twilight Samurai and *The Last Samurai* are not unprecedented, and are certainly not the last word on samurai, but as corresponding works of two different national cinemas, they have achieved a remarkable cumulative effect. The enormity of the films' success and the potency of their formal and thematic elements *in combination* is a transnational phenomenon that serves as a powerful demonstration of cultural globalization. A conservative figure in liberal times, the contemporary cinematic samurai appears self-contradictory, an explicit critique of moral relativism wrought by historical turns. The samurai functions as both contrast and comfort—a vehicle through which filmmakers can judge the uncertainty of their times while reassuring audiences of the certainty and the correctness of the filmmakers' own interpretation of bushidō philosophy. There are many types of samurai in both Yamada's and Zwick's films, but only a specific type comes across as "true": those who commit violence judiciously for the sake of others, and those who apply military discipline to worthier domestic goals. By extrapolation, we can consider the samurai in contemporary cinema as an exploitable archetype that either upholds or violates "universal" principles that transcend premodern Japan, transcend even Japan itself.

Notes

1 Iwashima Hisao, "Bushidō būmu; heiwa koso Nitobeshi no negai," (Bushidō boom; Nitobe's desire for peace), *Asahi shinbun* (March 6, 2004), 14. Translations from Japanese are mine unless otherwise noted.

2 *The Last Samurai's* high gross in Japan is partly due to the recent abolishment of block-booking practices in Japanese movie theaters, as well as a growing screen count and the highest standard adult admission ticket price in the world, at $17.14. A large-scale marketing campaign in Japan, where the film had its world premiere on November 20, 2003, is of course also a factor, along with high advance praise from entertainment publications catering to young audiences, such as *Pia*, which called the film "the real thing." See "Trendspotting: Japan," *Screen International* (February 20, 2004; December 5, 2003).

3 The phrase "samurai boom" appeared in Teramoto Shōji, "Bei akademiishō hariuddo ni [samurai] būmu," (American Academy Awards: [Samurai] Boom in Hollywood), *Tokyo shinbun* (January 29, 2004), 16. See also "Beikoku de chūmoku, eiga no naka no 'nihon' futatsu no [samurai]," (Attention in America: Japan and two samurai in films), *Mainichi shinbun* (February 3, 2004), 7. A *New York Times* article called the 2003 year in American cinema a "season of subtitles and samurai." Motoko Rich, "The Land of the Rising Cliché," *The New York Times* (January 4, 2004), http://www.nytimes.com/2004/01/04/movies/land-of-the-rising-cliche.html?_r=0, accessed January 1, 2017.

4 Wakamiya Yoshibumi. "Rasuto samurai; bushidō to iraku no teikō to." (Last Samurai: Bushidō and Iraq's resistance.) *Asahi shinbun* (April 25, 2004), 17.

5 Yūri Kazuko, "Samurai no hisō to hiai (dekoboko kagami)," (Samurai bravery and pathos [rough mirror]), *Asahi shinbun* (February 12, 2004), 12.; and Katō, Yuzuru, "[Kyō no nōto] samurai," (Today's note: samurai), *Yomiuri shinbun* (December 24, 2003), 10.

6 Ichiro Yamamoto, "The *Jidai-geki* Film *Twilight Samurai*—A Salaryman-Producer's Point of View," trans. Diane Wei Lewis, in *The Oxford Handbook of Japanese Cinema*, ed. Daisuke Miyao (New York: Oxford University Press, 2014), 324.

7 Articles of the time considering the resurgence in *jidai-geki* in Japan include Mark Schilling, "Screen dreams of the good old samurai days," *The Japan Times* (December 15, 2002), http://www.japantimes.co.jp/community/2002/12/15/general/screen-dreams-of-the-good-old-samura-days, accessed January 1, 2017; Aaron Gerow, "Period dramas back in fashion," *The Daily Yomiuri* (June 17, 2006), 19; and "Gendai de wa riaru , sugiru [jidai mono] naze ka ninki," (Why are very real period things popular today?), *Asahi shinbun* (January 20, 2002), 35.

8 Mark Schilling, "Showing samurai as they were," *The Japan Times* (March 16, 2003), http://www.japantimes.co.jp/community/2003/03/16/general/yoji-yamada, accessed January 1, 2017. Quoted in English.

9 Ty Burr, "Gentle 'Samurai' Stresses Words Over Swords," *The Boston Globe* (June 4, 2004), C8.

10 Nigel Andrews, "The finest hour of a man called Twilight," *Financial Times* (April 15, 2004), 15. Unfavorable comparisons of *The Last Samurai* to *Twilight Samurai* appeared mainly in English-language reviews of *Twilight* when it was released in the United States and Europe in spring 2004. See Stephen Hunter, "'Twilight Samurai': As Brilliant as The Setting Sun," *The Washington Post* (June 4, 2004), C01; Bob Strauss, "Taking the Samurai Genre to a Place It's Never Been," *The Los Angeles Daily News* (April 30, 2004), U11; and Mark Jenkins, "'Samurai' Cuts Wide and Deep," *The Washington Post* (June 4, 2004), T58. Film scholar Mina Shin argued that the two films have "sharply opposite perspectives," with *Twilight* critiquing the samurai system while *Last Samurai* glorifies it. See Mina Shin, "Making a Samurai Western: Japan and the White Samurai Fantasy in *The Last Samurai*," *The Journal of Popular Culture*, 43, no. 5 (2010): 1065–80. Film writer Ishitobi Tokuju, however, sees both films as equally skeptical of the benefits of modernization. See Ishitobi Tokuju, "Ishin eiga; tsukareta nihonjin ni [hankindai] wo," (Restoration Film: "anti-modern" to worn-out Japanese), *Asahi shinbun* (January 29, 2005), 10.

11 John Huston's *The Barbarian and the Geisha* (1958) and the 1980 television adaptation of James Clavell's *Shōgun* are arguably *The Last Samurai's* only American-produced large-scale predecessors.

12 See "[Rasuto samurai] nibei de kyōkan hankyō yobi 'hariuddo sei nihon eiga,'" ("Last samurai": Japan-America sympathy and influence, called a "Hollywood-made Japanese film"), *Tokyo shinbun* (December 13, 2003), 16; and Lorenza Munoz, "Cruise's 'Samurai': a battle of opinions," *The Los Angeles Times* (December 10, 2003), http://articles.latimes.com/2003/dec/10/entertainment/et-munoz10, accessed January 1, 2017.

13 Jayson Chun, "Learning Bushidō From Abroad: Japanese Reactions to *The Last Samurai*," *International Journal of Asia-Pacific Studies* 7, no. 3 (September 2011): 19–34. Midori Nakano, quoted in Rich (2004), speculates that if a contemporary Japanese director had made *The Last Samurai*, his or her political motives would be questioned. Sanada Hiroyuki agrees, describing the historical period covered in both films as "still a dangerous subject for Japanese filmmakers." "The Next Samurai," *Daily Yomiuri* (September 18, 2003), 13.

14 David Desser argues the international appeal of anti-feudal *jidai-geki* as a form of "bleakness" that appears unique to Japan and yet easily understood outside Japan as a critique of a "dead" system. David Desser, *The Samurai Films of Akira Kurosawa* (Ann Arbor: UMI Research Press, 1981), 37–38. S. A. Thornton discusses *Twilight Samurai* specifically in those terms, calling it "a confirmation of the viability of the period film as a traditional response to unease in Japanese

society." S. A. Thornton, *The Japanese Period Film: A Critical Analysis* (Jefferson: McFarland and Company, 2008), 200.

15 "Kanjō nomikudasu no ga jidaigeki no miryoku," (The charm of a jidaigeki that swallows emotion), *Mainichi shinbun* (November 13, 2002), 7.

16 Anne Nerissa C. Alina, "Japan Foundation presents films, theater and cartoons," *Business World* (September 13, 2006), S4/2; "Japanese film festival inaugurated in city," *The Hindu* (November 16, 2006), 6.

17 Saita Akiko, "[Suteeji] jidaigeki sasae 50 nen eiga bijutsu kantoku nishioka yoshinobusan riaru ni bakasemasu," ("Stage": Jidaigeki support; 50 years' art director Nishioka Yoshinobu enchanted by the real), *Yomiuri shinbun* (February 22, 2002), 3.

Part Two

The Exploitation Marketplace

Dragons, Ninjas, and Kickboxers: The Minor Transnational Action Films of IFD

Man-Fung Yip

Introduction

This chapter presents a preliminary study of IFD Films and Arts Limited (henceforth IFD), a fascinating but little-known company from Hong Kong specializing in the production and distribution of low-cost, transnational, English-language martial arts and action films. Founded by Joseph Lai in 1973, IFD released in a span of two decades hundreds of films, which covered a wide variety of action subgenres. They included, among others, bruceploitation[1] and other types of kung fu films in the late 1970s and early 1980s, many of which were collaborative efforts—both real and fake, as I will explain later—with South Korean companies and featured Korean action stars (Dragon Lee, Hwang Jang-lee, Casanova Wong, etc.); ninja films in the early to mid-1980s, a popular trend in world cinema following the huge box office success of Menahem Golan's *Enter the Ninja* (1981); and martial arts tournament films in the style of the kickboxing flicks of Jean-Claude Van Damme that came into vogue during the late 1980s and early 1990s. While most of these films were made with miniscule budgets and have been dismissed as z-grade trash movies, a deeper look at them, I argue, sheds light on the profound transformations in global film and media markets around the period. Taking the films seriously would also broaden our view on the issue of transnationalism in action cinema. Despite their limited production values and low cultural and critical status, IFD's films constituted a major part in the transnational cultural flows and formations of an increasingly globalized world. What this entails, then, is that transnationalism in cinema does not rest exclusively with the big-budget, high-visibility films (as exemplified by Hollywood's special effects-packed blockbusters today);

the marginal and less visible films are no less a border-crossing force, albeit one that operates on a different logic and takes significantly different forms, epitomizing a case of what Françoise Lionnet and Shu-mei Shih call "minor transnationalism."[2]

I

Following the kung fu film craze in the early 1970s, many Hong Kong companies were eager to break into the international film market. IFD was a case in point, although the company was not (yet) very active and took a rather low profile in the beginning. It turned out that Lai was still trying to learn the nitty-gritty of film business by assisting his sister, who was the owner of Intercontinental Film Distributors (H. K.) Ltd.[3] As an independent distributor, Intercontinental bought many non-Chinese films for distribution in Hong Kong, Taiwan, and throughout Southeast Asia, thus giving Lai a lot of firsthand knowledge and experience with both local and international film distribution. Besides, in order to capitalize on the global popularity of kung fu films, the company was beginning to move into making its own martial arts/action pictures. This can be witnessed in a series of titles featuring Chris Mitchum, including the Hong Kong-Filipino co-production *Master Samurai* (Cesar Gallardo and Jun Gallardo, 1974).[4] According to Lai himself, he was brought in as an assistant director in these films, in addition to offering help with translation, scriptwriting, and other tasks. Through these experiences, Lai acquired a better understanding of the filmmaking process and realized the lucrative but not yet fully tapped potential of international distribution.[5]

Feeling prepared to get more directly involved in film production and distribution, Lai set up Asso Asia Films Limited together with Thomas Tang.[6] Among the first films released by the company are Chan Siu-pang's *The Magnificent* (*Longxing diaoshou jinzhongzhao*, 1979) and *Rivals of the Silver Fox* (*Meihua tanglang*, 1979), as well as Godfrey Ho's *The Dragon, the Hero* (*Zajia gaoshou*, 1979). All these films, it is worth noting, had strong Korean connections. For one thing, there was plenty of location shooting in South Korea, not only because it was relatively cheaper to shoot there but also due to the country's abundant supply of open natural landscape and ancient Buddhist temples necessary for period martial arts movies. The films were also made with strong collaboration from Korean companies, which provided many of the cast

and crew members, notably those Korean action stars—Casanova Wong in *The Magnificent* and *Rivals of the Silver Fox*; Dragon Lee in *The Dragon, the Hero*—who had previously appeared in other internationally distributed martial arts pictures. Generally, the Korean companies would keep the rights of the films for their domestic market, while Asso Asia would distribute the films in Hong Kong and around the world.

Using such a collaborative model, Asso Asia was able to quickly build up its library and put into market a continuous stream of films during the late 1970s and early 1980s. Not surprisingly, most of these productions belong to the martial arts genre, specifically one of the following three types of film:[7] first, bruceploitation, examples of which include *The Dragon's Showdown* (1981) and *Enter the Invincible Hero* (1981), both nominally directed by Godfrey Ho and starring Dragon Lee, a Korean actor who had made a name for himself as one of the most successful "clones" of Bruce Lee (Figure 4.1).[8]

The second type is the Shaolin Kung fu film, a popular trend following the successes of Joseph Kuo's *The 18 Bronzemen* (*Shaolinsi shiba tongren*, 1976) and Lau Kar-leung's *The 36th Chamber of Shaolin* (*Shaolin sanshiliu fang*, 1978). Films in this category include Ho's *Fury in Shaolin Temple* (1982) and *The Grand Master of Shaolin Kung Fu* (1982). Last but not least, kung fu comedy in the style of Yuen Woo-ping's *Snake in the Eagle's Shadow* (*Shexing diaoshou*, 1978) and *Drunken Master* (*Zui quan*, 1978), both featuring a young Jackie

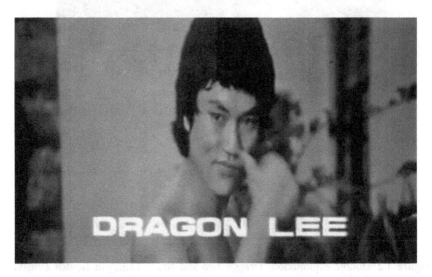

Figure 4.1 Bruce Lee's Clone: Dragon Lee in *Enter the Invincible Hero* (1981).

Chan, also made up a large portion of Asso Asia's films in this period. A good case in point is *Revenge of the Drunken Master* (Ho, 1982), which opens with the protagonist, a mischievous young man looking remarkably like Chan's character in the original *Drunken Master* film, performing the Drunken Fist under the same musical theme used in Yuen's movie. The same Jackie Chan look-alike actor (oddly named Bruce Leung) also appeared in *Golden Dragon, Silver Snake* (1980), in which he was paired with Dragon Lee giving another of his Bruce Lee impersonations (Figure 4.2).

As should be clear by now, these Asso Asia films were mostly imitations and knockoffs of Hong Kong martial arts movies, although their target market was, for the most part, not Hong Kong itself. Indeed, many of these films were never released in the then British colony; rather, they were dubbed in English and sold to markets worldwide.

All this seems pretty straightforward, but it needs to be said that the nature of the collaboration between Asso Asia and the Korean companies varied greatly between films. Some of the films can be called, for lack of a better term, "co-productions" in which Asso Asia participated actively, as equal partner, with its Korean counterparts. These films, which were relatively few in number and made mostly in the early years of Asso Asia, involved greater participation of

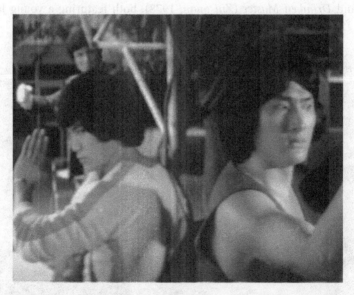

Figure 4.2 Double exploitation: Dragon Lee and Bruce Leung in *Golden Dragon, Silver Snake* (1980).

Chinese cast and crew members (as in *The Magnificent*, which included Chen Sing and Carter Wong, among others, in the cast), and were released both in Hong Kong and internationally. In other cases, Asso Asia simply bought the rights to what were essentially Korean movies and then repackaged them, often as its own productions, for international distribution. Such films featured predominantly (if not exclusively) Korean actors and actresses, and were mostly made under the helm of Korean directors (despite Godfrey Ho being frequently credited as director in the international releases).[9] Some of these films had been screened in Korea years before they were picked up and circulated globally,[10] while others were projects funded by Asso Asia through preselling. According to Kim Si-hyeon, a Korean director who made a number of these "pre-sold" films for the Hong Kong company, he would receive US$3,000–5,000 in advance for a typical production and obtained another US$25,000–30,000 upon the film's completion. He also noted that Hong Kong action stars like Carter Wong or Gordon Liu would sometimes be used, but Korean actors renamed with "Hong Kong-style" pseudonyms were preferred because they were less expensive.[11]

In the end, however, due to the paucity of available information pertaining to the company and its mode(s) of operation, it is very difficult to ascertain with certainty whether an Asso Asia film was a "co-production" or simply a Korean import acquired for international distribution. My discussion above assumes that the "co-productions" involved relatively larger budgets and thus allowed Asso Asia to use some well-known local action stars and/or crew members to make the films more appealing to Hong Kong audiences. This strategy made sense in the late 1970s when the martial arts film, while having past its golden age a decade or so earlier, was still a popular genre in Hong Kong. But as the genre started losing its grip in the local market at the beginning of the 1980s, Asso Asia had no choice but to increasingly shift its focus to international markets. As one might expect, the local "flavors" became less crucial, and Asso Asia reckoned that it was economically more feasible to simply outsource production to South Korea, to exploit low-cost Korean film talent and sell the cheaply made Korean films, in dubbed versions and with alternative director's credits, for global distribution.

II

Asso Asia had successfully made a name for itself in the world of low-budget martial arts cinema when it abruptly ceased operation in 1983, following an

alleged fallout between the two owners, Joseph Lai and Thomas Tang. Tang went on to establish his own production company, Filmark, while Lai returned to IFD and revived the hitherto dormant enterprise. Coincidentally or not, this split came at a time when changes in screen economies worldwide had significantly opened up new possibilities for low-budget action cinema. In the United States, Hong Kong and other Asian martial arts films had, by the late 1970s, been relegated to the margins of the film market and were shown mostly in nonmainstream venues such as drive-ins and grindhouse theaters. (Much the same can be said of other types of exploitation cinema, which had increasingly seen their theatrical market eroded by the new blockbuster-driven film industry and culture.) But despite the slumping theatrical market, martial arts films found a new exhibition outlet in television, in syndicated shows such as "Black Belt Theater" and "Kung Fu Theater." Even if this trend, too, gradually lost momentum and came to an end by the late 1980s, its impact had been substantial and undeniable. For instance, the spectacle of kung fu and karate action on television put Asian martial arts firmly in the American popular imagination and played a major role in sparking the growth of the American martial arts film—the ninja films, the *Karate Kid* series, and the numerous pictures starring Chuck Norris, Steven Seagal, and Jean-Claude Van Damme. While these movies represented in many ways an attempt by the American film industry to domesticate Asian martial arts cinema, their international popularity also rendered them a target of appropriation by some Hong Kong film producers, including Joseph Lai and Thomas Tang. For instance, in the wake of the global successes of ninja-themed movies such as *Enter the Ninja* as well as Sam Firstenberg's *Revenge of the Ninja* (1983) and *Ninja III: The Domination* (1984), Lai and Tang, savvy businessmen as they were, quickly shifted from making traditional kung fu flicks to focus almost exclusively on English-language ninja films.

But what is fascinating is not just the shift in production focus, but how prolific Lai's IFD was at the time, for during the 1980s, the company turned out close to 40 to 50 ninja films and released, at its peak, about 10 to 15 films a year. (Filmark, which followed closely the production model of IFD, was not far behind in mass-producing its own ninja flicks.)[12] To better understand this truly staggering productivity, we need to consider a larger trend—the worldwide video boom—and see how it ushered in new possibilities to global film financing as well as transnational film distribution and consumption. Since the introduction of the videocassette recorder (VCR) in the mid-1970s, home video had rapidly grown into a global culture industry. In 1980, only 2.4 percent

of American households owned a VCR. The figure increased to 51.7 percent in 1987, and by the early 1990s, nearly 75 percent TV households owned a VCR. As home video became more widespread, video rental grew into a vast and lucrative business, with the number of video stores skyrocketing from a few hundred to over 30,000 during the 1980s.[13] And this video revolution was not simply an American phenomenon; in Europe and other parts of the globe, too, home video technologies were enthusiastically adopted and used, which led to major changes in the ways films were produced and consumed.[14]

One result of the burgeoning global video market, and thus the copious shelves in video stores waiting to be filled, was a growing demand for films— especially action films and other "sensational" genres targeted at the working-class audiences. As the demand for films heated up, so too did the prices of video rights to films, and this new source of money was one of the major reasons for the prolific output of IFD—and similar companies such as Filmark—in the 1980s. As Joseph Lai himself pointed out, video prebuying grew so rapidly in the period that his company was "flooded" with projects and had many "contractual obligations" to distributors that it needed to fulfill.[15] A similar point was made by Godfrey Ho, the director behind many of IFD's ninja films. According to Ho, IFD's productions attracted video buyers from around the globe, and this hot trend in buying guaranteed that the company was able to secure 30 to 40 contracts in a film market like MIFED (the now-defunct film fair in Milan) every year.[16] In attending major film fairs and having distributors commit to prebuy their films, Lai and Ho were able to make sure that their projects were able to get into profit, or at least acquire partial funding, before they entered into production. The profit margin for each film was probably small, but one could still make lots of money through mass production. That is why the main goal of IFD was not to make artistic or technically sophisticated films, but rather to boost production and turn out as many low-budget films as possible for a ravenous video market.

IFD's business plan, then, was based on a high-volume, low-profit model of production; its films thus had to be made quickly and cheaply. This perhaps explains the most (in)famous feature of the company's ninja films, namely their "cut-and-paste" approach—that is, the method of recycling footage from some obscure Asian (primarily Taiwanese, South Korean, Filipino, and Thai) action film whose rights had been bought by IFD, splicing it with new materials featuring ninja characters (usually played by Caucasian actors) and ninja-fighting sequences, and then dubbing over the disparate footage to create a new

final product. It should be noted that IFD also released some of the Asian films it bought (in dubbed versions) without the reediting or the added footage. But the cut-and-paste method provided the company with a quick and cost-effective way of creating its own productions, which were deemed more marketable, more desirable to international buyers and audiences, than those Asian films due to their inclusion of Caucasian actors and elements from prevailing trends in action cinema. One of the first IFD films that made use of the cut-and-paste method is Godfrey Ho's *Mission Thunderbolt* (1983), which took *Don't Trust a Stranger* (*Bie ai moshengren*, 1982), a Taiwanese gangster film directed by Tung Chin-hu, as its source movie. *Mission Thunderbolt*, I hasten to add, was a conventional modern actioner rather than a ninja film, but once the cut-and-paste method was found to be working, Lai stuck with it and used it extensively when he turned his attention to ninja pictures.

To get a more specific idea of how the cut-and-paste method works, let us look at Ho's *Ninja the Protector* (1986), a film made at the peak of IFD's ninja film boom. The film—at least the part shot by Ho—is about a special police task force set up to trace the source of forged US banknotes in Hong Kong. The fraudulent operation, as revealed at the outset of the film, is controlled by a group of people all of whom are highly trained ninjas; so, too, is the head of the special task force, played by Richard Harrison.[17] These premises justify the inclusion of newly shot ninja-sequences, which together with some exposition scenes are constantly intercut with footage taken from an earlier Taiwanese movie. In one early scene, members of the special task force share photos of several individuals believed to be in charge of the money forgery operation, including Susan. Also introduced is Warren, the police's undercover agent. These two people turn out to be key characters in the Taiwanese film whose footage was appropriated by IFD. At one point, a scene newly shot by Ho shows a white woman in a hotel room calling Susan and asking for a hundred thousand dollars' worth of forged bills. As the conversation closes, the film cuts to an office, and Susan is seen hanging up the phone at the same time as Warren enters the room (Figures 4.3 and 4.4).

This latter scene at the office is taken from the Taiwanese film; in the original context, it is about an inexperienced man trying to find a job as a model. In Ho's cut-and-paste version, the setting remains the office of a modeling agency, but one that is used as a front for the forgers. And the man is not a mere job applicant but pretends to be one in order to infiltrate the gang.

The example above may give one a sense of fairly seamless transition, but in reality, *Ninja the Protector* is far from coherent. The Taiwanese source film is an

Figures 4.3 and 4.4 The cut-and-paste method: Splicing footage from disparate sources in *Ninja the Protector* (1986).

erotic melodrama and so does not fit in well with the undercover agent plotline. In fact, Warren does virtually nothing to keep track of the money forgery gang, but rather has affairs with several women (including Susan) and gets caught up in a love triangle with his brother and girlfriend—which are of course what the Taiwanese film is centrally about. To bridge these unconnected plot threads,

Ho devises a scene in which members of the special task force talk about the personal problems Warren has. In the end, they decide to check on his brother and girlfriend, which is nothing but a pretext to use, however awkwardly, some of the most extraneous materials (such as the girlfriend's attempted suicide and the subsequent confrontation of Warren by his brother) from the Taiwanese film.

As one might expect, then, the cut-and-paste method often resulted in films that have madly incoherent plots and styles, yet it also allowed producers to use a tiny budget to make several movies within a short period of time. In a changing global media environment where the demand for low-budget action films was rapidly growing, this fast and cheap production method proved to be a viable strategy and set IFD onto a consistent production path during much of the 1980s. More unexpectedly, the cut-and-paste films of IFD served to circulate some obscure Asian films—films that would otherwise be ignored—around the world. Among the Asian films used by IFD are Korean martial arts films, Thai and Filipino action films, and most interestingly perhaps, the Taiwan Black Movies. This last group comprises mainly exploitation films (gangster films, rape-revenge films, etc.) that flourished in Taiwan between 1979 and 1983, and which juxtaposed exposes of the darker sides of Taiwanese society—thus the name "Black Movies"—and sensationalist exploitation of violence and sex. While snubbed and censured by critics at the time, they have since been reappraised and are the subject of Hou Chi-Jan's recent documentary *Taiwan Black Movies* (*Taiwan heidianying*, 2005). Unfortunately, unadulterated prints of these films are difficult to come by; in many cases, the only way to watch them today, ironically, is through the dubbed versions distributed internationally by IFD (and preserved on video) or through the bits and pieces found in the company's cut-and-paste films.

III

The ninja craze started to fade in the mid-1980s, and while IFD continued to churn out ninja films until the late 1980s, it was also actively looking for new trends to capitalize on—or at least ways to add new elements to the existing ninja film framework. The *War City* series, for instance, sought to emulate the "gun-fu" films—that is, contemporary action thrillers that mix gunplay with kung fu—popularized by the female-cop movies of D & B Films and by the gangster films of John Woo.[18] At the same time, like Cannon Films in the United

States and other companies that targeted the ravenous market for "B" action pictures, IFD also sought to tap into the popularity of the *Rambo* franchise and Oliver Stone's *Platoon* (1986) by churning out its own war films (among them the *American Force* series).[19] It did not matter that IFD was too cash-strapped to stage a spectacular or even convincing battle scene; it could always resort to the "cut-and-paste" method, using the ready-made footage from some Thai or Filipino war films and intercutting it with newly shot (and more mundane) sequences.

Yet one of the most prominent trends in low-budget action cinema in the late 1980s—and one that was most successfully appropriated by IFD—was undoubtedly the kickboxing/martial arts tournament films made popular by Newt Arnold's *Bloodsport* (1988) and Mark DiSalle and David Worth's *Kickboxer* (1989), both starring a young Jean-Claude Van Damme. Joseph Lai, always sensitive to the changing tides in the market, quickly noticed the trend and saw it as a way to move beyond the waning ninja film craze. In the few years that followed, again with video presales providing a vital source of funding, IFD turned out an array of kickboxing films, including Alton Cheung's *Kickboxer the Champion* (1991), Albert Yu's *The Fighter, the Winner* (1991), Eric Tsui's *Year of the Kingboxer* (1991), and Cheung's *Kickboxer King* (1992). And like the ninja films before them, most of these kickboxing films adhere to the "cut-and-paste" approach discussed earlier, which was essential to IFD's high-volume, low-profit mode of production. In *The Fighter, the Winner*, for instance, footage from Tony Y. Reyes' *Grease Gun Brothers* (1985), a Filipino action film about two rival gangs, is intercut with new footage featuring two expert fighters involved in illegal kickboxing. Alton Cheung's *Zodiac America 3: Kickboxer from Hell* (1990), on the other hand, uses Mak Pang-chin's *The Obsessed* (*Ling mo*, 1975), a horror movie from Taiwan, as its source film and incorporates it within an action plot involving a kickboxer and a nun fighting against a Satan worshipping cult.

But if this strategy was working in the 1980s and turned IFD into one of the most prolific film companies in Hong Kong during the period, it proved to be increasingly ineffective in the 1990s. On the one hand, Hollywood had finally realized the commercial potential of martial arts and martial arts-inflected action films, and attempts were made to incorporate some of the most important figures associated with the genres, notably John Woo, Jackie Chan, Jean-Claude Van Damme, and Jet Li, into the mainstream of American and, by extension, global cinema. This became especially evident after the successes, through the burgeoning video market and in colleges and the repertory circuit,

of Ringo Lam's *City on Fire* (*Long hu fengyun*, 1987), Woo's *The Killer* (*Diexie shuangxiong*, 1989), and Jackie Chan's *Police Story* (*Jinhcha guishi*) series (1985, 1988, 1992). These Hong Kong films found their most ardent fans among leisure-craving adolescents and young adults—in the United States and around the world—actively looking for alternative entertainment options, but they were also able to capture the imagination of a new generation of filmmakers, not least Quentin Tarantino and Robert Rodriguez. With its expanding audience base, Hong Kong martial arts and action cinema started to attract the attention of Hollywood executives, who began looking for ways to tap the commercial potential of this burgeoning trend. It is precisely against this background that Woo went Hollywood and made his American debut with *Hard Target* (starring Jean-Claude Van Damme) in 1993. Other Hong Kong film talent (such as Jackie Chan, Jet Li, Yuen Woo-ping, Ching Siu-tung, and Donnie Yen) soon followed suit,[20] paving the way for what may be called the "mainstreaming" of the Hong Kong action style—a style characterized by, among other things, gestural clarity, rhythmic vitality, and a highly expressive use of the stylistic resources of the cinematic medium. As the martial arts action film genre, Hong Kong-based or otherwise, became increasingly "de-ghettoized," the niche appeal of IFD's films in the low-budget action film market also saw a gradual but indisputable decline.

On the other hand, action cinema in general was becoming more spectacle-oriented, and more reliant on visual and special effects than on sheer bodily action. This can be seen in the increasing prominence of science fiction action films such as Paul Verhoeven's *RoboCop* (1987) and *Total Recall* (1990), James Cameron's *Terminator 2: Judgement Day* (1991), and the Wachowskis' *The Matrix* (1999). Even the martial arts film, which is traditionally more reliant on concrete physical action and on the performative skills of the action stars, had to adapt to this trend by utilizing more airborne action choreography and digital visual effects. This trend can be traced to Tsui Hark's *Zu: Warriors from the Magic Mountain* (*Xin shushan jianxia*, 1983), a path-breaking film that combined traditional wire work with some of Hollywood's most advanced special and visual effects technologies (digital motion control, optical compositing, etc.), but it did not develop into a major force in the Hong Kong film industry until the late 1980s and early 1990s, with films like Ching Siu-tung's *A Chinese Ghost Story* (*Qiannü youhun*, 1987), Ching's *Swordsman II* (*Xiao ao Jianghu zhi dongfang bubai*, 1992), and Ronny Yu's *The Bride with White Hair* (*Baifa monü zhuan*, 1993) taking the market by storm. This "technologization" of martial arts and action cinema attested to the increasing dominance of high-tech visual

and special effects within the action genre, which had the effect of further marginalizing IFD's low-budget, body-centered action films and led to the rapid shrinking of the films' hitherto small but reliable market.

IFD did try to respond to this technological turn by introducing some sci-fi elements into its films, in the hope of making the films more appealing to the changing tastes of audiences. This can be seen clearly in Vincent Leung's *Rings Untouchable* (a.k.a. *Robo-Kickboxer*, 1990) and in the *Catman* series (*Catman in Lethal Track*, 1990; *Catman 2: Boxer's Blow*, 1990) directed by Alton Cheung. *Rings Untouchable*, as its alternative title implies, draws on the blockbuster hit *RoboCop* and features a robotic kickboxer who fights in a boxing ring (Figure 4.5).

The *Catman* series, on the other hand, is based on a central character who acquires superpower after being scratched by a radioactive cat during a fight with some thugs. On the costume he dons is a cat-insignia over a yellow oval, which closely resembles not only the iconic symbol of Batman but also the logo of a popular logistics company in Hong Kong known as Yamato (Figure 4.6).

Not surprisingly, with no real incorporation of high-tech visual and special effects, the invention of a robo-kickboxer or a tacky, derivative superhero did nothing to alter the downward trajectory of IFD. The problem is that, for a small company like IFD, it was simply a losing battle to compete with the more deep-pocketed studios—in Hollywood or elsewhere—in offering effects-based

Figure 4.5 The robotic kickboxer in *Rings Untouchable* (a.k.a. *Robo-Kickboxer* 1990).

Figure 4.6 The Cat-insignia in *Catman in Lethal Track* (1990) looks similar to the logo of Yamato Transport, a popular logistics company in Hong Kong.

entertainment. What is more, as if the cut-and-paste approach did not already make the films confusing enough,[21] the incorporation of a robotic or superhero figure who fights with a bunch of kickboxers made the films even harder to be taken seriously (if also turning them into perfect cult films). The time for low-budget action cinema had gone, and IFD, once a prolific company whose films reached a vast number of markets in all corners of the world, was in irreversible decline. Although the company is still in operation as of today, it has presumably ceased production. What is left is a sizable library of films, which IFD continues to exploit by changing their titles and selling their distribution rights to whatever companies were still interested in them.[22]

IV

What can one learn from this preliminary study of IFD, a little-known company from Hong Kong specializing in low-cost, transnational martial arts/action films? I would like to offer two observations here. First, it is my contention that these rather obscure films emerged out of profound changes in the global film and media markets, particularly the kung fu craze associated with Bruce Lee in the early to mid-1970s and the rapid rise of home video as a global mass

medium from the late 1970s on. At a time—that is, the late 1970s and early 1980s—when the global theatrical market for low-budget exploitation films was quickly eroding, the video revolution was crucial in continuing (and even reviving) the transnational circulation and consumption of low-budget martial arts/action films, while bringing at the same time new possibilities in financing. Video presales, for instance, provided IFD with a major source of funding, and it was through the rapidly expanding video market around the world that its films could gain an international following among predominantly working-class audiences. More recently, the digitalization of media technologies has helped to bring the films to a new generation of viewers. Not only have DVDs and YouTube made the films more accessible than ever, but internet connectivity has also enabled people to obtain and disseminate information about the films. This has created a kind of virtual community linked by blogs as well as by fans sites and forums,[23] and what were once seen as bottom-barrel films have turned into objects of cult appreciation. Undoubtedly, it is to a large extent their nonsensical, bricolage nature—as best manifested in the cut-and-paste method—that has given the films their current cult status. The continuing relevance of IFD's films is highlighted by *Ninja the Mission Force*, a parody web series that pays homage to the cut-and-paste ninja films of Godfrey Ho and company. The first season (with ten episodes) made its appearance in 2012 and won a Telly Award for best comedy, and a second season soon followed in 2013. In contrast to IFD's ninja films and their earnest but unintentionally hilarious attempts to find a niche in the low-budget action film market, the new series is more self-consciously parodic, a deliberate attempt to appeal to connoisseurs of the weird and the bizarre, as well as to those who harbor a nostalgia for a kind of "primitive" but "authentic" filmmaking absent in today's special effects-packed action films.

Second, despite their limited production values and low cultural and critical status, the IFD films formed a major part in the transnational cultural flows and formations of an increasingly globalized world. They managed to forge a niche in the action film market worldwide and left a not insignificant (if hardly acknowledged) impact on the global cultural imagination. To be sure, the ways in which these films were made and circulated around the globe are drastically different from those of, say, Hollywood's mega-blockbusters today. All the IFD films were super low-budget productions, characterized by a visceral style as well as a populist sensibility that appealed primarily to lowbrow, working-class viewers. They were also blatantly exploitative, paying scant attention to questions of taste or concerns over copyright infringement. But all this did not prevent

the films from finding a receptive global audience, although they were by and large relegated to "minor" exhibition outlets such as urban grindhouses, drive-ins, and later video and the internet. In their marginality (in both industrial and aesthetic terms) and their micro-practices of transnationality involving not so much a vertical relationship of domination and resistance as a horizontal process of tactical engagement and even mutual exploitation, these films are a good example of what can be called "minor transnationalism." More broadly, the example of IFD suggests the need of an alternative conception of cinematic transnationalism, one that does not see Hollywood as the dominant center, as is the general tendency, but rather as a node among others in the global network of films.

Notes

1 Bruceploitation refers to films, popular in the mid- to late 1970s and beyond, that sought to capitalize on the international popularity of Bruce Lee after his sudden death in 1973, typically with Bruce Lee look-alike actors whose stage names (Bruce Li, Bruce Le, etc.) sound similar to that of the legendary action star.

2 Françoise Lionnet and Shu-mei Shih, "Thinking through the Minor, Transnationally," in *Minor Transnationalism*, eds. Françoise Lionnet and Shu-mei Shih (Durham, NC: Duke University Press, 2005), 1–23. For a discussion of this concept in relation to certain modes of martial arts cinema, see Man-Fung Yip, "Martial Arts Cinema and Minor Transnationalism," in *American and Chinese-Language Cinemas: Examining Cultural Flows*, eds. Lisa Funnell and Man-Fung Yip (New York and London: Routledge, 2015), 86–100.

3 Founded in 1969, Intercontinental Film Distributors (HK) Ltd. was one of the first companies that focused on the distribution of Western films into the Asian market. Over the years, its business has expanded to include video distribution, cinema operations, full service advertising, and e-commerce. The company was incorporated into the Intercontinental Group Holdings Ltd in 1996.

4 According to the Internet Movie Database (IMDB), IFD was one of the co-producers of the film, but I could not find any other source to corroborate this information.

5 See Mike Leeder, "The Wonderful World of joseph Lai: An Exclusive Interview by Mike Leeder," *HK and Cult Film News* (March 30, 2010), http://hkfilmnews.blogspot.com/2010/03/wonderful-world-of-joseph-lai-exclusive.html, accessed August 5, 2016.

6 Records from the Hong Kong Companies Registry show that Asso Asia was
 established in 1976. In Chinese, the company is called *tongyong yingye youxian
 gongsi*, which is very similar to that (*tongyong yingyi youxian gongsi*) of IFD, thus
 causing some confusion over whether the two are the same or different companies.
7 In addition to the martial arts films, Asso Asia did buy the rights to several Korean
 war movies, including Shin Sang-ok's *The Last Flight To Pyongyang* (*Pyeong-
 yangpoggyeogdae*; 1971), which it shortened from its original 130 minutes down to
 85 minutes and released it internationally as *Sky Risk Commandos* in 1983.
8 I said "nominally" because many of these Asso Asia films had different director
 credits—and titles, for that matter—when released in South Korea. For instance,
 The Dragon's Showdown, released in Korea as *Yonggwonsasu*, was publicized as
 a film by Kim Si-hyeon, while Kim Jung-yong was credited as director in *Hard
 Bastard* (1982; Korean title: *Boggwon*).
9 When asked about his role in these Korean productions, Ho was rather vague and
 evasive, noting that he served as a "co-director" while pointing out at the same
 time that most of the films "were done by Korean directors." See Arnaud Lanuque,
 "Interview with Ninja Director Godfrey Ho," *Hong Kong Cinemagic* (March 3,
 2007), http://www.hkcinemagic.com/en/page.asp?aid=230&page==3,
 accessed August 5, 2016.
10 A good case in point is *The Grand Master of Shaolin Kung Fu*, which was released
 (as *Dalmasingong*) in South Korea in 1978, appeared as an Asso Asia production
 only in 1982.
11 See Jong-hwa Chung, "Making Action Cinema: An Interview with Kim Si-hyeon,"
 Film Language [*Yeonghwaeoneo*] (Spring 2004). I thank Sangjoon Lee for alerting
 me to this article.
12 The exact number of films made by IFD and Filmark during this period cannot
 be exactly determined due to the multiple titles used for the same film in different
 markets. For instance, *Ninja Operation 7: Royal Warriors* (Godfrey Ho, 1987) is
 known variously as *Hands of Death*, *The Secret of the Lost Empire*, or simply *Royal
 Warriors*.
13 See Frederick Wasser, *Veni, Vidi, Video: The Hollywood Empire and the VCR*
 (Austin, TX: University of Texas Press, 2001), 68, 101.
14 See, for instance, Paul McDonald, *Video and DVD Industries* (London: British Film
 Institute, 2007), 72–106; and Douglas A. Boyd, Joseph D. Straubhaar, and John A.
 Lent, *Videocassette Recorders in the Third World* (New York: Longman, 1989), 3–41.
15 See Leeder, "The Wonderful World of Joseph Lai."
16 See Lanuque, "Interview with Ninja Director Godfrey Ho."
17 Despite not a famous star, Richard Harrison did make a name for himself in the
 action film community through his many appearances in European B-movies

(sword and sandal films, spaghetti Westerns, and the like) of the 1960s and early 1970s. He originally agreed to appear in a few of IFD's ninja films only, but unbeknownst to him, the footage featuring him was used, thanks to the cut-and-paste method, in more than a dozen productions during the mid- to late 1980s.

18 The series, first released in 1988, comprises the following films: *War City: Die to Win*; *War City 2: Red Heat Conspiracy*; *War City 3: The Extreme Project*; *War City 4: Kingdom of Power*; and *War City 5: Law of Honor*. The first three films were directed by Philip Ko, while the last two were made under the helm of Anthony Pa and Charles Lee, respectively.

19 Released between 1987 and 1989, the *American Force* series includes Philip Ko's *American Force 1: The Brave Platoon*, *American Force 2: The Untouchable Glory*, and *American Force 3: High Sky Mission*; Charles Lee's *American Force 4: Soldier Terminators* and *American Force 5: Mission Dynamo*; and Paul Wong's *American Force 6: Soldier Champion*.

20 On this mini-exodus of Hong Kong film talent, see Steve Fore, "Home, Migration, Identity: Hong Kong Film Workers Join the Chinese Diaspora," in *Fifty Years of Electric Shadows*, ed. Law Kar (Hong Kong: Urban Council, 1997), 126–34.

21 Both films in the *Catman* series drew upon Thai action movies from the mid-1980s as their main body to which new footage was added.

22 The *American Force* series mentioned earlier, for instance, has been retitled to *Aerolite Force* in its latest incarnation.

23 One good example of these proliferating websites is *Golden Ninja Warrior Chronicles,* http://goldenninjawarriorchronicles.blogspot.com/?zx=bd7dbf66ecb4196d, a blog created and maintained by the Spaniard Jesús Manuel Pérez Molina.

Asia Restrained: J-Horror's Poor Beginnings and the Mismarketing of Excess

Tom Mes

Introduction

Among recent attempts at branding new Japanese cinema for foreign consumption, British distributor Metro-Tartan's Asia Extreme label has been considered the most significant.[1] Launched in 2001 and active until the company's demise in 2008,[2] the label released a variety of films from Japan, South Korea, Hong Kong, and Thailand, with a strong emphasis on the genres of horror and action, and the sensational and transgressive content these supposedly offer. Titles from Japan included Nakata Hideo's *Ring* (*Ringu*, 1998) and *Ring 2* (*Ringu 2*, 2000), Miike Takashi's *Audition* (*Ōdishon*, 2000) and *Dead or Alive* (*Deddo oa araibu hanzaisha*, 1999), and Fukasaku Kinji's *Battle Royale* (*Batoru rowaiaru*, 2001) and *Battle Royale 2: Requiem* (*Batoru rowaiaru II rekuiemu*, 2003).

One indication of the label's influence is the way it played "an instrumental role in promoting and disseminating East Asian films in the West in recent years."[3] By spring 2005, almost a third of Tartan's entire catalogue consisted of Asia Extreme titles.[4] Several other UK distribution companies established Asian genre cinema imprints, with such names as Optimum Asia, Premier Asia, and Momentum Asia. Recognizing the momentum, British DVD retailer HMV created a separate "Extreme Asia" category in its stores.[5]

Tartan's activities under the label did not pass unnoticed among scholars either. In 2006, Gary Needham criticized the provocatively named imprint for recontextualizing the films through its marketing, thereby contributing to placing new Japanese cinema within "discourses of excess, difference and

transgression."[6] Needham drew a parallel between such emphasizing of "exotic and dangerous cinematic thrills" and the yellow peril figures of turn-of-the-century adventure stories, both serving to construct a narrative of the Asian as a cruel "dangerous Other."[7] Needham's critique in turn influenced a number of other scholars who investigated Asia Extreme along similar lines. Examining Tartan and other companies' efforts at marketing and promoting their rosters as "the weird, the wonderful and the dangerous,"[8] and the subsequent media reactions, Oliver Dew arrives at a comparable critique of Orientalist intent: "The apparently transgressive nature of these titles is often discussed as if it is an integral part of the film text, or worse of Japanese culture itself, rather than being at least partly located in the way in which the films are marketed and consumed in Britain."[9]

Outside of academia too, the "Asia Extreme movement" became a target of commentators. Writing for *The New York Times* in March 2005 in response to a screening of Korean filmmaker Park Chan-wook's *OldBoy* (a title released under the Tartan Asia Extreme banner in both North America and the UK/Ireland) and its awarding of the Grand Jury Prize at the previous year's Cannes Film Festival, film critic Manohla Dargis opined:

> The filmmaker's success in the international arena, his integration into the upper tier of the festival circuit and his embrace by some cinephiles . . . reflect a dubious development in recent cinema: the mainstreaming of exploitation. Movies that were once relegated to midnight screenings at festivals—and, in an earlier age, grindhouses like those that once enlivened Times Square—are now part of the main event.[10]

Dargis sees a danger in the ascension of this and other "extreme" (a definition in which she also includes works by French filmmakers Gaspar Noé and Catherine Breillat) films to the "main event" of top tier film festivals. Tony Rayns, the British critic and specialist of Asian cinemas frequently referenced in scholarly writings on Asia Extreme, also specifically targets Park, arguing that he offers up archetypes rather than cultural specifics, and that "he has also opted to aim at the overgrown 'lad' audience which gets off on his hyperbolic violence."[11] Rayns also took aim at Kim Ki-duk, another Korean filmmaker whose work has been released abroad under the Asia Extreme aegis, accusing him of "sexual terrorism."[12]

Rayns at least did not extrapolate his dislike for specific filmmakers into a blanket statement about a perceived group of films. Dargis's warning against

the pernicious influence of "extreme cinema" on the festival mainstream, on the other hand, is an echo of the age-old cautions against the threat of mass culture. Invoking Bourdieu, Joan Hawkins published a reaction to Dargis's editorial rant, in which Hawkins pointed out the class distinctions implicit in the film critic's argument: "to speak as though everyone in a country like the United States has equal access to festival culture."[13] Hawkins argues instead that, "if there is a contemporary trend toward the 'mainstreaming of exploitation,' it is not happening at the high end of the culture spectrum (art houses and film festivals), where taste-cultures have always been eclectic. Rather it is happening at the level of DVD sales . . . and in shopping mall bookstore/DVD chain outlets,"[14] in other words the domain where Tartan Asia Extreme made its mark and most of its profits. Tartan head Hamish McAlpine already hinted at Hawkins' observation in a 2002 interview with the trade journal *Variety*, in which he noted that the audience for Asia Extreme titles does not always have access to art-house cinemas, and even those that do, do not usually encounter something that caters to their taste, finding "Italian soppy, weepy, romantic comedies rather than the more ballsy cinema that's out there."[15] By 2006 ten out of Tartan's twenty bestselling DVD releases were Asia Extreme titles.[16]

"Outlaw Texts": The Genrification of Asia Extreme

Chi-Yun Shin notes that the Asia Extreme label's prominence as a canon for East Asian films made it come to represent the Asian cinema as a whole.[17] Dew uses the terms "Asia Extreme," "Extreme Asia," and "Asian Extreme cinema" interchangeably, as a concept that no longer referred merely to the Tartan brand. Shin also spoke of "the problematic ways in which Tartan canonizes and genrificates the disparate East Asian film titles under the Asia Extreme banner."[18] By the time the scholarly debate had begun, the term "Asia Extreme," or some variant thereof, no longer indicated just a corporate trademark but a "pan-Asian faux-genre."[19]

Paul Willemen argues that what genre a film is assigned to depends "on which sector of the industry, production or distribution/exhibition, is doing the assigning. . . . Generic categories will thus vary according to the power relations between these sectors of the industry."[20] In the case of Asia Extreme, power was firmly in the hands of the distribution sector, where Tartan and its competitors

fueled the discourse of "the weird, the wonderful and the dangerous." Paul Smith, Tartan's former press officer, confirmed this in an essay for the journal *Cine-Excess*:

> Asia Extreme was devised and marketed to represent a very specific genre of contemporary film from Hong Kong, Japan, South Korea and Thailand. Whilst Tartan acquired a body of work from these new auteurs from the Far East, some of their work fell outside that definition and was released under the general Tartan Video label.[21]

Smith's use of the word "genre"—a "very specific genre," no less—is indicative of the company's (and the distribution sector's) attempts to generate a "generic discourse," identifying textual similarities in films from quite diverse cultural and industrial backgrounds and assigning them a conveniently marketable category. This strategy sacrificed, as Steve Rawle points out, local meaning and specificity in favor of "exoticism, otherness and extreme sexual and violent content as a norm."[22]

Dew qualifies what Tartan's was trying to generate as an "outlaw text": "the extreme nature of the film texts is emphasized in order to authenticate them as 'outlaw' vis-à-vis mainstream taste, and literally dangerous in terms of their potential for inspiring copycat behavior or inducing extreme physiological reactions such as vomiting or passing out."[23] The creation of an "outlaw text" had been tried and tested, as Carol Clover indicates in a reference to the hype[24] surrounding William Friedkin's 1973 film *The Exorcist*, which around the time of its release generated "consistent reports of vomiting and fainting in the theaters where *The Exorcist* was playing." Some of the people affected may have been planted there by the studio's publicity department, "thus in effect daring the viewer, evidently with great success, to match the terms."[25]

As Jinhee Choi and Mitsuyo Wada-Marciano indicate, "the category 'Asian cinema' has been used to refer to both filmmakers' conflicting aims and aspirations and audiences' multifaceted experiences"[26] It has also been used to bridge that very divide. In his examination of the role of individual filmmakers within the "Asia Extreme" category, Needham refers back to a similar mechanism at work during the early days of Western exposure for Japanese cinema, where interest was as much due to the talents of such filmmakers as Kurosawa Akira and Mizoguchi Kenji as to the films "being culturally other."[27] Paul Smith's quite deliberate use of the term "new auteur" for differentiating and positioning the films released under the Asia Extreme label (several years after the company's

demise) indicates that auteurism was a tool Tartan wielded in generating the "Asia Extreme" discourse, "employed not to legitimize otherwise problematic violence, but rather to guarantee the delivery of such violence; the auteur as sadistic 'plastic surgeon.'"[28]

Notable "new auteurs" "at the forefront of this economically constructed category of marketable movies"[29] included Miike Takashi and Nakata Hideo from Japan and, as we have already seen, Park Chan-wook and Kim Ki-duk from South Korea. "The Asia Extreme label suggests that the products of such film-makers display a predilection for excess content, usually along the lines of violence, often sexual in nature, gore, perverse sexuality, and narratives of nihilism and abjection."[30] Those works by these filmmakers that "fell outside that definition" were removed from the category and "released under the general Tartan Video label," presumably off the radar of those who made up the Asia Extreme audience so as not to interfere with the guarantee of "the delivery of such violence" attached to the "auteur" in question—as was the case with Kim Ki-duk, whose *Spring, Summer, Autumn, Winter . . . and Spring* (2003) "found critical and commercial success with more traditional world cinema audiences, whilst *The Isle* (2000) and *Bad Guy* (2001) fitted into the 'Extreme' category."[31] This removal of a single film from among an artist's body of work from the zone of "popular" taste into that of "middle brow" taste, forms a practical demonstration of Bourdieu's assessment that "art and cultural consumption are predisposed, consciously and deliberately or not, to fulfill a social function of legitimating social differences."[32]

The first titles that would go on to form the Asia Extreme brand, however, were not initially labeled as such by Tartan: *Audition, Ring, Battle Royale,* and *The Eye* were part of the company's general line-up of world cinema releases.[33] Shin quotes McAlpine in telling the Asia Extreme origin myth:

> The story goes that one weekend at the end of 1999, McAlpine watched two Japanese films on video, and he was "totally blown away by them." The two films he watched back to back that weekend were Nakata's *Ringu* and Miike's *Audition.* Soon after, he came across Thai and South Korean titles—*Bangkok Dangerous* and *Nowhere to Hide* (*Injeong sajeong bol geot eobtda,* Lee Myung-Se, 1999), which were also "outrageously shocking" to him. In an interview, McAlpine emphasized the fact that the films came first: "When I realised that these films were not one-offs and there was a constant flow of brilliant films coming out of Asia, I decided to brand it and make Asia Extreme." And, that was how the label was born.[34]

That Asia Extreme's origins were the reverse of this process, that is, transplanted from the respectably "middle-brow" category of world cinema to outlaw status of "dangerous" genre cinema, only serves to better illustrate the point. Within a discourse that "came to 'represent' the Asian cinema as a whole," the use of auteurism to legitimate the violence portrayed by some filmmakers makes genrification a process that is wholly "based on Western notions of the self."[35] As Needham argues, audiences look for the subversive and explicit treatment of sex and violence that they see as part and parcel of contemporary Japanese films, as well as "the multiple ways in which they transgress the norm and expectations of Hollywood cinema."[36] While the comprehensiveness of my own monographs[37] on the filmmaker refutes Dew's assertion that "an auteur reading of Miike [Takashi]'s films has hinged on an ever more selective sampling of his output," within the context of the Asia Extreme discourse it is a valid argument that "by promoting the auteur entirely through his 'offputtingly extreme' violence . . . Miike's work is positioned as a means of testing the viewer's ability to tolerate and take pleasure from material considered as oppositional to mainstream tastes, or 'paracinematic' to use Jeffrey Sconce's description of marginal cult cinema."[38]

Indeed, those in charge of the marketing for Tartan's Asia Extreme brand seemed to have been well aware of Sconce's assertion that "paracinema is . . . a counter-aesthetic turned subcultural sensibility devoted to all manner of cultural detritus."[39] They set out to create what Sconce says paracinema is not—a "distinct group of films"[40]—by focusing attention on "excess," in both its dictionary definition of "outrageous or immoderate behavior"[41] and in Kristin Thompson's application of the term in film studies as "those aspects of the work, which are not contained by its unifying forces."[42] The "excess" of "excess"—"the weird, the wonderful and the dangerous"—in films by Miike, Kim, and Park were thus exploited to serve as the "unifying force" of the Asia Extreme label, through promotional materials inviting audiences to "take a walk on the wild side."[43]

J-Horror and the "Restrained Tradition"

Gary Needham notes that in the discourse on Asia Extreme, "these ideas of transgression and subversion . . . are firmly contextualized in relation to Hollywood and therefore may not be shared by audiences, Japanese or otherwise, whose cultural limits and boundaries are altogether different."[44] This

is particularly true of one of the Japanese films that inspired the creation of the brand, and which can be credited with popularizing Japanese horror films in the West: Nakata Hideo's *Ring*. As Daniel Martin observed about the reception of Nakata's *Ring* upon its initial UK theatrical release (by Metro-Tartan in August 2000, before the establishment of the Asia Extreme label), the critics who praised it "failed to fully acknowledge that in Japan, the film is part of a popular, mainstream, highly commercial franchise" which includes Suzuki Kōji's novels, a made-for-television film and two TV series, a Korean film adaptation (*Ring Virus*, Kim Dong-bin, 1999) a video game, a *manga* series, and three theatrical sequels.[45]

The Asia Extreme discourse is inseparable from the dissemination of Asian horror cinema. In Choi and Wada-Marciano's suggestively titled scholarly anthology *Horror to the Extreme*, Chika Kinoshita gives a definition of what has become known as "J-horror," which:

> Specifically refers to a group of relatively low-budget horror films made in Japan during the late 1990s, such as the *Ringu* cycle. A closely knit network of filmmakers and critics . . . has been involved in the production of those films. Aesthetically, J-horror films concentrate on the low-key production of atmospheric and psychological fear, rather than graphic gore, capitalizing on urban legends proliferated through mass media and popular culture.[46]

Clover suggests that, "different genres can tell different stories about the same culture at the same moment."[47] Examining the initial Western reactions to the Japanese horror films of the late 1990s, specifically Nakata's *Ring*, reveals that the later Asia Extreme discourse did indeed minimize generic as well as cultural differences by recontextualizing them into "exotic and dangerous cinematic thrills." In his study of the British critical reception of *Ring*, Daniel Martin notes that, "When these British critics praised *Ring*, they were praising an entire tradition of horror made up of countless films."[48] This tradition was a largely Western one: before the creation of the "extreme" category closely tied to Asian cinema, critics looked for mostly British and American comparisons to qualify *Ring*, including the literary tradition of British ghost stories and the American films *The Blair Witch Project* (Daniel Myrick and Eduardo Sánchez, 1999) and *The Sixth Sense* (M. Night Shyamalan, 1999). "In locating the film among these other texts, reviewers used their discussion of *Ring* to enter into existing debates about the virtues of suggestive horror over graphic violence."[49] Citing Gregory A. Waller, Martin argues that *Ring* was seen as belonging to a

"restrained tradition" in horror film and criticism, "an aesthetic of restraint and suggestion [which] foregoes 'excessive exposure to crudity and violence.'"[50] The initial reception and categorization of *Ring* was therefore diametrically opposed to the reaction of "outrageous shock" that prompted McAlpine to launch the Asia Extreme label.

Martin points out that the opposition between restraint and explicitness are "crucial moves within the game of distinction."[51] With Asia Extreme, however, Tartan sought to erase this opposition, just as its marketing and promotional tactics could be said to have run counter to the assertions of Sconce and Thompson. "Many of the films, such as *Ring/Ringu* . . . could hardly be thought of as extreme in the terms that the distributors want us to imagine," Needham observed correctly in 2006,[52] yet so successful was the "repackaging" effect of the Asia Extreme discourse, that three years after Needham, Choi and Wada-Marciano treaded much more carefully by suggesting that "some of the subtle differences in Asian horror and extreme cinema are discernable to the attuned viewers with cultural knowledge, but might be erased when they are exported and lumped together under a homogeneous category 'Asia Extreme.'"[53]

Scary True Stories

Ruth Goldberg points out that "J-horror as it has become popularly known, has developed a wide range of tropes and tendencies, offering something for every possible taste."[54] Nevertheless, when both Nakata's "restrained" *Ring* and Miike's much more violent *Audition*[55] are generically considered to be horror cinema, the eyes of the public will not immediately discern the wide range and the differences, subtle or otherwise, between these titles merely from the way the films are categorized and displayed on the retail level. The development of J-horror as a style whose focus is on restraint and suggestion is closely linked to how the horror genre was seen in the public eye and displayed by retailers in Japan. It is generally acknowledged, by both film historians and many of the filmmakers associated with J-horror, that its starting point was *Scary True Stories* (*Honto ni atta kowai hanashi*), a trilogy of short stories of ghosts and the supernatural written by Konaka Chiaki, directed by Tsuruta Norio, and released directly onto video by distributor Japan Home Video (JHV) in 1991. This one-hour, very low-budget[56] feature contained "much of the thematic, iconic and stylistic attributes of what was later marketed under the term 'J-Horror.'"[57]

Alexander Zahlten points out that "the episodes' focus on prepubescent or pubescent girls was also an attempt to appeal to a target audience unusual for V-Cinema [straight-to-video features], young females."[58] The films' lack of graphically explicit and shocking scenes contributed to this. The switch in aesthetics to "atmospheric tension and an aesthetics of concealment"[59] was partly due to the 1989 "Otaku Murders" case, in which Miyazaki Tsutomu was sentenced to death for kidnapping and murdering four young girls between the ages of four and seven. The publicity surrounding Miyazaki's collection of horror videos created public pressure against explicit portrayals of violence in media. Among this collection, and prominently featured in the subsequent media attention, were several entries in the *Guinea Pig* series of explicit splatter films, produced and released by Japan Home Video. Tsuruta Norio worked at JHV as a subtitle producer at the time, after having been active in 8-mm independent filmmaking as a student. After seeing a fellow employee, Muroga Atsushi, given the opportunity to direct a film for Japan's booming V-Cinema market, Tsuruta managed to convince JHV's management to let him direct a horror film.[60]

Part of the reason why his employer allowed Tsuruta to mount a production in a genre it had shunned, was precisely because "atmospheric tension and an aesthetics of concealment" were unlikely to cause a furor: "I actually got the idea for a horror piece when I talked to a video store employee, and he told that me a kind of documentary on ghosts, *Yūrei no meisho annai* ("A Tour of Famous Haunted Places") was renting really well." The audience for this as well for Tsuruta's *Scary True Stories* was "fairly young and mostly female. At the time video stores were very happy with it, and usually it was placed in the same corner as animation and Disney films. There was no age restriction, as there was no gore or anything."[61]

Another reason why Tsuruta had managed to convince his employer was arguably the meager financial risk JHV incurred thanks to *Scary True Stories*'s very low budget. As Clover argues, "innovation trickles upward as often as downward, and . . . the fiscal conditions of low-budget filmmaking are such that the creativity and individual vision can prosper there in ways they may not in mainstream environments."[62] This could certainly be said to be the case within "V-Cinema," Japan's low-budget straight-to-video film industry. Film producer Shimoda Atsuyuki, who works extensively with another big name in J-horror, Kurosawa Kiyoshi, explains that V-Cinema distributors started up projects knowing that a loss on investment was highly unlikely: "They would know that with a certain cast and a certain genre, they could sell a certain amount of tapes,

so they could calculate what expenses they could recoup. This way they would have an idea of the budget, plus a cast and genre."[63]

Scary True Stories caught the eye of several other filmmakers, including Kurosawa and scriptwriter Takahashi Hiroshi, who became a strong proponent of this new strain of horror film and incorporated much of what he openly admired about *Scary True Stories* into the script for *Ring*. Chika Kinoshita goes so far as to refer to J-horror as a "movement" rather than a genre: "Most of the J-horror filmmakers belong to the same generation and culture. . . . All of them developed their film aesthetics and techniques through making low-budget made-for-video features (V-Cinema) and/or TV projects."[64] As main proponents of this movement, Kinoshita identifies: directors Tsuruta Norio, Nakata Hideo, and Kurosawa Kiyoshi; writers Takahashi Hiroshi and Konaka Chiaki; and producer Ichise Takashige. She also takes some of these filmmakers' theoretical writings on horror aesthetics (especially those of Takahashi, Konaka, and Kurosawa[65]) into consideration as an "integral part of the J-horror discourse."[66]

Without being aware of it, the British critics who later wrote about *Ring* were in fact quite correct in their tendency to position the film (and, by extension, J-horror) within a binary of restraint versus explicitness. This aspect, as well as the context of a theoretically underpinned movement of filmmaking inspired by a low-budget, straight-to-video release that was aimed at a female audience and positioned in video stores alongside children's films, were all lost in recontextualization of Asia Extreme's "generic discourse of violent exploitation, masculinity and female disempowerment." If we frame this discourse as a dominant ideology, then the J-horror style, seemingly so integral to Asia Extreme, can be read in accordance with Comolli and Narboni's "category E": "films which seem at first sight to belong firmly within the ideology and to be completely under its sway, but which turn out to be so only in an ambiguous manner . . . there is a noticeable gap, a dislocation, between the starting point and the finished product."[67]

"Thrashing" the canon

In her essay on Asia Extreme, Chi-Yun Shin remarks on "the problematic ways in which Tartan canonizes . . . the disparate East Asian film titles under the Asia Extreme banner." This canonization intentionally occurred through

mainstream venues, including multiplex cinemas and chain retailers such as HMV. Between 2003 and 2005, Tartan also organized an annual "Asia Extreme Roadshow," which toured around the UK. "Notably, the roadshows were set in multiplex cinemas, not in art-house cinemas, which have been the traditional outlets for foreign language films in the United Kingdom. Such 'mainstream' positioning of the films was clearly aimed to reach out to the younger audiences who frequent multiplexes rather than art-house cinemas."[68] By extension, Dew describes that the Asia Extreme titles were positioned in their own category within the layout of HMV's Oxford Street store in London, yet as a subsection of the larger "World Cinema" section. The titles that had achieved a degree of crossover, including pre-Extreme releases *Ring* and *Battle Royale*, appeared in both the "Extreme Asia" section and in the "World Cinema" section.[69] All of this happened concurrent with selections for the Cannes Film Festival of several titles subsequently absorbed into the Asia Extreme roster: Miike Takashi's *Gozu* (*Gokudō kyōfu daigekijō: Gozu*) in the Directors' Fortnight in 2003 and Park Chan-wook's *OldBoy* in the main competition in 2004, where the latter, as mentioned, was awarded the Grand Jury Prize, bestowing further prestige, visibility and notoriety upon "extreme" Asian cinema.

Around the same time too, "*Ring* had been established by overwhelming popular and critical consensus as an important and celebrated film and had become the benchmark against which all subsequent Asian horror films would be judged."[70] In early 2002, America's most prominent cinephile publication *Film Comment* ran a focus on "New Japanese Cinema," to which film critic Alvin Lu contributed a primer on J-horror, in which he boasted that "*Ring* is to these films what *The Exorcist* was to American cinema's 1970s horror boom,"[71] giving Nakata's film immediate iconic status as the spearhead of a phenomenon. The next step in the transnational migration and canonization of J-horror came with American remakes of a number of its proponents, starting with *The Ring* in 2002,[72] which "helped Asian horror cinema earn global saliency"[73] and entry into the mainstream. With this, *Ring* swiftly became "canonical,"[74] one of the "most discussed, re-made, and imitated horror films in recent memory."[75] Its central monster, the faceless female ghost Sadako, has entered the pantheon of genre icons.[76] If *Ring* is now considered "the vanguard of a wave of foreign horror films that have established their own identity and canon,"[77] it did so despite, and yet arguably also because of, Asia Extreme's attempts at recontextualization and repackaging.

The demise of Tartan Films in 2008 effectively ended the active role of the "Asia Extreme" category in the marketing and promotion of Asian films. Palisades Media acquired the company and its catalogue, including the Asia Extreme titles, swiftly thereafter, but it was not until 2014 that Kino Lorber announced it had picked up distribution rights and would start re-releasing films under the Asia Extreme banner. Since this announcement, little has been heard from the label. Tartan's Asia Extreme releases were firmly a product of the DVD age, a new kind of film for a new kind of medium, recognizably packaged and neatly stocked in their own easy-to-locate section at your local HMV or Tower Records. The more dispersed media distribution landscape of a decade later offers no such convenient funneling: DVDs and the chain outlets that carried them have disappeared, given way to the fragmented jungle of online distribution.

Maligned for creating a faux-generic category that emphasized dangerous Orientalist thrills over cultural specifics and artistic relevance, the once-buzzing Asia Extreme brand has now receded into obscurity, while several of the talented filmmakers whose diverse creations it once lumped together like offal for the meat grinder have survived by continuing to do what Asia Extreme sought to obscure. For their disparate and idiosyncratic styles of filmmaking, Miike Takashi, Kim Ki-duk, Park Chan-wook, Kurosawa Kiyoshi, and others have gone on to individual recognition as auteurs, while lesser talents have simply faded from the international scene. These auteur directors are now considered part of the establishment: Miike makes samurai epics and effects-heavy blockbusters; Kim won the Golden Lion in Venice for *Pietà* (2012); Park made his Hollywood debut with *Stoker* (2013), while Kurosawa sought new horizons in France. No amount of marketing can make the respectable dangerous. When the trash is in the canon, the thrill is gone.

Notes

1 Daniel Martin, "Japan's Blair Witch: Restraint, Maturity, and Generic Canons in the British Critical Reception of *Ring*," *Cinema Journal* 48, no. 3 (Spring 2009), 35.
2 The catalog was bought by Palisades Media in 2009 and rereleased under the same Tartan Asia Extreme banner, testifying to the brand's high profile.
3 Chi-Yun Shin, "The Art of Branding: Tartan 'Asia Extreme' Films," in *Horror to the Extreme: Changing Boundaries in Asian Cinema*, eds. Jinhee Choi and Mitsuyo Wada-Marciano (Hong Kong: Hong Kong University Press, 2009), 85.

4 Oliver Dew, "Asia Extreme: Japanese cinema and British hype," *New Cinemas: Journal of Contemporary Film* 5, no. 1 (April 2007), 54.

5 Ibid.

6 Gary Needham, "Japanese Cinema and Orientalism," in *Asian Cinemas: A Reader and Guide*, eds. Dimitris Eleftheriotis and Gary Needham (Edinburgh: Edinburgh University Press, 2006), 11.

7 Ibid.

8 A recurring tagline in Tartan Asia Extreme promotional material.

9 Dew, "Asia Extreme," 69–70.

10 Manohla Dargis, "Sometimes Blood Really Isn't Indelible," *The New York Times* (March 3, 2005), B7.

11 Tony Rayns, "Shock Tactics," *Sight and Sound* 15, no. 5 (2005), 84.

12 Tony Rayns, "Sexual Terrorism: The Strange Case of Kim Ki-duk," *Film Comment* 40, no. 6 (November/December 2004), 50.

13 Joan Hawkins, "Culture Wars: Some New Trends in Art Horror," *Jump Cut* (1999), http://www.ejumpcut.org/archive/jc51.2009/artHorror/, accessed November 25, 2013.

14 Ibid.

15 Ryan Mottesheard, "DVD Quick Study: Tartan Takes 'Extreme' Route to Genre Success," *Variety* (September 6, 2005), http://www.variety.com/article/VR1117928653.htm?categoryid=2063&cs=1, accessed December 12, 2014.

16 Shin, "The Art of Branding," 92.

17 Ibid., 97.

18 Ibid., 87.

19 Steve Rawle, "From *The Black Society* to *The Isle*: Miike Takashi and Kim-Ki-Duk at the intersection of Asia Extreme," *Journal of Japanese and Korean Cinema* 1, no. 2 (2009), 167.

20 Paul Willemen, "Action Cinema, Labour Power and the Video Market," in *Hong Kong Connections: Transnational Imagination in Action Cinema*, eds. Meaghan Morris, Siu Leung Li, and Stephen Chan Ching-kiu (Hong Kong: Hong Kong University Press, 2005), 227.

21 Paul Smith, "Distributing Outside the Box: Tartan's Development of Asia Extreme—A Response to Emma Pett's Article," *Cine-Excess*, http://cine-excess.co.uk/distributing-outside-the-box.html, accessed May 12, 2013. The article to which Smith responded, written by Emma Pett, published findings that were "part of a larger research project investigating audience responses to Asian Extreme films": Emma Pett, "'People Who Think Outside The Box': British Audiences And Asian Extreme Films," *Cine-Excess*, http://cine-excess.co.uk/british-audiences-and-asian-extreme-films.html, accessed May 12, 2013.

22 Rawle, "From *The Black Society* to *The Isle*," 168.

23 Dew, "Asia Extreme," 60.
24 Thomas Austin, *Hollywood, Hype and Audiences: Selling and Watching Popular Film in the 1990s* (Manchester, UK: Manchester University Press, 2001).
25 Carol J. Clover, *Men, Women and Chainsaws, Gender in the Modern Horror Film* (Princeton, NJ: Princeton University Press, 1992), 202.
26 Jinhee Choi and Mitsuyo Wada-Marciano, "Introduction," in *Horror to the Extreme: Changing Boundaries in Asian Cinema*, eds. Jinhee Choi and Mitsuyo Wada-Marciano (Hong Kong: Hong Kong University Press, 2009), 1.
27 Needham, "Japanese Cinema and Orientalism," 9.
28 Dew, "Asia Extreme," 67.
29 Rawle, "From *The Black Society* to *The Isle*," 167.
30 Ibid.
31 Smith, "Distributing Outside the Box."
32 Bourdieu, Pierre, *Distinction: A Social Critique of the Judgement of Taste* (London: Routledge, 1984), xxx.
33 Smith, "Distributing Outside the Box."
34 Shin, "The Art of Branding," 85–86.
35 Needham, "Japanese Cinema and Orientalism," 9.
36 Ibid.
37 Tom Mes, *Agitator: The Cinema of Takashi Miike* (Godalming, UK: FAB Press, 2003), and Tom Mes, *Re-Agitator: A Decade of Writing on Takashi Miike* (Godalming, UK: FAB Press, 2013). The former analyzes all Miike's works up to the year of the book's publication.
38 Rawle, "From *The Black Society* to *The Isle*," 172.
39 Jeffrey Sconce, "'Trashing' the Academy: Taste, Excess, and an Emerging Politics of Cinematic Style," *Screen* 36, no. 4 (1995), 371.
40 Ibid.
41 Oxford English Dictionary.
42 Kristin Thompson, "The Concept of Cinematic Excess," in *Narrative, Apparatus, Ideology: A Film Theory Reader*, ed. Philip Rosen (New York: Columbia University Press, 1986), 487.
43 Tartan Asia Extreme promotional material, quoted in Shin, "The Art of Branding," 88.
44 Needham, "Japanese Cinema and Orientalism," 9.
45 Martin, "Japan's Blair Witch," 48. Further additions since then have been *Sadako 3D* (2012) and *Sadako 3D 2* (2013, both directed by Hanabusa Tsutomu). As a promotional stunt for the latter, Sadako also showed up in person at Nagoya Dome sports stadium to pitch the first ball at a professional baseball game, http://www.hollywoodreporter.com/news/ring-character-throws-first-pitch-614180—accessed December 14, 2014.

46 Chika Kinoshita, "The Mummy Complex: Kurosawa Kiyoshi's *Loft* and J-horror," in *Horror to the Extreme: Changing Boundaries in Asian Cinema*, ed. Jinhee Choi and Mitsuyo Wada-Marciano (Hong Kong: Hong Kong University Press, 2009), 104.

47 Clover, *Men, Women and Chainsaws, Gender in the Modern Horror Film*, 99.

48 Martin, "Japan's Blair Witch," 50–51.

49 Ibid., 35–36.

50 Ibid., 36.

51 Martin, "Japan's Blair Witch," 39.

52 Needham, "Japanese Cinema and Orientalism," 9.

53 Choi and Wada-Marciano, "Introduction," 5.

54 Ruth Goldberg, "Demons in the Family: Tracking the Japanese 'Uncanny Mother Film' from *A Page of Madness* to *Ringu*," in *Planks of Reason: Essays on the Horror Film*, eds. Barry Keith Grant and Christopher Sharrett (Oxford, UK: The Scarecrow Press, 2004), 370.

55 "The grimmest exploitation of sadistic violence I have seen in months," wrote Alexander Walker of *Audition* in *The Evening Standard*. Alexander Walker, "The Cutting Edge of Censorship," *The Evening Standard* (March 15, 2001), 29, quoted in Dew.

56 It was shot in seven days for 7 million yen (US$ 51,581), according to its director, quoted in Alex Zahlten and Kimihiko Kimata, "Norio Tsuruta," *MidnightEye.com*, 2005, http://www.midnighteye.com/interviews/norio-tsuruta/, accessed August 7, 2013.

57 Alexander Zahlten, *The Role of Genre in Film from Japan: Transformations 1960s-2000s*. Dissertation. Mainz: Johannes Gutenberg University, 2007, 494.

58 Ibid., 334.

59 Ibid.

60 Ibid.

61 Zahlten and Kimata, "Norio Tsuruta."

62 Clover, *Men, Women and Chainsaws, Gender in the Modern Horror Film*, 5.

63 Interview with Shimoda Atsuyuki by the author, March 2014.

64 Kinoshita, "The Mummy Complex," 105–06.

65 Konaka Chiaki, *Hora eiga no miryoku: fandamentaru hora sengen* (The fascination of horror films: A manifesto of fundamental horror) (Tokyo: Iwanami Shoten, 2003); Takahashi Hiroshi, *Eiga no ma* (The demon of the cinema) (Tokyo: Seidosha, 2004); Kurosawa Kiyoshi, *Kyofu no taidan: eiga no motto kowai hanashi* (Conversations on fear: more scary film stories) (Tokyo: Seidosha, 2008).

66 Ibid., 104–05.

67 Jean-Louis Comolli, and Jean Narboni, "Cinema/ideology/criticism from Cahiers du cinéma, October–November 1969," *Screen Reader 1: Cinema/Ideology/Politics* (London: Society for Education in Film and Television, 1977), 32.

68 Shin, "The Art of Branding," 89.
69 Dew, "Asia Extreme," 57.
70 Martin, "Japan's Blair Witch," 46.
71 Alvin Lu, "Horror Japanese-style," *Film Comment* 38, no. 1 (January to February, 2002).
72 *The Ring*, directed by Gore Verbinski, starring Naomi Watts and released by DreamWorks SKG. According to imdb.com, it "sold more than 2 million DVD copies in the United States alone in its first 24 hours of video release." http://www.imdb.com/title/tt0298130/trivia?ref_=tt_trv_trv,—accessed December 14, 2014.
73 Choi and Wada-Marciano, "Introduction," 1.
74 Alastair Philips and Julian Stringer, eds., *Japanese Cinema: Texts and Contexts* (London and New York: Routledge, 2007), 9.
75 Jay McRoy, *Nightmare Japan: Contemporary Japanese Horror Cinema* (Amsterdam and New York: Editions Rodopi B.V., 2008), 2.
76 Goldberg, "Demons in the Family," 371.
77 Martin, "Japan's Blair Witch," 51.

6

Gifting Beauty: The Exploitations of Fan Bingbing

Mila Zuo

Only one woman in Chinese history has been granted the title of *huangdi* (emperor). Beginning her political career as an imperial concubine during the Tang dynasty, Wu Zetian is renowned for her cunning, beauty, and sexual appetite. With her image resurrected and remembered in the 2014 Hunan Television series, *Wu mei niang chuanqi* (*The Empress of China*), Wu is fittingly played by Mainland Chinese superstar Fan Bingbing. As with Wu's masculine honorific, Fan is unofficially but popularly accorded the gendered designation *Fan ye* (Master Fan) in acknowledgment of her exceptional fame, authority, and wealth.

Despite the material rewards, women renowned for their beauty and charm throughout Chinese history and folklore have also become scapegoats for death, disaster, and even dynastic downfalls. (Wu for instance is "remembered in history for her cruelty, her lack of scruples, her megalomaniac tastes.")[1] Today, China's suspect fascination with feminine beauty is observed in the reception of female film and television stars, among which Fan is considered the most commercially successful. Her distinct and "un-Chinese" features—large eyes, pale skin, and curvaceous figure—have helped the actress achieve a prolific career. However, some Chinese audiences heavily scrutinize Fan, accusing her of being a high-end prostitute and of undergoing cosmetic facial surgery. Despite the unsubstantiated nature of these rumors, such extratextual discourses reveal the complex gender and sexual politics in modern-day China. Readily found online and steeped in suspicious (vernacular) hermeneutics, these conversations attempt to discredit Fan's professional reputation and unveil the illusions of her beauty, charges that reflect fraught attitudes toward the spectacularization of female sexuality in postsocialist China.

During post-Reform China, "the figure of sexualized woman . . . returned in mass-media representation," and yet, cultural productions about female sexual desire and pleasure remain "for the most part submerged."[2] In other words, although the mediated eroticization of Chinese female bodies has become more socially acceptable, women's sexual desires and pleasures remain representationally underrepresented. Woman's image, alienated from her body, thereby becomes the site/sight of exploitation for male desire, consumer enterprise, and national symbology. In Dai Jinhua's words, "woman becomes a mere sacrifice, first on the altar of male desire and initiation to manhood, and again in the ceremonial scene of the national myth."[3] However, seen through a materialistic optic, Fan's professional successes are a testament to her ability to exploit her own beauty capital and erotic appeal, illustrating that economies of stardom are based on reciprocity and exchange between actors, filmmakers, and audiences. In other words, Fan troubles the distinctions of exploiter/exploited by inhabiting both roles through complicity in her own exploitation as a sexualized, commoditized image. In analyzing Fan's star body, rather than pursue a "hermeneutics of suspicion,"[4] which Eve Kosofsky Sedgwick aligns with "paranoid reading," a strong theory practice that fixates on inevitability and negative affects, this chapter turns to Sedgwick's methodological "reparative impulse," which redeems positive affects, in order to rethink cinematic practices of exploitation through politics of pleasure.[5]

An examination of Fan's on- and offscreen performances reveals the actor's calculated management of her star image. She consents to certain mediated conventions of female objectification, like wearing revealing, body-hugging clothing and performing hypersexuality, but she also embodies a certain undisciplined, aggressive femininity through her performances. Although many feel that Fan's acting ability leaves something to be desired, she has proven her exceptional box office value and topped the Forbes China Celebrity List for three consecutive years (2013–2015). Of course, Fan's success can be attributed not only to her strategic management of her own image, but also to directors like Feng Xiaogang and Li Yu who co-produce her onscreen performance through cinematic technique.

Classical screen theory and feminist film studies, drawing on psychoanalytic theory, compellingly explain the techniques and mechanisms by which women are objectified in narrative cinema. However, according to Chris Berry and Mary Farquhar, concepts of the "libidinal gaze" are "not so important

in Chinese cinema" because women in Chinese cinema are represented as both objects *and* agents, moreso than in other national contexts.[6] To reconcile their contention with Yang and Dai's claims about the mediated eroticization of Chinese women, the feminine image in modern China becomes a study in contradiction, necessitating frameworks outside of screen and apparatus theories. Star and celebrity studies augment film studies' analytical scope to the material and ideological economies attached to acting and fame. Richard Dyer, for instance, contends that Western stars produce images of lifestyle, conspicuous consumption, and success, in line with capitalist and democratic mythologies.[7] Similar relations between star images and capitalist/neoliberal ideologies can also be traced in modern-day, postsocialist China. Mainland star Zhang Ziyi's global product endorsements with Omega watches, Visa, and Tag Heuer, for instance, function as a "marketing device" aimed at the growing Chinese petty bourgeoisie.[8] Moreover, the extravagant lives of wealthy women like Zhang and Fan, profiting within capitalist systems, demonstrate the extent to which women's complicity with capitalist-masculinist order generates material gain. Thus, new frameworks beyond objectification are necessary to engage with the complexities of female film stardom, and the story of Fan's success in China's media industry is one of mutual exploitation between herself, co-producers of her image, and consumers/audiences. Contextualizing her polysemic stardom within film, beauty, and affect economies, this chapter is a case study of Fan's exploited *and* exploitative rise to stardom.

The image of beauty delivers a "good" that is implicitly desired. In other words, the spectacle of beautiful onscreen bodies, enhanced by lighting and makeup, has long been recognized as a primary cinema-going pleasure, operating as a type of "common media currency" that is "closely associated with acting."[9] However, beauty is not just an object for consumption; the experience of beauty as phenomena demands reciprocity from its partakers. Suggesting that beauty radically decenters its beholder, Elaine Scarry contends that beauty exerts pressure towards justice and fairness by "permit[ting] us to be adjacent [to the object of beauty] while also permitting us to experience extreme pleasure, thereby creating the sense that it is our own adjacency that is pleasure-bearing."[10] For Scarry, "This seems a gift in its own right, and a gift as a prelude to or precondition of enjoying fair relations with others."[11] Motivated by Scarry's recuperative concept of beauty and Sedgwick's reparative impulse, this chapter pursues the notion of beauty as a gift of affective reciprocity by

recognizing that cinematic beauty furnishes another such "adjacent" pleasure which seeks *fairness*, a multiply signified term that implicitly joins together aesthetics and justice.

"The Gift" of beauty

Since the 1924 publication of Marcel Mauss' *Essai sur le don* (*The Gift*), scholars have theorized about the gift's diverse cultural permutations. Feminist writers like Luce Irigaray and Hélène Cixous sought to reveal the role of gender in economic structures and philosophical treatises.[12] Countering Claude Lévi-Strauss' observation that women are exchanged as *gifts* in marriage, Irigaray asserts that women are exchanged as *commodities*, exploited for their reproductive value.[13] However, she also states that, "the value of a woman always escapes: black continent, hole in the symbolic, breach in discourse," suggesting that a woman's intrinsic value as an "object" cannot be quantified and her social value is only legible in a relationship of exchange (between men).[14] A compelling "paranoid reading," Irigaray's Marxist analysis nevertheless points to a generative loophole when we discuss the "commodification" and "objectification" of women.

Can we regard this "black continent, hole in the symbolic, breach in the discourse" as a generative rupture within hegemonic economies and masculinist texts? Could the beauty of a woman be considered to hold such immeasurable value? What do we gain when we do not reify evaluations of women as exploited objects within the patriarchal symbolic order, but rather, consider women's roles as gift-bearing subjects who may also exploit, and benefit from, the system? Reassessing the agential roles women play in gift economies and gift scholarship in an era of neocolonial exploitation and neoliberal commodification, recent anthologies like *Women and the Gift Economy* (2007) and *Women and the Gift* (2013) revise male-authored conceptions of the gift vis-à-vis feminine ideals of generosity and docility.[15] With a similar project in mind, this chapter analyzes Fan as a case study through which to examine beauty itself as a gift that acts as both "cipher, as an indicator of women's situation" and as a "vibrant way of being in the world" on women's own bodily terms.[16] In today's China, the question of gender equality and fairness is especially pressing, as women are considered *a priori* to have achieved socialist "liberation," a false tautology articulated by mainland feminist Li Xiaojiang: "Lack of freedom is precisely one of the important characteristics of Chinese women's liberation."[17] Indeed, modern Chinese women,

"poised uneasily between two masculine forces of the state and the market," must ambidextrously manage the demands of both spheres and attempt to carve out acts of feminine agency and autonomy in between such spaces.[18] In Fan's case, negotiated agency surfaces through an embodied engagement with the mediated images and conceits of feminine exploitation.

In consideration of the Chinese gift economy, we recognize the complex networking system of *guanxi* (relationships and/or social connections) based on reciprocity, exchange, and affection. *Guanxi* involves social processes by which "obligation and indebtedness are manufactured" with "specific rites, rituals, and rules attached" which suffuse these relationships with sentiment.[19] Fan claims that she has never depended on *guanxi* for her acting break, articulating instead a Hollywood "myth of success . . . grounded in the belief that the class system, the old-boy network, does not apply" in her case:

> In China, to be successful, it is often not enough to have talent and earn merit. Some *guanxi* is almost always necessary. But when I walked into the entertainment industry, my family had no *guanxi*.[20]

Fan's renunciation of the Chinese gift economy, even as her own image circulates within narrative and affective exchanges of reciprocity (as this chapter illustrates), becomes a structuring (and Westernized) plot point in the mythology of Fan's success, a story centered on merit and singularity.

Finally, this chapter is aligned with feminist film theories that destabilize Mulveyian arguments concerning the subjugation of woman as image-bearer and signifier of lack. As Kathleen Rowe suggests, the relationship between visual pleasure and power is bound and "historically determined." However, she notes that "visual power flows in multiple directions" and that "the position of spectacle isn't necessarily one of weakness," a point Rowe demonstrates with the figure of the "unruly woman" who defies conventional beauty ideals and exercises comedic resistance against masculine domination.[21] Does feminine beauty possess an "unruliness" that subverts or resists mastery? Even Laura Mulvey suggests that woman's onscreen presence "work[s] against the development of a story line, to freeze the flow of action in moments of erotic contemplation."[22] Can female beauty, or erotic contemplation, inspire resistant and just impulses? Scarry's capacious concept of beauty explores the ethical dimension of beauty, a call to its observers that compels a fair response. Arguing that beauty, defined by aesthetic symmetry, constitutes physical materialization of justice and equality, Scarry's theory constitutes a rehabilitative discourse. Similarly, this chapter is

an experiment in re-thinking embodied beauty as a gift that circulates within the spectatorial process and celebrity economy, revealing that beauty's object-ification reveals the possibility of woman's image as a site/sight for negotiated power and affective exchange.

Re-Gifting the male stare

In the 2012 blockbuster film, *Ren zai jiong tu zhi tai jiong* (*Lost in Thailand*), Fan plays "herself," the famous movie star, and an aspirational romantic object for Wang Bao (Wang Baoqiang), a dim-witted comic sidekick to straitlaced scientist Xu Lang (Xu Zheng).[23] Despite the film's queer coding of Wang Bao through his fixation on Thai "ladyboys," tight clothing, bleached-blond bowl-cut hair, and "feminine" mannerisms, Wang Bao insists that he has gone to Thailand to honeymoon with Fan, although he eventually confesses that this was a lie constructed to please his dying mother. By the end of their Thai road trip, Xu Lang bestows upon Wang Bao, whose nickname is Bao Bao (Baby), a honeymoon photo-shoot with Fan as a gesture of friendship. Occupying the role of an imaginary "beard," Fan ultimately provides assurance of Bao Bao's conformity with heterosexuality by eliciting his "straight" reaction to her beauty, as she transitions from fantasy to woman-as-gift within economies of male homosociality.

The gift exchange functions on several levels in this scene. Within a narrative reading, Fan symbolizes the token offering of male friendship or *guanxi*. Her body is a site/sight of exploitation; her willingness to lend her image to re-produce Bao Bao's romantic wish affirms the masculine prowess and heterosexuality inscribed within men's socioeconomic spheres. Verbally summoned by Xu Lang, Fan appears onscreen, long hair flowing (courtesy of an offscreen fan) with her corporeal beauty accented in slow motion as a non-diegetic male chorus sings over electric power chords, enunciating phallic desire. This beauty shot serves multiple functions: in its most superficial operation, it provides an "affective shot" (a term that speaks doubly to the affective jolt induced by visuality and to the basic unit of a film scene) of heterosexual relief after watching a homosocial romance develop between the male leads for an hour-and-forty-minutes. Rendered speechless and "stunned" by Fan's sudden appearance, Bao Bao's reaction shot externalizes both a "proper" heterosexual response and a "correct" affective response to beauty, performing Freud's observation of the "peculiar,

mildly intoxicating quality" of beauty contact.[24] Moreover, this scene neatly visualizes Irigaray's argument concerning the exchange of women-as-objects within a hetero-sexist masculinist economy. However, when we pivot toward affect as the primary analytic with which to examine the scene, the sight of beauty provides the possibility for an affirmative exchange between beauty and partaker.

When Bao Bao sees Fan, he is in such awe and disbelief that he finds himself suddenly unable to speak, an affect/effect hyperbolized by comically quivering lips signifying an involuntary loss of bodily control. Bao Bao's stare re-presents the "simplest manifestation of the phenomenon of beauty" and re-enacts the feeling upon seeing beauty that inspires one to witness the "'newness' or 'newbornness' of the entire world," a sensation reaffirmed by "Baby's" infantilized

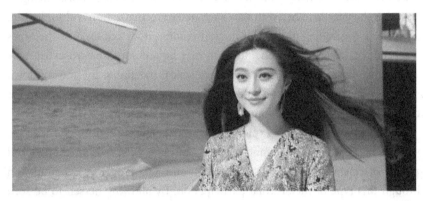

Figure 6.1 Fan Bingbing symbolizing the homosocial "gift" in *Lost in Thailand* (Xu Zheng, 2012).

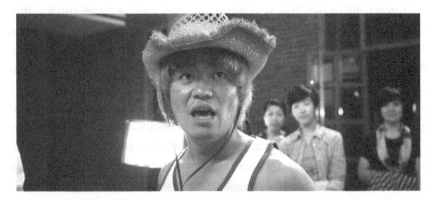

Figure 6.2 Bao Bao (Wang Baoqiang) is decentered and "unselfed" by Fan's beauty in a reaction shot to Fan's arrival in *Lost in Thailand* (Xu Zheng, 2012).

behavior (prelinguistic response with mouth agape).[25] In contrast with the "male gaze" which subjugates the female body as object, Bao Bao's helpless stare suggests that there are other types of "looking" that invert the power dynamic between seer and seen, encouraging a de-centering process Iris Murdoch terms "unselfing."[26] By encouraging the act of staring, Fan provokes an impulse to replicate, procreate, and to be closer to her and further away from one's self as center. Thus, the longer he looks at her, the more Bao Bao is disempowered and unseated from a narcissistic worldview. Mimicking a stare, the film's use of slow motion to prolong the sight of Fan's face contrasts with the phenomenological experience of screening beauty, which speeds up the body's response and enlivens corporeal sensations. Because it re-enforces life-affirming physiological processes, "beauty is lifesaving": "Beauty quickens. It adrenalizes. It makes the heart beat faster. It makes life more vivid, animated, living, worth living."[27] Although the gaze is tethered to Bao Bao's heteronormatization within the film narrative, a reparative, phenomenological reading does not exclude the types of spectatorial pleasures which, although may be present in heterosexual male subjectivity, do not necessarily re-produce sexual dynamics. By slowing down Fan's movements and enabling an extradiegetic stare, the film allows spectators to indulge, lingeringly and unselfishly, in beauty's adrenal gifts.

Indeed, to insist on Fan's exploitation is challenging when we consider the material rewards bestowed upon the star for such acts. Within the cultural spheres of celebrity, Fan builds her own brand and monetary accumulation through this type of metatextual participation. By allowing herself to be seen as an object of exchange, while muting her own desires—by inhabiting the role of fetish-object—Fan increases her "star power" through an *act* of generosity. Interpreted differently, Fan is engaged in a self-reflexive performance that registers with winking knowingness her role as the embodiment of feminine beauty with which to affirm heterosexual desire. As she instructs a bewildered Bao Bao to put his arms around her and give her a backrub before the camera, Fan empowers her to-be-looked-at-ness and comically steps into the role of metatextual director. *China Daily* journalist Raymond Zhou articulates the intersections between heterosexual and class politics within this exchange: "In a sense, [Fan] fulfills the dream of tens of millions of young Chinese men at the bottom of the social echelon whose ideals are boiled down to a meeting with a stunner. The role has cemented her stature as the national 'diva' or 'goddess.'"[28]

Zhou's use of the term "goddess" suggests that Fan's body is a physical rarity, ergo her fame is justified by the singularity of her appearance. Chinese

scholar Yu Shu also uses the phrase *xique ziyuan* (scarce natural resource) to describe Fan's looks, a notion that invites an "exploitative" reading and reveals how beauty valuation relies upon logics of scarcity wherein stars hold finite resources of beauty/body capital.[29] Describing Fan's facial characteristics with hyperbolic flourish: long, pointy chin; absent mandible or jawline; fair skin; and almond eyes "as big as possible," Yu paints a cartoonish image of her features and contends that the star approximates and adapts Caucasian standards of beauty to the Asian body.[30] In other words, celebrated Asian beauty like that of Fan's is an "imperfect version" or "contagion of imitation" of white beauty ideals, yet her celebrity supports a mythology that Chinese women can elevate their social position through mimicry of whiteness.[31] In a global framework, Fan's beauty indicates China's ascendancy to First Worldism through an implicit consent to white corporeality as the aspirational embodiment of high civilization. Domestically, Fan's celebrity brand as China's most beautiful woman encourages ordinary women to pursue plastic surgery as a neoliberal technology for social improvement, and photos of the actress are used as inspiration for popular procedures like double-eyelid surgery, blepharoplasty, and jaw reduction. *Lost in Thailand* thereby renders visual one of the basic industrial tenets of female stardom—that extraordinary screen beauty reproduces and encourages normative heterosexual fantasy and neoliberal ideology. Fan's extradiegetic function as a "marketing device" demonstrates the ways in which modern-day female stardom is exploited by mediated heteronormativities and neoliberalisms, even as the phenomenal value of her beauty "always escapes," creating an enlivening rupture within the cinematic text.

Postsocialist exchanges

Before Fan became "Master Fan" and "goddess" of the People's Republic, her early film and television roles reflected twenty-first century China's masculinist anxieties as the nation transitioned unevenly into postsocialism. In the 2003 top box office film *Shouji* (*Cell Phone*), 22-year-old Fan debuted in the national imaginary as a sexually attractive young woman, after acting in TV roles and smaller film parts for several years. Directed by leading commercial filmmaker Feng Xiaogang, the film is a moralistic tale about the dual temptations of sex and technology, which converge in Fan's characterization of an insatiable mistress. Rui Zhang, drawing from Stuart Hall, contends that Feng's representations of

modern society attest to the "'doubleness' of popular culture, exemplifying a 'double movement of containment and resistance.'"[32] This duplicity appears in the fact that although the film's protagonist receives narrative "punishment" for his morally questionable actions, the temptations in *Cell Phone*, which include Fan's sexualized body, are ambivalently represented in the film as attractive, pleasure-bearing forms of middle-class agency.

Adolescent and technological milestones converge in Feng's nostalgic portrait of innocence before the age of mobile technology; a young Yan Shouyi experiences his first romantic crush just as the first public telephone has been installed in his village. Decades later, we find our protagonist, middle-aged and well-to-do (Ge You), hosting a popular television talk show in Beijing. One day, his wife discovers his extramarital affair by answering a mobile call from his mistress, Wu Yue (played by Fan), and the couple subsequently divorces. Afterwards, Shouyi attempts another relationship but continues to secretly see Wu Yue. By the film's end, Shouyi loses his job along with all romantic prospects. Throughout the film, every occasion of infidelity is enabled by and discovered through the cell phone, justifying Shouyi's producer's cautionary message that the cell phone is a "hand grenade" that destroys relationships and ruins lives.[33] Indeed this type of popular didacticism was timely for audiences a mere two years after China's entry into the World Trade Organization, marking the beginning of the nation's explosive twenty-first century economic growth. Featuring sprawling, well-appointed Westernized apartments, modern studios and offices, the mise-en-scène is steeped in an upward *mobility* modeled upon Western materialisms, betraying the seductive "doubleness" of class aspiration as something that is both morally decadent and spectacularly desirable.

Playing an ambitious and sensational femme fatale, Wu Yue is lusty, pouty, and ferociously demanding about her sexual needs. Leaving her bite-mark on Shouyi's body, she catalyzes the dissolution of his marriage. Imbuing her character with a hint of erotic hostility, Fan performs *sajiao*, a performative femininity that draws on the behavior of a "spoiled child," considered charming and desirable to heterosexual Chinese men. *Sajiao* includes speaking in a high-pitched voice, pouting, and looking with wide "puppy-dog eyes" when returning a lover's gaze. However, in its aggressive form, *sajiao* also includes whiny, bratty behavior, like that of a child throwing a tantrum.[34] Some scholars believe that even as it ultimately re-affirms the care-taking, powerful role of masculinity, *sajiao* represents a woman's ability to negotiate

the power dynamic between herself and her male partners through gendered performativity.[35]

Persistently vocal about her desires, Wu Yue first "appears" in the film sonically as a disembodied voice calling Shouyi's cell phone to angrily ask why he has not answered her previous calls. Immediately characterized by the mobile object, Wu Yue's own bodily technologies—her unapologetic seduction techniques (*sajiao*) and glamorous appearance—are analogized to the slickly polished, savvy functionality of the film's featured cell phones, then-top-of-the-line models like the Motorola MotoA79, which premiered in the film alongside Fan's erotic debut. In one scene, Shouyi reminds the audience that Wu Yue was born in the year of the dog, a fact she takes seriously with bite marks and "scent-marking," courtesy of a strong perfume, on his body.

Although her devouring sexual nature characterizes her as a "man-eater," Fan's performance brims with humanity and complexity. In a scene that trails from the storyline, Wu Yue attends a private writing retreat, and from a humbly appointed room, she watches Shouyi on his television program "Tell it like it is" discussing "whether or not one should lie." As she lies down on the bed, a close-up frames Fan as a single tear streams from a closed eye. Just then, a China Telecom commercial airs in the background: "Communication connects our hearts." The juxtaposition between Fan's face with the sounds of the commercial conveys the anthropomorphic commercialization of technology and conversely, Wu Yue's embodiment of technology. She exemplifies a younger, newer model of femininity, in contrast with the outdated and "non-functional" womanhood embodied by Yan's ex-wife, who never bore children and thus failed to fulfill

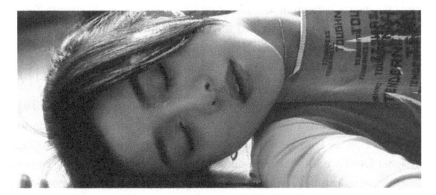

Figure 6.3 A beauty close-up on Fan in *Cell Phone* (Feng Xiaogang, 2003) produces an aesthetic moment wherein lovelorn sadness, yearning, and isolation commingle.

kinship responsibilities. Furthermore, this scene seems to be motivated, in large part, by an unconscious drive to gaze upon Fan's face. This close-up is, for all intents and purposes, a beauty shot, allowing the spectator to momentarily indulge in an aesthetic experience wherein lovelorn sadness, yearning, and isolation commingle to produce an image of a vulnerable, nonthreatening femininity. Fan's crying face produces a visual shock of beauty combined with the sentimentalism of tears. What this shot wants from us, in return, is to "decenter" and "unself" from moral high ground, to empathize with Wu Yue's plight and consider the emotional consequences of the affair from "the other woman's" perspective.

Later in the film, after one of their illicit meetings, Wu Yue reveals to Shouyi that she used her new cell phone to aurally record their lovemaking, further illustrating her body's instrumentalized, posthuman convergence with technology. When Shouyi tells her he cannot marry her, she replies, "I'm not that innocent," before proceeding to make it clear that she is after a hosting position on his show. After Shouyi accuses her of blackmail, Wu Yue corrects him: "It's an *exchange*." Turning away from him and toward the camera (and audience), she reasons in a calm, monotone voice, "It's been three years. You can't just leave me with nothing." Explaining that she helped secure a job for Shouyi's ex-wife at her publishing firm by sleeping with the company president, Wu Yue reinforces Irigaray's claim regarding women's sexual commodification within capitalist systems, including that of Chinese corporate *guanxi*. As in *Lost in Thailand*, Fan's character becomes the gift exchanged between men, reinforcing patriarchal economic structures and heteronormative desires. However, Fan's embodied performances in both films demonstrate her ability to pivot the viewer's attention toward her minor characters' predicaments. Beauty thus functions as a circumscribed form of feminine power and diversionary tactic that generates provocatively unmanageable affinities, particularly as it wraps itself around aggressive, unruly femininities like *sajiao*.

Reinforcing her desirable value through public celebrity, in recent years Fan has become a global fashion icon, known for exotic red carpet looks and daring fashion campaigns. The international attention to her fashion style began with her 2010 Cannes Film Festival appearance in which she wore haute couture designer Laurence Xu's intricate silk dragon robe, a variation on the imperial *longpao* (dragon robe), which was a formal gown worn by empresses, high-ranking consorts, and noblewomen during China's dynastic eras. By marking her body capital with the clothing of the highest social-ranking female members

of traditional society, Fan explicitly declares her social status and corporeal worth as a scarce and "classic" resource. Moreover, Fan's presentation indulges in self-Orientalizing and auto-ethnographic processes through which Chinese films became globally recognized in the modern era, a technique Rey Chow observed in Fifth Generation cinema.[36] Such strategies have assured Fan's top place in global celebrity, and as her nickname "Master Fan" suggests, it is a space of power and wealth typically occupied by men.

Despite Fan's self-aggrandizement and pronouncement of her high self-*worth* through bodily technologies like fashion, her beauty is an "unstable good" that "must appear unearned if it is to be authentic, as opposed to purchased, beauty."[37] Within the circular argument at the core of beauty's socio-cultural construction however, the unearned beauty is suspect *because* it is unearned. The uncertainty about the "good" of Fan's beauty can be found in the extratextual discourses surrounding her, as performance anxieties steeped in Confucianist moralism and discomfort with burgeoning Westernized femininities collect around Chinese female film stars.[38] Many, for instance, believe that Fan has undergone intensive plastic surgery in order to achieve her extraordinarily "un-Chinese" looks. Attempting to dispel those rumors in the public eye, Fan has consented to undergoing and publishing clinical examinations several times over the course of her career, revealing the extent of public territorialization over the female celebrity body, inside and out.[39] Along with actress Zhang Ziyi, Fan has also been accused of being a high-end prostitute in the euphemistic "dining" industry, wherein wealthy men pay for the sexual companionship of famous female stars. As an "intimate stranger," Fan thus demonstrates, as I have previously argued, the ways in which "anxieties around . . . female stars are rooted in the erotics of spectatorship, wherein they are both readily accessible yet enduringly unknowable to the public."[40]

Just gifts

Fan's body of acting work bifurcates into big-budget, commercial films and semi-independent, low-budget films. *Cell Phone* garnered Fan her first Best Actress Award at the Hundred Flowers Awards (China's "Audience Award" ceremony), after which the actress began her A-list climb. Several years later, when Fan outshone her "rival" Zhang Ziyi in Eva Jin's 2009 romantic comedy, *Feichang wanmei* (*Sophie's Revenge*), her status as one of China's biggest stars became

undisputed. Meanwhile, perhaps to garner international credibility as a serious actor, Fan also began appearing in the controversial independent films of Sixth Generation female filmmaker Li Yu, with whom she has collaborated on four films to date. In stark contrast with Fan's high-class haute couture persona, Fan's roles in these films, typically playing impoverished, ordinary women, involve a stripping down of her glamorous star persona. Through their collaborations, Fan is not only able to comment on her own beauty-making (or more precisely, lack thereof) but also uses her star power to draw attention to Li's postsocialist concerns.

Fan and Li's first film collaboration, *Pingguo* (*Lost in Beijing*, 2007), follows the events of a young migrant named Pingguo (played by Fan) who is raped by her massage parlor boss, Lin Dong (Tony Leung), an act accidentally witnessed by her husband, An Kun (Tong Dawei). After discovering that Pingguo is pregnant but uncertain about the paternity, her wealthy boss and window-washer husband agree that if the baby's biological father is Lin Dong, he will pay the couple 120,000 RMB to adopt him/her. If An Kun is the biological father, the couple will keep their offspring and Lin Dong will only pay them only for "damages and suffering." After the birth of Le Le, both couples affected by this incident separate (An Kun and Pingguo, and Lin Dong and his wife), and despite not being the biological father, Lin Dong wishes to retain sole custody. The film concludes with Pingguo taking her son and leaving the Lin home, where she had been working as wet nurse and housemaid.

Lost in Beijing is a postsocialist realist allegory about the patriarchal biopolitics that govern women's bodies and intimate lives. As Li Xiaojiang contends, Chinese feminists reject the Western mantra "the personal is political," because the personal has been *too* politicized in the People's Republic with regard to female bodies and reproductive policies, a fact reflected upon in the film through the men's surveillance and control over Pingguo's pregnancy.[41] Although An Kun is initially angry with Lin Dong, the men strike an uneasy reconciliation when Pingguo's husband realizes he can make money from adopting the child to the infertile Lins. Although the men occupy different socioeconomic classes, Li is interested in the ways that the men are engaged in a gift exchange that excludes Pingguo's desires. After Lin Dong rapes Pingguo, An Kun takes his Mercedes car emblem in exchange, a gesture signifying An Kun's material aspirations and the men's objectifying equivalence of Pingguo's body to Lin Dong's car. The men's machinations are fluid and biological. Just as both men sexually "share" Pingguo and Lin Dong's wife (who seduces An Kun in an

act of revenge), they also "share" a virus when Lin Dong passes his cold unto An Kun. The film's allegorical message gains particular poignancy during a scene in which the men go over the details of their business deal on the rooftop of Lin Dong's massage parlor. A young unknown woman ascends to the roof before suddenly disappearing, seemingly into thin air. As the men peer down from the rooftop to search for her, they verbally comfort one another, "There's no body." This unsettling digression forces the audience to think about Pingguo in relation to the anonymous woman. With no voice in her child's custody, Pingguo's body is a mere vehicle for her husband and rapist's sexual and reproductive desires. There is no autonomous female "body," a "fact" discursively agreed and decided upon by the colluding men.

While simple costuming establishes Pingguo's straightforward character, Fan authenticates her beauty by allowing Li to shoot her in close-up without glamorous aestheticization (no use of makeup, soft focus, or lighting to produce a more physically attractive look). In an interview, Li remarked that most actresses will not permit the camera being so close to their faces because it magnifies their imperfections, however, Fan allowed cinematographer Yu Wang to reproduce Li and Fan's *emotional* closeness vis-à-vis camera proximity.[42] Li not only instructed that Fan be shot frequently through close-up without the use of makeup, she even added a mole and blackheads to the star's face for principal photography.[43] By consenting to such cinematographic intimacy and un-beautification, Fan invites scrutiny while visually authenticating that her beauty is "natural" and "unmade," in turn exploiting the spectator's gaze for her own reputational benefit.

Fan's character in *Lost in Beijing*, as in *Lost in Thailand*, produces the gift that sustains masculine *guanxi*. Meanwhile, Fan's "biological" beauty is seamlessly incorporated into *Lost in Beijing*'s chaotic mise-en-scène, becoming a gift that induces rupture and produces an affective "lever in the direction of justice."[44] A three-minute montage bisecting the film interweaves documentary footage of urban street-life with narrative scenes of the characters resuming their lives with dull complacency. Advancing the narrative timeline, seasons change as Pingguo's pregnant belly grows. Glimpses of a real world beyond the narrative frame include guards raising the PRC flag in Tiananmen Square, people on the Beijing subway, homeless people and migrants sitting idly on the street, youths dancing, and happy couples flirting. An invisible order and harmony in the sequence is aurally suggested through measured non-diegetic electronic beats and contemplative melodies. Meanwhile the fragmented images, shot *xianchang*

("on the scene") using a lower-resolution digital camera, creates "an alternative cinematic space that is haptic rather than optic, sensuous and open rather than abstract and closed," a quality Zhen Zhang describes of Sixth Generation Chinese cinema.[45] The shaky handheld camera produces a haptic quality that situates the spectator as participant-observer and the open-ness of the text is reinforced by shots of subjects who peer directly into the lens, demonstrating the limits of filmic representation. By breaking the fourth wall and directly addressing the camera with their returning gaze, the extras demystify cinematic illusions premised on scopophilia and expose the underlying reciprocal exchange between image and spectator. The juxtaposition of Pingguo alongside ordinary citizens produces an aesthetic lateralization and adjacency that flattens class and social hierarchies, visualizing Fan as their equal—even if only momentarily and via cinematic fantasy. Pingguo's vulnerability as a young migrant is accented by Fan's beauty, which acts as a "small tear in the surface of the world that pulls us through to some vaster space" and attracts audiences to an urbanized Beijing occupied by lower-class migrant and service workers —a vision of China beyond the touristic gaze.[46]

Li explained her reasons for casting Fan as well as her own exploitation of the gendered gaze: "I wanted to use Fan's beauty first to *attract* male viewers' attention. But as they're watching the film, they're not only seeing her beauty, they're watching the film."[47] Through our fixation on and attraction to Fan-as-Pingguo, we simultaneously consume the sights of Beijing as glimpsed by ordinary people. As male and female viewers alike bear witness to Pingguo's abjection, the magnetizing effects of her beauty "intensif[y] the pressure we feel to repair existing injuries," in this case, the masculine violence and deprivations inflicted upon Pingguo.[48] It is precisely through an erotic fixation or attention on Fan's beauty that the film engages in a production of care toward its impoverished, marginalized subjects. Fan's beauty, according with a Platonic ideal, acts as a hinge that joins a viewing position of *eros*, which desires and "is seized by" Fan's body, with a *caritas* or a politics of care that extends compassion outward.[49] Simply put, and certainly not without injurious implications, we *care* about poor migrant worker Pingguo (and others like her) because superstar Fan is beautiful. Nevertheless, Li is not satisfied with simply exploiting Fan's pulchritude as a kind of empathy lubrication. Indeed, this sequence abruptly ends with an unseemly close-up of Pingguo as she agonizingly screams into the camera during labor (a third direct address in the montage). In stark contrast with Wu Yue's transcendently beautiful cry-shot in *Cell Phone*, we become the

recipients of an intensely affective punch/punctuation that forcefully commands our attention as it startlingly undoes Fan's beauty. Lacking the contextualization of an establishing shot, this moment transmutes into pure intensity, becoming what Elena del Río refers to as an "affective-performance" event that translates into sensational forces within the spectator body.[50] Just as beauty can "un-self" its beholder, the strategic un-doing of beauty, functioning as an affective alarm, can startle the spectator's attention back towards an unfolding urgency that calls attention to the vulnerable state of a woman's body under duress.

Wrapping it up

Parallel to the ways in which Fan ambiguates the exploiter/exploited dynamic, her beautiful onscreen image disrupts straightforward masculinist narratives by offering other identificatory possibilities and affective engagements. In her examination of the phenomenal perception of beauty within racialized American contexts, Anne Cheng inquires, "Can we think of beauty [as] a gift that brings us back into intense and lived contact with all the uneasy, multiple, and continuous psychical processes that go into the making and remaking of our own boundaries—the grace of perceptual questioning in a world of unremitting differences?"[51] Beauty's production of conscious difference, which Cheng describes as a wounding effect, delineates the boundaries between self and Other, ushering in a complex and ambivalent psychical process of (dis) identification. Indeed, the perceptual experience of screening beauty produces the radical possibility of *facing* alterity, tacitly raising questions about ethics and exploitation. Perceived doubly as a scarce resource and an unstable good, Fan's beauty is both immeasurably valuable and notoriously suspect. Nevertheless, Fan's rise to success is premised on mutual exploitation within a gift economy. The scarce resource of her beauty is given in exchange, not only for monetary compensation and to affirm male *guanxi*, but also to attract attention to the unequal gendered exchanges and vulnerability of women in modern-day China.

At the time of writing, Fan has just won the San Sebastián Film Festival Best Actress award for her second collaboration with Feng Xiaogang, *I am not Madame Bovary* (2016), about a woman "who feels wronged by China's justice system in her divorce case."[52] Unsurprisingly, given the film's content, its domestic release date has been pushed back, and some speculate that the film failed to acquire

proper state approval.[53] Equally foreseeable, Fan's beauty is deployed in pursuit of ethical *fairness* as Feng and Fan tackle the moral symbol of the PRC—its justice system. Although Fan's critics may accuse her of being a *huaping* (decorative vase), merely beautiful on the outside but talentless and empty on the inside, Fan not only demonstrates the profitability of being decorative, but also the ethical and affective exchanges wrapped up in gifting beauty—giving new meaning to the term "charm offensive." Indeed, perhaps what is at stake here is not a *defense* of beauty after all, but rather, the conditional possibilities of a "beauty *offensive*" and its capacity to exploit the exploiter.

Acknowledgments

The author thanks Li Li, Elizabeth Sheehan, Samantha Sheppard, Hunter Hargraves, and the editors of this book for providing helpful conversations, feedback, and suggestions for this chapter.

Notes

1 Jacques Gernet and Franciscus Verellen, *Buddhism in Chinese Society: An Economic History from the Fifth to the Tenth Centuries* (New York: Columbia University Press, 1995), 281.
2 Mayfair Mei-hui Yang, "From Gender Erasure to Gender Difference: State Feminism, Consumer Sexuality, and Women's Public Sphere in China," in *Spaces of Their Own: Women's Public Sphere in Transnational China*, ed. Mayfair Mei-hui Yang (Minneapolis, MN: University of Minnesota Press, 1999).
3 Dai Jinhua, "Rewriting Chinese Women: Gender Production and Cultural Space in the Eighties and Nineties," ibid., 196.
4 Sedgwick refers to Paul Ricouer's notion of a "hermeneutics of suspicion," describing the works and legacies of Marx, Nietzsche, and Freud, which lay bare "both the process of false consciousness and the method of deciphering." Eve Kosofsky Sedgwick, "Paranoid Reading and Reparative Reading, or You're So Paranoid, You Probably Think This Essay Is About You," in *Touching Feeling: Affect, Pedagogy, Performativity* (Durham, NC: Duke University Press, 2003).
5 Sedgwick, "Paranoid Reading and Reparative Reading," in *Touching Feeling*.
6 Chris Berry and Mary Ann Farquhar, *China on Screen: Cinema and Nation* (New York: Columbia University Press, 2013), 109.

7 Richard Dyer, "Stars as Images," in *The Celebrity Culture Reader*, ed. P. David Marshall (New York: Routledge, 2006).

8 See Leung Wing-Fai, "Zhang Ziyi: The New Face of Chinese Femininity," in *East Asian Film Stars*, eds. Leung Wing-Fai and Andy Willis (London: Palgrave MacMillan UK, 2014).

9 Alan Lovell and Peter Kramer, eds., *Screen Acting* (London: Routledge, 1999), 7.

10 Elaine Scarry, *On Beauty and Being Just* (Princeton, NJ: Princeton University Press, 2013).

11 Ibid., 114.

12 Hélène Cixous, "Sorties: Out and Out: Attacks/Ways out/Forays," in *The Logic of the Gift: Toward an Ethic of Generosity*, ed. Alan D. Schrift (New York: Routledge, 1997). Luce Irigaray, "Women on the Market," ibid.

13 Irigaray, "Women on the Market."

14 Ibid., 177.

15 Genevieve Vaughan, *Women and the Gift Economy: A Radically Difference Worldview Is Possible* (Toronto: Inanna Publications & Education, 2007); Morny Joy, *Women and the Gift: Beyond the Given and All-Giving* (Bloomington, IN: Indiana University Press, 2013).

16 "Introduction," in *Women and the Gift: Beyond the Given and All-Giving*, ed. Morny Joy (Bloomington, IN: Indiana University Press, 2013), 45.

17 Li Xiaojiang, "With What Discourse Do We Reflect on Chinese Women? Thoughts on Transnational Feminism in China," in *Spaces of Their Own: Women's Public Sphere in Transnational China*, ed. Mayfair Mei-hui Yang (Minneapolis, MN: University of Minnesota Press, 1999), 273.

18 Mayfair Mei-hui Yang, "From Gender Erasure to Gender Difference: State Feminism, Consumer Sexuality, and Women's Public Sphere in China," ibid., 64.

19 Thomas Gold and Doug Guthrie, *Social Connections in China: Institutions, Culture, and the Changing Nature of Guanxi* (Cambridge, UK: Cambridge University Press, 2002), 7.

20 Dyer, "Stars as Images," 157; Zigor Aldama, "Actress Fan Bingbing on Becoming the New 'Empress of China'," *South China Morning Post* (December 20, 2015).

21 Kathleen Rowe, *The Unruly Woman: Gender and the Genres of Laughter* (Austin, TX: University of Texas Press, 1995), 11.

22 Laura Mulvey, "Visual Pleasure and Narrative Cinema," in *Film Theory and Criticism: Introductory Readings*, ed. Leo Braudy and Marshall Cohen (New York: Oxford University Press, 1999), 837.

23 *Lost in Thailand* is a neocolonialist fantasy based on assumptions of the right for Chinese "flexible citizens," to use Aihwa Ong's term, to exploit Thailand as a pleasure-neocolony, on both economic and imaginative grounds. China's twenty-first century

global role as one of the major economic exporters benefiting from the Association of
Southeast Asian Nations (ASEAN) free trade agreements have raised Chinese citizens
to an elevated status within Southeast Asia. Exploitation thus doubly functions in the
film's diegesis: to signify China's economic dominance vis-à-vis travel mobility, and
in terms of the ways in which Fan and other women, including transwomen, become
objects of exchange between men.

24 Sigmund Freud, *Civilization and Its Discontents*, trans. James Strachey (New York:
 W. W. Norton and Company, 2005), 62.
25 Scarry, *On Beauty and Being Just*, 5; 22.
26 Ibid., 112–13.
27 Ibid., 24–25.
28 Raymond Zhou, "More Than Just a Pretty Face," *China Daily* (August 6, 2013).
29 Yu Shu, "*Dazhong Xiaofei De Shenhua: Cong Dianying Guanzhong Xue De Jiaodu
 Fenxi Fanbingbing De Mingxing Xingxiang* (the Myth of Mass Consumption:
 Audience Reception Analysis of Fan Bingbing's Star Image)," *Zhongguo dianying
 shichang (China Film Market)* 9 (2014).
30 Ibid., 34.
31 Scarry, *On Beauty and Being Just*, 6.
32 Rui Zhang, *The Cinema of Feng Xiaogang: Commercialization and Censorship in
 Chinese Cinema after 1989* (Hong Kong: Hong Kong University Press, 2008), 2.
33 What further complicates Feng's critique but betrays the film's duplicity is that the
 film was partly financed by telecommunications companies Motorola, BMW, China
 Mobile, and Mtone Wireless.
34 Qiu Zitong, "Cuteness as a Subtle Strategy: Urban Female Youth and the Online
 Feizhuliu Culture in Contemporary China," *Cultural Studies* 27, no. 2 (2013).
35 Ibid.
36 Rey Chow, *Primitive Passions: Visuality, Sexuality, Ethnography, and Contemporary
 Chinese Cinema* (New York: Columbia University Press, 1995).
37 Maxine Leeds Craig, "Race, Beauty, and the Tangled Knot of a Guilty Pleasure,"
 Feminist Theory 7, no. 2 (2006): 174.
38 Mila Zuo, "Sensing 'Performance Anxiety': Zhang Ziyi, Tang Wei, and Female Film
 Stardom in the People's Republic of China," *Celebrity Studies* 6, no. 4 (2015), 519–37.
39 For instance, "Fan Bingbing Has Hospital Disprove Face-Lifting Rumors,"
 Zhongguo Wang (China Web) (June 19, 2006). http://www.china.org.cn/english/
 features/film/171904.htm.
40 Richard Schickel, "Intimate Strangers: The Culture of Celebrity in America,"
 (Chicago, IL: Ivan R. Dee, 2000); Zuo, "Sensing 'Performance Anxiety'," 533.
41 Xiaojiang, "With What Discourse Do We Reflect on Chinese Women? Thoughts on
 Transnational Feminism in China."

42 Li Li and Mila Zuo, *Darao de yishu daoyan Li Yu zhuanfang* (Art That Disturbs: An Exclusive Interview with Director Li Yu), *Dangdai dianying* (Contemporary Cinema journal) 218, no. 5 (2012): 75.

43 Ibid.

44 Scarry, *On Beauty and Being Just*, 100.

45 Zhen Zhang, "Introduction: Bearing Witness: Chinese Urban Cinema in the Era of 'Transformation,'" in *The Urban Generation: Chinese Cinema and Society at the Turn of the Twenty-First Century*, ed. Zhen Zhang (Durham, NC: Duke University Press, 2007), 21.

46 Scarry, *On Beauty and Being Just*, 112.

47 Li and Zuo, *Darao de yishu daoyan Li Yu zhuanfang* (Art That Disturbs: An Exclusive Interview with Director Li Yu), 74. Author's emphasis.

48 Scarry, *On Beauty and Being Just*, 57.

49 Scarry makes mention of this Platonic "requirement" that we move from *eros* to *caritas*, arguing that this notion appears throughout early aesthetic thought. Ibid., 81.

50 See Elena del Río, *Deleuze and the Cinemas of Performance: Powers of Affection* (Edinburgh, UK: Edinburgh University Press, 2008).

51 Anne Anlin Cheng, "Wounded Beauty: An Exploratory Essay on Race, Feminism, and the Aesthetic Question," *Tulsa Studies in Women's Literature* 19, no. 2 (2000): 211.

52 Patrick Frater, "Feng Xiaogang's 'Madame Bovary' Release Delayed," *Variety* (September 21, 2016), http://variety.com/2016/film/asia/mystery-distribution-delay-for-feng-xiaogangs-madame-bovary-1201866753/.

53 Ibid.

Part Three

Exploitation, Art, and Politics

Part Three

Exploitation, Art, and Politics

Kitano's Outrageous Exploitation Cinema: Yakuza Nobility and the Biopolitics of Crime

Elena del Río

Introduction

In examining Kitano Takeshi's *Outrage* (2010) and *Outrage Beyond* (2012), this chapter will take as its point of departure these films' dismantling of the division between art and trash. Underpinning this dismantling is the idea that, while not invested in the conventional mold of art-house films, Kitano's filmmaking is a highly creative and inventive practice that follows its own idiosyncratic editing rhythms and affective contrasts. It may indeed be the case that Kitano's way of dodging expectations and clichés typical of an excessively self-conscious art cinema goes by way of getting his acute aesthetic sense deeply steeped in trash, in the process confusing the boundaries between high and low and reconfiguring the limits of both.[1] Kitano's focused, extreme deployment of violent actions—in particular his handling of the male body in its lethal encounters with other male bodies and of the struggle for power leading to and arising from these encounters—lends *Outrage* and *Beyond* a quality of grotesque excess that has also come to broadly define the otherwise diverse range of exploitation cinemas. No doubt, the extremity of the brutality leveled at the body in these films is rather in keeping with the brutal acts exchanged among yakuza gangs or between yakuza and cops already displayed in previous Kitano films such as *Violent Cop* (*Sono otoko, kyōbō ni tsuki*, 1989), *Sonatine* (*Sonachine*, 1993), *Fireworks* (*Hana-Bi*, 1997), and *Brother* (2000). And yet, the levity in tone that often colors the lethal or wounding acts in *Outrage* and *Beyond* results in an intensification of exploitation aesthetics relative to Kitano's former engagement with violence. This intensification manifests itself not only

through the proximity and affective contrast between brutality and comedy, but also through an exuberant formal inventiveness in the filmmaker's repertoire of violence—the sheer proliferation of ways in which a body can come undone. At the same time, as I implied earlier, despite their approximation to an aesthetic of the exploitation genre, these new degrees or qualities of violence in *Outrage* and *Beyond* do not compromise Kitano's originality and creativity, but instead preserve these from becoming stale or conforming to expectations. Beyond the strict context of Kitano's cinema, we may consider the exuberance of violence in the exploitation genre more generally as consistently fueling a restless desire for aesthetic experimentation and even the articulation of a resistance against normative ideologies.

In *Outrage* and *Beyond* the male body performs as a self-contained pain machine.[2] There is no distinction here between physical and psychological pain, as every thought or emotion is immediately registered at the surface of the body, with any potential remainders simply driving forward the affective momentum culminating in the next violent outburst. In its many forms and variations, the pain that colors these films is certainly familiar to the generic figure of the yakuza as a loner and a social outcast driven by restless, contradictory impulses. And Kitano himself, both in his directorial persona and in the many roles he embodies in his films, fleshes out the image of a man at odds with himself and the world. This pain machine that is the male body seems to be closed in on itself, both in the sense of the extreme egocentrism and calculated self-interest exhibited by the yakuza, and in the cinematic sense of the absence of an aesthetic outside to violence. But, as I will show later in this analysis, the male body's self-containment in these films is merely a surface impression—the façade of a fortress-like masculinity that is nonetheless intricately connected to the affective field formed by a supraindividual male body. In effect, the pain machine in *Outrage* and *Beyond* does not operate at the level of the individual, psychologized body, in any case irrelevant in affective terms and always secondary in Kitano's work, but at the level of the collective body of yakuza homosociality. And yet, I would argue that in terms of the films' overall affective organization, the pain remains rather self-contained, insofar as the negative affects eschew any outlets for aesthetic release. This would be in contradistinction with both art cinema's tendency toward self-conscious aesthetics and previous Kitano films, where the violent outburst typically alternates with a heightened artistic or performative moment to provide a vital, affirmative contrast with the violence.[3]

Pain and rage are the predominant affects that characterize the male body in these films, both in the ways it affects other bodies and in the ways the male body is affected by them. Thus, regardless of the exaggerated self-interest of the yakuza subject, and the attending fiction of its self-containment, his affective life is immediately marked by a collective ethos and modulation. As Brian Massumi has noted, it is important to insist on the primacy of the collective over the individual body in the domain of the affects—affect is directly collective, as it pertains to relation rather than individuality.[4] My aim in this chapter will thus be to discuss the yakuza modalities of violence in these two films as a tension between a strong, but deceptive, appearance of extreme individualism and a simultaneous sense of collective affectivity.[5] Here, the collective nature of affect takes two conflictive directions/dimensions: on the one hand, a nostalgic gesture that seeks to revalorize traditional yakuza nobility; on the other hand, the irreversible contamination of the yakuza code by the globalizing trends of financial capitalism and a managerial, biopolitical organization of crime. It is precisely the tension and collision between these two modes of yakuza ethics that drives the films' chaotic narratives as well as the affective movements that place Beat Takeshi's own character, Ōtomo, in a constant struggle against both the ignoble yakuza families and the police forces invested in the equally ignoble management of crime.

As I implied earlier, in *Outrage* and *Beyond*, Kitano seems to have deliberately stripped his cinema of explicit formal mechanisms that would categorize it as art cinema. This may have stemmed from a desire to reach younger international audiences unfamiliar with his former work or the vocabulary of a self-reflexive, meditative cinema, and more in tune with the fast and furious pace of action blockbusters and video games. Kitano's determination to make the films accessible for a general audience, and in the filmmaker's words, "not too indulgent and artsy,"[6] proved a resounding commercial success. While *Outrage* grossed over $7 million in Japan alone, *Beyond* became "the biggest release ever for a . . . Kitano film," with the producers encouraging him to make a third *Outrage* movie. As Ignatiy Vishnevetsky observes, following the success of *Outrage*, *Beyond* became "a cash-in produced to help fund Kitano's less commercial personal projects."[7] A similar emphasis on popular reach is suggested by the distribution strategies of the films, which took place mainly through DVD, with few screenings at commercial cinema venues in both Europe and North America.

But despite these films' minimal use of a self-conscious artistic discourse and their single-minded focus on narrative, *Outrage* and *Beyond* do not lack depth

in the way they resonate with important contemporary cultural and political realities. A certain adherence to the aesthetics/anti-aesthetics of the exploitation genre is perfectly matched in these films to the process of commodification of value accomplished by capitalism. In other words, as we shall see, the kind of exploitation developed at the cinematic/formal level is echoed by the strategies of capitalist exploitation and the biopolitical organization of crime exemplified in the yakuza narrative. And yet, the films also stage a nostalgic fight against such capitalist exploitation, as carried out by Beat Takeshi's own personification of yakuza nobility. Thus, *Outrage* and *Beyond* maintain an uneasy double position toward the concept of exploitation: on the one hand relying on aesthetic excess as the very basis of their entertainment value, hence fully participating in the commodifying dynamics of capital, on the other hand exposing the predatory forces of financial markets—responsible for both the commodification of cinema and for the perversion of the old yakuza way of life. While the corrosive influence of capital had certainly featured prominently since the heyday of the yakuza genre in the 1950s, Kitano's contribution to this theme, as we shall see, implies an acknowledgment of the intensified effects of transnational, financial capitalism in relation to the capitalist logic that we find in earlier yakuza films. The accelerated destruction of traditional yakuza codes, rituals, and hierarchies in *Outrage* and *Beyond* is aided not only by the strengthening of links between national and global circuits and flows of capital (and cinema), but also by Kitano's own Nietzschean willingness to propitiate an aesthetics of destruction that situates his work solidly within the contemporary trend of "biopolitical cinema."[8]

Narrative contortions, primitive masculinity

The narrative trajectory in *Outrage* and its sequel, *Outrage Beyond*, is both exceedingly confusing in its many meanderings and proliferating characters and simple in its basic affective compulsions. Despite the extraordinarily complex string of alliances and ruptures between yakuza gangs, the men's actions are always propelled by easily identifiable, primitive instincts: expansion of turf and accumulation of power. *Outrage* begins with a traditional Japanese banquet held by the Sannō crime syndicate. Sannō Chairman Sekiuchi (Kitamura Sōichirō) is furious over Ikemoto's (Kunimura Jun) pact of brotherhood with outsider Murase (Ishibashi Renji). To pacify Chairman

Sekiuchi, Ikemoto asks Ōtomo (Beat Takeshi), another subsidiary head, to rough up Murase.

Ōtomo's men use the Ghanan embassy to set up a casino and drug-dealing operation. Ikemoto's frequenting of the casino and smooching off its profits makes everyone uncomfortable. Ōtomo is banished for having killed Murase at Ikemoto's own request, and he then takes violent revenge against duplicitous Ikemoto. Ōtomo survives the all-out annihilation spree that ensues, and Detective Kataoka (Kohinata Fumiyo) persuades him to surrender and go to prison. At Mr. Chairman's compound by the sea, underboss Katō (Miura Tomokazu) eliminates underboss Ozawa (Sugimoto Tetta) and Mr. Chairman in cold-blood, making it look like these two have gunned each other down. In the prison yard, an unsuspecting Ōtomo is repeatedly stabbed by Kimura. Katō takes over Mr. Chairman as head of the Sannō and everyone wrongly assumes Ōtomo has been killed in prison.[9]

Beyond continues the convoluted saga of fight for dominion and revenge among yakuza clans, this time drawing more explicit attention to the affinities between politicians, cops and yakuza in their opportunistic alliances with each other and their common corrupted alliance with capital. Social opportunism and corruption are personified with particular intensity by Det. Kataoka, who takes an even more prominent place in the second film. Corruption of yakuza ethics is also showcased in the form of a generational struggle among the old-guard executives and the young yakuza. Acting more like common thugs than honorable yakuza, the younger men disregard traditional protocols and loyalties and instead seem to favor the modern profit-making methods of financial capitalism and expansion of markets.

Taking off right where *Outrage* ends, the Sannō clan is now ruled by former underboss Katō. Tomita (Nakao Akira), an old-timer, takes offense at the younger men's disrespect for the old creed. Continuing to pull the strings of crime and conspiracy, Det. Kataoka takes advantage of Tomita's grudges against the Sannō clan's new methods and instigates him to obtain assistance from the Hanabishi clan in the fight against the Sannō. Kataoka also instigates Ōtomo to join in the war, but after an early release from prison, Ōtomo is unwilling to take up his old yakuza life. Moreover, Ōtomo bears no ill will against Kimura, his assailant in prison. Instead, he strikes up an alliance with Kimura, and is finally driven to act against the Sannō when Kimura's young *protégés* (sons of old sworn brothers) get killed by the Sannō. In the meantime, rumors have spread far and wide that Katō killed his own boss Sekiuchi. In a ceremony at Police headquarters, Katō

is finally forced to declare his retirement from yakuza life, but soon thereafter he's stabbed at a game parlor by Ōtomo. In the film's closing scene, Ōtomo kills Kataoka on the spot with the gun the ever-treacherous detective has just handed him to defend himself against his enemies.

Throughout this complicated unfolding of intrigues and conspiracies, the men's behavior is ruled by a sort of primitive, knee-jerk reactivity. There is neither rational basis for their brutal behavior, nor any kind of recourse to psychology underpinning their actions. Instead, any psychological motivation for the violence is bypassed through the generic requirements of the yakuza film. Here, violence is an abstract given that belongs to masculinity in an essential/ essentialist way, and, as I said earlier, is indivisible from the male body's claims to self-containment. Yet, an extreme performance of self-containment and elimination of the other paradoxically depends upon these many others that one's life is spent annihilating. In the modern/biopolitical terms laid out by these films, terms that ostensibly differ from the maintenance of more stable traditional yakuza hierarchies, it is as if for one yakuza to exist, everyone else must eventually die. As Ōtomo says to fellow yakuza Mizuno (Shiina Kippei) in *Outrage*, "One of us must survive to see who will win."[10] A fierce commitment to the death drive is the only mode of living for the yakuza. His life consists of nothing but this struggle to the death and is therefore dependent on the existence of these others that it also must get rid of. This paradoxical confluence of extreme individualism and extreme interdependence attests once again to the relational nature of yakuza affects.

These relational dynamics do not give rise to new affects or potential new structurations of power outside those that already rule the process of mutual annihilation among the yakuza. Instead, they follow a model of fascistic, reactive forces that weave a narrative of hit and counter-hit, offense followed by an even more egregious revenge. Utterly oblivious to the old respect for yakuza hierarchy, yakuza power and action in *Outrage* and *Beyond* work instead by contagion mechanisms. Power is not relayed from on high, but it can be held and waged from any point at any time, thus multiplying the possibilities for forces to encounter other forces. As we see in the reversed fates of characters such as Murase, Ikemoto, Katō, Ishihara, or Kimura, positions are highly mobile and unstable in both directions. Actions and decisions are not the outcome of conscious intentionality or rationality, but are driven by affective, rather unconscious tendencies and habits—bodily commotions[11] that become expressive movements and gestures.

Aligning violence with comedy: Exploiting new methods of brutality

In her review of *Outrage*, Maggie Lee emphasizes the film's unconventional narrative. She describes the screenplay as having a "sprawling structure" formed by "individual nerve-tingling scenes of violence."[12] Rather than relying on the discontinuous dramatic action typical of classical storytelling, the film's narrative is constructed in a cyclical way, with a flat tempo that avoids high points of catharsis. Lee's description hinges on the more general narrative style that prevails in all of Kitano's films, a style that is profoundly marked by the director's career as a comedian. Thus, Kitano's cinema emerges out of the infolding and unfolding of his dual persona as Kitano Takeshi, the director, and Beat Takeshi, the actor and comedian. The signs of Kitano's attachment to physical comedy run through both *Outrage* and *Beyond* and manifest themselves in a structure that alternates between mostly aggressive conversations and extremely brutal physical assaults. Although masquerading as a continuous narrative, these aggressions resemble the stand-alone, episodic quality of comic gags or skits, which, placed in sequence, create a serial structure of individualized encounters and confrontations repeatedly colored by the same affects.

The serialized nature of the narrative spanning both films looks like a long inventory of increasingly sadistic and refined methods of killing, an inventory that feels more like a creative, cinematic necessity—an effort to avoid clichés and to enjoy oneself at all cost—than the requisite part of a realistically grounded story line. When one watches the extra features on the DVD of *Outrage Beyond*, where the actors speak at length about their affective and physical experience while engaged in the process of making the film, one realizes that the comic, exploitation effects of such violent moments build a performative, nonrealistic aesthetic which draws attention to the performers' intense enjoyment of the process as the basis for the spectator's enjoyment of the film. The point, once again, is that these Kitano films continue his ongoing tendency to disrupt the link between violence and realism that is upheld in most narrative films, this time through the alignment of violence with comedy.[13]

In some cases, it is the aftermath of a corporeal assault that materializes the most comic effects. After the first shock, the brutality leaves a mark on the body that cannot fail but make us laugh. The scene in *Outrage* where Ōtomo attacks Murase while the latter is at the dentist, is a case in point. While Murase is on the dentist's chair, Ōtomo grabs the dental drill and puts it right into his

mouth, thoroughly deforming the lower part of his face and forcing him to wear a nozzle-like orthopedic contraption that makes him look grotesque and clownish. Murase's inarticulate sounds in subsequent scenes, his inability to eat in public, or to express the fury at his humiliation—these are all signs that both extend the violent shock of the aggression while transforming it into sadistic laughter. Likewise, the image of Kimura's all-around bandaged head after his face is slashed by Ōtomo in the first film provides a similar comic effect, as do the repeated finger-chopping moments, which, although carried out to appease an affronted superior and to regain one's honorable standing, are so pervasively inflicted as to lose their traditional value or function within the yakuza creed. Fingers fly not just as self-inflicted aggressions, but also as aggressions against unsuspecting enemies. The exploitation effect, and consequently the devaluation, of the act of cutting off one's finger as a means of achieving reparation is nowhere more transparent and comic than in the scene in *Outrage* where one of Ōtomo's men pierces the ear of a noodle restaurant owner with a pair of chopsticks, while someone else chops off two of his fingers that then drop into a bowl of noodle soup an innocent customer is about to eat.

One scene in *Outrage* particularly stands out for its paradoxical blend of minimalism, a quality that generally defines Kitano's aesthetics, and a sense of grotesque excess in the execution of the violence.[14] This simultaneity of contrary methods again prompts us to question the boundaries between art and trash— the subtlety of affective strategies in art cinema and the tendency in exploitation cinemas to push affects toward their breaking point. In this scene, Mizuno, a yakuza in the Ōtomo family, is ambushed and killed by Ozawa's men. Out on a deserted road by the sea, they put a hood over Mizuno's head and a rope around his neck. Keeping him inside the car, they then tie the rope to an iron post on the road, all in preparation for an original form of decapitation. As the car drives off, Mizuno is instantly killed and ejected from the vehicle.

The three silent shots that follow Mizuno's execution, punctuated by Suzuki Keiichi's electronic-jazz score (described by Vishnevetsky as "an eccentric mix of guitar feedback textures and MIDI instrumentation [Musical Instrument Digital Interface]"[15]), merely show the aftermath of the killing and are therefore in excess of narrative necessity. Instead, these shots prolong the violence by transforming narrative factuality into uncanny and repetitive affective intensity. The first is a long shot of Mizuno's dead body lying on the road with the rope tied to the post, while his two assassins walk away from him and the car. The second is a medium long shot of Mizuno's girlfriend (Watanabe Naoko) having just been shot in their

apartment, with profuse blood covering the left side of her torso. Going back to Mizuno, the third shot gives us a view of the iron posts and the rope attached to one of them. As a car pulls into the frame of the shot from right to left, the camera pans left, following the car and leaving the posts offscreen. The camera then stops as the car reaches Mizuno's corpse and stays on it for about five or six seconds. The scene resumes a more realistic, narrative pace as the car picks up the two yakuza assassins and drives off.

This scene is the closest *Outrage*, or even its sequel, come to anything resembling the tendency in Kitano's earlier films to engage with death from the point of view of an aesthetic outside. However subtle, there is an attempt here to counter-actualize the physical event of Mizuno's death with a re-enactment or a performance that involves an affective surplus.[16] Instead of focusing on the crude physicality of death, these shots render the very action of killing and the materiality of the dead body aberrant and capable of expressing intense vitality. The intensity is forged through the slow movements of the camera and the explicit attentiveness it bestows on the dead body as something that persists and is valued/acknowledged beyond its narrative utility. Although this scene does not match the creativity that other Kitano films inject into the event of death, it differs from many of the other violent acts in both *Outrage* and *Beyond* in that it both surpasses generic requirements and builds a pure, nonchronological temporality that offsets the tone of levity attending the majority of wounding or killing acts, as the above examples have shown. And yet, despite the absence of levity, the grotesque, exploitative tone of the scene is still felt in the ghastly method of killing chosen here.

Decisive in determining the different kind of engagement with death showcased in these two films is the fact that Ōtomo/Beat Takeshi does not die at the end of the sequel. Although, as I implied earlier, his death at the end of *Outrage* is left conveniently undetermined, he is also alive and well at the end of the second film. As I have noted in *The Grace of Destruction*, previous Kitano films like *Sonatine*, *Fireworks*, and *Brother*, posit the death of the character played by Beat Takeshi as an event transcending the limits of the fictional narrative and entailing a philosophical enactment of death that intensely engages the actor and filmmaker as well. Bypassing death in *Outrage* and *Beyond* permits Beat Takeshi/Kitano to exclude such an auto-affective moment. Yet, at the same time, this exclusion works to curtail the virtual, creative possibilities that accrue when character and actor are fused together in a single creative life-death machine. For the most part, death in these films is divested of the affective weight and

creative, vital dimension that it garners in earlier films. More dependent on generic protocols, here the contours of death are drawn closer to the way it is handled in mainstream action flicks, its major difference resting on the prolific inventiveness and sheer originality of the methods by which it is actuated. In *Outrage* and *Beyond*, the machine of invention delivers a cold, cruel aesthetics closed in on itself and indivisible from the outrageous actions and gestures performed by the male body.

To finish this section on the exploitative qualities of acts of brutality in these films, I'd like to bring attention to the way sound punctuates these acts, and particularly the inflections of speech, as a channel/stream of violent affects. Sean Redmond has vividly described the effects of sound as a carrier of violence in these films, pointing to "the heavy concentration on dialogue and shouting matches in the first half of *Outrage*":

> Words become bullets and bombs that shoot out of mouths that are weapons of negation . . . while these are linguistic exchanges, the monosyllabic words used strip language right back to its bare essentials, and meaning becomes transmitted through the aural, the sonic; the angry, metallic vibrations of aggression thrown across a room.[17]

Likewise, at the meeting of Ōtomo and Kimura with the Hanabishi in *Beyond*, the aggression in the men's verbal exchanges is so pointed and so out of control that it overspills into bodily aggression. The men behave as if they belonged to rival animal packs in need of asserting their rights to food or territory. At a moment's notice, the violence transitions from language to the body. Mr. Fuse's underboss tells Kimura he needs to cut a finger to make amends for Ōtomo's outrageous disrespect. Ōtomo is then challenged into severing his finger, and to end it all, Kimura bites off his own finger, emitting a bestial roar of pain and power whose excess is not without comic effects.[18]

But whether the violence manifests itself through speech or action, it always seems to "interrupt the flow of meaning . . . the normalized interrelations and interactions . . . and the functions that are being fulfilled"[19] by bodies in their organized or territorialized milieus. Ōtomo's shouts and gestures in response to the Hanabishi's attempts to humiliate him, as well as Ōtomo's and Kimura's shouts and actions in resonance with each other's affects, are a matter of unreflective contagion, a "thought that is taking place in the body."[20] The dog-barking qualities of these dialogues expose the violence as a continuous force composing the yakuza collective body rather than an isolated aggression

appearing out of nowhere and disappearing back into normality. The aggression is shown to emerge in the context of yakuza homosociality rather than individuality, as these affective forces do not predate the relations constantly forming and changing in their collective body. Gestures, threats, killings—these are all affective resonances immanent to the yakuza group dynamics and their homoerotic charge. In this sense, the exaggerated heterosexuality of exploitation cinemas, at least of 1970s American exploitation,[21] is displaced in these films onto the violent homoeroticism that oscillates between, or even combines, blank, minimalist expression and lethal outburst.

Yakuza nobility

Amid a widespread degeneration of traditional yakuza principles of nobility, duty, loyalty, and honor, Ōtomo stands out as a throwback who still takes yakuza creed seriously. Ōtomo is rarely more offended than when Det. Kataoka declares that "the days are gone for old-time yakuzas," as statements such as this announce the capitulation of yakuza strength in the face of the oncoming corrupted ethos. It makes therefore sense for Ōtomo to end the sequel by killing Kataoka. No doubt Kataoka is Ōtomo's foremost enemy at the narrative level, while he also represents the real target of Kitano's and the film's yakuza ethics. As I have argued in *The Grace of Destruction*, Kitano replaces a code of slave, reactive morality with an ethics of creative aggression. In these Nietzschean ethics, "the good is expressed by forces that are superior by virtue of their activity, nobility and generosity, whereas the bad [not evil] is expressed by forces that are inferior by virtue of their passivity, reactivity [and] weakness."[22] Embodied by Beat Takeshi, these nobler, more generous forces stand up against the meaner, stagnant forces of yakuza men who, like Det. Kataoka and the majority of other yakuza in *Outrage* and *Beyond*, typically look ugly, arrogant, and stupid.

A salient characteristic of Ōtomo's that marks him as singularly noble is his ability to achieve a certain detachment from the external trappings of yakuza lifestyle and power, refusing advantages like sex with an expensive prostitute or the assignation of a bodyguard for his protection.[23] After his release from prison in *Beyond*, Ōtomo is hardly inclined to join the yakuza ranks again, and is drawn back into the bloody mayhem only because of the brotherhood bonds he develops with Kimura. Further, his involvement in joining forces with Kimura

against the Sannō now headed by treacherous Katō is only motivated by the Sannō's killing of the two young men (sons of old sworn brothers) that Kimura has taken under his charge. Later in the second film, when most of the Sannō have been eliminated except for Chairman Katō, Ōtomo pretends to vanish and go to South Korea, but instead he is the one to finish Katō off. Together with the final killing of Kataoka, these acts of Ōtomo's are felt as surprise returns that emphasize the special relation between Kitano, as a sort of magician pulling out his tricks when the audience least expects it, and the characters he embodies, who are charged with performing these tricks and stunts. The aim of these off-hand interventions is not only to enhance narrative interest, but also to avoid falling into sterile clichés and to develop and sustain an ethics of violence that confounds the moral boundaries between "good" police and "bad" yakuza and is motivated by affects that know no such boundaries. In other words, in *Outrage* and *Beyond*, as in the majority of previous Kitano films, the virtues of nobility, loyalty, and endurance surpass generic categories and binaries and may be indistinctly embodied by any character type.

On the other hand, the pervasive yakuza decadence around Ōtomo cannot help but bring on a sense of exhaustion and depletion that perhaps resonates in more ways than the narrative alone might be able to express. At Kataoka's request that Ōtomo take up his old yakuza lifestyle after his time in prison, Ōtomo replies, "I'm getting too old for this shit." Ōtomo's statement may easily be read beyond the narrative, fictional level to imply a tiredness that affects not only Beat Takeshi the actor, but Kitano Takeshi the director. We may hear in these words Kitano's disinvestment from his own previous generic tropes, or perhaps even a reluctance to participate in a popular film culture of action flicks whose predictable hit, counter-hit rules bore him to tears. Ōtomo's statement may also raise the possibility that Kitano's extensive work in the yakuza genre may have exhausted its own capacity to attract new audiences or to engage his loyal fans in new ways.

Regardless of this hint at Kitano's exhaustion, Ōtomo's embodiment of old yakuza nobility is insistently enacted in both films. When Kataoka asks Ōtomo why he never reported Kimura for stabbing him in prison, he replies, "I'm the only one to blame. . . . I slashed the face of a guy who came to apologize. Even a yakuza has principles he lives by." In *Outrage*, Katō dismisses Ōtomo's apologetic gesture of cutting his finger as old-fashioned and worthless. Not only is this gesture devalued at the narrative level, but the films themselves, in their repeated use and abuse of such iconic yakuza moments, seem to be

exploitatively engaged in an erosion of yakuza integrity that deprives the men's violence of its original purity. Ultimately, it is the capitalist redefinition of value that is shown to have the most corrosive effects on the former distinctiveness of the yakuza ethos.

Capitalist exploitation and the biopolitics of crime

Outrage opens with one of its most stylized shots, as the camera pans right to left over a row of immaculate black cars and limos outside the Sannō compound, the drivers patiently waiting outside for their bosses. Perfectly aligned as if intended for a TV commercial, the shiny, sleek surfaces of these luxury cars exactly capture the spectacle of power that capitalism thrives on. In *Outrage* and *Beyond*, the motor of corruption is not identified with yakuza criminality, but with the market forces of capital. For Kitano, corruption ceases to be a psychological concern, and it becomes the affective field spun by capital and binding yakuza and police into a knot of violent entanglements. The films do not locate the goal of capital in the greedy amassing of wealth, but in the capacity of capital's own abstract, self-referential movements for spinning the dominant structure of feeling that binds yakuza and police together in a single dance. The logic and circulation of capital indeed regulates their intricate dependence on each other. As a motor of affective relations, the forces of capital have a leveling effect on the traditional moral distinction between police and yakuza, legality and illegality. The erosion of the former becomes evident in the way Det. Kataoka mingles and plots with the yakuza daily, fueling the endless intrigues between the clans to advance his own interests. The erosion of the line between law and lawlessness is shown in the way yakuza criminal activities are seamlessly integrated with their "forays into politics" and their incursion into financial markets. In *Outrage*, Ishihara plainly admits to Det. Kataoka that they are now "going global in cooperation with the Foreign Ministry," expanding their activities into "trading, foreign exchange and hedge funding," while, in turn, Kataoka nonchalantly credits Ishihara's promotion to his ability to transition successfully "from drug dealing to illegal gambling and finally the stock market."

Crucial to the elimination of the line between crime and the law is a kind of biopolitical approach to crime that no longer aims to eliminate it, but rather to replace it with its efficient organization and management. As implied in Det. Kataoka's words to Det. Shigeta, "Watch carefully how I'll handle this," in

Outrage and *Beyond*, the police exhibit a managerial handling of crime that is quite consistently reminiscent of the functioning of biopolitics. The biopolitical management of life involves a continuous drawing and redrawing of the line between life and death—the handling of the positive term "life" simultaneously involving the drawing of the boundary that separates it from death in a constant remapping of the relation between positive and negative terms. In a similar fashion, the upholding of the law is in large measure defined by reference to its absence, and is therefore accomplished as a drawing and redrawing of the boundary between legality and illegality.[24] In this sense, organized crime does not entirely fall outside the bounds of the law, insofar as, as *Outrage* and *Beyond* demonstrate time and again, it accommodates the possibility of an organized response to it. A balanced control and containment of crime are certainly favored over the impossible idea of its eradication. Not surprisingly, from the perspective of the traditional yakuza ethos embraced by Ōtomo, such managerial appropriation or recuperation of crime makes the young generation of police-dealing yakuza perverted in relation to the old guard. The capitalism-induced leveling between the two sides has an irretrievably destructive effect on the loyalty- and honor-based ethics that regulated the yakuza code of behavior prior to the era of financial capitalism captured in these films. The system of global, financial capitalism that envelops the narrative of *Outrage* and *Beyond* uniquely enables and intensifies the approximation of the yakuza to the status of a commodity sign.

Det. Kataoka's manipulative cunning far exceeds yakuza tactics in calculation, self-advantage, and perversity. More exactly than any of the inveterately violent yakuza, Kataoka instantiates the height of biopower in its handling of the power over life and death and its sovereign ability to reassign (non-)value to both. Kataoka's intervention aims to regulate the territorial boundaries of the clans and their relations with each other, as we are reminded when the Higher Police Commissioner blames Kataoka for failing to curtail the Sannō clan's uncontrollable growth. As in a cancerous biological organism, the Sannō's growth must be reined in, yet the drawing and redrawing of turfs is not left to the police's disciplinary intervention, but it is the result of a constant, close collaboration between police and yakuza (As Kataoka tells Sannō chief Katō in *Beyond*, "Can't we cooperate as in the old times? That's how we've maintained our balance"). The police do not intervene directly, neither to judge nor to eradicate the criminal networks; instead, they rely on Kataoka, who, like a master puppeteer, subtly moves the affective strings of

the clans' intrigues against each other. In fact, there is no need to intervene at all except by surreptitiously encouraging the yakuza themselves to speed up the process of taking each other out. Kataoka's weapon of choice is not the brute, physical force of a bygone disciplinary regime, but the creative force of scriptwriting a plot and the forces of rhetorical persuasion and affective manipulation that assure its execution. Kataoka's overseeing of the circulation and distribution of information yields powerful affective effects among the clans, thus allowing for visible police intervention to be kept at a minimum. This relation between police and yakuza instantiates the passage from the disciplinary regime of biopolitics outlined by Foucault, one that relied on physical subjugation and the orchestration of actual spaces of confinement, to the society of control theorized by Deleuze, where biopower's smooth operations no longer require the physical subjugation or imprisonment of the body but rather rely on the invisible mechanisms and virtual spaces of information technologies.[25]

The last scenes in *Beyond* feature an illuminating example of the hands-off approach taken by the forces of the law in these films. When the Sannō clan disintegrates, chief Katō is forced to surrender to the law and to make a pact with the police whereby he will "cut ties with the underworld . . . [agree to] not be a nuisance to society . . . live as a legitimate citizen [and] contribute to society as a model citizen." This overvaluation of legality and its implied mythification of the relation between the individual and the social bodies, is all but dismissed as empty formality when Ōtomo later surprises Katō at a game parlor and stabs him on the side multiple times. Although Ōtomo ends up doing the police's dirty work for them, he does so by replacing the system of legality and established morality with an aggressive sense of Artaudian cruelty that is very much in line with Kitano's cinema as a whole.[26]

To conclude, in these singularly genre-oriented films, Kitano is walking a fine line between bemoaning the subsumption of the yakuza creed by capital and succumbing to the impossibility of resisting the commodification of value in his own aesthetic practice of cinema. *Outrage* offers a rather unequivocal reference to the globalized proportions of such commodification of aesthetic value. In a moment in *Outrage* that puts the Japanese and African cultures in touch via the use of the English language, a perpetually angry Ishihara intimidates the African ambassador into submission when he says, "You know you're dealing with the yakuza, right?" Mediated through the American appropriation of Japanese culture, and in the lips of an exceedingly unpleasant character, these words allow

Kitano to disown the erosion of ethics as an exclusively Japanese phenomenon, or a phenomenon merely affecting the figure of the yakuza. Instead, this ethical and aesthetic erosion is inscribed within a predatory process of globalization that in the arena of popular culture manifests itself in the out-of-control expansion of dumbness and the reign of the cliché.

What matters for our purposes here is the degree to which *Outrage* and *Beyond* might in their own way bear the marks of the generalized capitalist transformation of value. On one hand, it is fair to say that these films represent a departure from the usual affective strength of Kitano's cinema, as they lack its pervasive exploration of an aesthetic outside, its characteristic tendency to accumulate moments of affective counterpoint and to make transversal connections between incompatible worlds. And yet, it might be fairer—and more in sync with Kitano's proved disdain for repeating himself—to consider the unique creative qualities of these films rather than their failure to reenact the aesthetic tours de force we have come to expect from his idiosyncratic style. This is probably where the intensified aesthetics of exploitation in these latest films become a significant expression of something previously unseen in his cinema. Such aesthetic intensification seems to put Kitano's cinema in touch with a broader transnational context where the lines between exploitation and art cinema, exploitation and biopolitical cinema, are hardly discernible across national cultures and borders. At their most creative, these aesthetics extend Kitano's inventory of violent bodies and protect it from the risk of repeating a style that, however enticing, is no longer new. More ambiguously, exploitation displaces the former aesthetic impulse toward contrast and affective counterpoint without offering an equally satisfying alternative. Finally, at their least evocative and most suspect, the aesthetics of exploitation in *Outrage* and *Beyond* gesture toward the adolescent love of easy laughter and the capitalist expansion of (media) markets. In any case, as this chapter has tried to show, to assess the exploitation aesthetics in these Kitano films is to underscore the awesome potentialities that arise in the conjunction between the brutalities and cruelties of exploitation and the visual restraint and precise economy of gesture (of the body, of the camera) that are uniquely Kitano's. In large measure the result of the filmmaker's editing practices, the surgical precision he applies to the relation between the actions performed by the actors and those performed by the camera traces a continuous aesthetic line with his previous work and contributes to a smooth and reinvigorating blend of art and exploitation.

Notes

1 This discussion of Kitano's particular version of exploitation aesthetics follows Mark Betz's understanding of art and exploitation as continuous and interdependent codes. In his essay "High and Low and in between," Betz suggests that "art and exploitation cinemas share . . . much at the levels of small-scale location production, of dependence on international circulation to niche audiences as opposed to primarily domestic ones" (507). Betz rejects the idea of taking either art or exploitation as "either the figure or ground for any given reading" (509). "High and Low and in between," *Screen* 54, no. 4 (Winter 2013), 495–513.

2 I am using the term "machine" here in the Deleuzian sense of a "desiring machine" wherein desire is considered as productive and affirmative, even in its oftentimes seemingly negative connotations, in contradistinction with the psychoanalytic paradigm where desire is based on lack and absence. A "desiring machine" never ceases to produce effects and this production is never totalized into a fixed identity. Gilles Deleuze and Félix Guattari, *Anti-Oedipus: Capitalism and Schizophrenia*, trans. Robert Hurley, Mark Seem, and Helen R. Lane (Minneapolis, MN: University of Minnesota Press, 1983).

3 I have written at length on the contrasting and affective method that Kitano develops in such films as *Sonatine, Fireworks* and *Takeshis'* (2005) when he alternates extreme displays of violence or death with intense displays of beauty or creativity. See Elena del Río, *The Grace of Destruction: A Vital Ethology of Extreme Cinemas* (New York: Bloomsbury Press, 2016). For example, in *Fireworks*, detective Horibe (Ren Ohsugi), besieged by loss and mortality after being shot by a yakuza, joins an abstract machine of creation whereby his brain spins an endless string of flower-animal or flower-human assemblages prior to his execution of these paintings (184–85).

4 Brian Massumi, *Politics of Affect* (Malden, MA: Polity Press, 2015), 91.

5 Eric Cazdyn identifies the tension between the individual and the collective as having a structuring importance in the make-up of the Japanese psyche following the Second World War. In postwar Japan, a strengthening of individual subjectivity underpinning the necessity for mental alertness and capacity for action was at the same time restrained by the collective project of reconstruction. Eric Cazdyn, *The Flash of Capital: Film and Geopolitics in Japan* (Durham, NC: Duke University Press, 2002), 6. The yakuza genre may be said to stage a similar contradiction. But my reading of these Kitano films also aims to make a philosophical case for the collective dynamics of affectivity in a more general sense, thus defining affect as more dependent on mechanisms of "unreflective contagion," as I explain later in this discussion, rather than on the will of a conscious, sovereign individual.

6 Geoffrey Macnab, "Takeshi Kitano Considers Making a Third Outrage Movie," *Screen Daily* (September 5, 2012), http://www.screendaily.com/takeshi-kitano-considers-making-a-third-outrage-movie, accessed June 5, 2016.

7 Ignatiy Vishnevetsky, "The Yakuza Sequel *Beyond Outrage* Is Less Urgent than Its Predecessor," *Movie Review* (January 3, 2014), http://www.avclub.com/review/the-yakuza-sequel-beyond-outrage, accessed June 5, 2016.

8 I would not hesitate to place the exploitation leanings of Kitano's cinema within the recently theorized category of biopolitical cinema, especially if we consider the destructions it engages with not merely as a form of entertainment, but also potentially as a (however unintended) serious form of cultural critique. For an account of biopolitical cinema, see Asbjorn Gronstad and Henrik Gustafsson, eds., *Cinema and Agamben: Ethics, Biopolitics and the Moving Image* (New York: Bloomsbury, 2014); and Nitzan Lebovic, "The Biopolitical Film (A Nietzschean Paradigm)," *Postmodern Culture* 23, no. 1 (September 2012), http://www.pomoculture.org/2015/07/07/the-biopolitical-film-a-nietzschean-paradigm.

9 As Ken Provencher and Mike Dillon have pointed out to me, the film itself may have intended Ōtomo's death at the end of *Outrage*, in which case this impression was revised upon Kitano's later decision to produce a sequel.

10 All dialogue citations in this essay have been taken from the English subtitles in the DVDs of *Outrage* and *Beyond*. *Outrage*, DVD Video, directed by Kitano Takeshi, Magnolia Home Entertainment (2012); *Outrage Beyond*, DVD Video, directed by Kitano Takeshi, Magnolia Home Entertainment (2014).

11 Massumi, *Politics of Affect*, 54.

12 Maggie Lee, "Outrage," Hollywood Reporter 414, no. 36 (May 18, 2010), 10–11, www.hollywoodreporter.com/review/outrage-film-review-29615, accessed August 31, 2014.

13 As I argue in *The Grace of Destruction*, *Takeshis'* offers a unique example of the disruption of the link between violence and realism by featuring repeated shootings of characters that never actually get killed within the film's fictional universe. Likewise, in an interview with Pamela Jahn, Kitano comments on his decision to distance *Outrage* from a realistic aesthetics and to opt instead for exaggeration in the violence between rival gangs. In the same interview, Kitano refers to the humorous overtones of the violence as a direct, though largely unintentional, effect of the editing. Pamela Jahn, "*Outrage*: Interview with Takeshi Kitano," *Electric Sheep Magazine* (December 6, 2011). http://www.electricsheepmagazine.co.uk/features/2011/12/06/outrage-interview-with-takeshi-kitano.

14 Kitano's economy of means, which can be seen as a form of minimalism, may be assessed as an effective method for producing an aesthetics of excess or exploitation. Echoing a similar paradox, Vishnevetsky remarks that Kitano "has a

knack for de-sensationalizing action in a way that makes it seem commonplace, and therefore even more unnerving." (Vishnevetsky, "The Yakuza Sequel *Beyond Outrage*.")

15 Ibid.

16 I am using the concept of "counter-actualization" as discussed by Gilles Deleuze in *The Logic of Sense*: that is, as a "displacement of perspective" that extracts an impersonal event out of identities and contraries, making identities dissolve and contraries compatible. *The Logic of Sense*, trans. Mark Lester with Charles Stivale, ed. Constantin V. Boundas (New York: Columbia University Press, 1990), 175, 176, 178–79.

17 Sean Redmond, *The Cinema of Takeshi Kitano: Flowering Blood* (New York: Wallflower Press, 2013), 107; 107–08.

18 In his interview with Jahn, Kitano acknowledged his desire to color the use of sound in *Outrage* with the same sense of exaggeration one finds in comic book sound effects, "where you actually read the sound" in the form of a word like "bang" written on the picture. (Jahn, "*Outrage*: Interview with Takeshi Kitano.")

19 Massumi, *Politics of Affect*, 8.

20 Ibid., 9.

21 As Pam Cook has noted, 1970s American exploitation cinema was "viewed by many as pandering to sadistic male fantasies," with their heavy "use of sexualised [*sic*] images of women" and "the relatively graphic depiction of rape and sexual assault" (55). Pam Cook, *Screening the Past: Memory and Nostalgia in Cinema* (New York: Routledge, 2005), 52–64. Although we may safely assert that Kitano's cinema often represents a more or less conscious response to American cinema, and, as Sean Redmond has argued, his films undoubtedly "recognize the hybridity of culture" (69) across global networks and streams, we can identify a significant departure with respect to the way sexuality figures in his films. These films are marked by a general disinvestment from overt expressions of sexuality and a parallel investment in a kind of desexualized energy/desire, a consistent trait in Kitano's cinema that I have fully discussed in *The Grace of Destruction* (175–77). Otherwise, I see the homoeroticism in *Outrage* and *Beyond* not as something deliberately orchestrated, but as a form of desire consistent with the effects of the yakuza genre as a whole.

22 Del Río, *Grace of Destruction*, 181.

23 In his interview with Jahn, Kitano views detachment as the spectatorial position *Outrage* is likely to elicit in relation to the men's actions: "[The film] has this kind of detachment, it's like watching one of those nature documentaries [*sic*] shows where you see the bugs in the woods killing each other, or ants chasing worms—I . . . treated the characters in the film in that way." (Jahn, "*Outrage*:

Interview with Takeshi Kitano.") Kitano's words here also fit in with my later reference to the growth of the yakuza clans as that of biological organisms that should be kept in check.

24　As much of Foucault's work was aimed to demonstrate, the biopolitical management of life relies on the identification of normalcy by way of isolating the abnormal. Grounding its controlling operations on the interdependence of binary terms, biopolitics reconfigures the traditional relation between the state and the law. Thus, the state does not abjure violence, but it creates its own legitimate forms of violence. Unlike criminal violence, according to Johanna Oksala, legitimate state violence becomes "the necessary instrument for preserving and enforcing the law." And yet, as she argues, in a biopolitical regime, the state engages in forms of violence that are not strictly law-preserving, but concerned with ensuring "the smooth functioning of government: the preservation of order, control, security, and productivity." Johanna Oksala, *Foucault, Politics, and Violence* (Evanston, IL: Northwestern University Press, 2012), 103. The following words in Oksala's argument are directly relevant to the way Det. Kataoka, as a representative of the state police, embodies the logic of biopolitical violence: "These practices of violence are often hidden inside of various institutions. They are grounded on effective policy, professional management, and expert knowledge" (103).

25　Deleuze, "Postscript on the Societies of Control," *October* 59 (1992), 3–7. As I explain in *The Grace of Destruction*, "In control societies, visible forms of confinement or punishment are no longer prioritized as mechanisms of subjection. Instead, through its ubiquitous expansion, capitalism exercises control by turning every manifestation of human consciousness or activity into surplus-value, and by instituting a system of perpetual assessment, training, and education that continues throughout life. Under the socioeconomic requirements of constant modulation and metastability, the individual becomes a dividual, a concept that breaks down the classical distinction between mass and individual, and points to the function of the subject in terms of abstract marketing data and informational codes that serve the accumulative ends of capitalism" (227).

26　I discuss the relevance of Artaud's theater of cruelty to Kitano's cinema in chapter 4 of *The Grace of Destruction*, 166; 182; 192.

A Cinematic Half-Twist: Art, Exploitation, and the Subversion of Sexual Norms in Kim Ki-duk's *Moebius*

Hye Seung Chung and David Scott Diffrient

"You made a perverted film using 'art' as an excuse."
—*anonymous Korean Internet user, referring to*
Kim Ki-duk's Moebius (2013)[1]

In recent years, a considerable amount of scholarly attention has been given to the subjects of cult films, midnight movies, and exploitation cinema. Several important publications, including J. P. Telotte's *The Cult Film Experience: Beyond All Reason* (1991), Eric Schaefer's *"Bold! Daring! Shocking! True!" A History of Exploitation Films* (1999), Xavier Mendik and Graeme Harper's *Unruly Pleasures: The Cult Film and Its Critics* (2000), Ernest Mathijs and Mendik's *The Cult Film Reader* (2008), and Mathijs and Jamie Sexton's *Cult Cinema* (2011), as well as articles by Mark Betz, Matt Hills, Mark Jancovich, Mikel Koven, Jeffrey Sconce, and many others, have laid the foundation for subsequent scholarship concerning once-lowly film genres and long-disparaged cinematic texts. Indeed, the collective output of these individuals has helped to legitimize the study of so-called low culture, giving impetus to a fundamental shift in the aesthetic reckoning of a medium that has itself struggled to gain legitimacy in institutions (including the academy) where art is valued over "trash." Thankfully, the longstanding delineation between aesthetically rigorous art films and "morally bankrupt" exploitation films is beginning to evaporate, or at the very least is coming under scrutiny as evidence of a false dichotomy or hierarchy that no longer holds sway in an age when, increasingly, the educational and cultural capital of contemporary tastemakers (including high-profile cult fans and film connoisseurs) is gained *outside* the university.

In recent years, this blurring of the line between art and exploitation has become particularly salient in the transnational reception of East Asian cinema. In contrast with the auteur-centric canonization of Japanese art cinema during the 1950–60s (when the films of Kurosawa Akira, Ozu Yasujiro, and Mizoguchi Kenji received accolades from Western critics), so-called extreme cinema is a dominant trend in the contemporary Western canon of Asian films. Created and sustained by Western distributors, critics, and fans, the "Asia Extreme" classification is inclusive of a variety of horror films, thrillers, and erotic films hailing from Hong Kong, Japan, South Korea, and Thailand. Along with Park Chan-wook, Kim Ki-duk remains the most well-known Korean "extreme" auteur, a filmmaker whose 2000 production *The Isle* (*Seom*) induced fainting spells among audiences in the international festival circuit, from Venice to New York, due to graphic scenes of the main character's self-mutilation. While it is problematic to pigeonhole Kim's socially conscious cinema as just another example of the Asia Extreme brand without a deeper understanding of its cultural contexts, *excess* at the level of both representation and reception is what binds his low-budget, independent art films to the tradition of exploitation cinema. This will be demonstrated by taking up his 2013 film *Moebius* as a case study.

Before initiating our discussion of *Moebius*, we open up the parameters of this study to define exploitation cinema in a global context. Besides sanctioning the study of "bad objects," from the cheaply shot sexploitation films of Doris Wishman, to the equally shoestring splatter films of gore master Herschell Gordon Lewis, the aforementioned scholars have helped to define the ontological and epistemological limits within which exploitation cinema might be seen as a distinct cultural form, one in which frequently repeated formal and thematic elements link otherwise disparate texts. For example, Steve Chibnall states, "Movies that acquire a cult following are often challenging and confrontational in their style, imagery and themes. They will usually transgress genre boundaries, exhibiting an 'unhinged' quality, which revels in excess."[2] A representative film in this light is José Mojica Marins's (a.k.a. Coffin Joe's) *At Midnight I'll Take Your Soul* (*À Meia-Noite Levarei Sua Alma*, 1964), a Brazilian horror movie that, according Diana Anselmo-Sequeira, is "unapologetic" in its foregrounding of graphic violence, showing "inordinate amounts of blood" and "various close-ups of mangled bodies." As Anselmo-Sequeira states, "Excess is an important theme in Mojica's work," and functions as "the only action that can produce political change" in a country that, at the time of the

film's theatrical release, was on "the brink of self-destruction."[3] Chibnall's and Anselmo-Sequeira's use of the word "excess" is not uncommon. Throughout this critical literature, few other terms so consistently describe the textual "too-muchness"—the signifying surplus of exploitative images and themes (such as sex and violence), in both quantity (the number of occurrences) and intensity (degree of extremity)—that characterizes exploitation cinema. Indeed, many of the critics who take an aesthetic approach to understanding cult films and midnight movies argue that such texts are "defined through their representational and stylistic excess."[4] This feature becomes discernible "when style ceases to serve the diegesis (the story world of the film) and instead exists for its own sake, as a purely aesthetic element." As Mathijs and Sexton argue in their book *Cult Cinema* (the Index of which lists thirty-one instances in which the topic of excess is discussed), "Moments of excess within a film, because they can disrupt absorption within the film's narrative, are able to draw attention to a film as an illusory artifact."[5]

Significantly, this rhetoric of style-for-style's sake infuses not only the discourses surrounding exploitation cinema, but also those surrounding art-house cinema, despite the latter's longstanding association with refined minimalism rather than coarse excess. Viewers within academic communities (i.e., those who champion high-brow avant-garde films and counter-cinema works by experimental artists) and viewers within paracinematic communities (i.e., those who express a fondness for lowbrow genre productions and cult films) might similarly address "the complex relationship between cinematic 'form' and 'content.'" However, as Jeffrey Sconce points out, "their respective agendas and approaches in attending to questions of style and technique vary tremendously."[6] Moreover, the external parameters of a film's distribution and exhibition cycles (i.e., the paratextual materials attending its theatrical and/or home video releases as well as the digital platforms that facilitate online access to it) play a part in codifying or "genrifying" a given work as either "art" or "exploitation." This idea is broached by Joan Hawkins in *Cutting Edge: Art-Horror and the Horrific Avant-Garde*, another important book that reveals how specific kinds of cult cinema (e.g., "midnight sex-horror movies") and art cinema (e.g., "the downtown avant-garde") intersect, not just at the textual level but also within the sphere of consumption.[7] Indeed, "while excess and low production values may be discernable textual qualities," according to David Church, "the genrification of those qualities as 'exploitation' is largely determined by reception, including where the films [are] shown."[8] Simply put, if a motion picture was being screened

at a sleazy grindhouse theater (rather than an upscale film festival) during the 1970s, it was most likely an *exploitation* film, one that could attract audiences "through spectacularly lurid advertising" and "sensationalized subject matter."[9]

Sex and violence are the two most frequently sensationalized facets of exploitation cinema, which spills over with shocking plotlines and explicit images (including the partial and full-frontal nudity of onscreen performers) that might "scandalize" many mainstream audiences, but which might just as readily be found in representative examples of art-house cinema. At the height of the grindhouse phenomenon in the United States, prior to the home video boom of the mid-1980s, sex and violence were often combined in controversial films that pivoted on corporeal pleasure and pain, the latter being most palpably felt by (male) audiences during scenes involving acts of castration. Indeed, one image or activity in particular—the removal of a man's penis and/or testicles—is especially significant given the forcefulness and regularity of its appearance in a number of noteworthy "trash classics" from that period, including *The Last House on the Left* (1972), *Ilsa: She Wolf of the SS* (1975), *I Spit on Your Grave* (1978), *Cannibal Holocaust* (1980), and *Cannibal Ferox* (1981). Ironically, as we elaborate in the ensuing analysis of *Moebius*, the excessiveness of such wince-inducing representations hinges on a *lack*, on the removal of the phallus's material signifier or physical embodiment that, historically, has always been "too much" for cinema to openly display. In these scenes of emasculation and mutilation, exploitative excess is made experientially painful by virtue of a vicious *reduction* or "unmanning" of a man—the figure for whom the medium's much-debated "visual pleasure" is paradoxically tailored.

Such paradoxes can be resolved by considering how symbolic castration, which was lent "anatomical literalism" in Sigmund Freud's earlier psychoanalytic theory, has been linked by Laura Mulvey and other feminist critics to the asymmetrical looking relations between men (subjects of the gaze) and women (objects of the gaze) in cinema, a medium predisposed toward disavowal, fetishism, and spectacle. As outlined in Mulvey's pioneering essay "Visual Pleasure and Narrative Cinema" and further developed by subsequent scholars (most notably Kaja Silverman), female characters in film have been obliged to act out and embody the uncanny absence or symbolic loss against which male protagonists (and spectators) must diligently defend themselves, either through sadistic voyeurism or fetishistic scopophilia.[10] Summarizing Jacques Lacan's theory of perversion (which, along with neurosis and psychosis, constitutes the basic "diagnostic structures" or pathologized subject positions one adopts

in relation to the Other), James Penney adds a wrinkle to this formulation, stating that "castration has the effect of disrupting perverse voyeuristic pleasure by making manifest an uncanny agency of seeing—the gaze—which the voyeur necessarily fails to locate in space."[11] But what if that seemingly contradictory binary of agency and failure, as well as the surplus and lack brought together in the image of someone *actually* rather than *metaphorically* cutting off a man's sexual organs (a kind of excessive excision), refers to "the same phenomenon, and are simply two perspectives on it," to quote Slavoj Žižek in *The Parallax View*? As the philosopher explains, "An empty place in the structure would still sustain the fantasy of an element that will emerge and fill out this place," just as "an excessive element lacking its place would still sustain the fantasy of some as yet unknown place waiting for it." Ultimately, "castration and its disavowal are two sides of the same coin," Žižek concludes: two sides of a Moebius strip that, as a half-twisted band, shows front and back faces simultaneously.[12] Not coincidentally, this Moebius strip metaphor, which the philosopher has summoned in no fewer than ten widely published books, recently inspired the most direct and profoundly disturbing cinematic statement about castration as a source of combined pleasure and pain for exploitation fans and art film aficionados alike—an award-winning motion picture from South Korea's most controversial auteur: Kim Ki-duk.

Aptly titled *Moebius*, this 2013 film, which features "severed body parts and impalement,"[13] is indeed a "twisted," hard-to-pin-down narrative that demonstrates how "the categorical difference between low and high genres, body genres and elite art . . . is difficult to define."[14] Using this quote from Hawkins's study of "art-horror" cinema as a springboard, we offer an interpretation of the exploitative content of this minimalist yet excessive film, which lacks spoken dialogue yet features multiple acts of castration and showcases the masochistic sexual dalliances of mutilated men as well as the incestuous, carnal embraces between a mother and her son. Like Ōshima Nagisa's *In the Realm of the Senses* (*Ai no korīda*, 1976), *Moebius* is directed by an iconoclastic filmmaker who has been courted in the West yet remains largely misunderstood at home; someone who has earned a reputation within the international film festival circuit as a daring provocateur willing to take risks and tackle the most taboo subjects. Indeed, Kim's film recalls the Japanese film (which was labeled "pornography" in its country of origin, but received accolades around the world) as a subversive, sex-filled commentary on male-female relations that makes porous the boundaries separating art and exploitation, comedy and tragedy, pleasure and pain.

As viewers of Ōshima's film will recall, *In the Realm of the Senses* builds toward a productively destructive denouement in which the sex-addicted inn owner Kichi dies at the hands of his increasingly jealous lover, a former prostitute named Sada, who gets turned on by strangling her partner. Succumbing to erotic asphyxiation, the dead man is then castrated by the polymorphously perverse woman, who takes possession of his penis. But in the lead-up to that moment, they share a final passage of dialogue, in which Kichi explains that all the biting and strangulation "hurts but feels good too."[15] Facing strict censorship laws in his home country, where "the depiction of genitalia was expressly forbidden" (and where it would be banned from public screenings for several years), Ōshima's film underwent a similar set of excisions in which the offending footage— including non-simulated copulations and the infamous castration scene—was put "under the knife" for its international release.[16] Years after he was acquitted of obscenity charges in Japan "for the publication of the script that included stills photographed on set," the filmmaker would continue to decry the censoring of *In the Realm of the Senses*, stating, "By cutting and obscuring, you have made my pure film dirty."[17] Similarly, Kim Ki-duk, as one of South Korea's most notorious auteurs, has had a contentious relationship with his nation's cultural establishments (including the commercial film industry and the mainstream press) and shares his rebellious characters' jaundiced attitudes toward middle-class decorum and conventional bourgeois values, including sexual repression.[18] By challenging the societal policing of sex (which falls within the purview of his country's film ratings system) and by obscuring the boundary between soft-core sexploitation and cerebral art cinema, *Moebius* poses provocative questions about conformist attitudes and social divisions in South Korea.

Moebius: Critical reception and ratings controversy

Before engaging in a textual analysis of the film, it will be useful to first frame the contextual discourses that impinge upon its classificatory status as both/ either "art" and/or "exploitation." Even prior to its release, *Moebius* generated controversy in the filmmaker's home country, where (with a 19-or-older rating) it would be permitted to be exhibited to adult audiences exclusively, but only after two appeals were made with the Korea Media Rating Board (KMRB), resulting in the cutting of two and a half minutes of original footage. In its previous decisions

to restrict the film's exhibition to "specialty theaters" (which amounts to a de facto ban due to the absence of such theaters), the KMRB members labeled Kim's film as "unethical and antisocial" and "harmful to the national sentiment" for its inclusion of explicit, "pornographic" content, including scenes of mother-son incest and castration.[19] In his personal appeal letter to the KMRB, Kim pleaded indirectly by invoking his two decades-worth of art cinema credentials, as the winner of several prestigious awards at European film festivals (including Best Director Awards at the 2004 Berlin and Venice International Film Festivals, the Best Picture award in the Un Certain Regard category of the 2011 Cannes Film Festival, and the Golden Lion Award at the 2012 Venice International Film Festival). As Kim stated:

> Why would I make a film that shows taboo sex between a mother and a son simply to provoke primitive instincts at this stage of my career? There has been no such work in my past eighteen films. . . . If you acknowledge any value in my past works, please allow Korean adults the opportunity to see this film and make their own judgment.[20]

Domestic press coverage of *Moebius* was largely devoted to this high-profile ratings controversy and the question of creative freedom. When the film was finally allowed to be screened in South Korea for adults only, its admission stopped short of 35,000 theatergoers and it failed to garner critical attention. Writing for *Cine21*, a leading film magazine, the critic Song Gyeong-won observes:

> Despite the preconception of being difficult, it is in fact a simple, easy, and even light movie. It repeats and reassembles Kim Ki-duk's familiar themes, showcasing genitalia, obsessive sex, guilt, and masochism in a comic manner . . . Despite its destructive energy and power, it is not among Kim's best.[21]

Public opinion was harsher. Anonymous internet comments, such as "Don't make this kind of film just because you are a great director," "It is not necessary to express such gratuitous things," "You made a perverted film using 'art' as an excuse," and "I am disappointed in you, Director Kim," were not uncommon, and demonstrate the offense that was taken by mainstream audiences, many of whom are likely unaccustomed to the textual excesses associated with exploitation cinema.[22]

Met with a standing ovation at the Venice International Film Festival (where it premiered), *Moebius* has received more sympathetic, if also mixed,

reviews overseas. For example, in his assessment of the film for *The Guardian*, Jonathan Romney notes, "The Buñuel-esque *Moebius* must rank among the most oedipal films ever." Besides acknowledging the outrageousness of the film's themes, Romney commented on its unusual aesthetics, the "rough-edged verve" in which it was shot, stating, "*Moebius* is also remarkable for dispensing entirely with dialogue. . . . There's mischievous humour here—and, oddly, grace, right up to the enigmatic Buddhist sign-off."[23] In her review for *Variety*, Leslie Felperin opines, "A gloriously off-the-charts study in perversity featuring castration, rape, and incest, Kim Ki-duk's *Moebius* is right inside the Korean king-of-wackitude's wheelhouse of outrageous cinema." Significantly, Felperin compares Kim to Lars von Trier, "whose *Antichrist* the film sort of evokes." In her words, "Kim is something of a professional provocateur, which doesn't cancel out the fact that he's quite serious about exploring extreme emotional states."[24] Nicholas Rapold of the *New York Times* likewise sees similarities between the Danish and Korean filmmakers, gesturing toward their shared "deadpan amusement at the follies of carnal desire" and musing, "Mr. Kim shows off a Lars von Trier-esque talent for ratcheting his puppets and their boldfaced psychosexual issues into motion, but with convenient gaps in emotional intelligence."[25] Clarence Tsui of the *Hollywood Reporter* draws attention to some of the film's "faults," highlighting how Kim "has let high concepts and philosophical subtexts run amok without anchoring them to a substantial narrative." Tsui continues by noting that, "while dressed up as a contemporary version of a Greek tragedy—complete with a cast of a modern-day Zeus, Jocasta and Oedipus—Kim has offered morals without a tale." For him, *Moebius* ranks as one of Kim's "stop-gap, half-baked offerings," the kind of lamentable film that he makes "in between his artistic landmarks" (e.g., *Address Unknown* [*Suchwiin bulmyeong*, 2001], *Spring, Summer, Fall, Winter . . . and Spring* [*Bom yeoreum gaeul gyeoul geurigo bom*, 2003], *3-Iron* [*Bin-jip*, 2004], and *Pieta* [2012]).[26]

It is notable that, while trade magazines and newspapers forge linkages between Kim's film and European art cinema (name-dropping auteurs like Buñuel and von Trier) as well as Greek mythology, cult film and genre fan sites have highlighted *Moebius*' exploitation ties and shock value. For example, in his review for *Fangoria*, a magazine catering to enthusiasts of the slasher and splatter varieties of cinematic horror, Phil Brown comments, "Despite all of the shock tactics that [Kim] has pulled in the past, nothing comes close to the nightmarish glee with which he unleashes *Moebius*. . . . It takes an equal balance of guts and

insanity simply to launch a movie like this. . . . You'll never forget what you see here."[27] Answering his own rhetorical question, "What's *Moebius* about?" Brown concludes, in a word, "castration." It is to this topic, and to the manner in which Kim uses it as a vehicle for social critique, that we now turn.

Castration as family business

In his interview with Nigel M. Smith published in *IndieWire*, Kim Ki-duk sums up his film's central message, stating that he wanted *Moebius* "to be about genitals and family. In my line of question of 'what is a genitals . . . what is family?,' I came to the conclusion that genitals is family and wished to express specific connections between them."[28] This philosophical aside, presented in the (virtual) pages of an online movie magazine, echoes the caption that accompanies the film's English-language poster, which reads, "I am the father, the mother is I, and the mother is the father." Kim's use of castration as a means of exploring the ontological correspondence between "genitals" and "family" differentiates *Moebius* from the aforementioned cult films of the 1970s (e.g., *The Last House on the Left*, *I Spit on Your Grave*, etc.) as well as recent motion pictures such as *Hard Candy* (2005), in which castration—specifically, a female avenger's severing of a man's sexual organ—is a response to the threat of sexual violence and serves as a reminder of horror cinema's complex gender politics.

Moebius begins with an establishing shot of an affluent two-story upper-middle-class home but quickly reveals the dysfunctional relationship of its unnamed occupants (a trio of characters who are generically referred to as "father," "mother," and "son" in the film's press materials). An ensuing shot shows the depressed wife drinking a glass of red wine while seated at the top of a staircase. She wears an unhappy expression on her face and sits next to a lifeless statue of a dog, which hints at the deadness of her marriage (Figure 8.1). Next, we see her solipsistic husband practising golf swings in the study, an image that is followed by a shot of their teenage son looking despondent and lonely in his room (Figure 8.2). The icy atmosphere of the domestic scene shifts dramatically when the husband's cell phone rings and the jealous wife intercepts the call before he can answer. The couple begins a violent physical altercation over the phone and the wife slaps her husband before he leaves home. In the next scene, the source of their marital trouble is revealed as

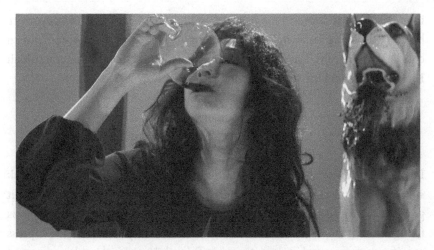

Figure 8.1 The scorned wife drinks next to a lifeless statue of a dog, which hints at the deadness of her marriage. *Moebius* (Kim Ki-duk, 2013).

Figure 8.2 The teenaged son looks despondent and lonely in a loveless bourgeois home. *Moebius* (Kim Ki-duk, 2013).

the philandering patriarch picks up his lover (a grocery shopkeeper) for an elegant dinner followed by car sex, which is witnessed by both his wife and son, who are shown separately snooping outside and peering into the vehicle. After vandalizing the woman's shop window, the scorned wife returns home and grabs a knife hidden under a prominently displayed Buddha statue. She sneaks into her husband's bedroom and attempts to cut off the sleeping man's

penis. Startled by the metallic attack, the man wakes up in the nick of time and kicks his wife out of the bedroom. Her rage now uncontrollable, the vengeful woman shifts her focus to their teenaged son and, in a shot that surely upsets many audiences, successfully removes the boy's genitals in lieu of his father's. The husband bounds into the screaming boy's room and confronts his blood-splattered wife, who holds the severed penis with a combined look of desperation and contempt. Striking her face, the man silently begs her to hand the son's penis over to him. The avenging woman, smiling defiantly, suddenly chews and swallows the severed member.[29] When he fails to forcibly retrieve the object out of his wife's mouth, the man takes his injured son to a nearby hospital. Left alone, the mother tries in vain to vomit out her son's penis, and stumbles aimlessly away from her home.

The above description of the film's first ten minutes will likely come across as shocking and disgusting to some readers. Undoubtedly, its content is exploitative and sensational. However, its art cinema aesthetics (including its suppression of dialogue and music, the director's reliance on handheld camera, and the overly symbolic mise-en-scène, which is both minimal and filled with connotation-laden objects), combined with a satirical tone aimed at bourgeois values, can be said to "elevate" its content above the realm of pure exploitation. Further removed from the trappings of exploitation is the film's *second* castration scene (Figure 8.3), which occurs at the fifteen-minute mark.

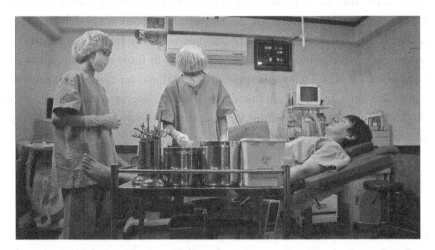

Figure 8.3 The film's second castration is presented as a detached surgical procedure voluntarily requested by the guilt-ridden father. *Moebius* (Kim Ki-duk, 2013).

As yet another potentially traumatizing moment in *Moebius* (for both the characters and the audience), it is treated as an emotionally detached surgical procedure voluntarily requested by the guilt-ridden father, who—planning for a future transplant—wants to give his own genitals to his son. Later, when the son successfully receives his father's penis through surgery, the member can only become erect when it is stimulated by the mother. In a controversial scene that drew opposition from the ratings board, she tearfully performs a hand job on her own son, expressing the emotional if not physical pain that such a "pleasurable" act stimulates. This outwardly incestuous relationship drives the boy's father into a state of jealous fury, and ultimately leads to spousal murder and suicide. After waking up from a wet dream, one in which he imagined having sex with his mother, the son discovers his parents' lifeless bodies and uses his father's gun to destroy his newly grafted penis, the literal "root" cause of this almost comically absurd family tragedy.

In the aforementioned appeal letter to the KMRB, Kim Ki-duk explained his authorial intention in the following way: "*Moebius* is a story about a couple whose jealousy and rage are transferred to their son and everyone involved gives up on pleasure and desire because of guilty consciences and sadness. This film does not reflect my own conclusion; it is rather a question I pose to society."[30] With these words in mind, castration attains deeper thematic relevance beyond its sensorial effect on shocked audiences, insofar as guilt is transferred between father and son and *atonement*, rather than pleasure (or pain), is what is being sought after. This theme is once again underscored in the film's redemptive final scene, in which the son, dressed as a monk, repeatedly bows to a Buddha statue—one that looks identical to the earlier object under which the mother found her weapon of castration but which is now displayed in front of an antiques shop window in a deserted alley of Insadong (a traditional tea district in Seoul) at night. The film's final shot cuts to a self-reflexive close-up of the monk, who displays a knowing smile, as if mocking the scene's own overcooked seriousness and art cinema pretentions.

Castrated sexuality as Lacanian *Lamella*

Overshadowed by the sensationalist themes of castration and incest, Kim's exploration of what the poststructuralist philosopher Michel Foucault calls "peripheral sexualities" or "manifold sexualities"—in this case the sexual

desire of castrated men—has received relatively little attention among film reviewers and cultural commentators.[31] As Foucault argues, in the service of heterosexual bourgeois monogamy, social power marginalizes and oppresses these nonnormative sexualities through the label of "perversion."[32] It is unsurprising, then, that film censorship and the Korean ratings system have served as ideological gatekeepers suppressing cinematic representations of castrated sexualities. *Moebius* is one of the rare films in the annals of world cinema (and one of a kind in the history of South Korean cinema), insofar as it explicitly depicts scenes in which castrated men achieve orgasm. After voluntarily giving up his penis, the father seeks alternative routes to sexual pleasure. Through a Google search, he learns that one can reach the peak of pleasure without a penis, simply by stimulating another of the body's many erogenous zones through self-inflicted pain (namely, scraping and peeling his skin with a rock). While his son is in prison on a false charge of gang rape (the victim of which was his grocer-ex girlfriend—the woman whom the castrated boy only feigned to attack so as not to lose face in front of a neighborhood gang leader he has tried to impress), the father brings a rock as a gift during his visit. Through this rudimentary and unconventional pleasure instrument, both father and son are able to experience orgasmic release despite the physically debilitating pain of self-abrasion, and while being literally and figuratively held captive within a carceral and ideological system that ostensibly acts on behalf of a society needing protection from such "perversions." Eventually, after being released from prison and upon initiating a romantic relationship with the father's former lover, the young man takes his masochistic sexual experiments to the extreme and stabs himself in the shoulder with a knife while attempting to engage in penis-less sex with the grocer woman. His partner helps him to climax by jerking the blade deeper into the body, below the surface of his skin. It is the *woman*, then, not the man, who penetrates the latter with an obviously phallic symbol, capsizing the conventional gender dynamics of onscreen/mainstream sexual relations. Despite Kim Ki-duk's debatable reputation as a misogynist among feminist critics,[33] *Moebius* pushes its deconstructive impulse past the point of pleasurable pain and destabilizes phallocentrism by foregrounding a female character as the *subject*, rather than object, of penetration into a castrated male body.

As previously mentioned, in *The Parallax View*, Slavoj Žižek mobilizes the trope of the Moebius strip as a way to emphasize castration's two paradoxical sides: the *emptiness* associated with the cut (which leaves an absence) and the

excess of the remainder (which, as a surplus of signification, gives meaning to castration). As the philosopher elaborates:

> At its most formal, "castration" designates the precedence of the empty place over the contingent elements filling it. . . . Castration has to be sustained by a noncastrated remainder, a fully realized castration cancels itself. Or, to put it more precisely: *lamella*, the "undead" object, is not a remainder of castration in the sense a little part which somehow escaped the swipe of castration unscathed, but, literally, the *product* of the cut of castration, the *surplus* generated by it.[34]

In *Moebius*, this paradoxical relationship between the lack of penis and the overpresence of libido is vividly portrayed in several sadomasochistic scenes involving carnal desire and simulated sex (between husband and wife, and between son and grocer woman). As Jacques Lacan defines it, *lamella* is a term given to the mythical missing part of libido "which moves like [an] amoeba" and "goes anywhere."[35] The castrated men's sexuality in *Moebius* can be equated with a Lacanian *lamella* that is amorphous and multivalent. Similarly, the Moebius strip-like paradoxes of a castrated male libido, which is both too little and too much, correlate to the inseparable linkage between art and exploitation in Kim Ki-duk's oeuvre. Indeed, void and excess are two sides of the same coin in *Moebius*, which outwardly *lacks* some of the basic devices of traditional cinematic signification, such as dialogue, non-diegetic music, and narrative closure, but which contains a total of *three* castration scenes (first, the son's castration by the mother; then, the father's castration as a self-sacrificial act; and finally, the rapist gang leader's castration at the hands of his avenging victim). The quantitative excessiveness of those genital cuts, which outnumber the castrations occurring in even the most grotesque exploitation films, might elicit chuckles while inducing cringes even among the most incredulous spectators.

In the aforementioned *IndieWire* interview, Kim Ki-duk attests to the fact that foreign audiences at international film festivals from Venice to Toronto laughed during the film's screenings, whereas Korean audiences generally "looked depressed and pained" due to their repressed sexual mores.[36] In his interview with *Fangoria*, Kim also said that he "laughed a lot while shooting and editing it."[37] Despite the film's philosophical underpinnings, transgressive subject matter, and tragic narrative events, perhaps Song Gyeong-won (of the journal *Cine21*) is correct, if a bit too glib, in calling it "a simple, easy, and even light movie."[38] But, like Ōshima's *In the Realm of the Senses* before it, *Moebius*

presents the viewer with a cinematic half-twist, showing its two seemingly contradictory but mutually constituent sides—art and exploitation—at the same time.

Notes

1 Quoted in Ha Seong-tae, "*Moebius*, The Discomfort of the Uncomfortable Gaze at Kim Ki-duk [Moebius *Kim Ki-deok gamdok ul bulpyeonhae haneun siseon ui bulpyeonham*]," *OhMyNews* (June 12, 2013), http://star.ohmynews.com/NWS_Web/OhmyStar/at_pg.aspx?CNTN_CD=A0001874491, accessed October 5, 2016.

2 Steve Chibnall, "Carter in Context," in *The Cult Film Reader*, eds. Ernest Mathijs and Xavier Mendik (Berkshire, UK: Open University Press, 2008), 228.

3 Diana Anselmo-Sequeira, "The Country Bleeds with a Laugh: Social Criticism Meets Horror Genre in José Mojica Marins's *À Meia-Noite Levarei Sua Alma*," in *Transnational Horror Across Visual Media: Fragmented Bodies*, eds. Dana Och and Kirsten Strayer (New York: Routledge, 2014), 144.

4 Ernest Mathijs and Jamie Sexton, *Cult Cinema* (Malden, MA: Wiley-Blackwell, 2011), 7.

5 Ibid., 90.

6 Jeffrey Sconce, "Trashing the Academy: Taste, Excess, and an Emerging Politics of Cinematic Style," *Screen*, 36, no. 4 (1995), 371–93.

7 Joan Hawkins, *Cutting Edge: Art-Horror and the Horrific Avant-Garde* (Minneapolis, MN: University of Minnesota Press, 2000). Laura Hubner also discusses this relationship between high-brow art cinema and lowbrow cult films in "A Taste for Flesh and Blood? Shifting Classifications of Contemporary European Cinema," in *Valuing Films: Shifting Perceptions of Worth*, ed. Laura Hubner (London: Palgrave MacMillan, 2011), 203.

8 David Church, "From Exhibition to Genre: The Case of Grind-House Films," *Cinema Journal*, 50, no. 4 (Summer 2011), 20.

9 Ibid.

10 Laura Mulvey, "Visual Pleasure and Narrative Cinema," *Screen*, 16, no. 3 (1975), 6–18.

11 James Penney, *The World of Perversion: Psychoanalysis and the Impossible Absolute of Desire* (Albany, NY: State University of New York Press, 2006), 20.

12 Slavoj Žižek, *The Parallax View* (Cambridge, MA: The MIT Press, 2006), 122–23.

13 Nicolas Rapold, "Sins of a Father Visited Upon a Son," *New York Times* (August 14, 2014), http://www.nytimes.com/2014/08/15/movies/moebius-directed-by-kim-ki-duk.html?_r=0

14 Hawkins, *Cutting Edge*, 7.

15 Nagisa Oshima, *In the Realm of the Senses*, DVD (New York, NY: Criterion Collection, 2015).

16 Julian Ross, "In the Realm of the Senses," in *The Routledge Encyclopedia of Films*, eds. Sarah Barrow, Sabine Haenni, and John White (London: Routledge, 2015), 21–24; Samara Lee Allsop, "In the Realm of the Senses," in *The Cinema of Japan and Korea*, ed. Justin Bowyer (London: Wallflower Press, 2004), 104.

17 Ross, "In the Realm of the Senses," 21–24.

18 For more information, see Hye Seung Chung, *Kim Ki-duk* (Urbana, IL: University of Illinois Press, 2012).

19 Pak Hyŏn-jŏng, "Twisted Rating for *Moebius* [*Kkoigo kkoin* Moebius *kŭnggŭp simŭi*]," *Hankyoreh* 21, no. 973 (August 8, 2013), http://h21.hani.co.kr/arti/politics/politics_general/35114.html, accessed October 5, 2016.

20 Yi Sŏn-p'il, "Kim Ki-duk's *Moebius* Restricted Screenings? [*Kim Ki-dŏk* Moebius *chaehan sangyŏng*]," *OhMyNews* (June 11, 2013), http://star.ohmynews.com/NWS_Web/OhmyStar/at_pg.aspx?CNTN_CD=A0001874381, accessed October 5, 2016.

21 Song Gyeon-won, "Kim Ki-duk's World Reassembled [*Kim Ki-deok segae ui jaejohap*]," *Cine21* (September 11, 2013), http://www.cine21.com/news/view/?mag_id=74371, accessed October 5, 2016.

22 Ha Seong-tae, "*Moebius*, The Discomfort of the Uncomfortable Gaze at Kim Ki-duk."

23 Jonathan Romney, "*Moebius* Review: An X-Rated Family Affair," *The Guardian* (August 9, 2014), https://www.theguardian.com/film/2014/aug/10/moebius-review-x-rated-family-affair, accessed October 5, 2016.

24 Leslie Felperin, "Venice Film Review: *Moebius*," *Variety* (September 3, 2013), http://variety.com/2013/film/global/moebius-review-venice-toronto-1200597647/, accessed October 5, 2016.

25 Nicholas Rapold, "Sins of a Father Visited upon a Son," *New York Times* (August 14, 2014), http://www.nytimes.com/2014/08/15/movies/moebius-directed-by-kim-ki-duk.html, accessed October 5, 2016.

26 Clarence Tsui, "*Moebius*: Venice Review," *The Hollywood Reporter* (September 3, 2013), http://www.hollywoodreporter.com/review/moebius-venice-review-619085, accessed October 5, 2016.

27 Phil Brown, "Kim Ki-duk's *Moebius* (TIFF Movie Review)," *Fangoria* (September 14, 2013), http://www.fangoria.com/new/moebius-review-kim-ki-duk-tiff/, accessed October 5, 2016.

28 Nigel M. Smith, "Kim Ki-duk on Why the Shocking *Moebius* is a 'Penis Journey,'" *IndieWire* (August 14, 2014), http://www.indiewire.com/2014/08/kim-ki-duk-on-why-the-shocking-moebius-is-a-penis-journey-23164/, accessed October 5, 2016.

29 This seemingly unprecedented moment actually recalls a similar scene of castration and ingestion in the Mondo-style Italian film *Emanuelle and the Last Cannibals* (*Emanuelle e gli Ultimi Cannibali*, 1977), a sexploitation shocker of the grindhouse era in which the titular heroine, a "savage" Amazonian prone to anthropophagy, cuts off and consumes a man's penis. Xavier Mendik, "Black Sex, Bad Sex: Monstrous Ethnicity in the Black Emanuelle Films," in *Alternative Europe: Eurotrash and Exploitation Cinema Since 1945*, eds. Ernest Mathijs and Xavier Mendik (London: Wallflower Press, 2004), 156.

30 Yi Sŏn-p'il, "Kim Ki-duk's *Moebius* Restricted Screenings."

31 Michel Foucault, *The History of Sexuality, Vol. 1: The Introduction*, Trans. Robert Hurley (New York: Pantheon Book, 1978), 42, 47.

32 Ibid., 36–42.

33 For more information, see Hye Seung Chung, *Kim Ki-duk*.

34 Žižek, *The Parallax View*, 122–23.

35 Jacques Lacan, *The Four Fundamental Concepts of Psycho-Analysis*, trans. Alan Sheridan (New York: W. W. Norton and Company, Inc., 1978), 197.

36 Smith, "Kim Ki-duk on Why the Shocking *Moebius* is a 'Penis Journey.'"

37 Brown, "Kim Ki-duk's *Moebius* (TIFF Movie Review)."

38 Song Gyeon-won, "Kim Ki-duk's World Reassembled."

Hara Kazuo and *Extreme Private Eros: Love Song 1974*

Jun Okada

Introduction

The reception of Hara Kazuo's films in the United States has remained mostly within the boundaries of art house, university, and museum archive venues and far from the nostalgic grindhouse spectatorship of exploitation cinema. However, the often-provocative topics of his films demands a reconsideration of his work—in particular, his most personal film, *Extreme Private Eros: Love Song 1974*—as one that traverses the divide between the rarefied, academic world of art cinema and that of exploitation. I argue that Hara's landmark personal documentary breaches the distantiation and respect for subjects usually practiced by his contemporaries in Japanese and international documentary movements, and instead exploits taboo issues in society through a uniquely intimate lens. Specifically, *Extreme Private Eros* explores one of the biggest taboos in postwar Japan: interracial relationships between Japanese women and black men, specifically the African American GIs stationed in Japan during the US occupation.

The presence of African Americans and black culture in Japan has been the subject of important works of scholarship, especially regarding the rising popularity of hip hop music and culture in Japan in 1980s. As Ian Condry points out in *Hip Hop Japan Rap and the Paths of Cultural Globalization*, although race was certainly not the only component of hip hop in Japan, it nevertheless represents one of its most vital, contradictory, and revealing ones. Before hip hop first emerged in Japan in the 1980s, the postwar presence of African American soldiers in Japan during the US occupation has been an object of, albeit underground, fascination and obsession in Japan and becomes one of the

central dramas in Hara's documentary. The central figure in Hara's film, played by his ex-wife Takeda Miyuki, bears a baby fathered by a black soldier. While it appears that Hara embarked on a personal journey to explore the complex nature of his relationship with his ex-wife under the weight of her impulsive, radical feminism, I believe that he also sensed the spectacular possibilities of filming the exhibitionist in Takeda, who, like many of Hara's characters, exposes the hypocrisies and prejudices of Japanese society, specifically that of a Japanese "racial purity." In this way, Hara's film seems to be about Japan's sexual and gender double standards, but instead becomes even more about taboo racial issues.

Yet what sets *Extreme Private Eros* apart is not merely that it exposes a taboo topic. The film becomes a meditation on exploitation through a series of formal relationships—that of filmmaker and subject, occupier and occupied, black and Japanese, and male and female. As an observational documentary, Hara's film invokes the problems inherent to the controversies surrounding Direct Cinema and Cinema Verité, which "give a particular inflection to ethical considerations. . . . when something happens that may jeopardize or injure one of the social actors whose life is observed, does the filmmaker have a responsibility, or even the right to continue filming?"[1] Due to the romantic and domestic history of the filmmaker and subject, these ethical questions are brought into even greater relief through the representation of an intimate, private space in which the intrusion of the camera into personal relationships sets the tone for exploiting the intimacy of everyday life—particularly of domestic and sexual strife. And the conflict that arises between Hara and Takeda sets the tone for the other oppositional dualities within the film.

Unlike the mode of "serious" left wing, collective documentary filmmaking in Japan epitomized by Ogawa Shinsuke in the 1960s to the 1990s, Hara's aesthetic is deeply personal, which is another kind of taboo, as Hara sees it, in established documentary cinema in Japan. As Hara directly points out,

> Ultimately, I think that the difference between Ogawa and myself lies in what each of us wants to see. What, then, do I want to see? In Inoue Mitsuharu's words, "the embarrassing things that human beings keep hidden inside themselves." Those "embarrassing things" are what I want to see: the things people want to hide, the parts they find shameful. Because people hide them, I want to see them. The idea runs through everything I do.[2]

Hara's acknowledged and evident aesthetic, then, is inherently exploitative in wanting to expose those things that are not supposed to be seen, whether it is disabled human beings, sexual intercourse, the birth of a child, or his own demasculinized humiliation, on camera. Though the conflict inherent in taking part in taboo behavior, epitomized by Takeda's biracial love child, is the focus of a lurid and shocking imagination in the film, Hara's film meditates meaningfully on other conflicts—of gender, race, and class. Ultimately, *Extreme Private Eros* is revealed to be a meditation on the nature of exploitation itself, as one of a power struggle between two seemingly opposite forces.

Distribution and global cinema

Made in 1974, *Extreme Private Eros* was Hara's second feature documentary. Begun shortly after the completion of *Goodbye CP* (1972), which is about individuals suffering from cerebral palsy and the effort to make those with this and other disabilities more visible (and, therefore, politically viable) in Japan, Hara decided to focus on his estranged relationship with his ex-partner, Takeda Miyuki, a would-be radical feminist and mother of their then-toddler son. The premise of *Extreme Private Eros* is that Takeda asked Hara to follow her on a mission to Okinawa to meet some women, presumably lower-class women and so-called bar girls, to explore her nascent feminist consciousness, and subsequently to film Takeda giving birth to her mixed-race baby, fathered by one of her black American paramours.

My research reveals that, though Hara's later films, particularly *The Emperor's Naked Army Marches On* (1987), received worldwide acclaim and some exposure stateside, *Extreme Private Eros* did not screen theatrically in the United States when it was released in the 1970s. However, it did screen at film festivals overseas during the over-40-year interim before the nonprofit distributor Facets released DVDs of Hara's suite of documentaries: *Extreme Private Eros*, *The Emperor's Naked Army Marches On*, and *A Dedicated Life* (1994), all in 2007. 2007 also coincides with the era that witnessed the release of multiple Hollywood films, *The Ring* (2002), *The Grudge* (2004), and *Dark Water* (2005), which were remakes of popular J-horror originals. This is significant because it means that Hara's films did not gain a wider, global, mainstream audience until their release on DVD during a time when J-horror became a significant genre and market

signifier, thus, arguably linking one "extreme" to another. Emerging in the late 1990s, "Asia Extreme" films were marketed by UK DVD distributor Tartan Films to capitalize on the trend of horror and violent action films coming out of Japan, South Korea, and Hong Kong for non-Asian audiences. J-horror is truly a phenomenon of contemporary global cinema, a movement set in motion since the end of the Hollywood studio era in the 1970s and which gained momentum in the 1990s, when Asian art-house and genre films became increasingly more popular in the United States. Certainly, I would argue that the link between a national cinema and genre through the ideology of "extremity" seems rooted also in an othering of Asian cultures by Western audiences tantamount to yet another iteration of Orientalism. The coincidence of the DVD release of *Extreme Private Eros* in the United States with the J-horror original versions and remakes demonstrates the market viability of Hara's own "Asia Extreme" nonfiction films.

The reception of the Facets DVD release of Hara's films in 2007 seems to point to various reasons for their resurgence. One reviewer relates the release to a general rise in interest in nonfiction cinema: "As with their recent release of essential works by the brilliant German filmmaker Harun Farocki, Facets has re-introduced Hara at a fertile moment, as documentary continues its ascendancy as a popular film genre and as films like *Borat* trouble the distinction between film production and social activism."[3] And yet, in 2007, *The Brooklyn Rail's* interview of Hara on the occasion of a retrospective at Anthology Archives as well as the release of Hara's first fiction narrative film, *The Many Faces of Chika* (2005), revolves around the "shocking" nature of Hara's oeuvre and relates the importance of shock to his aesthetic.[4] Moreover, a reviewer for the DVD release of *Extreme Private Eros* points out, "though its title suggests a *roman porno* (Japanese soft-core) sex film, it is a personal documentary that details the ambitions of a would-be radical feminist and the filmmaker's ex-wife."[5] The latter reviews attempt to associate Hara's films with an aesthetic of shock that both historicize them in context with Japanese exploitation cinema and with a general sense of "extremeness" that differentiates him from other documentary filmmakers. Therefore, though no explicit explanation is given regarding the revival of Hara, given the nature of the cinema marketplace, I would argue that contemporary stateside interest in Hara's documentaries benefited from the taboo nature of their subjects, and therefore, were readily and commercially able to ride the wave of the J-horror phenomenon.

Direct Cinema, Cinema Verité, Shockumentary?

What transforms the issue of exploitation into a question of documentary form is *Extreme Private Eros*'s use of a mode that is fundamentally ambivalent in terms of ethics. Ever since *Nanook of the North* (1922), questions of ethics have informed nonfiction filmmaking, and the 1960s saw the rise of this discourse with the evolution of film studies and theory. The global shift toward Direct Cinema and Cinema Verité exemplified by nonfiction filmmakers in the West like Richard Leacock, the Maysles brothers, and Frederick Wiseman found its own version of a stripped-down documentary style in Japan. Isolde Standish indicates that there was a shift that happened in Japanese documentary in the 1970s from an "observational and sympathetic mode of filmmaking" to a "more expository or interactive mode" exemplified by *Extreme Private Eros*.[6] It is this interactivity that lends the film an aesthetic of documentary exploitation, asking, who exploits—the filmmaker or his subject?

Although not a classic film within the traditions of Direct Cinema or Cinema Verité, *Extreme Private Eros* trades in the techniques of both modes, in which

> the ethical practices of direct cinema have been consistently called into question. The criticism started in the late 1960s (and were thus leveled at *Salesman* and to a lesser extent *Gimme Shelter*) and reached full voice by the time *Grey Gardens* came to theaters. Influenced by the theoretical approaches of ethnographers and anthropologists, many of those working in film studies argued that any documentary that presented a subject or subjects who could be regarded as suffering under difficult or primitive circumstances and which did not make explicit the filmmakers biases and motives ran the risk of exploiting the subject(s).[7]

Though Hara's film utilizes a Cinema Verité/Direct Cinema style, it is ultimately one that is both reflexive and performative, since Hara attempts to be an unbiased recorder of events but is also in an intimate relationship with the film's subject. The fact that, on the one hand, Hara allows Takeda to give birth to her child unassisted while filming, and on the other, cries when he witnesses Takeda take on new lovers, complicates the extant categories of nonfiction filmmaking. In other words, *Extreme Private Eros* defies Bill Nichols' taxonomy of documentary modes, which explains how the notion of the real as made evident through the representation of facts is deeply affected through each mode's unique relationships of filmmaker, audience, and subject.[8] Hara's film embodies the

participatory through interview techniques, the observational through its ceding of control to its subject, and the performative through the inclusion of Hara's own emotional states, therefore engaging in multiple modes at different moments in the film. And because of the film's protagonist, the question of who is exploiting and who is being exploited becomes part of the discourse and, in fact, destabilizes the classic ethical dilemma of nonfiction cinema. There are indeed moments in the film that challenge ethics, such as the home birth scene, in which Takeda gives birth in Hara's apartment without assistance, a scene that Hara shoots from beginning to end, but whose footage is completely out of focus due to Hara's anxiety about it. In interviews about this scene, Hara admits that he was so unnerved that he didn't notice that the lens was out of focus. The very fact that this intense, unedited scene is filmed through an unfocused lens seems to project Hara's vulnerable role in it. Though he is the one in charge of the camera, the visible evidence seems to indicate that Takeda's very existence in front of the camera compromises his professional detachment, rendering Hara incapable of getting his shot and instead succumbing to nerves and emotional "weakness," as Takeda accuses him of in the film. About his technique, Hara says:

> As a documentarian, I like to become involved in a relationship with my subject, and see how I myself am changed by the relationship, but I don't want to become directly involved, except by holding a camera. It's not that I didn't feel any emotions during the birth scene. I felt many things. But I also felt it wouldn't be appropriate for me to say something, or to add a voice-over later on and express my emotions then. At the time, I was very nervous and didn't know what I would do if something did happen to the baby. I was sweating so much that my glasses became foggy and I couldn't see . . . I was using two cameras, one with a wide-angle lens. With that camera it's sometimes hard to tell if you are in focus. Being nervous is no excuse for my shooting the footage out of focus, but I feel I couldn't have displayed my emotions in a more effective way.[9]

Extreme Private Eros initially approaches the representation of sex and birth as primal events; they are key events in the contentious relationship between Hara and Takeda as well as signifiers in a mythic narrative of heterosexual romance, which is heavily criticized in the film. When Hara films himself having sex with Takeda, it is potentially objectifying in a classic sense. He shoots her with his camera from above while seemingly penetrating her, recording the visible reaction of her sexual pleasure in a medium close-up of her face, eyes closed. (Figure 9.1)

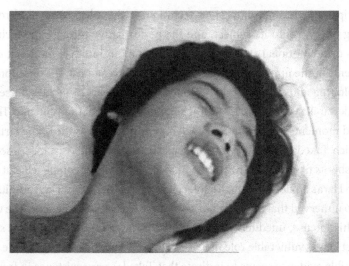

Figure 9.1 Takeda Miyuki filmed by Hara Kazuo while having sex. *Extreme Private Eros: Love Song 1974.*

And as with many parts of the film that seem to lack synchronous sound, sound is omitted here, and we are left with a purely visual image of a woman experiencing sexual ecstasy. Whereas Takeda is very outspoken, analytical, and philosophical in other parts of the film, here she is rendered silent by both Hara's body offscreen and his camera. This scene might fall into what many have categorized as the unethical basis of direct cinema.[10] Yet, despite the evident scopophilic nature of this scene, in an interview, Hara declares that it was Takeda who insisted on being filmed while having sex. He recalls that:

One day, she said, "I want to see what my face looks like while having sex, so I want you to film me." "Oh, I see. OK," I said, and filmed her. Which shows that she definitely knew the pleasure of being filmed. More than that, though what was driving her was her extraordinarily intense desire to see what should normally be hidden, what one is supposed to avert one's eyes from. Like someone's face during sex. That desire to see or know what cannot be seen. If someone told you that they wanted to see their own face in the act of having sex, you'd normally be taken aback . . . but when it came to something like that, Takeda Miyuki's curiosity was extraordinary . . . you might get the wrong impression because I'm always telling stories about women telling me to film things. That's not good.[11]

The sex scene, Takeda's birth scene, as well as yet another scene featuring Kobayashi, Hara's current partner giving birth to their child, may be classically

objectifying, but what the film shows is the question of what/who is controlling the filmmaking process. Hara's recollections confirm what is also already evident in the film. Takeda's "pleasure of being filmed" is so self-conscious and her behavior so narcissistic, that the image of sexual pleasure seems in a way secondary and again emphasizes the question of control that is central to Hara's aesthetic technique. Therefore, this documentary demonstrates an affinity to exploitation cinema through its very filming technique, which is at times scopophilic and pornographic, and at others, a willing exchange of power between filmmaker and subject.

Blackness

Beyond the ambivalence of Hara's filmmaking style, what is most pointed about *Extreme Private Eros*' distinction as exploitation is not only its superficial nods to exploitation cinema—in particular, its sexual content—but its desire to represent taboo behaviors that defy the limits of Japanese social boundaries. The most significant of these taboos is racial mixing. As Nina Cornyetz says, "Japanese racialism has historically marked differences between Asians by positing a variety of discourses on physical (bodily) distinctions, which include the notion of 'pure blood lineage' and the association of purity and acculturation with light skin, discourses which also mark inhabitants of the nation-state Japan as other."[12] While racial purity and whiteness have been deemed the standard in Japan in general, Cornyetz argues that more recently, "twentieth-century Japanese national racial identity was constructed in the shadow of Western black-white binarism, into which Japan could not neatly configure itself. Japanese (and other Asians), who inhabited an in-between space of being neither white nor black, experienced a certain degree of identificatory irresolution. Japanese racial identity frequently took on a relationalism: 'colored' in comparison to whites, 'pale' against blacks."[13] Despite the saliency of Cornyetz's theory, she makes a somewhat sweeping generalization about race in "Japan in the twentieth century," and I would intervene in her conclusions to argue that the presence of American soldiers of color during the postwar occupation of Japan had a specific, catalyzing influence on Japan's understanding of race, national identity, and modernization. I would also further ascribe the postwar presence of African American soldiers in Japan and its inextricability from the US occupation to

the ambivalent understanding of blackness in mainstream popular culture in the 1980s.

Not only is the director exploiting his subject in a documentary style that admittedly pushes the ethical envelope, but he also explores how the individuals and systems represented by the film are ones that exploit or are exploited. *Extreme Private Eros* is concerned mostly with the domino effect of racial exploitation, namely that of the Japanese against Okinawans, particularly Okinawan women; US soldiers against Okinawan and Japanese women; and the Japanese against the African American soldiers who are stationed in Okinawa after the Second World War. The representation of Okinawa is one of racial difference—Okinawa itself and the black US soldiers stationed there. Takeda's self-exile to Okinawa leads to her own exploitation of both Okinawan women and African American soldiers, which problematizes her equally forceful social change agenda based on her feminist, antipatriarchal, anticolonial position. The film itself represents one of the greatest taboos in Japanese culture, that of a Japanese woman consorting with black men. On the one hand, the relationship between Takeda and her brief liaison with Paul, the African American GI, is one of sympathy. In her search for alternatives to life on the Japanese mainland, presumably under the stifling patriarchy of that culture, she first resorts to a relationship with a woman, her friend Sugako, which is revealed to be strained and problematic and ultimately a failure as Takeda realizes that she is not a lesbian. Subsequently, she decides to embark on a tenuous relationship with Paul. However, the film shows the awkwardness and lack of communication between Takeda and Paul in a strained interview in which they struggle to communicate. Though Takeda carries a mixed-race child, presumably Paul's, her relationship with him lasts three weeks, as Hara says in voiceover. Later, Takeda self-publishes a leaflet that she distributes among the bar girls in her neighborhood, warning them of the dangers of black GIs. It reads "Don't fall for black guys with big cock. They will treat you like garbage. Just take the money and run . . . don't ever have sympathy for them. They should all be castrated." (*Extreme Private Eros*) Takeda's sudden reversal of attitude reveals not only her wounded narcissism, but the misdirection of her feminism that supposedly aligns with the African American soldiers and the black power struggle in the 1960s and 1970s, which reveals itself to be superficial at best.

In exploring the most shocking taboos available for exploitation in the Japan of 1974, Hara chose interracial sexuality and procreation. In chronicling the relationships between Japanese women and black American GIs in Okinawa,

Hara kills two birds with one stone. What is interesting about Takeda's foray into interracial relationship, is that, superficially, it is an act of feminist rebellion against Japanese patriarchy. Yet, it also exposes Japan's own history of racism against Okinawans. In other words, *Extreme Private Eros* confronts not just Japanese society's absolute taboo against women having sex with black men, but also the notion of its own internal racial other on the colonial island of Okinawa, which brings the notion of taboo to an even more nuanced level.

Okinawa's history as a historically liminal space in relation to the Japanese Empire is essential to a discussion of race in Japan. For instance, Japanese imperial logic has always seen Okinawa and Okinawans as not only different, but darker. Ever since Okinawa, as part of the archipelago of the Ryuku islands in 1879, was annexed to Japan, "Japan's discourse on Okinawan alterity has historically focused on their darker skin in addition to cultural differences."[14] And the Okinawans' perceived darkness was, inevitably, interpreted as inferiority. As anthropologist Masamichi Inoue points out:

> Okinawa's desire to be fully assimilated as subjects of Imperial Japan was perhaps most acutely and paradoxically expressed in the so-called "Pavilion of the Human Races" incident. During the 1903 Fifth Industrial Exhibition in Osaka, Korean, Ainu, Taiwanese-aboriginal, and Okinawan women were "displayed" in the "Pavilion of the Human Races" for visitors to appreciate the similarities and differences between "real" Japanese and some of the "primitive" Asian peoples within the expanding Japanese empire.[15]

Therefore, the concept of racial superiority and inferiority among the people of the Japanese Empire was an accepted notion since the turn of the twentieth century. And because racism was not a new concept to the Japanese, the Okinawans' default status as Japanese darker, racial other complicates the Japanese/black binaries in the post-Second World War period.

This historical reality contradicts the idea that some scholars have argued that the idea of blackness had come almost entirely from an external source—films, especially—and not from internal sources in Japan, unlike in the United States. As Cornyetz argues in her essay on the racialization of hip hop through blackface performance in Japan in the 1980s and 1990s:

> In spite of the subtexts informing Japan's embrace of hip hop style, such as phallic empowerment, erotic desire, and racial liminality, Japan's enthusiasm for African American style does not emanate from an internal, alternate discourse. Rather, it is introduced through mostly American images (MTV, movies, commercials),

which are then reproduced by Japanese youth. In Japan, a contemporary focus on "surface," coinciding with a mature capitalist disengagement of style from content, facilitates extreme forms of disjunctive montage which reverberate with the formal aspects of hip hop's reconfigurations.[16]

Though Cornyetz discusses how the specificity of African Americans came from an external source to Japan, I argue that when considering the history of Okinawans as Japan's "black other," the concept of blackness and the encounter between Japanese and darker people has always informed ideas of Japaneseness in modern Japan. Before hip hop, one of the major sources of this external American influence derives, of course, from the US occupation of Japan after the Second World War, and in particular, the stationing of black GIs, the concentration of whom happened to be in Okinawa, an island and former Japanese colony whose native inhabitants do not consider themselves racially or culturally or politically Japanese. What is instructive about Hara's film is that it shows how ideas about blackness as taboo can be found in its subordination of Okinawa as its own dark colony, full of its own racial others, an idea that is occluded by Japan's shaky ideology of racial purity. So, although the embracing of "the blackening of the bodily self" through hip hop in Japan reveals a desire for blackness uncomplicated by the history of racism in the United States, Hara's film shows how the fetishization of black men in Japan via the context of Okinawa hides Japan's own troubled relationship to Okinawans.

Much of the scholarship on the presence and representation of African Americans in Japan (Russell, Condry, Graburn, Ertl, Tierney, Weiner) has tended to focus on the influence of outside popular cultural forms, such as the novel, television, film, and pop music to reflect on racial and racialist attitudes. For example, the mainstream global popularity of hip hop in the 1990s generated scholarship about the uses of hip hop in Japan that negotiated the complex strands of consumer culture, US race relations, and Japanese racialism to formulate an understanding of the status of blackness in Japan. Though this discourse is provocative and true, and demonstrates Japan's liminal position with regard to racialization and self-concept in the black/white discourse of global race dynamics as represented through US popular cultural forms, Hara's film, made more than a decade before hip hop became a fixture in the Japanese youth scene, shows how the fetishization of American blackness seems to occlude its own racial skin color politics pertaining to its colonial others, notably Okinawans.

Passive versus Aggressive

One of the film's less concrete but nonetheless central antinomies is that of passivity versus aggression, the notion of which is uttered by both Takeda and one of the "bar girls" in the Okinawan bar that becomes the hub around which much of the drama of the film's Okinawa segment circulates. Upon closer examination, the film's theme of passivity versus aggression is the platform on which the film tries to resolve the power struggles of race, nationality, gender, and class. At first, the obvious struggle is between Hara and Takeda, who reverse their prescribed roles within Japanese gender configurations. In a scene in which Takeda tells Hara of her decision to move in with Paul, Hara weeps on camera, repudiating both the classic notion of an overpowering male filmmaker and objectified female muse/subject. Shortly after Takeda reveals her pregnancy in the film, she expresses to Hara that she wants her child to grow up into a wild and aggressive person, not a passive one like him. The chapter heading of the *Extreme Private Eros* DVD titled "Bar Girls and Black Men" introduces the denizens of the racially segregated "black section" of the US occupied Okinawan city where they live. In this segment, Takeda's estranged partner Sugako parties with African American soldiers in a local bar, dancing to R&B music. Her hair is curled into an Afro-like hairstyle, and she smiles broadly while dancing. Over these scenes of pleasurable nightlife, the voice-over is of a Japanese women saying, "White people use black people and when black men come over here, they use Japanese women."

The film cuts to a new scene of a heavily made up Okinawan teenager in a voluminous Afro hairstyle or wig, who Hara's voice-over introduces as Chichi, a 14-year-old girl working in a bar. She is seen dancing to James Brown's "Hot Pants," scantily clad in just a brassiere and bell bottom pants. She says, "I don't know who the father is. My mother will be furious." (Figure 9.2).

We understand through the interview that Chichi is pregnant with a mixed-race baby and has dropped out of middle school for fighting and receiving bad grades. Though there is an air of resignation about Chichi, her story seems, again, inflected with the notion of aggression that seems to be the elusive quality that Takeda is looking for. She says:

> When I went to school, I dyed my hair red and wore a short skirt. My teacher called me and I told him if I got really mad, I would kill him. Like I would really kill him so he should go away. I think I had too many fights.

Figure 9.2 Fourteen-year-old Okinawan bargirl, "Chi Chi." *Extreme Private Eros: Love Song 1974.*

This confession is shot over an image of Chichi sitting, then undressing, and then lying in bed with her African American lover. These images, within the context of a national culture obsessed with racial purity, would appear to be made to shock its middle-brow Japanese audience at the time. Hara, in his own words has said:

> In Japan, there are many social systems: the system of the imperial family, other cultural systems. There are many restrictions—you cannot do this or that. But the biggest restriction is privacy. What I want to do is not to intrude on *other* people's privacy, but to reveal my own, and to see how far I can go in that revelation. I want to drag my audience into my life, aggressively, and I want to create a mood of confusion. I am very frightened by this, and by the things I film, but it's because I am frightened that I feel I must do these films.[17]

It is telling that, immediately after this segment, Hara cuts to an interview with Takeda in which she argues:

> Life is pointless without the adrenaline rush. When you fear something. Don't you think so? I'm going to raise my kid like a wild child. That's the only way. I will raise him to become someone who can survive on his own no matter where he is and what happens. That's what I mean by "wild child" . . . I don't want my kid to grow up to be gentle and sweet. I want my child to be aggressive. This is how I want him to be.

Takeda addresses Hara, while pointing to their son, saying "You haven't got it in you. He doesn't have the look. That's the way to grow up. Be sweet, gentle and happy.

My ass." One might think that Takeda is making a condescending comparison between her passive, too "sweet and gentle" child with Hara, and her soon to be born black baby. Yet the film seems to elude the possibility of a fair comparison as the baby's father and the other black men that pass through the women's lives barely register in the film. In other words, though the favored "aggression" may be thought to be attributed to the fetishized stereotype of the African American soldiers with whom the Japanese women consort, it is more strongly evident in the film that the most aggressive people in the film are the women, and in particular, the Okinawan women who, unlike Takeda and Sukgako, have nowhere to go and are not merely "slumming it" as bar girls in the name of radical feminism.

The dichotomy between aggression and passivity, in which passivity is reviled, is later confirmed when the despised owner of Bar Ginza reveals that she, too, is "not an aggressive person." The ongoing dispute between the bar owner and Kaylie, one of the film's older Okinawan bar girls, reveals the film's sympathetic position toward wildness and aggression, all the while understanding that Hara himself does not possess these traits and is deemed weak by Takeda, the much stronger presence in the film. Kaylie, for example, discusses the gory details of fights she has gotten into over men. She recalls that her finger fell off and someone stabbed her in the stomach and she had to pull the knife out herself. She started being a bar girl at nineteen and says that girls have it easy today and girls today are wimps, crying when they drink or when a man leaves her. "Girls today have no guts," she says. "They fall in love too easily. Then they lose themselves."

Hara's interview with Kaylie provides the linchpin that clarifies Takeda's misguided race and gender politics in the film while delivering a simple statement about the role of Japanese colonialism, echoed by the inherent power structure of filmmaking. Essentially, by allowing women like Kaylie and Chichi to speak about their experiences as poor Okinawan women working as bar girls, Hara dismantles the ruse of power struggles between men and women and between African American men and Japanese women, which superficially appear as central narratives in the film and, importantly, what generates the potential for the film's generic foray into sexploitation. Hara presents a sexual triangle between Takeda, Sugako, and himself; shoots Takeda and himself having sex; then reveals himself weeping on camera as Takeda goes off with Paul, the African American soldier, and ultimately shoots Takeda giving birth to her mixed-race child. These are narratives of taboo attitudes and experiments by denizens of the Japanese middle class. When we hear Chichi and Kaylie discuss their experiences, the realization of the racial, economic, and colonial otherness

of Okinawans against the bourgeois concerns of the Japanese characters in the film become evident. The submerged discourse of passivity versus aggression and the film's advocacy for aggression is not in Takeda's posturing and bravado, but is instead revealed to be in the rebellion of Okinawan bar girls who have fought their parents; American men, both black and white; and Japanese, both men and women, for their right to dignity, which they find, though scant, in this documentary.

Therefore, the film's thematic meditation on exploitation and the identification of exploiters and exploited becomes apparent in its search for the truth of power dynamics between Takeda and Sugako, Hara and Takeda, Takeda and Paul, et al. Even in the postwar discourse of Japan versus United States becomes less pertinent in the film's understanding of what it means to be a prostitute in a colonial outpost regardless of context. Yet, in the context of Japan's history of imperialism and the stories of poor Okinawan women in *Extreme Private Eros* reveals that true aggression arises out of true exploitation, which both Chichi and Kaylie seem to have experienced.

Notes

1 Bill Nichols, *Representing Reality* (Bloomington, IN: Indiana University Press, 1991), 39.

2 Kazuo Hara, *Camera Obtrusa: The Action Documentaries of Hara Kazuo* (Los Angeles, CA: Kaya Press, 2009), 7.

3 Travis Miles, "Extreme Close-Up: The Fierce Documentaries Of Kazuo Hara," *Stop Smiling* (June 8, 2007), http://www.stopsmilingonline.com/story_detail.php?id=845, accessed January 4, 2017.

4 David Wilentz, "More Freedom and More Shocking," *The Brooklyn Rail* (June 2007), http://www.brooklynrail.org/2007/6/film/more-freedom-and-more-shocking, accessed January 4, 2017.

5 Stuart Galbraith IV, "Extreme Private Eros—Love Song 1974," DVD Talk (May 26, 2007), http://www.dvdtalk.com/reviews/28268/extreme-private-eros-love-song-1974/, accessed January 4, 2017.

6 Isolde Standish, *Politics, Porn and Protest: Japanese Avant-Garde Cinema in the 1960s and 1970s* (London: Continuum, 2011), 142–43.

7 Jonathan B. Vogels, *The Direct Cinema of David and Albert Maysles* (Carbondale, IL: Southern Illinois Press, 2010), 145.

8 Nichols, *Representing Reality*, 39.

9 Scott Macdonald, *A Critical Cinema 3: Interviews with Independent Filmmakers* 3 (Berkeley, CA: University of California Press, 1998), 134.

10 Ibid.

11 Hara, *Camera Obtrusa*, 105.

12 Nina Cornyetz, "Fetishized Blackness: Hip Hop and Racial Desire in Contemporary Japan," *Social Text* 41 (1994), 121–22.

13 Ibid., 123.

14 Michael S. Molasky, *The American Occupation of Japan and Okinawa: Literature and Memory* (New York: Routledge, 2005), 71.

15 Masamichi S. Inoue, *Okinawa and the U.S. Military: Identity-Making in the Age of Globalization* (New York: Columbia University Press, 2007), 57.

16 Cornyetz, "Fetishized Blackness," 117.

17 Scott MacDonald, *Critical Cinema 3: Interviews with Independent Filmmakers* (Berkeley, CA: University of California Press, 1998), 135.

Don't Bother to Dispatch the FBI: Representations of Serial Killers in New Korean Cinema

Kyu Hyun Kim

Introduction

On January 26, 1983, a forty-two-year old Korean man named Yi Tong-sik—an amateur photographer and a professional plumber—was arrested for the murder of a twenty-four-year old woman named Kim. Yi had grown up in poor circumstances, subject to violent abuse by his father, and had committed several felonies. He had shown considerable talent in photography, however, and won prizes at several public photo contests. He befriended Kim, who was then working as an assistant in a local barbershop; in reality, she was a sex worker, and he coaxed her into working as a nude model for him.

On December 14, 1982, Yi lured Kim to an isolated spot on a nearby mountain, allegedly to prepare for a photo session. There, he tricked her into drinking a bottle of cough medicine laced with arsenic, and as she slowly expired in agony, he proceeded to take twenty-one pictures capturing her moments of death. Investigations into Yi's life—he was a married man with three children—revealed that he had previously submitted photographs of dead bodies as a part of his portfolio. His previous, now-missing ex-wife, Pang, had been subject to nightly photography sessions in which she was stripped naked, bound in ropes, and made to suffer other sadistic practices. Pang's immediate family suspected that Yi had actually murdered her and possibly other young women whom he used as "dead models," yet the police and prosecution emphasized Kim's alleged blackmail of Yi as the possible motivation for her murder and downplayed any psychosexual motivation. Ultimately, the police either ignored or could not

uncover any evidence that Yi committed other murders. Yi was executed by hanging on May 27, 1986, only three months after being sentenced to death for the murder of Kim.[1]

Yi Tong-sik's case is lurid, disheartening, and shocking, but is also remarkable for its features that closely resemble the kind of "psychotic serial killer" narrative that would have been perfectly suitable, almost clichéd, for an American thriller/horror film in that particular subgenre. Yet, this real-life story has never been adapted into a motion picture in Korea.[2] This was so despite, first, the alleged massive and dominant influence of Hollywood blockbusters on Korean cinema, and second, numerous examples of vicious serial killers in South Korea's recent history: Kim Tae-tu (1949–76), with seventeen confirmed murders throughout the nation; Chŏng Nam-gyu (1969–2009), a victim of severe sexual abuse during childhood and mandatory military service who turned into a serial rapist-murderer of thirteen young children and women; and Yu Yŏng-chŏl (1970–), responsible for twenty deaths between 2003 and 2004, specifically seeking out the wealthy elderly and sex workers as his victims.

Contrary to the assumption one might have, that the American-style serial killer narrative would have been an ideal candidate for transplantation to the Korean thriller genre, "Korean serial killer films" in the last decade and a half have evolved into a distinctive pattern from the dominant American one. The theoretical and analytical literature that emphasizes the predominance of serial killer narratives as emblematic of the postmodern, late capitalist social condition, therefore, must be severely qualified in terms of their relevance, especially in relation to films outside the United States. These works tend to assume that the serial killer phenomenon—not just the prevalence of a particular mode of crime, but also the great popularity and fascination such killings command in the news media and popular cultural representations—has "universal" messages or insights to confer about the late capitalist/postmodern conditions of the world.[3] However, many features of the serial killer narratives in popular fiction, including contemporary cinema, that one automatically accepts as constituting their distinctive characteristics and iconography, are in fact American, more specifically originated in the post-1980s (culturally Republican-conservative) United States.

In a previous article, I analyzed one of South Korea's best serial killer films, *Tell Me Something* (*T'elmi ssŏmsing*, 1999) to illuminate how its subtle subversion of genre conventions could be read as a critique of the patriarchal social order in

South Korea. The film's sophisticated invocation of artistic symbolism (frequent references to the classic fine art such as Rembrandt's *The Anatomy Lesson of Dr. Tulp* and John Everette Millais' *Ophelia*) as well as its knowledgeable manipulation of the conventions of Hollywood serial killer films and the Italian *giallo* already marked it as meaningfully distinct from its supposed Hollywood models, such as *The Silence of the Lambs* (1991).[4]

For the present chapter, I concentrate on the subgenre of serial killer films from South Korea, in particular three significant films that generated considerable controversies: *Memories of Murder* (*Sarinǔi ch'uŏk*, 2003), *The Chaser* (Ch'ugyŏkcha, 2008), and *I Saw the Devil* (*Angmarŭl poatta*, 2010). The category has been limited to those South Korean thriller/horror films that prominently feature serial killers who are without apparent motives, such as revenge or sexual desire, or are given the kind of motives socially codified as "insane." While there is no shortage of both real-life serial killers (interestingly, some of the most famous serial killers operated under the draconian rule of military dictatorships of the early to mid-1980s) and of cinematic depictions of serial killers in South Korea, we find that they ill suit theoretical perspectives developed on American films. Why and how this is so will be explored below.

I

To begin with, it is helpful to disabuse us of the (often unstated) claim that the serial killers are mainly products of the United States, or of commercial or industrial capitalism: Germany, Japan, Communist China, and Soviet Union have all been home to serial killers, whether the authorities of these countries wanted to acknowledge them or not.[5] Statistically, it does appear that the United States does claim a disproportionately large number of the world's serial killers in relation to its population size: as of September 6, 2016, there are 3,204 serial killers identified in the United States, some 67.58 percent of the worldwide figure (England and South Africa are next in the rank, with 166 and 117 serial killers respectively).[6] The Radford/Florida Gulf Coast University database, however, uses a strongly inclusive definition of serial killing, defining it as "the unlawful killing of two or more victims by the same offender(s) in separate events," and thus includes those cases that involve, for instance, the large-scale slayings of members or civilians by a religious cult, or gangland/

criminal killings with organizational or financial motives. Cinematically, however, dominant serial killer narratives are clearly distinguished from those classifiable as gangster films (murders committed by organized criminals) and horror films featuring near-supernatural characters with no interior psychology to speak of (including "slasher films" like the *Halloween* or *Friday the 13th* franchises) or overtly supernatural perpetrators (e.g., "Freddy Krueger" from the *Nightmare on Elm Street* franchise). The serial killer in these cinematic (or popular culture) narratives is a much more exclusive creature, a joint discursive construction of American law enforcement agencies, in particular the Federal Bureau of Investigation on the one hand and the culture industry, which includes such creative figures as Thomas Harris, the author of the "Hannibal Lecter" novels, Jonathan Demme, Director of *Silence of the Lambs*, David Fincher, Director of *Se7en* (1995) and *Zodiac* (2007), and Andrew Kevin Walker, screenwriter of *Se7en*, on the other. The typical serial killer film, the apex of critical and popular reception for which may be *The Silence of the Lambs*,[7] usually maintains a heavy emphasis on the behavioral characteristics of the killer, often rendered psychopathological and sexually motivated, and the profiler or "mind detective" as the killer's counterpoint figure and antagonist. An important point to remember is that, even though this archetypal modality of the serial killer film subgenre has become entirely absorbed into the mainstream culture in the United States and still commands enormous popularity in the 2010s, as testified by the critical success and/or popularity of TV series that explicitly draw upon it—such as *Criminal Minds* (2005-), *Dexter* (2006-13), and *Hannibal* (2013-15)—it was in fact a rather contemporary "invention," specifically of the Reagan-Bush-early Clinton years, based on a historically limited phenomenon that peaked in late 1980s and early 1990s—the times of the most notorious contemporary serial killers, Ted Bundy (1946-89) and Jeffrey Dahmer (1960-94)—and subsequently declined.

In the immediate postwar United States, "insanity (madness)" was increasingly perceived as a social problem, and "psychopathology" was accepted as a cultural tool for "understanding" criminals. This trend culminated in two masterpieces of non-supernatural horror, Alfred Hitchcock's *Psycho* (1960) and Michael Powell's *Peeping Tom* (1960). Robert Cettl points to the Boston Strangler murders, allegedly committed between 1962 and 1964, as a landmark in terms of introducing psychological "profiling" of the murderer, in this case the confessed killer Albert De Salvo, to cinema as an investigative technique.[8] Subsequent sensationalization of "motiveless" killings, such as the so-called

Zodiac killings (1968–69) and the Charles Manson killings (1970–71) were followed by the creation of the Behavioral Science Unit within the FBI in 1972. The FBI collaborated with mass media to entrench the concept of serial killers in the public consciousness as a great threat to public security and the welfare of the nation. During the news conference, Roger Depue, Director of the FBI's Behavioral Science Unit, allegedly claimed that an estimated thirty-five serial killers were prowling the United States of America and were responsible for 4,000 deaths per year, a patently ridiculous claim, according to which one serial killer had to commit an average of 114 murders every year. In 1984, with the blessing of President Ronald Reagan and the Senate Judiciary Committee, the National Center for the Analysis of Violent Crime was launched, greatly enhancing the public prestige of the FBI's investigations of "repeat killers" and psychological profiling in particular.[9]

Indeed, the notion of the profiler as a specialist in solving these serial murders, and the popular cultural conception of such an investigator "who thinks like the killers" to ultimately deduce the meaning behind his/her modus operandi, a critical component of almost all American serial killer films or TV programs since 1980s, was constructed with the active participation of the select, media-savvy FBI personnel.[10] Philip Simpson points out that well-known FBI profilers like John Douglas, who contributed much to the popularization of the aforementioned image of "mind hunters," consciously drew upon fictional models of crime and detective novels rather than models based on available behavioral science or psychological studies. He characterized his methods by acknowledging that, "though books that dramatize and glorify what we do, such as Thomas Harris's 'memorable' *The Silence of the Lambs*, are somewhat fanciful and prone to dramatic license, our antecedents actually do go back to crime fiction more than crime fact."[11] Since the 1990s, the FBI's profiling methods as well as its highly publicized and touted emphasis on serial killers as a significant public menace have come under increasing criticism and scholarly debunking, while the agency's overall reputation was damaged through a series of scandals and exposures, including its disastrous 1993 engagement with the Branch Davidian cult in Waco, Texas.[12] Maurice Godwin, a former police officer and a psychologist, finds the FBI's profiling methods disorganized, full of discrepancies, biased in terms of selecting case samples, and applying unwarranted value judgments to stated motivations of the perpetrators. He notes that the profilers tend to rely on "inferred deductive assumptions" derived from the perpetrator's life narratives—"story lines"

as it were—in favor of actual empirical data. Godwin acknowledges in his conclusion that:

Detectives and police investigators are particularly vulnerable to the creative fictions of "profilers" because their task is very similar to that of a novelist. Investigators feel the need to invent a narrative that makes sense of all the facts and also indicates the psychological processes that gives [*sic*] the plot its dynamics, usually rather ambiguously referred to as the "motive."[13]

In other words, the desire on the part of the profilers to come up with "motives" that explicitly tie the perpetrator's psychological dispositions to their crimes is so strong that they in essence "construct" such narratives, sometimes with willing participation of the murderers themselves. The profiling methods have never been based on any scientific understanding of the human psychology or inductive-empirical analysis of the actual crimes, yet they have proven to be supremely attractive to the culture producers in the sense that they provide the means to "make sense" of "what make the killers tick," thus subordinating themselves to the dominant ideology of law and order without sacrificing their transgressive appeal.

Of course, one of the tendencies of the Gothic literary traditions is to keep serial killers as ultimately mysterious and eliding rational explanations for their motives, and some serial killer films try to subvert the viewer expectations by deliberately keeping the latter unclear or unarticulated, as we find in, for instance, films such as *The Hitcher* (1986) and *Henry: Portrait of a Serial Killer* (1986). The key information disclosed here is not so much an "explanation" behind the killer's motivations but his/her modus operandi and other aspects of killings themselves. This allows the films to present the serial killers as taboo-breaking "artists" capable of transgressive acts of murder that challenge the accepted ethical norms of mainstream society. This notion of a serial killer as a transgressive artist is strikingly put forward by the FBI profiler John Douglas:

I always tell my agents, "if you want to understand the artist, you have to look at the painting." We've looked at many "paintings" over the years and talked extensively to the most "accomplished" artists.[14]

Thus, despite its (largely superficial) interjection of scientific rationality, American serial killer films are strongly linked to the Gothic Romance tradition, evincing the fascination with "psychology" that often has little to do with the real-life dynamics of how psychology actually affects criminal behavior. It has more to do

with the "literary" logic of a narrative in which the killer is allowed to disavow the "accepted values" of society (Robert Cettl emphasizes "patriarchy") and is then captured, destroyed, or otherwise neutralized by the profiler-detective, his "good" twin, suturing the potential of disruptive schism in the reigning moral order.[15] It is the tension between identification and rejection shared by the serial killer and the profiler-detective that allows the subgenre to effectively comment on the ideological tension of American society.

II

It is not difficult to see that many of the important characteristics regarding the US serial killer subgenre, especially the centrality of the interaction between the serial killer and the profiler-detective, did not take hold in South Korea. *The Silence of the Lambs* opened in South Korea in June 1991 and was a substantial hit, with approximately 280,000 tickets sold in Seoul (before 2004, there are no accurate tabulations of the tickets sold nationwide, only estimates based on Seoul's box office records), and even though it was well received both critically and commercially, its impact on popular culture was not great.[16] In terms of popularity, the moody, allegorical serial killer film *Se7en*, which featured a much more beloved star in Brad Pitt than in either Jodie Foster or Anthony Hopkins from *Silence*, was probably more influential, spawning domestic thrillers such as Kim Sung-hong [Kim Sŏng-hong]'s horror-thriller *Say Yes* (*Sei yesŭ*, 2001), which features a "motiveless" psycho-killer played by the macho star Park Joong-hoon [Pak Chung-hun] and a denouement copied directly from *Se7en*.

The serial killer subgenre, however, received a strong boost with the runaway critical and commercial success of Bong Joon-ho's [Pong Jun-ho] *Memories of Murder* (2003). Based on the real-life case in which ten young women, including two fourteen-year-old junior high school students, were raped and murdered in Hwasŏng County, Kyŏnggi Province, between 1986 and 1991,[17] *Memories of Murder* originated as a play, *Please Come and See Me*, written by Kim Kwang-rim and first put into production in 1996. The play unambiguously focused on the absurdity and incoherence of police investigations under the military dictatorship regime of Roh Tae Woo (No T'ae-u), employing the device of having suspects from various backgrounds and regions played by the same actor, thereby heightening the irony of the arbitrariness of differentiation and identification (which one looks more like a rapist-murderer?) in the supposedly

objective process of the police investigation. The play is less concerned with the social conditions that produced such a monstrous criminal, nor is it really about "what makes the killer tick." This police-centered perspective is carried forward into Bong's film version: it retains the four-person structure constituting the police investigation team and generates much sympathetic reaction and humor from the contrast between Detective Park (Song Kang-ho), a loud-mouthed, mildly corrupt yet sincere local detective, and Detective Seo (Kim Sang-gyung [Kim Sang-gyŏng]), a by-the-book and compassionate detective sent from Seoul. As the film progresses, Seo becomes increasingly frustrated and saddened through his empathizing with the female victims, and he ultimately becomes psychologically unstable, coming to believe the premier suspect Park (Park Hae-il [Pak Hae-il]) was indeed the culprit, even without physical evidence. Meanwhile, Detective Park gradually reveals the ambivalence of the moral position of a state agent under an undemocratic regime, grappling with the oppressive investigation technique that eventually results in the death of a mentally challenged suspect (Park No-shik).

Joseph Jeon's analysis shows that the police investigation in the movie ultimately fails to capture the culprit, paralleling the failure of the process of retrieving historical memory for Korean viewers. The film gradually undermines genre-bound pleasures of watching the police putting together the clues, making sense of the killer's motivations and objectives and bringing the story to an emotionally satisfying conclusion, and instead giving way to repetitions rather than progress, that is, "banalities and dead ends."[18] This allows the film to raise the kinds of questions seldom asked in "serious dramas" recreating or reflecting on the historical traumas of 1980s Korea (say, *Peppermint Candy* [1999] or *May 18* [2007]), or other generic thrillers set in the recent past. Such questions include the complicity of ordinary Korean citizens in the rape-murder case itself, allegorically represented as one of the symptoms of compressed Korean modernity. In the final shot of the film, Detective Park, upon hearing a little girl's testimony that the prospective murderer looked plain, "just ordinary," is deeply disturbed, and he turns around and gazes directly at the camera, that is, the viewers. He is presumably looking at the serial killer who had never been apprehended, and who just might be one watching the motion picture in a theater. But he is also implicating the viewers in the rape-murder: are you not responsible, too, for these terrible victimizations of women? Aren't you, the viewer, who can easily set aside the traumas of the military dictatorships and indulge in the heroic, triumphant narratives of democratization and globalization, oft repeated in

cinema as well as in TV, forgetting this and other incidents of history that never really achieved the status of national trauma?

It is critical here to point out how Bong's thorough and masterful awareness and manipulation of the generic conventions of crime thrillers, and indeed American serial killer films, are brought to enhance the film's power. For instance, Detective Park and Seo, egged on by two befuddled police chiefs (played by Byun Hee-bong [Pyŏn Hŭi-bong] and Song Jae-ho [Song Chae-ho]), at one point engage in an amusing but poignant conversation about why the FBI's scientific method is useless in South Korea of the 1980s. Detective Park insists that South Korea is so small, they just need some legwork to canvas the whole country, against Seo's insistence that the investigation must follow scientific and objective methods, like those of the FBI. Seo's faith in the FBI's "scientific method" is betrayed later in the film when the prime suspect's DNA information does not match one uncovered at the crime scene. Without actually undermining the integrity of forensic science, Bong clearly exposes Seo's belief in "scientific research" as a form of faith, and thus not as rational or objective as he believed.[19] Meanwhile, the efforts of both detectives to draw up a "psycho-sexual" profile of the rapist-murderer fail at every turn: their full acceptance of the socially constructed imagery of "sexual perversity"—metonymically represented in the film by an obsession with female underwear—lead only to impasses, and worse, the death of an innocent person.

The clues presented concerning the motivations or behavioral patterns of the murderer—his preference for certain pop songs, prowling in a rainy night, and so on—are never resolved into any satisfactory interpretation about his identity, just as in the real-life case; yet the film almost seems to be mocking tropes of romantic melodrama, as if the serial killer is "romancing" his victims anonymously. The killer is represented only through his raincoat-covered silhouette and close-ups of his ironically soft, "feminine-looking" hands, which may point to his middle- or upper-class, urban origins. The final murder suspect, Park, ambivalently presented as either sinister or merely affectless (a sense of ambivalence further stressed by the slightly androgynous, dark beauty of the actor Park Hae-il), depending on the audience's interpretation, momentarily appears to be the filmmaker's substitute for the real serial killer, but Bong refuses to supply diegetic clues as to whether he "really" is the killer (i.e., a fictional construction of one) or an innocent victim of the violent yet inefficient investigation methods of the 1980s Korean police. The viewers are denied a cathartic resolution that would have allowed them to come to identify (and

thereby purge from their imagined community) the "real" killer.[20] Originally, Bong had filmed a dream/fantasy sequence in a strongly horror film mode, in which Detective Seo confronts the killer, in person but Bong excised it from the final cut. Aside from its mismatching tonality, the sequence brought attention to the killer's ability to stand outside social reality and directly manifest himself in the protagonist's consciousness. This would have pushed the film toward the kind of psychic link between killers and profilers often observed in American serial killer films.[21]

By the end of *Memories of Murder*, the serial killer is still free and his motives or psychological traumas are never explained. It is not just that he is invisible or inscrutable; he is a character diffused into the narrative, without a firm locus of identity. He is neither the individualized center of wounded trauma, as Mark Seltzer has analyzed, nor the taboo-breaking "artist," as Cettl and others have posited, whose handiwork we can admire while feeling guilty, and then safely remove from our social life and consciousness when he is apprehended or destroyed. He is literally everywhere, an "ordinary" figure who in fact may be one of "us." Even with this truly sobering resolution for Korean viewers, *Memories of Murder* became the biggest box office hit of 2003, having sold approximately 5.26 million tickets nationwide, and has become one of the most influential films of New Korean Cinema. Its critical and commercial success spawned a whole subgenre that might be characterized as "real-life crime films," many of them based on similar real-life unresolved cases, with varying degrees of fictionalization (such as *Voice of a Murderer* [*Kŭnom moksori*, 2006], *Children* . . . , *The Classified File* [*Kŭkpi susa*, 2015]). This subgenre in turn evolved into those thrillers that specifically address the statute of limitations as a device for suspense and milking moral outrage on the part of the viewers (such as *Confession of Murder* [*Naega sarinbŏmida*, 2012] and *Blood and Ties* [*Kongbŏm*, 2013]).[22]

III

Thus, most works of New Korean Cinema dealing with serial killers, following the example of *Memories of Murder*, are concerned primarily with history/memory and the question of social responsibility, marked by the absence or incomplete iteration of the profiler-detective and his counterpoint, the aesthetic-psychotic serial killer, who recasts the serial murders as the problem

of individual psychology rather than social conditions. However, in the 2010s, Korean cinema produced two controversial films that explicitly attempted to transplant the elements of American-style "motiveless killer" narrative into Korean cinema: Na Hong-jin's *The Chaser* and Kim Jee-un's [Kim Chi-un] *I Saw the Devil*. Both films, especially the latter, received much publicity outside South Korea as exemplary cases of "Asian Extreme Cinema,"[23] featuring extreme and grotesque violence, sadistic, graphic, and exploitative content often regarding female victims, and disturbingly aestheticized styles that attempt to render the moments of abjection and terror "beautiful."

Nonetheless, the basic structure of *The Chaser* is solidly based on what I would define as "socially conscious" serial killer films, modeled after *Memories of Murder*. The serial killer featured in the film, Yŏng-min (a star-making performance by Ha Jung-woo [Ha Chŏng-u]), is in fact a fictionalized version of the aforementioned real-life serial killer Yu Yŏng-chŏl. Yu, like Yi Tong-sik discussed in the beginning of this chapter, had artistic aspirations, but unlike Yi, he was not able to have his talents recognized by society. (After failing the entrance examination to a fine arts high school, he apparently gave up on further education.) Initially a petty criminal, he burgled several homes of the retired elderly and strangled or bludgeoned to death at least ten people in 2003. When his profile became widespread, he proceeded to lure "massage girls," mobile sex workers, to his house so that he could rape and then murder them, mostly using a nine-pound hammer that he himself assembled for the specific purpose of cracking human skulls with ease and certainty. All in all, he murdered eleven young women this way between 2003 and 2004.

Writer-director Na Hong-jin's chief innovation was to make the film's investigator-protagonist, Chŏng-ho (Kim Yun-seok [Kim Yun-sŏk]) an antihero only slightly less morally despicable than the killer. A gangster and pimp for one of the missing massage girls, he sets the film's plot in motion when he starts looking for one of his "charges," Min-ji (Seo Young-hee [Sŏ Yŏng-hŭi]), who has a kindergarten-age daughter and is unluckily kidnapped by Yŏng-min. Fascinatingly, the character of Chŏng-ho is also based on a real-life figure, No, who had been a "business associate" of a missing prostitute and was actually rewarded with cash after the police were able to apprehend Yu by drawing upon No's own private investigation and intelligence-gathering. Despite his not insignificant contribution to the capture of Yu, No did not "clean up" his act afterwards and was eventually prosecuted and jailed for committing narcotics-related felonies.

Director Na, by casting the movie-star handsome Ha Jung-woo as the serial killer, presents Yŏng-min as an attractive, sexy young man, yet he explicitly incorporates into his film those features of the American serial killer subgenre that emphasize the monstrosity and psychopathology of the character. The contrast between "normal," even sexually attractive aspects of the killer on the one hand, and his "abnormal," disgusting, animal-like aspects on the other, is unmistakable, yet Yŏng-min is shown to integrate these characteristics into a coherent personality, rather than be subject to uncontrollable schizophrenic tendencies as in *Dr. Jekyll and Mr. Hyde*. Also unlike Bong in *Memories of Murder*, Na inserts a sequence in which Yŏng-min is interrogated by a profiler who verbally pushes him by rudely and provocatively repeating the question, "Aren't you sexually impotent, you piece of shit?" The outcome, however, remains inconclusive, as Yŏng-min's angry reaction does not quite convince the viewers that he is "sincere" about disclosing his pathological conditions. Indeed, Na seems to be much less interested in exploring the psychological state of the serial killer than in the visceral, sensual reaction his looks, behavior (modus operandi), and the environment he operates in (his mock-abattoir for killing and dismembering female victims) generate in the viewers. He does not dwell on excessive gore or graphic violence, but some of the sequences are skillfully suggestive of extreme content, far removed from a typical Korean example of socially conscious cinema. For instance, there is a horrifying sequence in which a piece of a human skull, still attached to clumps of hair, is found on the floor of Yŏng-min's bathroom. Also, a disturbingly aestheticized scene, invoking sadistic pleasures in seeing a murder being perpetrated, is the controversial climactic murder of Min-ji, in which drops of scarlet blood spurting from her head are artfully spread in slow motion over the killer's sunglasses-wearing, inconspicuous face. Yet, we discover very little about Yŏng-min's psychological trauma or his connection to the socio economic or political conditions of the early 2000s Korea: he may be a killer-artist, but we never get to find out "what makes him tick."

Again, fascinatingly, journalistic reports of Yŏng-min's real-life model Yu Yŏng-chŏl's crime spree and eventual arrests include many details, factual or fabricated, that accord much more closely to the American-style narrative of the aesthetic serial killer. Yu allegedly broke into pieces a wooden cross he had been carrying since his teenage years during the sentencing of his first felony trial, violently renouncing his Christian faith; he also practiced killing by stabbing a dog with a kitchen knife, eventually settling on the hammer as an effective

murder weapon. He also, allegedly, kept a list of "people to kill" inscribed on his prison cell walls, only to turn his murderous rage toward anonymous sex workers rather than to his girlfriends or common-law wife. The news report also suggests that he "actively collaborated" with the then Chief of Investigation at the Seoul Metropolitan Police, Kim Yong-hwa, an intellectual policeman with a degree in criminology, when the latter decided to interrogate him directly.[24] All these "story elements" with heavy emphases on Yu's traumatic background and psychopathic tendencies, could have been incorporated into Na's screenplay, but the latter chose against it. As a result, *The Chaser* cleverly picks and chooses those elements out of the American serial killer genre that maximally affect the fear and anxiety of the viewers, leaving out the (mock) cathartic effect of having the serial killer "explained" to them by the profiler-detective.

IV

Conversely, *I Saw the Devil* is calculated to push the envelope of the American-style serial killer subgenre, making killings as disturbing and impactful as possible and essentially eliminating the moral division between the investigator figure Su-hyŏn (Lee Byung-heon [Yi Pyŏng-hŏn]) and the serial killer Kim Kyŏng-chŏl (Choi Min-shik [Ch'oe Min-sik]). In the film, the serial killer, Kim, murders Su-hyŏn's fiancé, Ju-yŏn (O San-ha) and dismembers her body. Having discovered her decapitated head, the NIS protective agent (equivalent to a US Secret Service agent), Su-hyŏn, is consumed by desire for revenge and smuggles out the government's fancy intelligence-gathering gadgets—including a capsule-shaped tracking machine ingested like a medicine pill—to locate Kim. But instead of killing him right away or handing him to the law enforcement, Su-hyŏn lets him go in order to make the latter suffer the same anxiety and fear his victims have felt. Whenever Kim attempts to rape and murder his next victim, Su-hyŏn shows up to punish him both mentally and physically. However, Kim eventually strikes back, removing the tracking system from his body and putting Su-hyŏn's family in jeopardy.

This basic premise could have been carried forward in a number of ways. It could have been deployed to bring a fresh perspective to the relationship between extreme, individualized crimes and the post-9/11 state's increasing surveillance, for instance,[25] or to question the ethical stance of an investigator who brings mortal danger to innocent people in his desire to "punish" the serial killer. The

film, at least in my opinion, fails to realize these potentials because it presents its moral dilemmas in a mechanical, schematic fashion. On paper, Su-hyŏn's action might have been designed to be agonizingly ambivalent in its conflict between the desire for revenge and the duty to uphold the socially ordained moral order, but in the film, the government agent appears to be another psychopath, albeit one who is not deriving any sadistic pleasure out of his actions. The "artist-killer" Kim, too, is portrayed as a foul-mouthed, uncouth middle-aged man, who, when given a chance to articulate his motivations for murder, simply lets out a long, coarse diatribe against his real and perceived enemies and how he is going to cruelly destroy them. This characterization of the killer as a commonplace evil runs directly counter to the extreme aestheticization director Kim Jee-un brings to the scenes of murder and, perhaps equally significantly, the taboo desires he evokes in the viewers in the scenes of anticipation and the aftermath of the murders. For instance, Kim films the first cinematic victim, Ju-yŏn, in the killer's lair, from a bird-eye-view shot as she lays nude, supine, and swathed in blood-stained opaque plastic sheets, pleading in a weak voice that she is pregnant, before the killer, puffing on a cigarette in a display of utter indifference, chops off one of her arms with a cleaver. This scene is presented in a starkly erotic manner to suggest pornographic invocation of sadistic desire. So is the scene in which the camera dwells on the spectacle of Ju-yŏn's decapitated head slowly floating up from below, partially refracted through running stream of water; it is horrific and beautiful all at once. Indeed, this extreme aestheticism in presenting Kim's female victims might be considered the film's genuinely transgressive quality, as few mainstream Korean films have acknowledged the (male) viewer's aesthetic gaze toward victimization of women in such a blatant manner.[26]

However, Park Hung-sik's screenplay and Kim's direction cannot shake loose the dominant mode of the socially conscious serial killer genre in South Korea, and end up making concessions to it. Despite extremely aesthetic representations of the murders, the character of Kim Kyŏng-chŏl is counterbalanced by his explicit crudeness, all too familiar from real-life examples of angry, middle-aged Korean men. Neither does Su-hyŏn become a sympathetic figure who challenges the complacent moral position of the viewers, as his final revenge on Kim involves the serial killer's own parents and children. Su-hyŏn rigs a guillotine-like device so that Kim's parents and children rushing to the latter's rescue activate it and decapitate him, a disappointingly reactionary resolution.[27] In the final image of the film, Lee Byung-heon wails at the sky, presumably regretting that he has become as morally despicable as the killer himself, but again this is not made

explicit and fails to elicit any significant affective response from the viewers. His access to James Bond–like gadgets, superb physical agility and pleasing looks (he is played by one of the most handsome actors in New Korean Cinema), and his behavior—ripping a person's jaw from his skull with bare hands and other acts of superhuman violence—prevents the viewer's identification with him. The viewer is likely to take away moral nihilism, couched in the celebration of aesthetic sadism, as the films ultimate message.

V

In conclusion, based on our brief discussion of the way select critically and commercially successful South Korean serial killer films have responded to the American iterations of the subgenre, I must say Korean filmmakers have eschewed some of the key aspects of the American serial killer films, and went strictly in their own direction. Particularly problematic for the Korean filmmakers is the notion of profiler-investigator as a moral and aesthetic counterpoint to the serial killer, individualized and psychosexually defined. Bong Joon-ho's *Memories of Murder* in essence reversed the formula: to "socialize" the serial killer into a metonymic figure for the incompletely democratized and modernized post-1980s Korean history. The efforts to re-introduce or re-invent "aesthetic" serial killers in the context of New Korean Cinema have been made by Na Hong-jin in *The Chaser* and Kim Jee-un in *I Saw the Devil*. But the former stops at cleverly exploiting such qualities to enhance visceral responses in the viewer, while the latter ultimately lacks the courage to confront the Korean (male) viewer with anything meaningful in the eroticized (virtually pornographic) spectacle of mutilation and dismemberment of female bodies. Despite the commercial success of these two films—*The Chaser* sold 5.6 million tickets nationwide and *I Saw the Devil* 1.8 million, respectively claiming 50th and 175th positions in the all-time box office ranking—subsequent films in the serial killer genre, including aforementioned variants of *Memories of Murder* and other examples such as *My Scary Girl* (*Talkom, salpŏran yŏnin*, 2006), *Our Town* (*Uri tongne*, 2007), and *The Neighbors* (*Iut saram*, 2012), have not attempted to fully embrace the "artist-killer" modality of the subgenre.

Given that there have been in South Korea real-life serial killers, such as Yi Tong-sik and Yu Yŏng-chŏl, whose behavior could have been easily shaped to match the dominant narrative patterns of the American variety—sexually

motivated psychopaths with their "artistic" streaks—I believe we can safely conclude that it is the peculiar artistic and commercial choices of New Korean Cinema filmmakers that resulted in such notable disparity. Our brief discussion suggests that New Korean Cinema, even within a disreputable genre that slides easily into exploitation cinema, has disrupted the imposition of a Hollywood trend and continues to produce locally meaningful works of cinema, while incorporating select aesthetic components from American examples.

Notes

1 See "Naeyŏn p'ongno wihyŏp aein toksal: Chungnŭn mosŭp sajin jjigŏ," [A Threat of exposing an adultery leads to poisoning of a mistress: Photographs her death throes], *Tonga ilbo* (January 21, 1983) and "Yŏnsok ch'waryŏng sarinbŏm chŏnchŏdo haengbang pulmyŏng," [The Ex-wife of the serial photographer-murderer is also missing], *Chungang ilbo* (January 26, 1983).

2 To be fair, one could argue that photographing someone's death throes has served as a motif in several South Korean horror films, such as *The Record* (*Jjik-hŭimyŏn chungnŭnda*, 2000), and this motif might have been put there to invoke the Yi Tong-sik case in popular memory.

3 See Jane Caputi, "American Psychos: The Serial Killer in Contemporary Fiction," *Journal of American Culture*, 16, no. 4 (December 1993), 101–12; Mark Seltzer, "Wound Culture: Trauma in the Pathological Public Sphere," *October*, 80 (Spring 1997), 3–26; Mark Seltzer, *Serial Killers: Death and Life in America's Wound Culture* (London: Routledge, 1998); Steffen Hantke, "'The Kingdom of the Unimaginable:' The Construction of Social Space and the Fantasy of Rivalry in Serial Killer Narratives," *Literature/Film Quarterly*, 26, no. 3 (1998), 178–93; Philip L. Simpson, *Psycho Paths: Tracking the Serial Killer Through Contemporary American Film and Fiction* (Carbondale, IL: Southern Illinois University Press, 2000); Sonia Baelo Allué, "The Aesthetics of Serial Killing: Working Against Ethics in *The Silence of the Lambs* [1998] and *American Psycho* [1991]," *Atlantis*, 24, no. 2 (2002), 8–21; David Schmid, *Natural Born Celebrities: Serial Killers in American Culture* (Chicago, IL: University of Chicago Press, 2005).

4 Kyu Hyun Kim, "Horror as Critique in *Tell Me Something* and *Sympathy for Mr. Vengeance*," in *New Korean Cinema*, eds. Chi-Yun Shin and Julian Stringer (New York: New York University Press, 2005), 106–16.

5 Robert Cettl, "Serial Killer Cinema: An Introduction," in *Serial Killer Cinema: An Analytical Filmography with an Introduction* (Jefferson, NC: McFarland, 2003), 5–10.

6 M. G. Aamodt, *Serial killer statistics* (September 4, 2016), 14, http://maamodt.
 asp.radford.edu/serial killer information center/project description.htm, accessed
 October 25, 2016.

7 Sonia Baelo Allué in "The Aesthetics of Serial Killing" discusses the centrality of
 the 1991 film in terms of aligning the FBI-originated archetype of psychosexually
 disturbed serial killers to the popular cultural images of such criminals, abetted by
 the media reportage of real-life criminal cases (11–21). See also Philip L. Simpson,
 Psycho Paths (70–112), for the contribution of Thomas Harris's novels, including
 Red Dragon and *Silence*, to popularization of such archetypes.

8 Cettl, "Introduction," 10–23. It is worth pointing out that the cinematic retelling
 of the Boston Strangler case (directed by Richard Fleischer, 1968) adds entirely
 fictional details concerning De Salvo's "split" personality, allowing Tony Curtis as
 De Salvo to portray the harrowing psychological process of a seemingly ordinary
 man coming to terms with his own "hidden self." The real-life De Salvo was a
 known criminal with no known history of psychosis.

9 "35 Murderers of Many People Could Be At Large, U.S. says," *New York Times*
 (October 28, 1983); Schmid, *Natural Born Celebrities*, 77–83.

10 The Federal Bureau of Investigation's official webpage lists a "profiler job
 description" which includes competencies in crime data analysis (photos,
 material evidence, and witness reports but not forensic data, which is assigned
 to another group of specialists), working with field personnel over details of the
 crime, maintaining knowledge of cases and investigative techniques, training
 field agents in "behavioral analysis techniques," obtaining psychological and
 behavioral information about violent crimes from local law enforcement agents,
 and "[conducting] research into aberrant psychology and other aspects of violent
 or serial criminal behavior." http://www.fbiagentedu.org/careers/intelligence/fbi-
 profiler/, accessed November 5, 2016.

11 John Douglas, Mark Olshaker, *Mindhunter: Inside the FBI's Elite Serial Crime Unit*
 (New York: Pocket, 1996), quoted in Simpson, *Psycho Paths*, 80.

12 Schmid, *Natural Born Celebrities*, 93–101.

13 Maurice Godwin, "Reliability, Validity and Utility of Criminal Profiling Typologies,"
 Journal of Police and Criminal Psychology, 17, no. 1 (2005), 16.

14 Seltzer, *Serial Killers*, 121.

15 Cettl, "Introduction," 28–31. Mark Seltzer defines this American obsession with the
 transgressive violence of serial killers, along with the propensity to locate the seed
 of such violence in the personalized domain of psychic trauma, as "wound culture,"
 a symptom of the assimilation of the modern subject into the mechanisms of a
 mass-reproduction society. Mark Seltzer, "Wound Culture," 8–15, 18–21. This is a
 fascinating theoretical proposition but again, one must be cautious in applying this
 perspective to other societies and cultures.

16 For a comparison, Jerry Zucker's *Ghost* (1990) was a megahit among Korean viewers, raking in more than 1.6 million tickets in Seoul, only below *Titanic* as the biggest 1990's Hollywood hits of Korea. This illustrates the 1990s domestic viewer's preference for romantic melodramas over thrillers and other horror- or suspense-oriented genre cinema.

17 One of them, the murder of a junior high school student, is now considered to be a copycat killing unrelated to the rest of the murders.

18 Joseph Jonghyun Jeon, "Memories of Memories: Historicity, Nostalgia and Archive in Bong Joon-ho's Memories of Murder," *Cinema Journal*, 51, no. 1 (Fall 2011), 82.

19 For the relationship between archival of memory as a way to remember the past and Detective Seo's character, see Jeon, "Memories of Memories," 92–95. Jeon comes to a positive appraisal of the film's carefully modulated stance toward historical memory, that it presents "a modest historical hope, not for facts or historical narratives, but for the attitudes required to interpret them." That is, the struggle to uncover truths goes on, even though specific cases may never be resolved.

20 *Children . . . [Aidŭl,* 2011], a film based on the unresolved murders of young boys who disappeared in 1991 in the Taegu area, resorts to this very strategy of fictionally creating the murderer with a notably psychotic countenance and butcher-like skills.

21 *Memories of Murder*, Special Edition 2-Disc set DVD (Seoul: Sidus Entertainment, 2003), Supplementary Features: Deleted Scenes.

22 The Hwasŏng murder case's statute of limitations had been reached in 2006. In 2015, the South Korean government eliminated the statute of limitations for any murder, but this law cannot be retrospectively applied to the murders committed before 2015, giving the filmmakers ample room to devise stories involving the statutes of limitations making it impossible to prosecute known murderers.

23 For an analysis of the category of "Asian Extreme Cinema," see Chi-Yun Shin, "The Art of Branding: Tartan 'Asian Extreme' Films," in *Horror to the Extreme: Changing Boundaries in Asian Cinema,* eds. Jinhee Choi and Mitsuyo Wada-Marciano (Hong Kong: University of Hong Kong Press, 2009), 85–100.

24 "10 nyŏnman e: sarinma Yu Yŏng-chŏl pihwa konggae, [After 10 years: Unknown tales of the Serial Killer Yu Yŏng-chŏl now made public]" *Ilyo sisa* (December 21, 2015). http://www.ilyosisa.co.kr/news/articleView.html?idxno=91953, accessed November 7, 2016.

25 For this angle of examining the serial killer genre, see Alzena MacDonald, "Serial Killing, Surveillance and the State," in *Murders and Acquisitions: Representations of the Serial Killers in Popular Culture,* ed. Alzena MacDonald (New York: Bloomsbury Academic, 2013), 33–48.

26 For the possibility of turning around an open acknowledgment of pornographic desire within the structure of the serial killer narrative to provide a critique of hegemonic patriarchal ideology, see Robert Cettl, "Forced Entry: Serial Killer Pornography as Patriarchal Paradox," in MacDonald, ed., *Murders and Acquisitions,* 49–66.

27 "Guilt by association" remains a thorny specter in contemporary Korean society despite its legal rejection of the notion, having been practiced by both Communists and the so-called democratic government in oppressing their political enemies.

Select Bibliography

Allmer, Patricia, Emily Brick, and David Huxley, eds. *European Nightmares: Horror Cinema in Europe Since 1945*. New York: Wallflower, 2012.

Allsop, Samara Lee. "In the Realm of the Senses." In *The Cinema of Japan and Korea*, edited by Justin Bowyer, 103–10. London: Wallflower Press, 2004.

Allué, Sonia Baelo. "The Aesthetics of Serial Killing: Working Against Ethics in *The Silence of the Lambs* [1998] and *American Psycho* [1991]." *Atlantis* 24, no. 2 (2002): 8–21.

Altman, Rick. *Film/Genre*. London: British Film Institute, 1999.

Anderson, J. L., and Donald Richie. *The Japanese Film: Art and Industry*. Rutland and Tokyo: Charles E. Tuttle, 1959.

Anderson, Mark. "Mobilizing Gojira: Mourning Modernity as Monstrosity." In *In Godzilla's Footsteps: Japanese Pop Culture Icons on the Global Stage*, edited by William M. Tsutsui and Michiko Ito, 21–40. New York and Basingstoke: Palgrave MacMillan, 2006.

Anselmo-Sequeira, Diana. "The Country Bleeds with a Laugh: Social Criticism Meets Horror Genre in José Mojica Marins's *À Meia-Noite Levarei Sua Alma*." In *Transnational Horror Across Visual Media: Fragmented Bodies*, edited by Dana Och and Kirsten Strayer, 141–57. New York: Routledge, 2014.

Austin, Thomas. *Hollywood, Hype and Audiences: Selling and Watching Popular Film in the 1990s*. Manchester: Manchester University Press, 2001.

Barr, Jason. *The Kaiju Film: A Critical Study of Cinema's Biggest Monsters*. Jefferson: McFarland, 2016.

Baschiera, Stefano. "Streaming World Genre Cinema." *Frames Cinema Journal*, no. 6 (2014). http://framescinemajournal.com/article/streaming-world-genre-cinema/

Berry, Chris, and Mary Ann Farquhar. *China on Screen: Cinema and Nation*. New York: Columbia University Press, 2013.

Betz, Mark. "High and Low and in between." *Screen* 54, no. 4 (Winter 2013)): 495–513.

Browne, Nick, Paul G. Pickowicz, Vivian Sobchack, and Esther Yau, eds. *New Chinese Cinemas: Forms Identities, Politics*. Cambridge: Cambridge University Press, 1994.

Blouin, Michael J. *Japan and the Cosmopolitan Gothic: Specters of Modernity*. New York: Palgrave MacMillan, 2013.

Bourdieu, Pierre. *Distinction: A Social Critique of the Judgement of Taste*. London: Routledge, 1984.

Bordwell, David. *Planet Hong Kong: Popular Cinema and the Art of Entertainment.* Cambridge, MA: Harvard University Press, 2000.

Boyd, Douglas A., Joseph D. Straubhaar, and John A. Lent. *Videocassette Recorders in the Third World.* New York: Longman, 1989.

Campbell, Joseph. *The Hero with a Thousand Faces,* 3rd ed. Novato, CA: New World Library, 2008 (1949).

Caoduro, Elena, and Beth Carroll "Introduction: Rethinking Genre Beyond Hollywood." *Frames Cinema Journal* (6): 2014. http://framescinemajournal.com/article/introduction-rethinking-genre-beyond-hollywood/

Caputi, Jane. "American Psychos: The Serial Killer in Contemporary Fiction." *Journal of American Culture* 16, no. 4 (December 1993): 101–12.

Cazdyn, Eric. *The Flash of Capital: Film and Geopolitics in Japan.* Durham and London: Duke University Press, 2002.

Cettl, Robert. "Serial Killer Cinema: An Introduction." In *Serial Killer Cinema: An Analytical Filmography with an Introduction,* 5–10. Jefferson: McFarland,2003.

Chan, Kenneth. "The Shaw-Tarantino Connection: Rolling Thunder Pictures and the Exploitation Aesthetics of Cool." *Mediascape: UCLA's Journal of Cinema and Media Studies* (Fall 2009). http://www.tft.ucla.edu/mediascape/Fall09_ShawBrothers.html

Cheng, Anne Anlin. "Wounded Beauty: An Exploratory Essay on Race, Feminism, and the Aesthetic Question." *Tulsa Studies in Women's Literature* 19, no. 2 (2000): 191–217.

Chibnall, Steve. "Carter in Context." In *The Cult Film Reader,* edited by Ernest Mathijs and Xavier Mendik, 226–239. Berkshire: Open University Press, 2008.

Choi, Jinhee, and Mitsuyo Wada-Marciano. "Introduction." In *Horror to the Extreme: Changing Boundaries in Asian Cinema,* edited by Jinhee Choi and Mitsuyo Wada-Marciano, 1–12. Hong Kong: Hong Kong University Press, 2009.

Chow, Rey. *Primitive Passions: Visuality, Sexuality, Ethnography, and Contemporary Chinese Cinema.* New York: Columbia University Press, 1995.

Chun, Jayson. "Learning Bushidō From Abroad: Japanese Reactions to *The Last Samurai.*" *International Journal of Asia-Pacific Studies* 7, no. 3 (September 2011): 19–34.

Chung, Hye Seung. *Kim Ki-duk.* Urbana: University of Illinois Press, 2012.

Church, David. "From Exhibition to Genre: The Case of Grind-House Films." *Cinema Journal* 50, no. 4 (Summer 2011): 1–25.

Church, David. *Grindhouse Nostalgia: Memory, Home Video and Exploitation Film Fandom.* Edinburgh: Edinburgh University Press, 2016.

Cixous, Hélène. "Sorties: Out and Out: Attacks/Ways out/Forays." In *The Logic of the Gift: Toward an Ethic of Generosity,* edited by Alan D. Schrift, 148–73. New York: Routledge, 1997.

Clark, Randall. *At a Theater or Drive-In Near You: The History, Culture, and Politics of the American Exploitation Film.* New York: Garland Publishing, 1995.

Clover, Carol J. *Men, Women, and Chainsaws: Gender in the Modern Horror Film.* Princeton: Princeton University Press, 1992.

Comolli, Jean-Louis, and Jean Narboni. "Cinema/ideology/criticism from Cahiers du cinéma, October–November 1969." In *Screen Reader 1: Cinema/Ideology/Politics,* edited by John Ellis, 2–11. London: Society for Education in Film and Television, 1977.

Condry, Ian. *Hip Hop Japan Rap and the Paths of Cultural Globalization.* Raleigh, NC: Duke University Press, 2006.

Cornyetz, Nina. "Fetishized Blackness: Hip Hop and Racial Desire in Contemporary Japan." *Social Text* 41 (1994): 113–39.

Cook, Pam. *Screening the Past: Memory and Nostalgia in Cinema.* New York and London: Routledge, 2005.

Craig, Maxine Leeds. "Race, Beauty, and the Tangled Knot of a Guilty Pleasure." *Feminist Theory* 7, no. 2 (2006): 159–77.

Curtin, Michael. *Playing to the World's Biggest Audience: The Globalization of Chinese Film and TV.* Berkeley: University of California Press, 2007.

Dannen, Frederick, and Barry Long. *Hong Kong Babylon: An Insider's Guide to the Hollywood of the East.* New York: Miramax Books, 1997.

Davis, Darrell W. and Yeh Yueh-Yu, "Warning! Category III: The Other Hong Kong Cinema." *Film Quarterly* 54, no. 4 (2001): 12–26.

Deamer, David. *Deleuze, Japanese Cinema, and the Atomic Bomb: The Spectre of Impossibility.* New York and London: Bloomsbury, 2014.

Del Río, Elena. *Deleuze and the Cinemas of Performance: Powers of Affection.* Edinburgh: Edinburgh University Press, 2008.

Del Río, Elena. *The Grace of Destruction: A Vital Ethology of Extreme Cinemas.* New York and London: Bloomsbury Press, 2016.

Deleuze, Gilles. *The Logic of Sense.* Edited by Constantin V. Boundas. Translated by Mark Lester and Charles Stivale. New York: Columbia University Press, 1990.

Deleuze, Gilles. "Postscript on the Societies of Control." *October* 59 (1992): 3–7.

Deleuze, Gilles, and Félix Guattari. *Anti-Oedipus: Capitalism and Schizophrenia.* Translated by Robert Hurley, Mark Seem, and Helen R. Lane. Minneapolis: University of Minnesota Press, 1983.

Desser, David. *The Samurai Films of Akira Kurosawa.* Ann Arbor: UMI Research Press, 1981.

Desser, David. "The Kung Fu Craze: Hong Kong Cinema's First American Reception." In *The Cinema of Hong Kong: History, Arts, Identity,* edited by Poshek Fu and David Desser, 19–43. Cambridge: Cambridge University Press, 2000.

Dew, Oliver. "Asia Extreme: Japanese Cinema and British Hype." *New Cinemas: Journal of Contemporary Film* 5, no. 1 (April 2007): 53–73.

Doerr, Neriko Musha, and Yuri Kumagai. "Singing Japan's Heart and Soul: A Discourse on the Black Enka Singer Jero and Race Politics in Japan." *International Journal of Cultural Studies* 15, no. 6 (2012): 599–614.

Douglas, John and Mark Olshaker. *Mindhunter: Inside the FBI's Elite Serial Crime Unit.* New York: Pocket, 1996.

Dyer, Richard. "Stars as Images." In *The Celebrity Culture Reader*, edited by P. David Marshall, 153–76. New York: Routledge, 2006.

Fore, Steve. "Home, Migration, Identity: Hong Kong Film Workers Join the Chinese Diaspora." In *Fifty Years of Electric Shadows*, edited by Law Kar. 126–34. Hong Kong: Urban Council, 1997.

Foucault, Michel. *The History of Sexuality, Vol. 1: The Introduction.* Translated by Robert Hurley. New York: Pantheon Book, 1978.

Freud, Sigmund. *Civilization and Its Discontents.* Translated by James Strachey. New York: W. W. Norton & Company, 2005.

Galbraith IV, Stuart. *Monsters are Attacking Tokyo!* Venice, CA: Feral House, 1998.

Galloway, Patrick. *Asia Shock!: Horror and Dark Cinema from Japan, Korea, Hong Kong, and Thailand.* Berkeley: Stone Bridge Press, 2006.

Gernet, Jacques, and Franciscus Verellen. *Buddhism in Chinese Society: An Economic History from the Fifth to the Tenth Centuries.* New York: Columbia University Press, 1995.

Godwin, Maurice. "Reliability, Validity and Utility of Criminal Profiling Typologies." *Journal of Police and Criminal Psychology* 17, no. 1 (2005): 1–18.

Gold, Thomas, and Doug Guthrie. *Social Connections in China: Institutions, Culture, and the Changing Nature of Guanxi.* Cambridge: Cambridge University Press, 2002.

Goldberg, Ruth. "Demons in the Family: Tracking the Japanese 'Uncanny Mother Film' from *A Page of Madness* to *Ringu*." In *Planks of Reason: Essays on the Horror Film*, edited by Barry Keith Grant and Christopher Sharrett, 468–86. Oxford: The Scarecrow Press, 2004.

Graburn, Nelson H., John Ertl, and R. Kenji Tierney, eds. *Multiculturalism in the New Japan: Crossing the Boundaries Within.* New York: Berghan, 2008.

Greta Aiyu Niu, "Techno-Orientalism, Nanotechnology, Posthumans, and Post-Posthumans in Neal Stephenson's and Linda Nagata's Science Fiction." *MELUS* 33, no. 4 (2008): 73–96.

Gronstad, Asbjorn, and Henrik Gustafsson, eds. *Cinema and Agamben: Ethics, Biopolitics and the Moving Image.* New York: Bloomsbury, 2014.

Guerrero, Ed. *Framing Blackness: The African American Image in Film.* Philadelphia: Temple University Press, 1993.

Guffey, Elizabeth, and Kate C. Lemay. "Retrofuturism and Steampunk." In *The Oxford Handbook of Science Fiction*, edited by Rod Latham, 434–49. Oxford: Oxford University Press, 2014.

Hammond, Stefan. *Sex and Zen & A Bullet in the Head: The Essential Guide to Hong Kong's Mind-bending Films*. New York: Fireside, 1996.

Hantke, Steffen. "'The Kingdom of the Unimaginable:' The Construction of Social Space and the Fantasy of Rivalry in Serial Killer Narratives." *Literature/Film Quarterly* 26, no. 3 (1998): 178–93.

Hara, Kazuo. *Camera Obtrusa: The Action Documentaries of Hara Kazuo*. Los Angeles: Kaya Press, 2009.

Hawkins, Joan. *Cutting Edge: Art-Horror and the Horrific Avant-Garde*. Minneapolis: University of Minnesota Press, 2000.

Hawkins, Joan. "Culture Wars: Some New Trends in Art Horror." In *Horror Zone: The Cultural Experience of Contemporary Horror Cinema*, edited by Ian Conrich, 125–38. New York: I. B. Tauris, 2010.

Hubner, Laura. "A Taste for Flesh and Blood? Shifting Classifications of Contemporary European Cinema." In *Valuing Films: Shifting Perceptions of Worth*, edited by Laura Hubner, 198–215. London: Palgrave Macmillan, 2011.

Huang, Betsy. "Premodern Orientalist Science Fictions," *MELUS* 33, no. 4 (2008): 23–43.

Hayles, N. Katherine. *How We Became Posthuman: Virtual Bodies in Cybernetics, Literature, and Informatics*. Chicago: The University of Chicago Press, 1999.

Hughes, Sherick A. "The Convenient Scapegoating of Blacks in Postwar Japan: Shaping the Black Experience Abroad." *Journal of Black Studies* 33, no. 3 (2003): 335–53.

Hunt, Leon. *Kung Fu Cult Masters: From Bruce Lee to Crouching Tiger*. London: Wallflower Press, 2003.

Hunt, Leon, and Leung Wing-fai, eds. *East Asian Cinemas: Exploring Transnational Connections on Film*. New York: I. B. Tauris, 2008.

Hunter, I.Q. *British Trash Cinema*. London: British Film Institute, 2013.

Igarashi, Yoshikuni. *Bodies of Memory: Narratives of War in Postwar Japanese Culture, 1945-1970*. Princeton: Princeton University Press, 2000.

Inoue, Masamichi S. *Okinawa and the U.S. Military: Identity-Making in the Age of Globalization*. New York City: Columbia University Press, 2007.

Inuhiko, Yomota. "The Menace from the South Seas: Honda Ishirō's *Godzilla* (1954)." In *Japanese Cinema: Texts and Contexts*, edited by Alastair Phillips and Julian Stringer, 102–11. London and New York: Routledge, 2007.

Irigaray, Luce. "Women on the Market." In *The Logic of the Gift: Toward an Ethic of Generosity*, edited by Alan D. Schrift, 174–89. New York: Routledge, 1997.

Iwabuchi, Koichi. *Recentering Globalization: Popular Culture and Japanese Transnationalism*. Durham and London: Duke University Press, 2002.

Jenkins, Henry. *Convergence Culture: Where Old and New Media Collide*. New York: New York University Press, 2006.

Jeon, Joseph Jonghyun. "Memories of Memories: Historicity, Nostalgia and Archive in Bong Joon-ho's Memories of Murder." *Cinema Journal* 51, no. 1 (Fall 2011): 75–95.

Jinhua, Dai. "Rewriting Chinese Women: Gender Production and Cultural Space in the Eighties and Nineties." In *Spaces of Their Own: Women's Public Sphere in Transnational China*, edited by Mayfair Mei-hui Yang, 191–206. Minneapolis, MN: University of Minnesota, 1999.

Joy, Morny. "Introduction." In *Women and the Gift: Beyond the Given and All-Giving*, edited by Morny Joy, 1–52. Bloomington: Indiana University Press, 2013.

Kalat, David. *A Critical History and Filmography of Toho's Godzilla Series*. Jefferson and London: McFarland, 1997.

Kim, Kyu Hyun. "Horror as Critique in *Tell Me Something* and *Sympathy for Mr. Vengeance.*" In *New Korean Cinema*, edited by Chi-Yun Shi and Julian Stringer, 106–16. New York: New York University Press, 2005.

Kim, Kyung Hyun. *The Remasculinization of Korean Cinema*. Durham: Duke University Press, 2004.

Kinoshita, Chika. "The Mummy Complex: Kurosawa Kiyoshi's *Loft* and J-horror." In *Horror to the Extreme: Changing Boundaries in Asian Cinema*, edited by Jinhee Choi and Mitsuyo Wada-Marciano, 103–22. (Hong Kong: Hong Kong University Press, 2009.

Konaka Chiaki, *Hora eiga no miryoku: fandamentaru hora sengen* [The fascination of horror films: A manifesto of fundamental horror]. Tokyo: Iwanami Shoten, 2003.

Kurosawa Kiyoshi. *Kyofu no taidan: eiga no motto kowai hanashi* [Conversations on fear: more scary film stories]. Tokyo: Seidosha, 2008.

Lacan, Jacques. *The Four Fundamental Concepts of Psycho-Analysis*. Translated by Alan Sheridan. New York: W. W. Norton & Company, Inc., 1978.

Lebovic, Nitzan. "The Biopolitical Film (A Nietzschean Paradigm)." *Postmodern Culture* 23(1) (September 2012). http://www.pomoculture.org/2015/07/07/the-biopolitical-film-a-nietzschean-paradigm/

Leong, Anthony C. Y. *Korean Cinema: The New Hong Kong*. Victoria, BC: Trafford, 2002.

Lee, Hyangjin. *Contemporary Korean Cinema*. Manchester: Manchester University Press, 2000.

Li, Li, and Mila Zuo. "*Darao de yishu daoyan Li Yu zhuanfang* [Art That Disturbs: An Exclusive Interview with Director Li Yu]." *Dangdai dianying* [Contemporary Cinema Journal] 218, no. 5 (2012): 73–76.

Lionnet, Françoise, and Shu-mei Shih. "Thinking through the Minor, Transnationally." In *Minor Transnationalism*, edited by Françoise Lionnet and Shu-mei Shih, 1–23. Durham: Duke University Press, 2005.

Logan, Bey. *Hong Kong Action Cinema*. Woodstock: Overlook Press, 1996.

Lovell, Alan, and Peter Kramer, eds. *Screen Acting*. London: Routledge, 1999.

MacDonald, Alzena. "Serial Killing, Surveillance and the State." In *Murders and Acquisitions: Representations of the Serial Killers in Popular Culture*, edited by Alzena MacDonald. New York: Bloomsbury Academic, 2013), 33–48.

MacDonald, Scott. *A Critical Cinema 3: Interviews with Independent Filmmakers.* Berkeley and Los Angeles: University of California Press, 1998.

Martin, Daniel. "Japan's Blair Witch: Restraint, Maturity, and Generic Canons in the British Critical Reception of *Ring*," *Cinema Journal* 48, no. 3 (Spring 2009): 35–51.

Massumi, Brian. *Politics of Affect.* Malden: Polity Press, 2015.

Mathijs, Ernest and Xavier Mendik, eds. *Alternative Europe: Eurotrash and Exploitation Cinema Since 1945.* London: Wallflower Press, 2004.

Mathijs, Ernest, and Jamie Sexton. *Cult Cinema.* Malden: Wiley-Blackwell, 2011.

McDonald, Paul. *Video and DVD Industries.* London: British Film Institute, 2007.

McGray, Douglas. "Japan's Gross National Cool." *Foreign Policy*, 1 May 2002: 44–54.

McRoy, Jay. *Nightmare Japan: Contemporary Japanese Horror Cinema.* Amsterdam and New York: Editions Rodopi B.V., 2008.

Mendik, Xavier. "Black Sex, Bad Sex: Monstrous Ethnicity in the Black Emanuelle Films." In *Alternative Europe: Eurotrash and Exploitation Cinema Since 1945*, edited by Ernest Mathijs and Xavier Mendik, 146–59. London: Wallflower Press, 2004.

Mes, Tom. *Agitator: The Cinema of Takashi Miike.* Godalming: FAB Press, 2003.

Mes, Tom. *Re-Agitator: A Decade of Writing on Takashi Miike.* Godalming: FAB Press, 2013.

Mes, Tom, and Jasper Sharp, *The Midnight Eye Guide to New Japanese Film.* Berkeley: Stonebridge Press, 2005.

Molasky, Michael S. *The American Occupation of Japan and Okinawa: Literature and Memory.* New York: Routledge, 2005.

Morris, Meaghan, Siu Leung Li, and Stephen Chan Ching-kiu, eds. *Hong Kong Connections: Transnational Imagination in Action Cinema.* Durham: Duke University Press, 2005.

Mulvey, Laura. "Visual Pleasure and Narrative Cinema." *Screen* 16, no. 3 (1975): 6–18.

Napier, Susan J. "Panic Sites: The Japanese Imagination of Disaster from Godzilla to Akira." *The Journal of Japanese Studies* 19, no. 2 (Summer 1993): 327–51.

Needham, Gary. "Japanese Cinema and Orientalism." In *Asian Cinemas: A Reader and Guide*, edited by Dimitris Eleftheriotis and Gary Needham, 8–16. Edinburgh: Edinburgh University Press, 2006.

Nichols, Bill. *Representing Reality.* Bloomington: Indiana University Press, 1991.

Noriega, Chon. "Godzilla and the Japanese Nightmare: When "Them!" is U.S." *Cinema Journal* 27, no. 1 (1987): 63–77.

Nornes, Abé Mark. "The Postwar Documentary Trace: Groping in the Dark." *Positions: East Asia Cultures Critique* 10, no. 1 (2002): 39–78.

Nornes, Abé Mark. *Cinema Babel: Translating Global Cinema.* Minneapolis and London: University of Minnesota Press, 2007.

Oksala, Johanna. *Foucault, Politics, and Violence.* Evanston: Northwestern University Press, 2012.

Oliete-Aldea, Elena, Beatriz Oria, and Juan A. Tarancón. "Introduction: Questions of Transnationalism and Genre." In *Global Genres, Local Films: The Transnational Dimension of Spanish Cinema*, edited by Elena Oliete-Aldea, Beatriz Oria and Juan A. Tarancón, 1–15. New York and London: Bloomsbury, 2016.

Penney, James. *The World of Perversion: Psychoanalysis and the Impossible Absolute of Desire*. Albany: State University of New York Press, 2006.

Philips, Alastair, and Julian Stringer, eds. *Japanese Cinema: Texts and Contexts*. London and New York: Routledge, 2007.

Rawle, Steve, "From *The Black Society* to *The Isle*: Miike Takashi and Kim-Ki-Duk at the Intersection of Asia Extreme." *Journal of Japanese and Korean Cinema* 1, no. 2 (2009): 167–84.

Redmond, Sean. *The Cinema of Takeshi Kitano: Flowering Blood*. New York: Wallflower Press, 2013.

Robb, Brian J. *Steampunk: An Illustrated History of Fantastical Fiction, Fanciful Film and Other Victorian Visions*. Minneapolis: Voyageur Press, 2012.

Ross, Julian. "In the Realm of the Senses." In *The Routledge Encyclopedia of Films*, edited by Sarah Barrow, Sabine Haenni, and John White, 21–24. London: Routledge, 2015.

Rowe, Kathleen. *The Unruly Woman: Gender and the Genres of Laughter*. Austin: University of Texas Press, 1995.

Russell, John G. "Consuming Passions: Spectacle, Self-Transformation, and the Commodification of Blackness in Japan." *positions* 6, no. 1 (1998): 113–77.

Ryfle, Steve. 1998. *Japan's Favorite Mon-star: The Unauthorized Biography of "The Big G."* Toronto: ECW Press, 1998.

Scarry, Elaine. *On Beauty and Being Just*. Princeton: Princeton University Press, 2013.

Schaefer, Eric. *"Bold! Daring! Shocking! True!": A History of Exploitation Films, 1919-1959*. Durham: Duke University Press, 1999.

Schickel, Richard. *Intimate Strangers: The Culture of Celebrity in America*. Chicago: Ivan R. Dee, 2000.

Schilling, Mark. *Contemporary Japanese Film*. Trumbull: Weatherhill, 1999.

Schmid, David. *Natural Born Celebrities: Serial Killers in American Culture*. Chicago: University of Chicago Press, 2005.

Sconce, Jeffrey. "Trashing the Academy: Taste, Excess, and an Emerging Politics of Cinematic Style." *Screen* 36, no. 4 (1995): 371–93.

Sedgwick, Eve Kosofsky. *Touching Feeling: Affect Pedagogy, Performativity*. Durham: Duke University Press, 2003.

Seltzer, Mark. "Wound Culture: Trauma in the Pathological Public Sphere." *October* 80 (Spring) 1997: 3–26.

Seltzer, Mark. *Serial Killers: Death and Life in America's Wound Culture*. London: Routledge, 1998.

Shapiro, Jerome F. *Atomic Bomb Cinema: The Apocalyptic Imagination on Film.* New York and London: Routledge, 2002.

Shin, Chi-Yun. "The Art of Branding: Tartan 'Asia Extreme' Films." In *Horror to the Extreme: Changing Boundaries in Asian Cinema,* edited by Jinhee Choi and Mitsuyo Wada-Marciano, 85–100. Hong Kong: Hong Kong University Press, 2009.

Shin, Chi-Yun, and Julian Stringer, eds. *New Korean Cinema.* New York: New York University Press, 2005.

Shin, Mina. "Making a Samurai Western: Japan and the White Samurai Fantasy in *The Last Samurai,*" *The Journal of Popular Culture* 43, no. 5 (2010): 1065–80.

Simpson, Philip L. *Psycho Paths: Tracking the Serial Killer Through Contemporary American Film and Fiction.* Carbondale: Southern Illinois University Press, 2000.

Smith, Iain Robert. "'You're Really a Miniature Bond': Weng Weng and the Transnational Dimension of Cult Film Stardom." In *Cult Film Stardom: Offbeat Attractions and Processes of Cultification,* edited by Kate Egan and Sarah Thomas, 226–39. London: Palgrave MacMillan, 2013.

Smith, Iain Robert. *The Hollywood Meme: Transnational Adaptations in World Cinema.* Edinburgh: Edinburgh University Press, 2017.

Stokes, Lisa Odham, and Michael Hoover. *City on Fire: Hong Kong Cinema.* London: Verso, 1999.

Sontag, Susan. "The Imagination of Disaster." In *Against Interpretation and Other Essays,* edited by Susan Sontag, 209–25. London: Penguin, 2009.

Standish, Isolde. *Politics, Porn and Protest: Japanese Avant-Garde Cinema in the 1960s and 1970s.* London: Continuum, 2011.

Steinberg, Marc. *Anime's Media Mix: Franchising Toys and Characters in Japan.* Minneapolis and London: University of Minnesota Press, 2012.

Tanaka, Motoko. *Apocalypse in Contemporary Japanese Science Fiction.* New York: Palgrave MacMillan, 2014.

Takahashi Hiroshi, *Eiga no ma* [The demon of the cinema]. Tokyo: Seidosha, 2004.

Teo, Stephen. *Chinese Martial Arts Cinema: The Wuxia Tradition.* Edinburgh: Edinburgh University Press, 2009.

Thomas, Brian. *Video Hound's Dragon: Asian Action & Cult Flicks.* Detroit: Visable Ink Press, 2003.

Thompson, Kristin. "The Concept of Cinematic Excess." In *Narrative, Apparatus, Ideology: A Film Theory Reader,* edited by Philip Rosen, 130–42. New York: Columbia University Press, 1986.

Thornton, S.A. *The Japanese Period Film: A Critical Analysis,* Jefferson: McFarland & Company, 2008.

Tsutsui, William. *Godzilla on My Mind: Fifty Years of the King of Monsters.* New York: Palgrave MacMillan, 2004.

Vaughan, Genevieve. *Women and the Gift Economy: A Radically Difference Worldview is Possible.* Toronto: Inanna Publications & Education, 2007.

Vogels, Jonathan B. *The Direct Cinema of David and Albert Maysles*, Carbondale: Southern Illinois Press, 2010.

Wasser, Frederick. *Veni, Vidi, Video: The Hollywood Empire and the VCR*. Austin: University of Texas Press, 2001.

Weiner, Michael. *Japan's Minorities: The Illusion of Homogeneity*. London and New York: Routledge, 2009.

Weisser, Thomas. *Asian Cult Cinema*. New York: Boulevard Books, 1997.

West Alexandra. *Films of the New French Extremity: Visceral Horror and National Identity*. Jefferson: McFarland, 2016.

Willemen, Paul. "Action Cinema, Labour Power and the Video Market." In *Hong Kong Connections: Transnational Imagination in Action Cinema*, edited by Meaghan Morris, Siu Leung Li, and Stephen Chan Ching-kiu, 223–47. Hong Kong: Hong Kong University Press, 2005.

Willis, David Blake, and Stephen Murphy-Shigematsu, eds. *Transcultural Japan: At the Borderlands of Race, Gender and Identity*. Routledge, 2007.

Wing-Fai, Leung. "Zhang Ziyi: The New Face of Chinese Femininity." In *East Asian Film Stars*, edited by Leung Wing-Fai and Andy Willis, 65–80. London: Palgrave Macmillan UK, 2014.

Xiaojiang, Li. "With What Discourse Do We Reflect on Chinese Women? Thoughts on Transnational Feminism in China." In *Spaces of Their Own: Women's Public Sphere in Transnational China*, edited by Mayfair Mei-hui Yang, 261–77. Minneapolis, MN: University of Minnesota Press, 1999.

Yamamoto Ichiro. "The Jidai-geki Film Twilight Samurai—A Salaryman-Producer's Point of View." Translated by Diane Wei Lewis. In *The Oxford Handbook of Japanese Cinema*, edited by Daisuke Miyao, 306–26. New York: Oxford University Press, 2014.

Yang, Mayfair Mei-hui. "From Gender Erasure to Gender Difference: State Feminism, Consumer Sexuality, and Women's Public Sphere in China." In *Spaces of Their Own: Women's Public Sphere in Transnational China*, edited by Mayfair Mei-hui Yang, 35–67. Minneapolis, MN: University of Minnesota Press, 1999.

Yang, Wei. "Voyage into an Unknown Future: A Genre Analysis of Chinese SF Film in the New Millennium." *Science Fiction Studies* 40, no.1 (2013): 133–34.

Yip, Man-Fung, "Martial Arts Cinema and Minor Transnationalism." In *American and Chinese-Language Cinemas: Examining Cultural Flows*, edited by Lisa Funnell and Man-Fung Yip, 86–100. New York and London: Routledge, 2015.

Zahlten, Alexander. *The Role of Genre in Film from Japan: Transformations 1960s-2000s*. Dissertation. Mainz: Johannes Gutenberg University, 2007.

Zhang, Rui. *The Cinema of Feng Xiaogang: Commercialization and Censorship in Chinese Cinema After 1989*. Hong Kong: Hong Kong University Press, 2008.

Zhang, Zhen. "Introduction: Bearing Witness: Chinese Urban Cinema in the Era of 'Transformation.'" In *The Urban Generation: Chinese Cinema and Society at the*

Turn of the Twenty-First Century, edited by Zhen Zhang, 1–48. Durham, NC: Duke University Press, 2007.

Zitong, Qiu. "Cuteness as a Subtle Strategy: Urban Female Youth and the Online Feizhuliu Culture in Contemporary China." *Cultural Studies* 27, no. 2 (2013): 225–41.

Žižek, Slavoj. *The Parallax View*. Cambridge, MA: The MIT Press, 2006.

Zuo, Mila. "Sensing 'Performance Anxiety': Zhang Ziyi, Tang Wei, and Female Film Stardom in the People's Republic of China." *Celebrity Studies* 6, no. 4 (2015): 519–37.

Notes on Contributors

About the Editors

Ken Provencher has taught film and media studies at Josai International University in Tokyo, Japan, and Loyola Marymount University, Los Angeles. He received his PhD in Critical Studies from the USC School of Cinematic Arts. His published work has appeared in *[in]Transition: The Journal of Videographic Film and Moving Image Studies*, *A Companion to Wong Kar-wai* (Wiley-Blackwell), *The Quarterly Review of Film and Video*, and *The Velvet Light Trap*.

Mike Dillon teaches film and media industry studies at California State University, Fullerton. His publications include articles in *Journal of South Asian Film and Media Studies*, *Mediascape*, and *Reconstruction* and chapters in the anthologies *Negative Cosmopolitanisms* (McGill-Queens), *The Encyclopedia of Japanese Horror* (Rowman & Littlefield), and *Transnational Horror Cinema*.

About the Contributors

Kenneth Chan is Professor of English and Director of Film Studies at the University of Northern Colorado. He is the author of *Yonfan's Bugis Street* (Hong Kong University Press, 2015) and *Remade in Hollywood: The Global Chinese Presence in Transnational Cinemas* (Hong Kong University Press, 2009). He has also published many essays in various book-length collections and academic journals, such as *Cinema Journal*, *Asian Cinema*, *Journal of Chinese Cinemas*, *Discourse*, and *Camera Obscura*.

Hye Seung Chung is Associate Professor of Film and Media Studies at Colorado State University. She is the author of *Hollywood Asian: Philip Ahn and the Politics of Cross-Ethnic Performance* (Temple University Press, 2006) and *Kim Ki-duk* (University of Illinois Press, 2012). Her latest book, *Movie Migrations: Transnational Genre Flows and South Korean Cinema* (co-authored with David Scott Diffrient), was published by Rutgers University Press in 2015.

Elena del Río is Professor of Film Studies at the University of Alberta. Her essays on the intersections between cinema and philosophies of the body in the areas of technology, performance, and affect have been featured in numerous journals and edited collections. She is the author of *Deleuze and the Cinemas of Performance: Powers of Affection* (Edinburgh, 2008) and *The Grace of Destruction: A Vital Ethology of Extreme Cinemas* (Bloomsbury, 2016).

David Scott Diffrient is Professor of Film and Media Studies and William E. Morgan Chair of Liberal Arts (2013–16) at Colorado State University. He is the author of *M*A*S*H* (Wayne State University Press, 2008) and *Omnibus Films: Theorizing Transauthorial Cinema* (Edinburgh University Press, 2014) as well as the editor of *Screwball Television: Critical Perspectives on Gilmore Girls* (Syracuse University Press, 2010). His latest book, *Movie Migrations: Transnational Genre Flows and South Korean Cinema* (co-authored with Hye Seung Chung), was published by Rutgers University Press in 2015.

Kyu Hyun Kim is Associate Professor of Japanese and Korean History at University of California, Davis. He is the author of *The Age of Visions and Arguments: Parliamentarianism and the National Public Sphere in Early Meiji Japan* (Harvard Asia Center Publication, 2007), and numerous articles and book chapters on Japanese and Korean history as well as Korean cinema, including those found in *Korean Horror Cinema* (University of Edinburgh Press, 2013), *East Asian Film Noir* (I. E. Tauris, 2015), *The Korean Popular Culture Reader* (Duke University Press, 2014), and *New Korean Cinema* (University of Edinburgh Press, 2005). He also serves as Academic Adviser and reviewer for Koreanfilm.org.

Tom Mes is a self-funded PhD candidate at the Leiden Institute for Area Studies, Leiden University, the Netherlands. His current research project *V-Cinema: Canons of Japanese Cinema and the Challenge of Video* received the Japan Foundation Japanese Studies Fellowship in 2012. As a film critic he founded the online journal MidnightEye.com and published books on Japanese cinema including monographs on directors Miike Takashi and Tsukamoto Shinya. He also regularly contributes liner notes and audio commentaries to DVD and Blu-ray releases of Japanese films.

Jun Okada is Associate Professor in the Department of English, State University of New York Geneseo, where she teaches courses in Film Studies, English and

writing. She is the author of the book *Making Asian American Film and Video: History, Institutions, Movements,* published by Rutgers University Press. Okada has also published essays and reviews in publications such as *Cinema Journal, Film Quarterly, Velvet Light Trap, Screen,* and *Asian Studies Journal.*

Steven Rawle is Associate Professor of Film and Media at York St. John University. He has published several journal articles and book chapters on American independent cinema and cult Japanese cinema. He is the author of *Performance in the Cinema of Hal Hartley* (Cambria Press, 2011) and the co-editor (with K. J. Donnelly) of *Partners in Suspense: Critical Essays on Bernard Herrmann and Alfred Hitchcock* (Manchester University Press, 2017).

Julian Stringer is Associate Professor in Film and Television Studies at the University of Nottingham, UK. His books include *Movie Blockbusters* (Routledge, 2003) *New Korean Cinema* (Edinburgh University Press, 2005), *Japanese Cinema: Texts and Contexts* (Routledge, 2007), and *Japanese Cinema: Critical Concepts in Media and Cultural Studies* (Routledge, 2015). He is Director of the Institute for Screen Industries Research—the first ideas incubator and innovation generator for the film and TV industry based at a leading UK university.

Man-Fung Yip is Associate Professor of Film and Media Studies at the University of Oklahoma. He is the author of *Martial Arts Cinema and Hong Kong Modernity: Aesthetics, Representation, Circulation* (2017) and co-editor of *American and Chinese-Language Cinemas: Examining Cultural Flows* (2015).

Mila Zuo is Assistant Professor of Film at Oregon State University. She holds a PhD in Cinema and Media Studies from UCLA, and her current book project examines the affective work and world-making of Chinese women film stars. Her work on Chinese cinema, gender, and body politics can be found in *Journal of Chinese Cinemas* and *Celebrity Studies.* As a filmmaker, she explores her research interests through creative praxis.

Index

228 *Index*

4
Van Damme, Jean-Claude 7, 77, 82, 87–8
Varan the Unbelievable (Daikaijū Baran,
 1958) 44
Verhoeven, Paul 88
 RoboCop (1987) 88, 89
 Total Recall (1990) 88
Vids (1999-2001) 48
villain 1, 20, 26, 38, 40
Vishnevetsky, Ignatiy 137, 142
Voice of a Murderer (Kŭnom moksori,
 2006) 197
von Trier, Lars 162

Wachowskis, The 88
Wada-Marciano, Mitsuyo 98, 101–2
Wakamiya, Yoshibumi 58
Walker, Andrew Kevin 191
Waller, Gregory A. 101
Wang, Baoqiang 116
Wang, Yu 125
War City series 86
War of the Gargantuas (Furankenshutain
 no kaijū: Sanda tai Gaira,
 1966) 38, 41, 44
Watanabe, Ken 63
Watanabe, Naoko 142
Weiner, Michael 182
Wild Wild West (1999) 21
Willemen, Paul 97
Wiseman, Frederick 176
Wishman, Doris 156
Wong, Carter 81
Wong, Casanova 77, 79
Wong, Kar-wai 15
Woo, John 15, 86, 87
Woo-ping, Yuen 79, 88
Worth, David 87
wuxia pian xiii, 15–31

X From Outer Space, The (*Uchū daikaijū*
 Girara, 1967) 35, 42
Xu, Laurence 122
Xu, Zheng 116

yakuza 135–54
Yamada, Yōji 60–2, 66, 70
Yang, Wei 20
Year of the Kingboxer (1991) 87
Yen, Donnie 88
Yeon, Sang-ho xii
Yi, Tong-sik 188–9, 198, 202
Yongary: Monster from the Deep (Taekoesu
 yongary, 1967) 43, 45
Young Detective Dee: Rise of the Sea Dragon
 (2013) 19
Yu, Albert 87
Yu, Ronny 88
Yu, Shu 119
Yu, Yŏng-chŏl 189, 198–9, 202
Yuan, Xiaochao (Jayden Yuan) 23

Zahlten, Alexander 103
Zhang, Rui 119
Zhang, Yimou 15
Zhang, Zhen 126
Zhang, Ziyi 113, 123
Zhongkui: Snow Girl and the Dark Crystal
 (*Zhong Kui fu mo: Xue yao mo ling,*
 2015) 19
Zhou, Raymond 118
Žižek, Slavoj 159, 167
Zodiac America 3: Kickboxer from Hell
 (1990) 87
zombie movie x–xiii, 25
Zu: Warriors from the Magic Mountain (Xin
 shushan jianxia, 1983) 88
Zwick, Edward 60, 67, 70